Black State of the Arts

A Guide to Developing a Successful Career as a Black Performing Artist

BookWorld Press & *ANACUS* PRESS INC.

Published by Anacus Press Inc. & BookWorld Press

Distributed by
BookWorld Services, Inc.
1933 Whitfield Park Loop
Sarasota, FL 34243
24 hour ordering line: 1-800-444-2524

Publisher's Cataloging in Publication

Kersey-Henley, Tanya
 Black state of the arts: a guide to developing a successful
career as a black performing artist / Tayna Kersey-Henley with
Bruce Hawkins. — 2nd ed.
 p. cm.
 ISBN: 1-884962-04-1

 1. Afro-Americans in the performing arts—Vocational
guidance. 2. Performing arts—Vocational guidance. 3. Career
development. I. Title.

PH1590.B53K37 1996 790.2

Forever, this book is lovingly and gratefully dedicated to my late aunt Hilda Haynes, one of the first black actresses to break down the color barriers in television, soap operas, and commercials.

To contemporary audiences, Hilda is probably best remembered as the first actress to play Nell Carter's mother on the television show *Gimme a Break*. Her career spanned over 45 years and 200 roles. Hilda's most memorable Broadway performances included roles in the original Broadway companies of *A Street Car Named Desire*, *The Great White Hope*, *Blues for Mr. Charlie*, and *Golden Boy*. Roles in the feature films *Purlie Victorious*, *The River Niger*, *The Pawnbroker* and *Let's Do It Again* were among her best known work. Hilda was also featured in countless television shows, including *Starsky and Hutch*, *The Jeffersons*, *That's My Mama*, *The Rookies*, *Trapper John, M.D.*, *Dynasty*, *The White Shadow*, *Family*, *Sanford & Son*, and *Good Times*.

The inspiration for this book came from Hilda's unfinished plan to educate black performers about their show business careers. This book is a tribute to Hilda and other black trailblazers whose unprecedented accomplishments and recognition have opened the doors of opportunity for performers like me and left us with a legacy that we are proud to follow.

Tanya Kersey-Henley

Acknowledgements

We would like to acknowledge the following people and offer our heartfelt thanks and gratitude for their personal assistance and contributions to *Black States of the Arts*: Lisa Kersey; Shirley Jordan; Dr. George Hill; Peggy Epps; Lucille and Eddie Varner; Earl Grandison; Tracey Moore Marable; James Thomas; Joanne Morris; Delores Morris; Ph.D.; Lisa and Paul Jones; Quad Right Copy Center of New York; Denise Locke; Geneva Grace Kellam; Sid Blaize; Patti Carpenter and Saiyuri Doi; Gregory Gray; Phillip Swenson; Leo Shull Publications; Evalyn Hamilton; Richard Andert Photography, Los Angeles; Bill Morris Photography, New York; Chiquita Ross; Vivian Robinson, President, AUDELCO; Jackie Jones, Esq.; Johnnie Mae Allen; Karen Williams, Ford Models; Robin Dunn, Duntori & Company; Gwendolyn Quinn; Ocean Capital Corporation; and World Graphics. We would also like to thank all the actors, actresses, models, and other performers who graciously donated their photographs, both new and old, to complete our Photo Gallery section.

This book could not have been written without the courage and generosity of countless active members of the show business community. Special thanks to all of the industry insiders for their candid and honest interview comments.

Our deepest appreciation goes to Al and Cynthia Kersey, Ron Henley, Monique Henley, Brittany Henley, Franz Wallace Sr., and Brenda Joyce, without whom the completion of this project would not have been possible.

Finally, thanks to God—He knows why.

CONTENTS

Tanya Kersey-Henley is a savvy young black woman who bears watching in the '90s. She is the founder and CEO of Love Child Publishing, an independent publishing company dedicated to the service and progress of African-Americans in the entertainment industry. Ms. Kersey-Henley formed Love Child Publishing to nurture, support, inspire, motivate, and aid in the growth of African-Americans interested or involved in show business careers, and she's on a mission to navigate and spearhead this growing new market. In addition to authoring *Black State of the Arts: A Guide to Developing a Successful Career as a Black Performing Artist*, Ms. Kersey-Henley is also the author of *The Performer's Plan: A Business Plan for Performers*. She is the publisher and editor-in-chief of *Black Talent News*, a trade publication for African-Americans in the entertainment industry; editor and publisher of the annual *Black Talent News Industry Directory*, an annual directory of career services and talent contacts for African-Americans in show business; and editor of *The Black Actor's Book of Original Scenes and Monologues*.

In addition to being the creative brain behind Love Child Publishing, Tanya writes for several trade publications and is editor of two newsletters. She has been interviewed on count-less radio and television shows and is also a versatile seminar leader and public speaker. Her "Doin' The Show Biz Shuffle" for large-scale public events such as Black Expo and "You Gotta Stay in School If You Wanna Be a Star" for high school students in the L.A. Unified School System have been well received. She has plans to take these seminars on the road to colleges, universities, and high schools throughout the U.S.

Prior to embarking on her writing/publishing career, Ms. Kersey-Henley earned her living as an actress in New York for many years. A member of SAG and AFTRA, Tanya appeared on *All My Children*, *Search for Tomorrow*, *The Guiding Light*, on several primetime television

shows and commercials, and on the N.Y. stage. She honed her acting skills in the Mason Gross School of the Arts B.F.A. Acting Program at Rutgers University, where she studied under the tutelage of veteran actor Avery Brooks. While acting in New York City, Tanya formed Talent Unlimited, a talent consulting company that helps aspiring performers map out successful career strategies to break into the industry. Upon moving to Los Angeles to continue her acting career, Tanya continued working behind the scenes, guiding the careers of over 200 young models as Agency Director for a California modeling agency. She currently serves on the Board of Directors of the Los Angeles Women's Theatre Festival and has been selected for the prestigious listings of *Who's Who in American Authors, Writers and Poets*; *International Who's Who of Professional & Business Women*; *Who's Who in America;* and *Who's Who of American Women*.

Tanya was recently awarded a full fellowship to the prestigious Stanford Professional Publishing Course at Stanford University. She resides in Los Angeles with her husband, Ron, and her two young daughters, Monique and Brittany.

BRUCE HAWKINS has worked in film, television, theatre, industrials, daytime television, commercials, and print. He has danced in five dance companies and has taught dance in Europe, Africa, Japan, the Carribean, and the United States. His special skills also include work as a junior puppeteer, a hand model, and an editorial makeup artist.

A native of Baltimore, Bruce has appeared in the pages of *Emerge, Essence, Encore, Jet, Ebony, Mademoiselle, Brides, and Glamour* magazines and is a 1983 AUDELCO Black Theatre Achievement Award winner.

Bruce currently resides in New York City, where he continues to pursue his acting work while teaching dance in private studios, colleges, and universities and writing two new books. Bruce is a member of the Screen Actors Guild, the American Federation of Television and Radio Artists, and Actors Equity Association.

PREFACE

Continuing the legacy of the late great Dr. Martin Luther King Jr., African-American performers are engaged in a day-to-day battle for fair and equal rights and consideration, for equal access to job opportunities, for a fair chance to get their foot in the door. And, as was with Dr. King's crusade, it's a non-violent battle. It's a fight fought with the weapons of knowledge, money, and power, knowledge of what you're up against, money used to pave your own way and develop your own projects, and the power which you use to make a difference.

Dr. King saw the other side of the mountaintop and the glory of the promised land. And he was right when he said, "How long? Not long!" Because 25 years later—today—African-American performers are living his dream in the promised land with the stardom, money, and the power to pave their own way. Sure, there are many others still forging ahead, but with faith, hope, and change, we all will be sitting on the mountaintop.

INTRODUCTION

*B*lack State of the Arts is about being a black performer in the entertainment industry—the black state of the arts.

For African-Americans in the entertainment industry, the past several years have provided some encouraging developments. In 1990, two black actors were honored with Academy Award nominations for their brilliant work in feature films, and one of those actors won. Since then, several more have received Academy Award nominations. Numerous black performers have premiered in their own network television shows and several writer/producer/directors have bought their talents to prime time television in the form of successful dramatic and comedy series. Others have had feature film box office successes and find themselves with long-term production deals with the industry's biggest powers. And the list goes on. The entertainment industry appears to be realizing the talents and money-making potential of African-Americans. With this in mind, black performers who are beginning their careers and who aspire to have careers in the entertainment industry desperately need to be informed about the "black state of the arts."

In response to the needs of all the potential creative black talent who have the desire, yet who do not know how or where to begin their careers, *Black State of the Arts* will take you by the hand, step-by-step, and lead you into the wonderful and fickle world of show business. It is very important for African-American performers to understand how this industry operates because, with this knowledge at hand, they will be better equipped to deal with the bad cards they will often be dealt. They'll be better able to understand that the unfairness they experience is not a direct personal assault. In the United States, it's the direct result of decades of institutional racism, discrimination, oppression, and ignorance about the black American community in general. With this knowledge at hand, black performers will be in a better position to knock down the doors and jump over the hurdles that lie before them.

Black State of the Arts is not an attack on the existing problem of industry discrimination and racism, which is still rampant. Nor is this book meant to convey the impression that we are content with the current status of blacks, who remain severely under-represented in the field. The negative stereotyping of blacks as fat mammies, maids, rascally picaninnies, shuffling Uncle Toms, and dim-witted buffoons is indeed a serious problem that must be reckoned with. Though this book is not a thesis on racism and discrimination in the entertainment industry, black performers must understand that, by virtue of color or ethnicity, they will encounter situations that have racial undertones.

It is still unfortunate that industry racism exists in 1995. Black performers have made such great progress in front of and behind the cameras of the American entertainment industry. There are actors, writers, directors, producers, technicians, and other creative professionals who constantly challenge the images we see presented in the media. The walls created by fear and prejudice are slowly beginning to fall.

Black State of the Arts will expose you to the negative situations you may encounter and inform you of the obstacles you may face in the pursuit of a show business career. Whether you choose to be totally "artistic" or merely want to cash in on your commercial marketability, you will undoubtedly be faced with the familiar questions that are representative of this unpredictable career path, and you will also be bait for the many rip-off artists, charlatans, and sleazy crooks who are out to take advantage of anyone in this business.

Black State of the Arts gives you inside information from some of the entertainment industry's most illustrious casting directors, agents, writers, directors, producers, and performers, who were interviewed for this book. These industry professionals offer their advice on a broad range of topics including pictures, résumés, networking, agents, managers, casting directors, interviews, auditions, career management, money management, grooming, and training, and they discuss concrete strategies to develop, maintain, and sustain productive careers as African-American performers.

Black State of the Arts honestly examines the black performer's plight in the entertainment industry, with sensitivity and insight, from a black perspective.

Written specifically to educate the public about the industry options open to the black performer, this "forum," as we like to call it, has taken more than seven years of research, legwork, interviews, and note collecting. We hope our findings will be of specific interest to all performers and show business professionals.

In researching our topic, we found many generous and talented people of all persuasions who were willing to talk about their related experiences openly and freely. We will be forever grateful to the producers, directors, writers, casting directors, agents, performers, and other industry professionals who gave unselfishly of their time, materials, and opinions. This is not an easy

subject for everyone to talk about, and many people, those both in front of and behind the camera, wanted to be reassured that there would be no negative repercussions beforehand. Since this is the first book of its type, the publication of *Black State of the Arts* will cause some expected controversy. And it's about time this happens, in an educated, positive way.

In spite of the generosity of many people who gave interviews, there were many painful rejections. The reasons sometimes were subtle, but they had an impact on the text of this book. Anyone who had the courage, insight, and personal direction to address the issues presented in this book should be respected and applauded.

We hope our readers and supporters will find only success in their professional endeavors, and we hope this book will provide some insights into the black state of the arts.

1

BLACK STATE OF THE ARTS:
A HISTORICAL PERSPECTIVE

Overview

Black performers appear to be making gigantic strides in the entertainment industry. See for yourself—turn on your television set. You'll be hard-pressed to find many of today's daytime and prime time shows without a black performer. The 1995 prime time television schedule boasted 11 shows with primarily black casts: *The Wayans Brothers*, *The Parenthood*, *In the House*, *Family Matters*, *The Fresh Prince of Bel Air*, *Hangin' with Mr. Cooper*, *Martin*, *Living Single*, *Sister Sister*, *Cleghorne*, and *The Preston Episodes*. Five other shows—*Touched By An Angel*, *New York Undercover*, *Homicide*, *ER*, and *Walker, Texas Ranger*—feature black performers in starring or co-starring series roles. Six years earlier, in 1989, the prime time television season boasted six shows with primarily black casts—*The Cosby Show*, *A Different World*, *227*, *Amen*, *Family Matters*, and *Snoops*.

The latter part of the 1980s saw an onslaught of films with all or large black casts: *Coming to America*, *Harlem Nights*, *Hollywood Shuffle*, *She's Gotta Have It*, *A Soldier's Story*, *Cry Freedom*, *Glory*, *Sidewalk Stories*, *The White Girl*, and *House Party*. That trend appears to have continued. In 1995, 19 black-cast films made it into theatres—*Bad Boys*, *Clockers*, *Dead Presidents*, *Demon Knight*, *Devil in a Blue Dress*, *Drop Zone*, *Friday*, *Higher Learning*, *Major Payne*, *New Jersey Drive*, *Out of Sync*, *Panther*, *Tales from the Hood*, *The Glass Shield*, *The Nutty Professor*, *The Show*, *The Walking Dead*, *Vampire in Brooklyn*, and *Waiting to Exhale*.

On the surface, the trend seems to be to include black performers in more visible roles in television and film. But what's happening beneath the surface? What's the situation like for the

African-American performer struggling to begin a career in the entertainment industry? What's the career reality for the average black actor?

In an article that appeared in *Black Talent News*, the numbers speak for themselves:

> In 1995, the six television networks (ABC, CBS, NBC, Fox, UPN and WBN) introduced 42 new shows for the fall prime time television season. In all, the 1995 schedule had 107 new and returning shows. Comedies represented 68% of the new series (compared to 45% last year). Dramas were outnumbered 2 to 1. And how did African-Americans fare? Of the 42 new prime time shows, only three fall into the category of "black" shows—*Cleghorne!* (starring Ellen Cleghorne with Alaina Reed Hall, Garrett Morris, Cerita Monet Bickelmann, and Sherri Shepherd), *The Preston Episodes* (starring David Alan Grier), and *Minor Adjustments* (starring Rondell Sheridan). None were produced by African-Americans. There were, however, several African-Americans starring and co-starring as series regulars in new shows—Michael Michele in *Central Park West* and Hill Harper in *Live Shot*. On the normally conservative CBS network, of the eight series regulars on *Courthouse*, three were African-American—Robin Givens, Jennifer Lewis, and Jeffrey D. Sams. Over at Fox they ordered 13 more episodes of *New York Undercover*. Fox also aired the pilot for Thomas Carter's drama *Divas* as a Fox Tuesday night movie. *Divas*, executive produced by Thomas Carter (*Under One Roof*), was originally scheduled as a mid-season pickup, but Warner Brothers TV began haggling with the network over how many episodes would be ordered, so Fox decided to throw it at audiences to see what kind of ratings it will get. *Sister, Sister* got a new life as it moved to the WBN network, and *In the House*, which premiered as a mid-season replacement the previous spring, got picked up again.

Have the television and film industries met their responsibility to depict honest portrayals of African-Americans, as opposed to caricatures and one-dimensional stereotypes? Has the entertainment industry offered fair and equal job opportunities for black performers? Controversial as these questions may be to some, we can't ignore them. Black performers are underemployed, underpaid, and unrealistically portrayed. Indeed, black performers may be quantitatively more visible on television than ever before, but, qualitatively, the stereotypical depiction of black Americans and black family life is still a major hurdle we have yet to overcome. And African-American performers are still flagrantly denied a fair and equal "piece of the action."

The NAACP Image Awards, presented annually since 1968, are awarded to people and programs that portray positive images of blacks and individuals who have given outstanding performances in the fields of film, television, music, sports, and theater. In the late 1970s, the NAACP Image Awards were unable to nominate actresses in the leading actress category due to the shortage of black actresses in leading lady roles that year. This unfortunate situation reoc-

curred in 1987. A February 1995 study conducted by *Black Talent News* revealed that series roles for black actresses were usually those of a co-star, ensemble cast member, or a supporting role. Moreover, more than 75% of these roles were on series with primarily black casts. Out of 20 prime time series on ABC, 4 had black actresses in regular roles; out of 18 series on CBS, 3 had black actresses in regular roles; out of 19 series on NBC, 5 had black actresses in regular roles; out of 13 series on Fox, 3 had black actresses in regular roles; and out of 4 series on the Warner Bros. Network (WBN), 2 had black actresses in regular roles. The United Paramount Network (UPN) had no black actresses in regular cast roles on any of its five series. Thus, although there are more black actresses on television than ever before, the number of black female characters integrated into non-black shows is still disappointing.

> There was a time when I would turn on the television set without a *TV Guide* and would flip the channels one by one to see what was playing. I would stop to watch only when I came to something that looked interesting or when I saw a black face. If I came across a show that had a black person, I would immediately call up my friends and tell them to turn on the TV, quick, there was a black person on. Not much has changed in the way of flipping channels, except now we don't have to get up, thanks to remote control. What has changed in a very noticeable way is the presence of more black faces, especially black women. Actresses have come a long way.
>
> *Dr. George Hill*

Every time it seems we're going to take a giant step forward, we are set back. For example, take the network airing of *Roots*, the most watched television miniseries ever to appear on prime time, which presented more employment opportunities for black performers in one single project than ever before. This history-making program was nominated for several Emmy Awards and was critically acclaimed across the United States. Yet the airing of *Roots* (1977) and *Roots II* (1979) failed to inspire the industry's view of the employability and bankability of black talent. Many of the performers in *Roots* couldn't get another acting job.

Is the entertainment world widening its doors to black creative talents? Are employment opportunities on the upswing? Those that answer "yes" point to the increasing number of black performers visible on daytime and prime time television, films, and commercials and "crossing over" into the mainstream music industry as evidence.

The emergence of films independently produced, directed, written, and starred in by black filmmakers include Spike Lee's *She's Gotta Have It* and *Do the Right Thing*, Robert Townsend's *Hollywood Shuffle*, and Keenen Ivory Wayans' *I'm Gonna Get You Sucka*.

And what about the salary picture? Star salaries have climbed into double digits. Jim Carrey reportedly will get $20 million for Columbia Pictures' *Cable Guy* and $20 million for Universal

Pictures' *Liar, Liar*. Sylvester Stallone is said to have signed a three-picture deal with Universal Pictures for $60 million, and he already has a $20 million deal from Savoy Pictures. And a relatively unknown young 18-year-old actress, Alicia Silverstone (*Clueless*), will earn $10 million from a two-picture deal with Columbia. Finally reaching the double digits, Denzel Washington saw his fee rise from $7.5 million for Paramount's *Virtuosity* to $10 million in *Courage Under Fire* (20th Century Fox). Martin Lawrence reportedly has inked a three-picture deal with Columbia worth $20 million. He will star and direct the comedy *Thin Line*, a script he co-wrote with writers from *Martin*, and he'll do a sequel to *Bad Boys*, which grossed over $60 million in domestic sales alone. Wesley Snipes reportedly made $7.5 million for Columbia's *Money Train*. Snipes makes $7.5 million for his umpteenth flick, and a newcomer (Silverstone) gets $10 million for her second film? Something ain't right here!

Dr. George Hill commented on the changes that have occurred in the entertainment industry in recent years:

> The greatest change has been the increase in African-American filmmakers since 1987. George Jackson and Doug McHenry's deal with Savoy Pictures is a major breakthrough. They now have the power to green light their own films. Other significant milestones are the marriages between Quincy Jones and Warner Bros., Andre Harrell and MCA, Spike Lee and Universal, and Russell Simmons and just about everyone. All of these men have the opportunity to produce records, television programs and films. And as for significant film deals, we have John Singleton/Columbia and Denzel Washington/TriStar.

Major recording artists like Michael Jackson, Whitney Houston, Prince, and Janet Jackson continue to have tremendous crossover appeal, selling millions of records and playing to sold-out audiences worldwide. Once considered a trend, rap music has crossed over into the mainstream of the international music industry. Americans, both black and white, are finally beginning to understand and listen to what our rappers are saying. Rappers like Kool Moe Dee, Ice T, MC Hammer, Public Enemy, NWA, Heavy D and the Boyz, the controversial 2 Live Crew, and Big Daddy Kain focus on anti-drugs, anti-gang, anti-gun, and anti-violence lyrics.

Oprah Winfrey, today's most celebrated talk show host, is also the first black female multimillionaire studio mogul, reigning over her own vast entertainment production complex, Harpo Productions, in Chicago. In the fall of 1995, Oprah Winfrey and her production company, Harpo Films, entered into an exclusive long-term agreement with The Walt Disney Motion Pictures Group. Under the terms of this new creative alliance, Winfrey will produce motion pictures over five years and will star in some of the films she produces. Among the prestigious projects on the Harpo Films slate is an adaptation of the Pulitzer-Prize-winning novel *Beloved,* written by Toni Morrison and scheduled to star Winfrey.

Russell Simmons has emerged as a leading force in black entertainment since he controls dozens of entertainment firms (including Def Jam Records and Rush Artist Management) under the banner of Rush Communications. Rush Communications has become one of the largest black-owned entertainment corporations. Simmons has gotten involved in all aspects of the entertainment industry, from feature films and television to records and publishing.

In the late 1980s, *The Cosby Show* and *A Different World* continued to place among the top 10 television shows. *The Arsenio Hall Show* became a major breakthrough on the competitive late night talk show field. Arsenio captured the hearts of the viewing American public while at the same time maintaining a strong sense of African-American culture and racial pride. *The Arsenio Hall Show* featured black guests on almost a nightly basis, giving black performers, not usually asked to appear on the other late night talk shows, a chance for greater exposure. And Keenen Ivory Wayans' hit Fox television series *In Living Color* had Keenen at the helm as creator, writer, producer, and star comedy performer.

In a 1990 article in *The New York Times*, writer John J. O'Connor said:

> There is one part of the American scene in which the black presence over the last decade has become dramatically less separate and more equal. That's on television, the Great Emulation Machine whose very existence depends on correctly identifying and servicing its audiences. In the mid-1980s, *The Cosby Show* stunned a good many industry experts by vaulting to the top of the ratings—and staying there. The effects of that success have been rippling across a broad entertainment spectrum, from the solidly entrenched *Arsenio Hall Show* to Keenen Ivory Wayans' new *In Living Color* to Oprah Winfrey's forthcoming *Brewster Place*. Radical changes concerning race areas are being registered throughout the schedule—prime time and daytime, comedy and drama, young people's programming and, not least, all those commercials starring superstars like Michael Jackson and Magic Johnson. And black performers are going into writing and directing and producing, steadily gaining more control over the finished product. The result: viewers in general are having perceptions refocused and preconceptions challenged.[1]

Overall, hiring statistics reported by the Screen Actors Guild (SAG), support the theory that performers of color are finally breaking through and making some overdue gains in screen presence. In the 1981-82 season, 12% of the 40,174 SAG performers hired in features and TV were ethnic. In calendar year 1987, 14% of the overall 46,560 performers hired were ethnic. That translates into 4,636 ethnic jobs in '81-82 and 6,700 in 1987—an encouraging increase of 45% in five years. This is partly due to a general production boom and a 16% increase in the

[1] John J. O'Connor, "On TV, Less Separate, More Equal," *The New York Times*, Sec. 2, p. 1, April 29, 1990.

total number of SAG film and TV jobs available—still, 2,065 new ethnic jobs is certainly cause for optimism.[2]

While new black talent becomes visible on the one hand, the "what ever happened to?" list is growing larger—in with the new, out with the old. As black actors of the past become decreasingly employed, a new group of black actors become increasingly employed and step into the financial limelight. This recycling of talent leads to the controversy over whether things in the industry have really changed or not. Have profound changes really taken place, or does it just appear that way because we are constantly seeing new black faces in the limelight?

> I know a lot of our folks who are still starving. I can't say [black actors' employment in the business] has changed, when I think of Sidney Poitier, Ron O'Neal, and Rosalind Cash, who aren't working like they should be, who should be working all the time. Hey, this is 1987. It's been very difficult for them to sustain themselves the way I feel they should. They are all talented, articulate. They should be the role models. Why do we have to go out and scramble, struggle, and scuffle to come up with work because there's no other way for it to happen? Because the industry is not really interested in funding or distributing or exhibiting things that we may deal with, or from our perspective, whatever that is.

> *Bill Overton*

The same applies to African-Americans in behind-the-scenes positions. Decades before, directors Spike Lee, Robert Townsend, Charles Lane, Keenen Ivory Wayans, and the Hudlin Brothers showed that blacks can attract integrated audiences and be appreciated by a broader society. Before them, Oscar Micheaux, Gordon Parks, Melvin Van Peebles, Harry Belafonte, Bill Cosby, and Sidney Poitier met with the same success, but Hollywood forgot it.

In the 1995 Directors Guild of America (DGA) annual employment report for ethnic minority and women DGA members, the DGA found discrimination still persistence. Based upon hiring information provided to the Guild by studios and production companies since 1983, the number of total days worked by directors, unit production managers, first assistant directors, and second assistant directors during 1994 reveal a continuing pattern of underemployment of women and ethnic minority members in every area of film and tape production. "The new DGA figures reveal a major flaw in our industry's efforts to deal with this problem," commented Guild Western Executive Director Warren Adler, who characterized the percentage of days worked by minorities and women in each of the four measured DGA categories as "disgraceful" and pledged renewed Guild efforts targeted at employers with the poorest results. One result of the Guild's stepped up efforts to improve employment opportunities for minorities and women is the Di-

[2] *Screen Actor*, Vol. 27, No. 3, Fall 1988.

rectors Training Program launched by the DGA and Walt Disney Network Television Division, which is aimed at identifying new directorial talent among ethnic minorities. The new program came out of discussions initiated at a DGA networking event sponsored by the Guild's African-American Steering Committee. Subsequent meetings between Disney and members of the African-American Steering Committee and the DGA Mentor/Mentee Committee yielded the plan for the new Disney Directors Training Program. Ongoing talks to establish similar programs are proceeding with other studios and networks, including Paramount, CBS, and NBC. African-Americans currently makeup only 3.17% of DGA's membership.

A similar sentiment was echoed in a *Los Angeles Times Magazine* article:

> In America, blacks have historically attained clout within the film industry, only to fade quickly from center stage because they didn't have the support of a wider power base. (And in a transitory business like entertainment, even that can't guarantee longevity, as any recently fired studio executive can attest.) In the early 1970s, Melvin Van Peebles gained acceptance by directing such films as *Watermelon Man* and *Sweet Sweetback's Badasssss Song*. Gordon Parks Sr. won praise for *The Learning Tree* and commercial success for *Shaft* and *The Super Cops*. Yet it has been years since Van Peebles or Parks directed a film. Even Richard Pryor didn't complete a multi-picture deal, estimated at $40 million, with Columbia Pictures, after internal conflict developed in his own company, Indigo Productions.[3]

We asked writer-producer Travis Clark for his personal appraisal of the black state of the arts, and he had this to say:

> It's nonexistent. It's reverted. It's worse than it was 10 or 15 years ago. And its mostly because of us, African-American people ourselves. And there are several reasons for it. I think it's so complicated that it's simple. African-American people don't face certain realities. If you look back at any people, any nationality who came to this country, we were the only ones who were bought here as property, forced against our will. And we were pets—people cringe when I say that, but we were. The Supreme Court of the United States of America, in the *Dred Scott* decision, Chief Justice John Taney wrote the decision. When Dred Scott escaped from this master, it went all the way to the Supreme Court, and he was returned to his master because the Supreme Court decision said a white man had a right to keep his property and to own it—whether that property is his ox, his ass, or his "nigger." Now, throughout our history, what have we tried to do? Please our master, our white man. And it's gone down through the ages. We still do it. Some of the major people that we know—and I'm not going to call names—all they want to do is please and prove

[3] Gail Buchalter, "The New Black Clout in Hollywood," *Los Angeles Times Magazine*, February 28, 1988, p. 8.

something to the white man rather than accept themselves as a complete human being and help their own people. But they don't think they've made it until they've helped the white man. Every major African-American entertainer today who has started a production company, who has fought for it and has asked, "How come they are no black people?", has white people running their companies. They all do—from Arsenio Hall, Quincy Jones, people I respect, to Eddie Murphy. White people are running their companies. Subconsciously, it has to be because of a lack of confidence. And they don't think their companies are viable unless they have that white guy running their company. They think that gives them more credibility. What they don't realize themselves is that they're complete within themselves and they've made it. But it's something subconscious in us. When we were doing *Hawk*, 80% of the crew was black, African-American people. And people would walk on the set and the white actors' guests would never say anything. It would be only the black guests who said, "Look at all these black people; where did you guys get all these black people from?" I've never seen, never heard, someone walk on the set when there are all white grips and say, "How come there aren't any black people here?". You see how we are trained and programmed. When we walk into an office and we see African-American people, we figure that is not a viable office. So what do all of our major people do? They put a white secretary out there. But when you come to my office, you see a black secretary. So what we have to do—we, as African-American people—we have to get beyond that before we ask white people to do it. See, we're always asking white people to do things we're not willing to do ourselves. How can you expect white people to do it when you're not doing it? How can you ask white people to hire black talent when you don't do it? And you're only there because of the struggles of those of us who fought during the Civil Right Movements, and put our necks out on the line, and our forefathers and mothers before that. So I don't blame white people and Jewish people for our plight. I blame us, because we do it to ourselves more than them. And that's just the way it is. And it's getting worse. I respect Spike Lee to the infinite degree because he hires African-Americans. Because you know why? He's comfortable with who he is, and most African-American people are not. And that's the sadness of this whole thing.

We have to toot our own horns. Black folks can't rely on the industry to keep them working, nor to keep them in the limelight. Thanks to the NAACP Image Awards, the Black Achievement Awards, the AUDELCO Black Theater Achievement Awards, the Soul Train Awards, and other programs that award black excellence in the performing arts, African-American performers are publicly recognized for the work they do.

It's really a war out there and they're not going to give us anything. That happens all the time and you've really got to be aware that it's going to happen and it's going to be tough. But don't give up and you'll get through somehow. We have to really under-

stand that. I don't think any of us feel so secure and safe. I mean, we feel secure in our work because we know what we're doing. But if I were given some of the opportunities that are given to a lot of whites, I think I'd be working all the time. Thank God there's *The Cosby Show* that I get to work on. Bill [Cosby] wanted a black to come in [and direct].

<div align="right">*Tony Singletary*</div>

Even though the black state of the arts is more promising in some aspects, it remains bleak in others.

A Brighter Future?

In the 1980s and 1990s, black performers found increased employment opportunities, but certainly not in relation to the black consumer population and its black viewership. A vast majority of African-American performers and technicians work primarily in all-black productions. There are more black performers and behind-the-scene production personnel that have broken the barriers and risen into the mainstream of the entertainment industry. We should be proud of these personal advancements and small victories, although at the same time we should not become complacent or content. We still have a very long way to go. The doors are opening wider, but not wide enough. We are being accepted because the industry has to accept us, not because they want to accept us. We still have to fight for every little advance we make.

In an article which appeared in the August 1990 issue of *Ebony*, Keenen Ivory Wayans was quoted as saying:

> Nobody was asking "Where are the black movies?". Not a soul. We supplied them. And people responded. Now, there is an awareness, but no demand. People are aware of what we do and we do have our following. Everybody is courting us, but they are not developing us. No studio has programs to develop writers and directors. I think it would be dangerous to even give the illusion that there is a big change going on, because there is not. What you've seen is a few seeps through the cracks. Hopefully, we'll make enough noise to burst a hole, but we haven't yet.[4]

Gail Buchalter echoes the same sentiments as she states in her *Los Angeles Times Magazine* article, "The New Black Clout in Hollywood":

> Many blacks say they have been unable to gain a foothold in Hollywood because nepotism and social connections remain the town's two greatest employment agencies. In other words, when blacks are doing the hiring, more blacks will be hired.[5]

[4] Aldore Collier, "Fighting the Power in Hollywood," *Ebony,* August 1990.

[5] Buchalter, p. 8.

The emergence of independent filmmakers Spike Lee, Robert Townsend, and the Hudlin Brothers and television producers Keenen Ivory Wayans and Thomas Carter are good examples of blacks taking the responsibility to make an impact on expanding the image of black America and the employability of African-American performers. Dissatisfied with the existing images of blacks presented in the media and the lack of work for qualified black performers, these independent filmmakers have parlayed their own successes into opportunities for many performers and production people. They have been able to retain artistic and editorial control over their projects, presenting their own images and storylines. They are also largely responsible for increasing the visibility of many lesser known black performers by giving them the well-earned chance they might not otherwise have gotten.

Eddie Murphy's controversial statement at the 1988 Academy Awards highlights the emerging social awareness of young black entertainers. Murphy went from successful television comic (*Saturday Night Live*) to motion picture star (*Trading Places*, *Beverly Hills Cop* I and II) and major motion picture performer/producer/writer/director (*Coming to America* and *Harlem Nights*). He purchased the film rights to the Pulitzer Prize-winning play "Fences" and has joined Arsenio Hall, Robert Townsend, comedian Paul Mooney, and Keenen Ivory Wayans in establishing a show business partnership in a group affectionately called "The Black Pack." The Black Pack is undeniably a social group, but it is also a political statement about the importance of developing a strong black talent pool and power base identity within the film and television industry.

Oprah Winfrey has capitalized on her film and talk show success, acquiring *The Oprah Winfrey Show*, forming her own production company, Harpo Productions, and buying the Chicago Studio where her talk show is taped. Harpo Productions produced the television miniseries *The Women of Brewster Place* and has produced a weekly television show, *Brewster Place*, based on the miniseries. Winfrey has broken through the intellectual talk show barriers once reserved only for white males. Not only did Oprah open doors for black talk show hosts Arsenio Hall, Marsha Warfield, and Byron Allen, but she has also impacted the women's forum, opening doors for mainstream hostesses Joan Rivers and Sally Jesse Raphael.

Prince has emerged as a powerful force in the music industry, singlehandedly developing a musical dynasty based in Minneapolis. His production company, Paisley Park, is involved in producing and writing for musical artists and developing new theatrical ventures. Prince has also led the way in showcasing new talent, many of who have become stars in their own right. He produced four feature films—*Graffiti Bridge*, *Purple Rain*, *Under the Cherry Moon*, and *Sign O' the Times*.

Our power base continues to grow behind-the-scenes as the list of blacks getting into other creative areas of the industry increases. Tim Reid parlayed a successful TV career into producing

his own project, *Frank's Place*; Ron O'Neal, Kevin Hooks, Eric Lauerville, Ted Lange, Helaine Head, and Neema Barnette are all working African-American TV directors. Debbie Allen produces and directs. Susan Raines writes and co-produces. Many top black TV directors were former actors and technicians and are therefore sensitive to the actor's dilemma and can often use their decisionmaking and creative freedom to hire blacks in nontraditional roles—roles that may have been originally written for white actors.

Black casting directors are also becoming increasingly visible. Reuben Cannon, formerly one of the industry's leading casting directors, has become heavily involved in producing. He co-produced *The Women of Brewster Place* and the hit television series *Amen*. Independent casting director Pat Golden hired Dr. Haing S. Ngor in the lead role of the Academy Award winning film *The Killing Fields*. Independent motion picture and television casting newcomers Jaki Brown-Karman, Robi Reed, and Mel Johnson are also heavily involved in casting major projects.

A 1988 study on prime time television by the Howard University Center for Communication Research shows "a definite improvement in the portrayal of blacks." "Ten years ago," the study says, "blacks were largely shown as young, poor, and male and stuck in blue collar jobs. Only 30 black females had starring roles on TV between 1968 and 1983. Black and white interaction was featured in a dismal 2% of all TV shows A decade later, there are 26 series on the air with recurring black characters. Women are now equally portrayed with men and children and most blacks are shown in middle to upper class settings with professional or managerial jobs." The study goes on to say that "19% of blacks on TV today are shown in major roles, although 69% still appear in predominantly black sitcoms. Twenty-one percent appear in action/adventure shows, while only 10% appear in dramas."[6] According to the Writers Guild of America, less than 2% of the active membership is black.

Writer Gail Buchalter in the *Los Angeles Times Magazine* said:

> Today, blacks are more visible in the film and television industry, both on camera and behind it, than ever before. And what has surprised and caught the attention of TV executives is the size of the black audience: blacks spend 1.4 hours watching television for every hour spent by the rest of the population. Still, there are shockingly few blacks in creative power positions: 120 of the 6,500 members of the Writers Guild, or almost 2%, are black; the Directors Guild lists 195 blacks out of 8,558 members (about 2.25%); and black producers number less than a handful. (In contrast, 4,033 of the Screen Actors Guild's 70,411 members, or about 5.75%, are black.) Fewer than a dozen blacks hold creative decisionmaking jobs at the major studios and television networks. And without representation in these institutions,

[6] *Screen Actor*, Vol. 27, No. 3, Fall 1988.

some black artists say, the inroads they have made in the entertainment industry will be a passing trend—like the rash of black action-adventure films of the 1970s—instead of a lasting, fundamental change.[7]

Blacks need to become studio executives and use their influence to create increased job opportunities for African-Americans. Black stars need to insist on control of their own projects. The white man's age-old story, "I'd hire blacks if I could find qualified ones," is not going to "cut the mustard" anymore. And African-Americans can't wait around for the "qualified ones" to be recognized by the industry. We have to take charge of our own careers, our own projects, and develop into full participants in the industry in order to make major decisions and wield power. We have to deal with the challenges and opportunities cohesively.

In an article from the National SAG newsletter, Toey Caldwell, National Chair of the SAG Ethnic Employment Opportunities Committee (EEOC), stated:

> Entertainment and advertising are finally catching up with society. People of color are advancing in American society in general, including politics. We're becoming more influential and showing more economic strength—the networks, advertisers, and studios can't ignore that. Performers of color are also more sophisticated and self-reliant now. In our frustration with the system, we've created effective advocacy groups, and we're investing in and creating our own productions.[8]

Commenting on how the Hudlin Brothers got *House Party* distributed, in his *Ebony* article, Aldore Collier states, "One of the reasons they were able to connect with New Line Cinema [the distributor of *House Party*] was because there was a black on staff who was attuned to black filmmakers."[9]

> The sad thing about television is there's one person at each network making all of the decisions. So we have to start lobbying Congress and advertisers to make sure that more ethnic people are part of this process.
>
> *Travis Clark*

Unity equals power. If blacks pool their energy, help, and support and encourage one another, we'll be able to open the doors into more powerful positions within the industry, improve employment opportunities for black performers, and change the entire complexion of the entertainment industry. We'll be better able to choose the projects that we want to see produced and the people we want to work with. We need to work together to build a lasting power base in this

[7] Buchalter, p. 8.

[8] *Screen Actor*, Vol. 27, No. 3, Fall, 1988.

[9] Collier, August 1990.

often fickle business where there's no guarantee of longevity, and where major players come and go. In this way, we can take control of creating new black images and dismissing old demeaning stereotypes.

> We have to start producing, directing, and writing our own projects for our own marketplace. The unfortunate thing about African-American people are that we're still brainwashed and we still think we need white approval, when our people are the most loyal consumers in the world and love you when you make it. It's as if we don't think we've made it unless we're known by whites. And until we get beyond that, we will always suffer.
>
> *Travis Clark*

As the talent pool of black performers becomes more sophisticated and educated, and as black participation in casting, directing, and producing increase, the black state of the arts will continue its upward spiral far into the 1990s.

2

MOVING TO THE BIG CITY:
GETTING STARTED WITH YOUR CAREER

The first thing you should do is decide where you want to begin your career. Let's weigh the options. Would it be better to stay in your hometown or move to New York or Los Angeles?

If you're a beginner and there are local television and theater acting opportunities available, it may be wise to build connections and get some experience and credits on the local level before taking your chance in the major theatrical markets of New York and Los Angeles. There are plenty of legitimate show business opportunities in cities such as Dallas, Chicago, Atlanta, Miami, Boston, San Francisco, and, most recently, due to cheaper production costs, several cities in Canada. Most large cities have local television and cable companies that run local programming and commercials. You should also investigate your local community theater companies.

If you've got your mind set on moving to New York or Los Angeles, there are a number of things you have to take into consideration. If you're interested mainly in theater, New York is the place you want to be. If you're interested in television and film work, you should be heading out west to California.

Be prepared to have a lot of money saved before moving. The cost of living and your personal expenses will be much higher in New York and Los Angeles than in most other parts of the country.

Plan your move carefully. Consider the lifestyle of the city to which you're moving. Put together a budget ahead of time, taking into consideration initial setup costs and your overall monthly expenses. Figure out how much money you'll need to survive for at least six months without any earnings. You don't want to make survival an additional issue—have enough money saved so you can lead a somewhat normal life until things get rolling.

Your initial setup costs will hopefully be a one-time-only major expense. You have to figure air fare costs to New York or Los Angeles; the cost of moving your belongings; your first month's rent; security deposits; utility deposits for telephone, gas, and electricity hookups; and, if you're moving to Los Angeles, the costs of renting or owning a car. Because public transportation is not a practical means of daily transportation in California, you'll need to rent, lease, or purchase a car if you don't already have one. That's a rather costly expense you'll need to plan for. If you have a car already, it might be an wise idea to drive your car out to Los Angeles. The cost for shipping a car across the country ranges from $500 to $1,000.

If you don't have enough furniture and personal belongings to meet the 1000 lb. minimum required for many moving companies, consider shipping your things via UPS or the U.S. Mail or, if you're driving, by pulling a U-Haul trailer behind your car.

If you're moving out of your parents' home for the first time, consider the cost of apartment living as well as buying furniture, bedding, linens, and kitchen utensils.

New York—"The Big Apple"

Manhattan is an island approximately 12 miles long and 2.5 miles wide. It's a congested city where tall skyscrapers abound and millions of people walk the streets. Getting around in New York is far easier than in L.A., and driving and maintaining a car is considered a luxury for most N.Y. actors. With the high cost of food, rent, entertainment, and living expenses, most working actors have a rough time making ends meet. The great majority of actors walk from appointment to appointment whenever possible or use public transportation to quickly get to auditions, interviews, and employment. Public transportation (and access to communication) is a convenient way of life in New York City. Subways and buses run far more frequently there, and they go just about everywhere. Since most of the streets and buildings in the city are numbered or coded, it is easy to find neighborhoods, addresses, and contacts, and there are public telephones, subway entrances, and taxicabs available virtually on every other corner in Manhattan. It's not uncommon to walk 50 blocks a day in New York City—it's a way of life! One of the major artistic advantages to living in New York City is the diverse cultural and theatrical activities associated with a major metropolitan center. Aside from the theaters and sightseeing attractions, New York offers the centers of world finance, business, and fashion and is a melting pot of urban tradition.

Finding a place to live in New York should be first on your list of priorities. If you have a friend or relative with whom you can stay for a while, that's great. Otherwise, you'll have to look for an apartment. Unfortunately, housing is extremely difficult to come by. A small, one-room studio apartment with kitchenette and no amenities in a walk-up building in a fairly decent area of New York City can cost anywhere from $900 to $1,500 per month. Get the Sunday *New York*

Times and the *Village Voice*, read the real estate rental listings, and try to go see apartments immediately. You'll find many apartments are rented before you even get to them—that's how the tight the rental market is in New York. Most of the time, you'll have to sign a lease to rent an apartment in New York; the standard lease will be for two years.

In addition to the first month's rent, landlords often require a credit check, a security deposit, and the first and last months' rent. Keep in mind that, according to the law, a landlord may increase the rent a certain percentage each time the lease expires. If you're planning to stay in New York for a while, it may be better to sign a long-term lease.

An option to getting your own apartment is to share an apartment. In order to share ever-increasing expenses, many actors, singers, dancers and other professionals become roommates. This enables the group to live cheaply in a nice, divided living space. If you don't know anyone in the city, check out the bulletin boards at Actor's Equity, the Screen Actors Guild, or the American Federation of Television and Radio Artists, where performers looking for roommates regularly post notices. You can also check these bulletin boards for apartment sublets. Many performers leave New York during pilot season (beginning in January) and head for California; others go out of town during the summer months to work in summer stock theater, and some just move out of the city altogether. Because it's so hard to find an apartment in New York, performers usually sublet their apartments, fully furnished, while they are gone.

Remember that you don't have to live on the island of Manhattan—there are many nice areas in the outer boroughs of New York. Queens and Brooklyn rental prices are slightly lower than in Manhattan. Many New York actors even choose to live in northern New Jersey, which is accessible by public transportation. Rental prices vary, depending on the area in which you live.

Your New York theatrical and commercial career depends upon your own personal ability to accept life's daily lifestyle challenges, to persevere, and to be organized and disciplined. Population density and the frantic pace of N.Y. are much different than that of the casual, laid-back Los Angeles scene. Yet N.Y. actors feel their city provides them with a cultural energy and professional career excitement unlike that of any other place in the world. New York actors don't have to "sit by the pool" and wait for the phone to ring. Many actors, while waiting for their big break, can find and even create work by making the rounds on foot, boldly knocking on the doors of casting directors, ad agencies, and agents. The more aggressive the talent, the more the desired result. In N.Y., timing and luck can also be essential to career success. In L.A., everyone must have an agent; in N.Y., through networking and sheer hard work, many actors have established their own professional careers.

In New York, it is not necessary to be signed to any one particular agent. Because of the great numbers of calls and the abundance of casting offices, no one agent will get all of the casting calls. Many N.Y. actors, especially those of color, find it better to freelance with several

different agencies in different areas. Sometimes this system can be beneficial for the actor and the agency because it allows both parties the opportunity to establish a working relationship before signing. This type of relationship can also give an actor a little more control over how he is being publicized and presented to casting directors. Once the agency has openings on its talent roster, the freelance actor that has established a good working relationship is right in line to be accepted.

The New York audition usually takes place in a highly competitive and emotionally cold atmosphere. There are few personal pleasantries and no frills. Time is of the essence, and, by the time you have the audition sides in your hand, you only have a short time to read them over before you find yourself in front of the panel in the audition room. In most cases, these are cramped quarters with little or no room for grooming and waiting. Casting people tend to be quick and efficient, rather than friendly and chatty.

Wardrobe colors and fabrics are definitely influenced by the ever-changing East Coast weather. Northeasterners tend to wear darker, heavier fabrics with severe, hard-fashion stylings. Unlike California, beachwear and skimpy casual wear are out, unless specifically called for. Who could ride the N.Y. subways in a bathing suit or a provocative dress? Colors are usually darker, and sometimes even black is in. Makeup and hair are more natural, and glamour is more conservative. Also, your wardrobe usually needs to be simpler because most actors have more than one stop on their agendas, since everything in New York City is so accessible and close in proximity. Consequently, an actor, dancer, or model's bag is packed for an entire day of changes of wardrobe and the necessary makeup and grooming tools. Along with your appointment book, your reading materials and your own personal "junk," an actor's bag can weigh in excess of 50 pounds! An auditioning actress during a busy day may be a young mom at 11 a.m., a corporate executive at 2 p.m., and a nightclub singer at 3 a.m. N.Y. actors become famous for knowing where to go to make quick and subtle changes in appearance. An actor may enter a public facility dressed one way and within a half hour may leave dressed and made up to be someone completely different.

In New York, actors' photographs tend to be a little more commercially urbanized, in keeping with the big city profile of N.Y. Glitz and high glamour are reserved for the fashion world. N.Y. actors have a tendency to represent themselves as real people, with a diversity of cultures, skin colorings, and ethnic backgrounds. Aside from the standard, conservative "whitebread" types, it is now fashionable for actors in N.Y. to play up their ethnicity to portray the wide spectrum of African-American castings. Afrocentricism in dress and personal grooming is definitely in.

Headshots in New York have now come full spectrum and, in addition to the formal head-and-shoulders bust shot, agents are now seeing a trend towards three-quarter length actor photos that reveal

more body consciousness, character, and personality. Many N.Y. actors work from a series of 8 x 10 photographs that subtly specify types for castings rather than use composites.

Many initial agent and casting contacts are made through the mail. In order to stay fresh in the minds of the talent buyers, unless you are a favorite actor on an agent or manager's talent roster, most working New York actors have to mail frequently and in high volume. Because of the great number of experimental and professional theatre companies and the cultural diversity of the city, the N.Y. talent pool is not only diverse, but also highly competitive. It is easy to get lost in the stack of hundreds of pictures received by mail each day. In order to compete, you must stay firmly and regularly implanted on the minds of the careermakers.

The N.Y. actor also has to cross discipline lines to make a steady employment income due to the seasonality of film and commercial work. Cold weather on the East Coast can easily halt production outdoors, and many actors have found that combining their theatre, film, and television careers with print, industrials, and voiceovers can be both challenging and lucrative. In N.Y., one quickly learns that *any* show business experience can heighten your marketability.

Los Angeles—"The City Of Angels"

Los Angeles is a vast metropolis that covers over 70 miles and consists of many small communities connected by boundless freeways. In Los Angeles, a car is an absolute necessity. Forget using public transportation—although there is a public bus system (the RTD), it is not a practical way of getting around. The buses rarely operate even close to schedule, and it can literally take hours to get from one appointment to another.

Los Angeles is a transient city. Because industry people move around so much, there is an abundance of temporary and month-to-month housing available. The Oakwood Apartments (with several locations throughout the Los Angeles area) rent furnished or unfurnished apartments on a month-to-month basis. And if you're looking for permanent housing, you'll find "For Rent" signs on almost every block. You can get a single (equivalent to a studio apartment) in many parts of Los Angeles for as little as $500 per month. And for the $800 to $1,500 you would spend on a studio apartment in New York, you can get a luxury two- or three-bedroom townhouse apartment in many parts of Los Angeles. Also, much of the housing in Los Angeles comes with amenities like wall-to-wall carpeting, dishwashers, garbage disposals, microwave ovens, patios or balconies, health spas, jacuzzis, and swimming pools. You definitely will get a lot more for your money in Los Angeles. Check out the *Los Angeles Times* or *Daily News* for the most comprehensive rental listings. There are also several smaller community newspapers that list rental apartments. You may not be required to sign a lease in order to rent an apartment in Los Angeles. If you do, the lease is usually for six months to a year.

Most landlords require a small security deposit in addition to the first month's rent. If you move into one of the many newer buildings, which often offer move-in incentives, you may be able to move in with just the security deposit—the first month's rent is often free! Some landlords will even offer the new tenant a free color television set, video cassette recorder, or microwave oven as a move-in bonus! There are so many new apartment buildings going up in the Los Angeles area that landlords work hard to entice new tenants to rent in their buildings. As in New York, you can also look for a roommate to share an apartment or look for a sublet. Check out the bulletin boards at the Screen Actors Guild or American Federation of Television and Radio Artists where performers regularly post notices for roommates and sublets. Aside from being the center of American film and television production, one major advantage to living in California is the outdoor lifestyle associated with agreeable weather. The availability of outdoor activities (beaches, camping, etc.) adds to the pleasure of coastal living.

If you come straight from a New York winter into Hollywood's heat—to L.A., land of hard, tight bodies, sports cars, cellular phones, beepers, managers, computers, fax machines, and an extremely laid-back attitude, all of which you probably do not possess—be prepared for a "psych-out." In L.A., looks, image, money, and who you know are a large part of the game. You may need to lighten up, but don't make the mistake of loosening up too much and dropping your New York "hustle," your edge, your hunger. There's a lot to distract you—the weather, the beaches, the gyms, the road trips, even snow a couple of hours north. There's no seeing 15 or so industry folks at 250 West 57th Street, then walking to the east side to do more of the same. In L.A., there are the studio lots—Paramount, Warner Bros., Universal. There's no rat race of subways at rush hour where it seems that everyone in N.Y. is getting on at your stop. Instead, there are the freeways (which usually turn into the world's largest parking lots). You'll be lucky to get to three or four auditions in one day, and they had better be well-timed and in fairly close proximity. You can't just step off the curb and hail one of a dozen yellow cabs going by or leisurely walk to each with a "dirty water dog" (hot dogs sold by street vendors) in hand. You have to get in your car and drive. Cars are serious business in L.A. They're a status symbol, saying a lot about who you are. They're also what throws your budget off should they break down or get stolen or, worse, get hit!

Many New Yorkers turn tail after a couple months of trying to get a bi-coastal career going, saying it's too laid back, too lonely. If you do go to L.A., don't do it with the idea of becoming an overnight star. Go with a job or a friend and arrange to camp out on some couches for a while. In New York, you'll see friendly faces on the overcrowded subways or the corner bodega or just walking down the street to the bank. In L.A., you hop in your car, alone, and see one or two of those faces at an audition and maybe plan to do lunch—it can get lonely. You'll have to work at cultivating and keeping friends and acquaintances; just like your career, it will take work. You

won't be able to freelance with four or five agents like you can in New York. You may be "hip-pocketed" by one for a while, but if you're not signed, you won't get the preferential treatment until you earn it. Your "legit" agent in N.Y. becomes your "theatrical" agent in L.A.

Headshots can be fun, depending on what you want and what your agent feels you need. Costs can run the gamut, from do-it-yourself makeup and hair to paying the big bucks to get it done right; from three-quarters to full length; from standard headshot to something artsy; from sloppy boarders to bleeds. Outdoors, indoors, studios—it's all there. Videotapes (or reels) are the thing in L.A; both commercial and theatrical actors have them. If you do industrials, it's wise to have one, too. It's not a must, but it is sure to get you noticed quicker than if you don't have one. A voiceover tape wouldn't hurt, either.

L.A. is a TV and film town. It's not really known for theatre, as N.Y. and Broadway are, but that's changing daily, especially with the influx of theatre-based actors, directors, and producers from all around the country. Monologues are few and far between, used mostly for theater auditions, but don't forget to have one or two ready just in case. Having a theatrical background is impressive, and it can go a long way. Your résumé will change, too. The area that usually specifies where the work was performed now states the names of the director and production company.

Names are big in L.A. For being such a large business, you'll find it gets smaller with every audition. Where you've previously given your "extra" character a name, L.A. résumés will say "featured," "guest-star," "star," "co-star," "principal," etc. Extra work tends to stick out like a sore thumb. Remember, L.A. is film and TV land. Don't forget the fact that some of the N.Y. industry folks are now also bi-coastal, and they probably cast most of your N.Y. credits, so anybody can be seen at one of the many cold reading workshops.

How Much Money You'll Need

In addition to your initial setup costs, figure the following expenses into your budget:[10]

Personal Living Expenses (Monthly)		
	New York	*Los Angeles*
Rent (one room studio or single)	$ 900-1500	$ 500-750
Home Telephone	50	50
Pay Phone Calls	25	25
Gas	10	10
Electricity	25-50	25-50
Food	200	200
Car Payment	n/a	200-400
Auto Insurance	n/a	75-100
Public Transportation	200	n/a
Parking	n/a	50
Gasoline	n/a	50
Health insurance	250	250

[10] These are approximate figures based on 1990 prices. Add 10% each year thereafter for inflation.

Career Expenses

Initial Photo Session	$150-650
Photo Reproductions	$50-100 for the 1st 100 copies $35-60 for each additional 100 copies
Résumés	$5 per 100 copies
Photo postcards	$50-75 for 1st 100 copies, $35-60 for each additional 100 copies
Trade papers	$1.85/wk for *BackStage* (NY), *BackStage West* (LA), $3/mo for *Black Talent News*
Trade directories:	
Studio Blu Book (LA)	$50
Ross Reports Television	$3.50/mo
Postage	$0.55 for a 9 x 12 envelope, $0.19 for a 4 x 6 postcard
Mailing Envelopes	$10 for 100 envelopes
Mailing Lists	$10-50
Classes:	
Basic acting class	$ 80-150/mo (once a week)
TV commercial workshop	$150-300 for an 8-week workshop
Dance class (3 times/wk)	$24-30/wk
Voice lessons	$50-200/hr
Union Initiation Fees:	
SAG	$1,008 (including 1st period dues)
AFTRA	$628.75 (includes 1st period dues)
Union Dues (semiannual)	Based on earnings
Talent Directories:	
Academy Players Directory	$15/issue or $45/yr
Players' Guide	$80/yr
Black Players Directory	$50/yr
Beauty Maintenance	$50-100/mo
Answering Service	$15-30/mo
Office Supplies	$15-25
Appointment Book	$10-50
Personalized Stationery	$25-50
Answering Machine	$150-200
Typewriter	$150-300
Color Television	$200-750
Video Cassette Recorder	$200-300
Audio Cassette Player	$50-100
Computer	$1,500

Your Financial Survival

Most performing artists suffer from financial deprivation in varying degrees of severity, and the "starving artist syndrome" isn't a myth—it's a reality for the majority of performers. According to the Screen Actors Guild (SAG), in 1989 the average yearly income for its members was $13,000.[11] You can bet the figures for black performers are considerably lower, considering we don't work as much as white performers due to fewer opportunities and the stiff competition for the relatively small amount of castings. So the prospects for supporting yourself entirely in the entertainment industry don't look terribly promising. But, there is some hope—you can get a maintenance job to make ends meet until your lucky break comes.

Performing artists need to live, eat, and stay healthy, as well as dress and look their best at all times, while paying for acting, dance, and voice lessons, pictures, and postage. Performers must also have loads of free time available to pursue their careers. This is your standard "Catch-22" situation. So many performers find outside maintenance jobs to help with their day-to-day living and career expenses. But that also presents a problem, particularly if you have an inflexible 9-to-5 day job. You will need your days free to look for work and do your theatrical training, and your nights free if you want to do theater or just get a good night's sleep. The point is, you can expect yourself to be busy working and studying 24 hours a day, with no time left to make money.

So how are you going to make ends meet? Sacrifice and ingenuity! It will indeed be difficult to make money when you have so little free time available, but you do have options. Among the most popular ways performers earn a living are:

Option #1: Temping

Working for a temporary personnel agency (commonly called "temping") is a good option, especially if you can type or do word processing. The income is good, and the hours and days are flexible, with evening and weekend work available. Even if you can't type or do word processing, there is temporary work available for receptionists and general clerical workers as well as proofreaders, bookkeepers, accountants, and paralegals. The trade papers feature temporary agency advertisements on a regular basis, and you can check your local Yellow Pages under "Employment Agencies—Temporary" for a listing of personnel agencies in your area.

Option #2: Working Evenings or Nights

You could get a full time job working the second shift (5:00 p.m. to 12:00 midnight) or the "graveyard" or third shift (12:00 midnight to 8:00 a.m.). This leaves you all day and afternoon to pursue your career. But if you have an early morning call, you will sometimes lose out on a

[11] Statistics obtained from *Screen Actor*, Vol. 27, No. 3, Fall 1988.

good night's sleep. Hotels hire front desk clerks for second and third shifts. Most large law firms and publishing companies have word processing centers that operate around the clock. You could deliver food (like pizza or Chinese) in the evening hours. And if you're lucky to be skilled as a computer operator, computer operation centers, found in most large companies, require 24-hour personnel.

Option #3: Waiting Tables and Bartending

Waiting tables and bartending are the stereotypical "second profession" of the struggling performer. The days and hours are usually flexible, and the pay will vary depending on where and what shift you work. You can also check out catering companies, which hire the experienced and non-experienced, to wait tables or bartend catered functions, on a freelance basis. The pay for catering jobs is very good—around $75 for three hours of work—but the work is not always consistent and permanent.

Option #4: Running Your Own Small Business

This option allows you the luxury of setting up your own schedule. Be creative and use your talents to develop a business that will provide you with enough money to live on. Performers often support themselves doing calligraphy, needlepoint, landscaping, house painting, lawn mowing, babysitting, taxi cab driving, telephone solicitation, or teaching performing arts and career preparation classes.

Option #5: A Flexible, Full-Time, 9-to-5 Job

With this option, in New York you can schedule interviews and auditions during lunch breaks. But if you live in Los Angeles, it will be very difficult to get to appointments during lunch breaks because metropolitan Los Angeles covers such a large geographical area. You can save your sick days, personal days, floating holidays, and vacation time for when you book a job. Keep in mind that this option only works in the early stages of your career. Once you begin going out on regular auditions and booking jobs with more regularity, you'll probably have to choose another option for your personal income maintenance work.

Option #6: Teaching

If you are a performer, why not share your talents with others? If you're a dancer, teach dance classes. Actors can develop their own acting workshops in their specialty area—stage, commercial, soap opera, comedy, improvisation, television, film, or voiceover technique. Get involved in other creative areas of your field—teach private voice lessons, piano lessons—and sell your talents to others for a price!

None of these options are tailor-made for everyone, but most are manageable if you just put your mind to it. "Sacrifice" is the key word here. And we're sure that you, being such a creative and talented person, will be able to adapt to any one of these options. Maybe you'll even think of a new option that we haven't covered here!

It is important to remember that, whatever option you choose, an income maintenance job is exactly what it says. You have made the decision to be a performer, not an employee in a part-time business. Your maintenance job should allow you enough freedom to get to the endless number of auditions and job bookings without creating conflicts.

3

NEWCOMER BLUES

If you are considering becoming a performing artist, you must think about this: every day there are hundreds of people entering the professional show business world. They come from all walks of life, and many are beautiful and talented, or both. With the widespread appeal of television, feature films, commercials, and music videos, people are beginning to feel like they fit in—they are convinced they have the necessary natural abilities for show business success. Sure, many people possess character traits similar to the top stars. How may talent contests feature impersonations of Diana Ross, Michael Jackson, Prince, and the like? Can you recall seeing friends trying to imitate the high fashion images created by leading magazines? We all have attributes that can be impressive to our loved ones, families, and friends. But when we speak about the natural talents in the professional work place, as sung in the immortal words of Gershwin's "Porgy and Bess," "It ain't necessarily so."

Why do you want to get into show business? What does it take to make it? Do you have what it takes to make it? These are the first questions you should ask yourself when considering a career in show business.

It seems that almost everyone wants to get into show business, and why not? Who wouldn't want a lifestyle of the rich and famous while being adored by fans worldwide, chauffeured around in luxury limousines, dining in the finest restaurants, filming on exotic locations with all expenses paid, with a mansion in Bel-Air, a house on the beach in Malibu, a penthouse on Park Avenue, and fancy sports cars? The media make it all look so glamorous. But the reality is that it's not all that it appears to be. And it certainly isn't an easy profession to break in to. It's true we often hear the overnight sensation stories that the media glamorize. But the majority of stars "pay their dues," enduring years of suffering, sacrificing almost every human necessity, and living at sub-poverty income levels before they gain their celebrity status. A successful show business career is *made*, not born. That is the reality! The late comedian Redd Foxx, lovable

junk dealer "Fred Sanford" of television's *Sanford and Son*, spent many years working clubs on the legendary "Black Chitlin' Circuit" and recording adult party albums before achieving personal and career successes in Las Vegas nightclubs and network television. Then Foxx, in a bizarre turn of events, after becoming an international celebrity, had to face poverty and public indignity after the IRS seized all his personal assets and possessions to compensate for unpaid back taxes. Talk about paying dues!

Most performers spend many long and hard years paying their dues. Picture this: barely making it year after year, hoping for a break or a stroke of luck in a profession that offers absolutely no guarantees, never knowing where your next penny is coming from, finishing one job and not knowing if you'll ever work again. This is the common reality of the life of the performer. Don't be fooled by the stories you see on television and in the rag sheets. These stories are the end result for the few fortunate ones that survived and whose endless persistence finally paid off.

> What is more rewarding than getting up on stage or in front of a camera and getting folks to believe that you're something that you really aren't, and then getting paid handsomely for it? It's the ultimate. The difficulty is there's so much mystique and prestige attached to being an actor that it's very difficult to get in [the door] and to prevail, or just to be. There's thousands of people walking around saying "I'm an actor" and they're starving to death. And when you look at an industry that's supposed to reward you because of your talents—a lot of things happening are very unfair.
>
> *Bill Overton*

> It's a matter of the right place, right time, destiny, hard work, preparation—all of those things go together. I don't think you can separate one and talk about it. I think it's a combination of all that we do.
>
> *Lou Myers*

So why do you want to hustle and scuffle just to make ends meet in a completely insecure business? Were you voted "Most Likely to Succeed" in junior high school? Does your mother think her little darling is the most beautiful child in the world? Did you play all the lead roles in your college productions? Are you a frequent beauty pageant winner? These are just a few of the many reasons people want to get into show business. But notice something: none of these reasons has anything to do with what you want or how you feel. The single most important reason that anyone should want to tackle this business is because he has a burning passion to perform—a passion so hot that nothing could ever make him want anything else, a passion so sizzling that he'll subject himself to varying degrees of deprivation for what may be an eternity, just for the love of performing. Because he cannot imagine himself doing anything else. Never mind what other people think and want. The important issue is that he wants it—and wants it real bad.

The key to making it are your burning desire, drive, and curiosity.

Sassy Gerhardt

Coming to this town [Los Angeles] as a novice, or from New York with credits, if you feel you're an actor, just say it. You have to call yourself how you want to be received. And you religiously and aggressively pursue what you feel you're best suited for. However, you've got to look at it from an economical standpoint and a realistic standpoint, and that is this: there are thousands in this town and there are not a lot of opportunities in comparison to the numbers that are coming here, just like in New York. And with that being the case, then you have to wear a couple of hats so that you're not victimized by the controlling entities or powers that be. It's real simple. When you are in the minority but you control the majority of the power, then you dictate. And when you dictate, you cause a lot of people to dance and do the "Hollywood shuffle"—no pun intended. And therefore, when coming to this town, if you're black, white, red, yellow, green, or what have you, you've got to understand that there are a lot of people out here who want what you want. You've got to create a space for yourself, not give yourself away emotionally, spiritually, physically, or morally, just to make what you think is supposed to be your mark in this town. If it's supposed to happen—and I'm a firm believer in faith—then it will happen. But you'd best be aware of who you are when you get here because this town is no place to be nobody.

Bill Overton

Show business is fickle and insecure, offering no guarantees whatsoever, so be prepared for the long haul. The best advice we can give you is learn all you can about the business, decide what approach you think will work best for you, map out a clearly-defined plan of action, and then pursue your goals unrelentingly. Because there are so many different schools of thought on how a performer should pursue his career, it is easy to become frustrated and confused. Everyone has his own ideas and theories. And most times, everyone's ideas and theories will have their own merits and sound like the right way to go. But, in fact, there is no right or wrong, although there are better approaches than others. Since it's your job to decide which is the best approach for you, it's in your best interest to know what you're getting yourself into and what lies ahead. Learn everything you can about the business from books, magazines, seminars, other professionals, and, yes, even television. You are in control of your own destiny. In order to navigate yourself through what are sure to be unknown territories, be a smart commander and map out a route to follow.

Why do so many talented people fail while others, perhaps less talented, succeed? In many cases, the answer is shockingly simple: they have no career skills. They fail

to realize that the performer must master skills that will help him advance in show business. Time and again, I see actors frustrated and confused because they simply don't have the right information on the workings of the industry. Often these talented people lose work or find the process unduly difficult because of this lack of simple, yet important, information. This business is not fair, nor is there a checklist for success. Unlike medical or law school, the curriculum is uncertain, often controversial, and the job outcome capricious. One does not advance on merit alone: the actor must concentrate on constructing an awareness and execution of his career as if it were an enterprise—a business.[12]

Eve Brandstein

Tracey Moore-Marable, a leading independent black casting director, offers this advice:

You say you're an actor, right? You're just oozing talent and you're dying to display it. Here's your opportunity. You enter the audition space, do your thing, and you feel like you blew it. Now what? Regardless of where you are in your career, you must feel good about yourself and the talent you possess. If you are constantly perfecting your craft by attending classes, working on monologues, and going on auditions, then you are doing everything possible to move your career along. If you are waiting to be "discovered," then you're living in a dream world. It's true talent has been "discovered," but those situations are very rare. Why wait for an opportunity to find *you* when you can create an opportunity for yourself? This business is filled with people who are constantly judging you as an actor. Some may tell you, some may not. The point is that you must learn very early on how to handle constructive criticism. You must not take anything personally. If you don't get a role, that doesn't mean you're not talented—it just means that you didn't get the role. Don't try to read into it. Let it go and move on. You'll drive yourself crazy. The reality is that there are several reasons why you may not be cast—the studio may need a marquee name, or you're too tall. Whatever the reason, it is not relevant. Just go to the audition and make the most of the situation. Time is so precious—don't waste it. Nurture your talent and be proud to share it with others. Maintain a positive attitude and do the best you can at every audition.

Tracey Moore-Marable

Back to Basics

For anyone entering the entertainment industry, a formal education is a plus. This industry now demands intelligent, literate, and articulate participants who are able to integrate them-

[12]Eve Brandstein, with Joanna Lipari, *The Actor, A Practical Guide to a Professional Career* (New York: Donald I. Fine, Inc., 1987).

selves into any number of professional situations with people of all ages and races from many different backgrounds.

You must be able to quickly read and decipher the scripts you are given. You must know how to pronounce the words correctly according to the industry-accepted guidelines of standard American English. Many African-Americans, raised in inner-city areas, have acquired a unique speech pattern often referred to as "black English" (sometimes called "street black"). This way of pronouncing words, the intonation of the voice, and the use of slang terms may be called upon for certain roles, but if you are asked to portray a middle-class, college-educated lawyer or doctor, you usually will be expected to speak in standard American English.

New York actress and commercial acting teacher Joan See had this to say on the subject:

> The young minority performer—the black performer in particular and, next, the Hispanic performer—has several things that he has to come to grips with as he moves into the marketplace, if he's thinking about doing this professionally. The black performers that I have dealt with, that I have seen be truly successful, and that I've been able to help the most, have been the ones that have addressed certain matters. And I think one of the things that you find, almost across the board, if you were to do a survey, is many more language problems in black performers, which are holding them back. Basic reading skills. I find, on the average, the reading skills of the black performers that I interviewed and have worked with tend to be far weaker than the white performers. In my estimation, in the performing arts, that's where one of the big weaknesses is. And that's something that has to be addressed because there's no place in our training to do that kind of remedial work. And I think the young black performers have to really be honest about that with themselves and have to say, "Okay, I didn't get it. I came from a school that didn't give it to me." If you can give me "street black," but you can't give me standard American pronunciation at the same time, then you've got to look to those skills first. Those are the ones that you're going to be called upon to use, because the spectrum of work now is so much more available. It's very hard if you have a guy who's 40 and tall and good-looking, and you could cast him as a judge, or you could cast him as a police chief, or you could cast him as a New York City detective, but his English is black English, which is a dialect. He's already cut his market in half. I have to cast him as the bad guy—I can't cast him as the detective. I have to cast him as the defendant, not as the judge, because the language problem, the dialect problem, is something that he hasn't addressed. And I think, of all of the areas where young black performers have to sit back and be really honest and evaluate their skills, it's here. It has never been talent. It's never been, "Are the goods there?" It has been, "Have some of the other skills been there?". Those are the skills that I've found, repeatedly, over six years of teaching, to be the weakest—and they need to start addressing that. I would say any kid

who is thinking at 16, 17 and 18 that he wants a life in the theater as a performer, those are the skills you gotta go back to. You know if those reading tests in school are [not good], it doesn't matter if you're gorgeous, it doesn't matter if you sing like a dream—it doesn't matter, because someday you're going to have to deal with the words on the page.

Because of the variety of roles you may be asked to play, formal studies in English, history, and the social sciences are also helpful. For example, if you are asked to play a militant character that lived during the turbulent Civil Rights era of the 1960s, yet you weren't even born until the 1970s, knowledge of that era learned through your study of history will help you prepare a character study. But if you don't know anything about that era because you didn't study history, you can't possibly understand the political climate of the period and the racism and discrimination the character experienced.

Equally important are the social experiences that come with a formal education—learning to communicate your ideas and thoughts, participating in structured situations, and working together with different personalities. These experiences will be useful as you become more involved in the entertainment industry. These social skills will help you comfortably express your ideas about a character and teach you how to use psychology in working on the set with other performers.

Actor Lou Myers, who played campus restaurant owner "Mr. Gaines" on the hit television series *A Different World*, talks about the importance of education:

> I went to West Virginia State College and got a degree in sociology. Then I went to New York University (NYU) and got a Master's degree in sociology. I wanted something to fall back on, and I found that anything that you learn is good for acting. There's nothing you can learn that's not going to help you, and sociology, psychology, history—any of the social sciences—I think every actor should take because it gives you a way to analyze the dynamics of the character and society and the character in it. For instance, the play I'm in now [*Piano Lessons on Broadway*] is set in Pittsburgh in 1936. Now, I did not live in 1936 and the character that I'm playing, Whinin' Boy, he's a piano player, he drinks whiskey, he chases women. If you took him in the vernacular of today without any understanding of history, you may label him as a pimp, which he certainly is not. So, without any understanding of history of the period in time, an actor can get far off the mark.

Being in the Right State of Mind

Attitude and the role it plays in a performer's career are critical considerations. Even though we all have our "thing," there are redeemable qualities about everyone. It is important to build your image and your marketing plan on a positive, secure foundation. If you are following the guidelines, be willing to accept positive criticism of your role in today's commercial industry.

Go to the source. Take classes geared towards group interaction, learn to follow directions, and explore your craft well. Keep in mind that one man's opinion is exactly that. One casting director may love you, while another may not even give you the time of day.

As an actor, if you present yourself with dignity, humility, and class, you will be responded to accordingly. Many actors, trying to hide feelings of insecurity and helplessness, often are "on the attack" with their prospective employers. It is important to develop an aura of professional calm around yourself, putting you in command of any given situation.

Admit it—we all hate playing games. No one likes to be cheery when the rent is overdue, work has been slow, and you're not getting the breaks you've come to expect. Show business can be quite unpredictable, to make matters worse. However, playing politics in show business is just like playing the game in any other business.

Many performers spend years fighting the system, refusing to change with the times. Rather than keeping up with current performance styles, industry trends, and contemporary grooming, many performers will blame their nonworking unemployment status on the business itself. The smart performers change with the times. They keep up with the perpetual, day-to-day changes within the industry. As part of playing good politics, a performer must quickly accept and adapt to industry change. Rather than expecting the industry to accept the performer the way he is, the unknown performer, if he wants to work, will have to accept the industry the way it is.

Countless times, we hear from out-of-work actors, "I hear the business is slow." This is a myth. It is true that there are times when theatrical and commercial activity is heavier, but that does not account for the small percentage of ethnic actors who work on a weekly and daily basis. Never believe that the business is slow. If things are slow for you, it is your responsibility as a performer to hit the streets and find out who's working and why. It is also your responsibility to investigate the reasons why *you* are not working. Are you marketing yourself properly? Do you have promotional materials that accurately and positively represent your look, talents, and skills? Does anyone know that you're out there looking for work? Are you turning down jobs because of your ego, or are you turning down jobs because they conflict with your career goals or other job demands? Are you distributing your photos and résumés on a daily basis? Is your personal life getting in the way of your marketability? Are you distributing your photos and résumés to the right people, the people in a position to directly hire you for a job? Have you slacked up on your disciplines? If you want a job, you must keep working at it.

Don't let agents, other performers, or even friends con you into believing there is nothing happening. If you consider that we can turn on the television and see more black performers working than ever before, then there must be work somewhere. As each new television season begins, you will be hard pressed to find a new show without a black performer in some kind of regularly-featured role. So there is work—your job is to find it and get it!

Changing financial times have forced unions, employers, and performers to accept cutbacks, as in any other profession. Production discounts are now being offered in negotiations between unions and producers, giving producers more financial "perqs," allowing them to save more money when a production is operating on a strict budget. Sometimes this is a needed bargaining tool and at other times just a shrewd financial move on the part of greedy producers and directors. Nonetheless, these discounts have dramatically changed union rules and hiring practices in all areas of the business and has made the daily competition for lucrative work more intense for the performer.

If you are experiencing difficulty with the continuing progress of your career, it is usually just time to stop for reevaluation. Are your pictures of good quality and up to date? Do your pictures accurately represent you as a person? Is your personal grooming stylish, fresh, and in step with current fashion trends? Do you possibly need cosmetic dentistry, surgery, hair, or makeup services or voice lessons? Making minor "adjustments" can revitalize a stalled career.

Never *envy* anyone else's position or good fortune. There is enough work to go around for everyone. Everybody, including major stars, goes through occasional slump periods. It is during these slow times that you should push the hardest, rather than giving in to depressing, negative behavior patterns. Ever notice how the stars continuously keep their names in the paper? This is evident during the periods when they are not working. Major stars dress up and go out frequently so the public will be constantly reminded of their existence and won't forget them while they're unemployed. But unemployment is a commonplace reality in the entertainment industry. We like to call it "temporary unemployment." Performers are destined to be temporarily unemployed at various points throughout their careers due to the nature of the business. Acting is not always a 9-to-5, five-day-a-week job that guarantees a weekly paycheck. And unless you are a contract performer on a daytime soap opera, nighttime serial, or prime time sitcom or drama, you are likely to have several different employers. Even actors under contract may find themselves temporarily unemployed when their contract expires. Film actors work on a movie for a couple of months and then, unless they begin working on a new project immediately, they, too, find themselves temporarily unemployed. The point is, most actors don't work every single day. There will be periods of days, weeks, and sometimes even months or years when you won't work. But don't be put off—your time will come, with hard work and perseverance. During these periods of temporary unemployment, refine your skills, take a class, learn a skill, or work on upgrading your image. Constantly improve your product. When the unemployment blanket is lifted, you will be ready for work.

Competition is rough. More people are entering the ranks of amateur thespians than ever before because it looks easy. Today, every racial attitude and identity wants to be represented on screen, and rightfully so. Unfortunately, many advertisers will only allow a suggestion of racial

identity, often using only one ethnic performer in a theatrical or commercial project. This opens the competition across the board to blacks, Asians, Latinos, other ethnic groups, women, and disabled performers. Thus, there are even fewer jobs available to black performers. Many advertisers will hire ethnic talent to do background work in commercials, thus eliminating so-called "discrimination" in their talent hiring. This is blatant racism in reverse. At the same time, there is interracial competition for the same roles. The days of casting "black is beautiful" may still exist, but only in proportion to the beauties of every other ethnic and social group.

As black talent, you may come across racially-prejudiced and biased people. Some of them will be in a position to hire you for a job, and you may have to work with others on a job. A good rule of thumb in this situation is this: First, try to avoid personal confrontation as much as you can; second, do not get into conversations about racism and racially-oriented subjects; and third, if you do get into a deep conversation about racism or racially-oriented subjects, try to end it as quickly as possible—don't let your conversation turn into a heated argument. Getting all bent out of shape and into yelling matches is counterproductive. Even if you did not *start* the argument, you will always be remembered for being *in* the argument, and that could hurt your career forever. This is the real world, folks, and we are all bound to run into bigoted personalities. The best thing to do is to take a deep breath and maintain your composure. If you feel you are being treated unfairly, speak to your union representative. Their job is to protect all actors in the workplace.

4

THE "BUSINESS" SIDE OF THE BUSINESS

The very first thing you should do for your career is to sit down and outline a clearly defined plan, an overall strategy that you will use to guide and develop your career. To build a successful business, you need more than a great idea or enthusiasm—you need a winning business plan. A thorough and well thought-out program for action can mean the difference between success and failure. You know how tough it can be to keep track of all the things you need to do and how things can change at a moment's notice. Your plan will keep your business activities organized and manageable. This will require careful planning.

Your career plan should be based on a strong working knowledge of what this business is really all about. You will also need to acquire a solid understanding of how, why, and where you fit into the industry as a performing artist and, more specifically, as a black performing artist. Only then can you weigh the alternatives open to you. Keep in mind that your career plan will undoubtedly change as you mature and gain actual working knowledge. Therefore, you should always be open-minded and flexible in planning your career. New show business experiences can open doors previously unseen.

> If you're sitting at home, sitting by the phone, being depressed, wondering about what
> you're going to do tomorrow, then you're in trouble.
>
> *Sassy Gerhardt*

You can't build a house without knowing anything about architecture and construction. Nor can you build a career as a performing artist without knowing anything about how the entertainment industry works. Don't naively assume that you can forgo a show business education. If you do, you'll be at a great disadvantage to your fellow performers who are well-educated about the industry. Always remember that your career is a business—*your* business—and no business will thrive and survive without a well-informed and knowledgeable business owner—you!

Talented newcomers naively arriving in New York or Los Angeles fresh from college with drama degrees and small-town, community theater credits have to redevelop their orientation towards seeing their talent as the road to fame and fortune. They usually come face-to-face with the harsh reality that it is not enough to possess great natural talent, and that they can't sit back and wait for their talent to be discovered. Even the most talented will quickly learn that they will have to work long and hard to meet with the success that their talent deserves.

Show business is definitely not as easy as it may appear. Too often, we hear people comment on how they'd like to do commercials, while pecking away on the computer at their full time secretarial job. Many of these people think show business is a way out of their boring, 9-to-5 jobs, and a quick and easy way to make money. But it's not. In fact, many professional actors look to other careers (real estate, teaching) as a way out of their self-absorbed, show-business lifestyles.

You have to deal with reality. And reality dictates that everyone is not destined for a show business career. Just because you may look beautiful enough to be a model doesn't mean that you will make modeling a career. Beauties are a dime a dozen in this business. And just because your parents, family, and friends comment on what a wonderful little actor you are, it surely has nothing to do with how well you will do in pursuing an acting career. What really counts is a combination of factors including talent, personality, intelligence, attitude, good business sense, and smart politics. It's not so much how you look or act; rather, it's about how well you combine all of these factors to project a talented, winning, professional image.

> Everybody depends on everybody in this business. Nobody operates in a vacuum. The agents depend on the casting directors, the casting directors on the agents, the producers on their casting directors. Nobody can go it alone, and everybody needs everybody else to do their jobs well, because nobody can do his job alone. Nobody can do it all by themselves. And in that kind of head, I think there's a certain kind of sanity and understanding about the personalities and what happens when you meet them. They're human beings, too, and they're under a tremendous amount of pressure. Every casting director is only as good as his last tape. Every agency is only as good as its signed client list. And every talent is only as good as his last job. So we all suffer from the same thing. We all need to always be the best we can be. Nobody can slack off. There's not a lot of "Peter Principle" in this business. There's some, but there's not a lot. The people who rise to the top and work all the time generally rise to the top and work all the time because they do it right, and well, and efficiently, and creatively, and with good humor. There's only so far this business will go with the prima donna because there's no time on the set—the clock is running, and [the actor is] only one part of that budget.
>
> *Joan See*

It's more than talent—it's got to be more than just talent because there are a lot of people who are talented. Talent is an important part, but you have to sustain yourself if you're going to thrive, your talent has to be proven—but there are a lot of people who get opportunities 'cause they're smart, but they can't help it because, on the other side of the coin, they don't have the talent to help it.

Paul Laurence Jones

This is first and foremost a *business*—a business that offers no promises. Talent or beauty alone is just not going to make it. And sometimes, talent will have nothing *at all* to do with success. Many performers will sit back, relax, and wait for their talent to be discovered, having believed this fantasy as it is presented in film and television. But this is not film and television fantasy wonderland. It is your responsibility as a performer to approach your career as you would any business: with a plan, clearly defined goals, and a targeted marketing strategy.

People have to have a sense of business in this business.

Sassy Gerhardt

My father always said, in order to get somewhere, you've got to find out what you're up against, what you're involved with. So I went to the library, theater stores, read "how to" books. All these "how to" books, "how to get into show business" books, looking for that key, took me a while. Then I said, wait a minute, all these books are saying the same thing—it's a *business*. And I'm compiling information from these books and talking to people naturally; I realize it's not my talent and that somebody will see me. Yeah, that's part of it. But find out what you want. The two biggest words in some of these books—marketing and advertising. I had to find out where I'm going, what I want, and what they [the talent buyers] want. That started it. I got a hook then. I said okay, let me open an office [home office], let me run this as a business. This took time to set up, think it all out, and organize all of my thoughts. I had to find out what I wanted to attack first and find out how to attack it.

Kerry Ruff

This is a *sales* business. You are essentially a commodity, a product. As a performer, your real job is to sell your product—you! And as a salesperson, you will probably spend well over 90% of your time continually selling yourself to the talent buyers. Very little time will be spent actually displaying your wonderful talents. This is a business where you can spend years of training, studying, and developing your talents and still be rejected for a job because you don't have the right look—par for the course!

This business is a very trying gig. You're going to get an unbelievable number of turn downs and no's—but don't give up and you'll get through somehow.

Tony Singletary

You're selling yourself, your physical appearance, your talents, and your personality, so you'll need to market yourself in such a way that your assets are the focal point. You have to sell yourself as a performer with something that is unique and different from everyone else. Also, consider your promotional tools, including photographs and résumés, union memberships, agency and management representation, audition techniques, industry connections, current industry trends, and, most of all, the political climate. Sound like a lot for a talented performer to have to deal with? Well, it is! But in order to reach your full success potential, you will need to consider and guide all of these factors.

Read the trade papers and know what's going on from the business side so you have a sense of who the producers are when you go in to read for them and you know who they are. Be aware of the world you live in from a business sense. Actors really need to develop more of a business sense. There are many talented actors who are not working because they don't know how to market themselves. Especially for those who feel stuck in a career crossroad, they really need to get into a workshop to tune up their instrument. They need to flex their artistic muscles by being in an artistic environment where they're working and stretching, be it a scene study, cold read, improv, whatever the need or desire is. Make sure that all of your materials are current—your photos, résumés, and demo tapes, if you have them.

Adilah Barnes

The turnaround for me was the time I said, "I'd better set up a [home office] and see this as a business." I believe I got this [idea] from a few books. I'd hear it from other actors and actresses but I didn't know what it really meant. But it wasn't until I started setting up my own base, my own business, bringing in my own tools and materials, that I started thinking like a working performer. As long as I was sending out postcards and hauling one agent, even though I wasn't doing anything right then and I wasn't auditioning, I was working on my business. Working on the craft, I was doing that also—going to classes and studying acting, dance, and singing. That to me was the time I started working as a performer. When I hooked onto the idea that if I took care of the business aspects along with taking care of my creativity—studying and working, doing the theater at night, showcases, and whatever—then I felt like I was accomplishing things, things were moving, and they were because now I was getting pictures out and getting my mind programmed, focused, and centered.

Kerry Ruff

Tracey Moore-Marable had this to say about being a "professional" performer:

Over the past five years I have had the pleasure of auditioning all types of actors. I have found that, regardless of the level of experience, there are just some things that actors don't know. The lack of knowledge ranges from not stapling your picture and résumé to not following directions. I have always felt a need to embrace actors with the knowledge that I have as a casting director. I have found that the seminars that I give have been a great help and inspiration to actors because I am truly honest and sincere about my job. I want actors who are committed to their craft to get the jobs! There are so many times when I have literally wanted to take an actor to the side and educate him on the process of auditioning, but time does not allow me to reach out to every actor. I am a strong believer that failure is lack of preparation. So many actors are fascinated by the glamour of this business and do not take it seriously. Actors need to take control over their careers and gain as much knowledge as possible to maintain their power.

Discipline and Time Management

In order to successfully pursue work in the entertainment industry, your life must be extremely disciplined. For a working performer to keep up with the endless number of appointments, auditions, interviews, and actual jobs, you must always be on a flexible, yet productive, time plan. From the very beginning, it is important to set both daily and weekly time schedules, accounting for your work and leisure time. The way to determine your scheduled time allotments is by writing down, on a daily basis, the amount of time you plan to spend engaging in work-related and entertainment activities. Be sure to schedule ample time for classes, mailings, and other self-improvement activities. As a beginner, you may want to schedule only a few work hours per week until your career activities merit more of your attention. Every day should be spent in some sort of productive activity, working on improving your craft, business skills, and personal appearance. So many performers really believe that they have a grip on what is happening with their careers. They are confident to accept themselves as they are upon entering the business, without realizing this is an ever-changing industry where one's abilities and existence are constantly being challenged and questioned. This puts the responsibility upon the individual performer to be the most talented, best looking, and most professional performer he can be.

Confidence—part of it comes with you in the beginning, part of it you have to fight very hard to get. Every performer has to learn how to get out of his own way—every one of us. And the performers, again regardless of race, the ones who make the most of what they have, look upon what they have as a gift. They take care of it. They pay attention to it. They value it. They feel they've been given something that they owe a

responsibility to. And out of that comes the confidence, the discipline, the ability to self-discipline—which ultimately is what you have to do to make it. Because nobody disciplines you in this business except the business. So that if you have no self-discipline, and you don't pay attention, and you don't do the things you should, all the business is going to do is not pay attention. That the only way it's going to discipline you.

Joan See

When putting together your plan, you may even want to consider your own biological clock. Some people function better early in the day, some later. It is best to schedule your most taxing and demanding activities during the hours of the day in which you are the most productive. It is not unusual to find performers juggling several different activities while still maintaining a household and a stable income. The black performer, due to limited work opportunities and ever-increasing amounts of competition, has to work twice as hard to achieve this success, but it can be done.

I think an actor should punch his own clock. You need discipline. You shouldn't wait for the phone to ring and jump out of bed crazily. You should get up in the morning. You have to be productive day-to-day. That's your goal. Now say, "What time does my body need to get up?" If I get up by eight, get dressed and eat by nine, then I need time to exercise for a half hour and vocalize for a half hour and write some postcards, which is the key to following up. Then you make survey calls, do whatever you have to do, and then maybe go out and do your rounds, go to classes, or read or study or be somewhere that's networking in the arts.

Sassy Gerhardt

Clear your mind and your home of distractions and unnecessary evils. Everyone has bad habits and everyone can name two or three people in their lives who cause confusion. The smoother you can make your home and personal life, the more at ease you will be when you are auditioning. When your house is a wreck, when your rent and bills are overdue, you are splitting your concentration. When you choose to be a party animal, remember your health will affect your looks and your disposition. It can be sheer misery to work under boiling hot lights or in unusual elements with temperamental artists when you are tired and grumpy.

As the industry grows and changes, the techniques of talent presentation also change. It is important to maintain an open, positive, and flexible attitude when dealing with the business. Nothing should be taken personally when it comes to criticism. True, there are those unfortunate souls who never learned how to politely answer a phone or a question. And there are those people who are rude, curt, and sometimes just downright nasty. But if you take the burdens of the world upon your shoulders, you will stifle your spontaneity and creative juices. You are constantly being

watched, listened to, and judged. You cannot afford to take the chance and put yourself on the line. You have created a professional image, and it is your duty to make sure that image is what people remember, not your personal life or your attitude.

As a professional, you should always be prepared for the unknown and the unexpected. Often, casting calls are handed down to casting personnel at the last minute due to script changes or last-minute decisions. You can be called for auditions or work with less than an hour's notice. It is important to always be organized and responsible. The performer who is able to organize and process information quickly and accurately will always put himself ahead of the competition.

Assessing Your Career

Suppose you've been working at your trade for several years and you have had a great streak of beginner's luck. You have been lucky to have had a taste of professional success. Then, all of a sudden, the glass bottom falls out of your boat. Your wonderful show business career seems to have suddenly died. The phone has stopped ringing, and you are now anxiety ridden, wondering what you have done wrong. Or even worse, "Am I still talented?" These are questions we all ask ourselves each time we fail an audition or lose a job. This rejection is natural, part of the ever-changing responsibility of being an actor or an actress. Every year will not be a great one, and sometimes, these elements of success have absolutely nothing to do with you directly. On a daily basis, projects are cancelled, information changes, offices close, files are destroyed or stolen, and people move.

Despite what anyone tells you, this is a business that requires a certain amount of luck. There are hundreds of actors who are talented, studied, and disciplined, yet they still haven't been able to get the right break. What can you do if you fall into this trap?

Don't panic! This is a business of odds. Some actors have auditioned for years before they have gotten that one right chance. It is far more constructive to rethink your business strategy. You may just need a fresh start. You have to persevere, going from experience to experience until you are eventually "discovered."

There are some constructive things you can do to put new energy into your stalled career. First, check your promotional materials. Is your 8 x 10 current? Are you working in the right age category? You must be totally honest with yourself about how you are perceived by others. If you cannot be objective about your career goals, you need to get the opinion of a respected friend or industry professional. Take all career criticism constructively and, if you can, try to get more than one professional opinion. Sometimes the continuing advice of agents and managers can be profitable. Consider the source. They are in the daily business of selling talent. If you hear the same criticism more than once from someone you trust in the business, it is time to stop and take stock of what you have heard.

Maybe you need to be a little more aggressive about how you find and look for work. Until you have become an "overnight success," you are directly responsible for getting your name in front of the agents, managers, and casting directors who can offer you work. You must always make your presence known to the people in power in a positive, yet politely aggressive manner, despite your life's changes or changes of representation and personal appearance.

Are you mailing with regularity? If you are not, consider this: there are many actors who mail on a weekly basis. If your picture is coming across a casting director's desk only once in a blue moon, how do you expect to compete? The price of weekly postage is a small price to pay if it will lead to career success and personal happiness.

What about your working habits? Have you developed a reputation for being unprofessional? Are you on "CP time" all the time? Are you properly groomed and prepared for your day's work? Are you bringing your personal problems to the set or the stage? These problems may impact upon your employment. Word travels very quickly in show business. The casting circles, especially among African-Americans, are very small. Are your acting skills up to par? Do you need refresher courses in speech, audition skills, or acting? Don't be too proud. Be realistic. This business is constantly evolving. Use your spare time taking supplementary theatre-related classes that will improve your skills and chances for work. You may want to hire an image consultant or an acting coach to tackle a specific problem. If this expense is tax-deductible, you should definitely consider the consequences.

You may also want to consider relocating your career. A change of scenery may be what is needed for you to be put into a more profitable career arena. This is a major life and career move and it will involve careful logistical and financial planning. You will also have to consider the differences between working in different types of regional markets, and you will have to adjust your materials and your personal grooming accordingly.

If you are really feeling stalled, you may want to think about taking time off to train, study, and reevaluate. A temporary loss of career momentum is normal for most show business artists, and, sometimes, performers have only reached success after a frequent series of career setbacks. Spiritually, it may be important for you to experience some of these character-building obstacle courses, so it is always wise to have a well-structured family life and a network of social support systems outside of the business.

Your Basic Business Tools

Your most basic business tools are your headshot and résumé. Together, your 8 x 10-inch black & white headshot photograph (known as your "8 x 10" in industry jargon) and résumé are your professional business cards. (They will be discussed in greater detail later.)

There are several other important business tools that should be used in order to prepare yourself for an endless schedule of auditions, interviews, rehearsals, and performances. The following tools should be accessible at all times, in addition to your photo and résumé: an appointment book with an up-to-date phone index, a catchall bag, props or pieces of costume used to suggest changes in range or character for audition situations, an answering service, and a post office box.

It is important to maintain your appointment book on a daily basis. As your career becomes more successful, you will have multiple appointments per work day. In order to keep abreast of everything, it is important to keep accurate records of all calls, including dates, times, phone numbers, contacts, and addresses. Your appointment book should be light enough to travel everywhere. Your appointment book can contain not only basic appointment scheduling in a chronological fashion, but it can also contain locator maps, goal sheets, financial planners, receipt envelopes, phone indexes, pencil cases, business card sleeves, note pads, and sometimes even mini-calculators for quick figuring. Many of the new books even include writing utensils (ever notice how you never have a pen when you need one?). Though it may seem a burden carrying a year's worth of notes, it can often prove beneficial. Referring to past notes and numbers can save lots of time, money, and 411 phone calls.

Discipline yourself to maintain accurate, dated notes for future referral. Nothing can ruin your reputation quicker than lateness, missed appointments, and unreturned phone calls. Your agent or your manager should supply you with the date, the time, and the place of your audition, along with any other specific casting or wardrobe information. If you have questions about any of the information, don't hesitate to ask for clarification.

It is always assumed that performers will be responsible for meeting appointments promptly with accurate information. Write all notes and messages in your book. It is better to have your agent or a casting director hold the line than to lose the slip of paper on which you wrote vital casting information. Better yet, always have a pen when you're on the phone.

As your schedule becomes busier, you will constantly be meeting people in the industry who can help you climb the ladder of success. It is important to always leave behind either photo business cards, composites, 8 x 10 photo-résumés, or photo postcards. Each should contain your contact information. Again, don't rely on small slips of paper or matchbook covers. These items tend to get misplaced and lost. Ask your agent for adhesive stickers with the agency's name, address, and phone number printed on them. Attach these labels to a corner of your photo and résumé.

Once you have assembled your appointment book and photos, it is wise to invest in a comfortable shoulder bag. This bag may be small and simple or, depending upon your needs, it may have zippered compartments, side pockets, and accessory bags inside. It should easily facilitate

long distance travel and should fit comfortably in luggage bins and under public transportation seating. For walking long distances, make sure your bag is weather-resistant and can be comfortably carried by handles or shoulder straps. Nothing is worse than an uncomfortable and overloaded bag when you are on foot. Also remember, the more weight you carry, the more energy you expend. Never carry your money or wallet in your tote bag. Too many times, while concentrating on rushing from location to location, performers have been pickpocketed or ripped off and have even misplaced or lost their bags.

Your catchall bag should contain not only your appointment book and your pictures, but also your print portfolio, your makeup kit, and simple accessories used to suggest changes in range or character for audition situations. Be sure to stock your bag with office supplies; a travel-size office supply case can be purchased at a stationery store. There is a never-ending need for staples, paper clips, tape, pens, note pads, glue, and the like.

This brings us to another all-important word of advice: make sure, if you carry your portfolio, 35 mm slides, and negatives with you, that you have copies of everything in case you lose your pictures. This way you will be able to replace the photos in your book if it gets lost or stolen. If you don't take this precaution and you lose your book, you will have to start from scratch with new photo sessions and compiling all of your tearsheets again. Often on the news we hear stories about famous models leaving their portfolios on the back seat of a New York City cab. A lost portfolio can cost a model thousands of dollars in bookings, not to mention the hard work of collecting tear sheets, prints from testings, and expensive promotional materials. Don't be a casualty.

Another essential business tool for the professional performer is an answering service. There are several types of answering services. The first and most common is a 24-hour, operator-assisted telephone answering service. These services operate through a large switchboard that can handle many calls at once. When a client dials a predetermined phone number and asks for you by name, the operator will act as an intermediary and record the message with the time, date, name of calling party, and the party's instructions including their phone number. During the day, the actor is responsible for calling his service periodically to check for his messages. It is wise to check messages frequently, on the weekends and well into the evening, because casting directors have been known to make emergency casting calls as late as 11:00 p.m. the night before a 7:00 a.m. shoot. The answering service is also a great way to screen your incoming calls while maintaining your privacy. Answering services operate on a basic monthly service fee, which is paid by the performer. The monthly fees range from $15 to $50 for 24-hour, seven-day-a-week service. Some offer other services including wake up calls, phone mail, mail collection, tracing, call forwarding, direct pickup, and beeping services. You will be charged an additional fee if you choose any of these additional services. Ever hear a beeper go off on a movie or television set during rehearsal?

Hopefully, some talented actor just got a job! Develop a good rapport with your answering service. It is easy for operators to record wrong numbers and information for unfriendly and displeasing performers, and you may find yourself missing valuable messages if you're not nice to them. If the service operators like you, many times they will go out of their way to locate you in emergency situations. Always be polite. Your answering service operators are usually fellow performers.

> An answering service is very very important. It's very inexpensive. It's very convenient for us and it's very convenient for the talent. Some people look to save money by having a machine. This girl had a machine on her home phone in Long Island. I'm very disinclined to make a toll call, especially on a big call when I'm sending 30 girls—why should I want to spend 50 cents to call Long Island when I can spend 10 cents to call someone else? And it's quicker.
>
> *Peter Lerman*

The second type of answering service is an answering machine attached to your home telephone. After a series of rings, the machine will deliver your personally-recorded outgoing message to the caller. After the outgoing message, there is usually an electronic tone or beep which activates the tape recorder within the machine. The machine will now record a message from the caller. Shop around for a voice-activated answering machine that can record messages of unlimited length. Your agent, casting director, or production staffer will often have to leave a great deal of involved casting or wardrobe information on your machine.

There is also a new type of answering service available called phone mail. The caller hears your voice originating from a computerized switchboard that responds to the touch tone phone. By pressing different assigned signals or numbers, your client is able to edit, record, and erase his message to you through the computerized switchboard. Usually, phone mail automatically records the exact time and place of your call, thus cutting out the human error factor. When you call the switchboard, your preassigned code allows you to hear the exact recorded message your caller left with time and date.

In either case, a reliable method of phone answering is an absolute necessity. Since most business is conducted on a last-minute basis, returning calls will be important. The quicker you return calls, the more dependable and reliable you will appear to be.

It is also smart for the performer to get a post office box to use as his professional mailing address to maintain privacy. The cost is approximately $30 per year or $15 for six months. Anyone can get his hands on your photo postcards with your return address as they are traveling through the mail. There are a lot of weirdos out there! You could put your postcards into envelopes

for 25 cents each, but it is far safer and cheaper (15 cents each without an envelope) in the long run if you get a post office box.

Your Home Office Space

Throughout your career you'll spend a great deal of time getting prepared—stapling photos and résumés together, organizing mailings, updating your appointment book, sending thank you notes, etc. You need a separate place to work, a home office space. Find a corner of your living room or bedroom, or, if you have a spare room, turn it into a home office. You need a place, away from any distractions, where you can concentrate on the business details of your show business career.

Your home office space should have a desk, a comfortable chair, and adequate lighting. Stock your desk with office supplies such as a stapler, glue, scissors, writing utensils, message pads, etc. It is a wise idea to invest in a typewriter or personal computer—you will need it to type your résumé, cover letters, and names and addresses on mailing labels or envelopes. You want to make sure all of your business materials look professional. Sloppy, handwritten notes are unbecoming.

A personal computer is a valuable tool for a performer because, with it, you can create and save files and store them for years. This ability, coupled with other functions a computer offers, can cut down on the amount of writing and note-saving you have to do—kind of like your own personal office staff! With a computer, you can keep records of your taxes and your show business contacts and make personalized address labels, stationery, and letters.

You should also invest in personalized stationary. You will need standard-size letterhead for cover letters and note pads for short notes. You will also need business envelopes, large 9 x 12 envelopes for mailing your photos and résumés, and return addresses stickers (or a stamper). It's wise to purchase a "Photo: Do Not Bend" and "First Class" stamper to help label envelopes.

Being a professional performer implies you are always prepared for any casting emergency. The disciplined, more professional actor is always on time, prepared, and ready to work with a positive attitude. The competition is stiff, and no performer can afford a sloppy work reputation. The professional performer is remembered and constantly employed because casting directors can depend upon his reliability as a business person and as a talent. When you have built the reputation, you become more than just another 8 x 10 photograph in a pile—you become a talent to be remembered and employed.

> You have to have such confidence in yourself because you throw your whole life in front of someone and say, "Judge me, do you like me?" Every time you go out in the marketplace, you deal with rejection. You have to have a strong sense of self-worth.
>
> *Bill Overton*

5

THE COLOR ISSUE

As a performer, you should realize that, at this particular point in time, the industry and the institutions that run the industry are white run, owned, and operated, as are the overwhelming majority of talent buyers and related industry personnel, including talent agents, managers, casting directors, and production personnel. Unfortunately, White Hollywood[13] doesn't usually encourage realistic ethnic images in the media. Because White Hollywood is isolated from the black experience and doesn't always interact with the African-American community in a meaningful way, their image of black America is shaped by their perception of black people as depicted in the news and print media. And in the news and print media, drug abuse, gang violence, and crime are all presented to the viewing American public in black face. No wonder they perceive black people in shower caps and handcuffs. Through the window, it's like an outsider looking in. If people perceive blacks to be a certain way, they will, of course, portray us that way. And until a revolutionary change takes place in the power structure of the industry— when blacks find their way into powerful decisionmaking positions at the top of network television programming and feature film production, it is unlikely that the persistent stereotyping and unrealistic portrayal of the ethnic American will disappear.

As a performer, you will be addressing a broad spectrum of the American public, including Americans of all races and colors. The American public is also affected by the mass media images of blacks as they, too, are isolated from the African-American experience. Therefore, the image you have of yourself will often be different from the viewing public's image of blacks.

Knowing who you are as a black person is vital to your survival in this industry. You should have a positive attitude and the self-image and self-respect to compensate for the attempted

[13]The term "White Hollywood" is used throughout this book to mean the majority, white-run, white-owned, and white-operated entertainment industry and the institutions that run the industry, including network heads, producers, directors, talent agents, personal managers, casting directors, and production personnel.

image reversals that you are bound to encounter. Remember, this is not an attack on you personally. This attacks all ethnic performers. So don't take the weight and burden on yourself. You are entering into a business that does not always project a sensitive, positive, and realistic black image, as it does not always project similar images of all ethnic groups, women, and the disabled.

Pride vs. Money

As an African-American performer, you are likely to be confronted with choices that relate to your ethnicity. Black performers should realize that deciding whether to accept roles that are stereotypical and demeaning to blacks is not only a question of career opportunities and money—it may also be a question of racial pride and compromising your personal values for the sake of greater financial rewards. As a performer seen through a variety of media outlets, you are a role model. Americans all across the country will view you as a representative of all African-Americans. You should, therefore, think about how the roles you choose will influence others. Are certain "racist" roles too high a price to pay for stardom? Do the ends justify the means? These are questions you must ask yourself. Though you may set out to only play roles that portray blacks in a positive and dignified manner, there will be times when you are presented with a role that does not depict black Americans in a flattering way. In this case, you must weigh the consequences. Are the money and career advancement more important than your bringing dignity and pride to the role? Or does the lack of work for performers—African-American performers in particular—make this seemingly unflattering role more appealing in the face of your financial survival? Sometimes it may be more important, other times it will not. Also consider that if you decide on a role that negatively portrays blacks, your choice may have political consequences. Remember in the movie *Hollywood Shuffle* when the NAACP picketed Robert Townsend's movie role because it was a flagrantly negative role model? This movie scenario can happen in your real-life career. It did happen in the career of actor Danny Glover, who received a lot of negative attention for his realistic portrayal of "Mister," the abusive character in *The Color Purple*. And depending on your clout in the business, this type of situation could have devastating personal and career implications. Fortunately for Danny Glover, the negative publicity surrounding his role appears to have had no profound effect on his illustrious career. Be prepared to make important career decisions relating to the type of roles you choose to play.

This has been a controversial topic in recent years—should actors be held accountable for the roles they play? Is it fair to expect a struggling performer to take a social and political stand and refuse work because it may not be to everyone's liking? Some argue that black people can't be presented in stereotyped roles if black actors don't accept stereotyped roles. While this may in fact

be true, where do we, as black people, draw the line of responsibility, and who should draw the line of responsibility?

Dealing with Discrimination

Discrimination exists in show business just like in any other area of life. People will be people and, because of our varied upbringings, we will work with many different types of people on many different levels. The major thing for the black performer to remember is, if discrimination exists, the problem belongs to the discriminator, not the struggling black performer.

It is extremely important for an ethnic artist to always rely on his integrity, discipline, and, above all, class. Too often, performers have been raked over the coals and given a raw deal, sometimes blatantly. Why should a black performer jeopardize his entire career by being a racial champion? This is not in any way a wish for you to back down from someone who may be ignorant, tasteless, vulgar, or even common. However, in viewing the overall perspective, it's to your advantage to ignore biased people and just steer clear of racial confrontation. You do not have to work with these people.

There will be situations you find yourself in that have racial undertones. These are daily, commonplace occurrences performers should learn to accept and deal with intelligently and professionally. One young black actor once found himself nervously audititioning with 15 other black actors at a prestigious New York advertising agency for a major product campaign. Upon making it through the preliminary auditions, and knowing from his agent's response he had booked the commercial, he was later informed, the day before the shoot, that, although the client loved his audition, they had decided to cast an all-white commercial. In the words of the agency producer, "The client felt a black person could not sell the product effectively." The young actor, upon viewing the final commercial, had to watch the white actor duplicate his audition performance after having studied the black actor's audition videotape.

On another occasion, two black actresses were called into an audition for a black radio commercial. After the advertising agency had narrowed the candidates down, and after several callbacks, these two experienced and intelligent actresses were asked by the white director to "talk black." In other words, he wanted them to "blacken up" their vocal interpretation more to sound more "street."

As a performer, you will often be faced with audition and work situations requiring you to "act black." Think about this scenario: you walk into an audition room jam-packed with some of the most admired, respected, and classically trained and studied black actors. They are sitting around the room practicing "being black." You will often find yourself in this type of situation, where your audition material is full of stereotyped, jive-talking, streetwise language and move-

ment. And though you may find the material offensive, you are a performer auditioning for a role, and you should go through with the audition, even if you have no intention of taking the role if offered to you. Walking out on this type of situation with an attitude and snide remarks will only tarnish your professional reputation. Casting directors are not endeared to actors who get uptight about the contents of the audition material. The casting director is there to review the available talent and make preliminary casting decisions. He is not there to get your personal, social, and political feelings about the audition material, and often he is uncomfortable as well. If you think the audition material is negative and unflattering, go through with the audition anyway. And if, by chance, you get the part, politely and diplomatically turn down the role through your agent. This is part of your agent's job—to protect you from doing demeaning work. Handling the situation in this manner won't offend the casting director and will leave the door open to you for future auditions. If you find it necessary to comment on the audition material, consider the consequences of your actions—you could conceivably label yourself as a radical or troublemaker.

6

TOOLS OF THE TRADE

One would think that actors get work on the merit of their acting abilities, but it doesn't work exactly that way. Career advancement is seldom based on great talent as much as it's based on your public relations materials. Great talent is sometimes slow to be discovered, while the not-as-talented performer who skillfully and professionally promotes himself will often advance must faster.

As a performer, you need to call attention to yourself among the vast pool of competing talent. You need to promote yourself and effectively project the unique qualities that make you special, so you'll stand out from your professional peers. Your promotional presentation has to be packaged just right and be impressive enough to get the casting people interested in you.

In getting your promotional campaign together, you want to choose promotional tools that will let the talent buyers know you take a serious approach to your career. These include pictures and résumés. You may also want to incorporate fliers, newsletters, press clippings, publicity stills, press kits, and demonstration ("demo") video and audio tapes into your promotional campaign.

You must think of yourself as a product. Talent is often secondary to how good your sales performance is. To sell your product effectively, you must employ all the skills and techniques of a professional public relations person, until you can afford the luxury of hiring a publicist. Read books on advertising, public relations, and publicity techniques. Learn all you can about sales and how to sell a product effectively. Attend professional sales seminars to learn how to effectively market yourself as a commodity. There are a number of adult education courses that offer inexpensive, short-term learning programs in advertising, public relations, product sales, and marketing. Then apply all you have learned to *yourself* to create an effective public relations campaign. Generate your own publicity—remember, *you* are your own product.

Photographs

Your most basic selling tool is your 8-inch by 10-inch black & white photograph, your "8 x 10." This is your calling card, the means by which you will introduce yourself to the talent buyers. You'll use your postcard-size and business-card-size photographs to keep in touch with people you've already met. A good picture can be worth more than a thousand words—it can also be worth thousands of dollars in income! You should be satisfied with the look your photo represents. Many times, the casting director will work only from photos. One of the biggest complaints casting directors have about performers is they seldom look like their pictures.

> The face has to look like you—that's your calling card—it's going to get you work, it's going to get you the interview.
>
> *Annamarie Kostura*

> Pictures are very important and they must never lie. Nothing is more disconcerting than calling somebody in because you think they look one way and then they come in and they look an entirely different way. That's why a good photograph is very, very important.
>
> *Betty Rea*

> Pictures should look reasonably like you're going to look like when you walk into an agent or casting office. The pictures should be flattering, certainly never unflattering.
>
> *James Kriegsman, Jr.*

Your headshot is a photo of your face from about the shoulders up, usually cropped just below the point of the collar. Profile photos will not do. Neither will photos where your face is hidden in dark lighting. Talent buyers want to see your full face, so you should be looking directly into the camera. Your headshot should represent your personality. It should be a friendly, natural photograph with a warm and open quality, as if you were saying, "Hi! Here I am! Hire me!".

> If [your photograph] looks like you—if there's some warmth, some humor, same hairstyle—it should be the same as when you walk through the door.
>
> *Annamarie Kostura*

Performers will often use different headshot photographs to satisfy the requirements for the many casting situations in which they will find themselves. The most important thing is that the photograph reflect the character or type of image the performer wants to project. For com-

mercial auditions, the performer should have a bright, upbeat, smiling photograph. Theatrical dramas are best served with a more emotionally expressive photograph that reflects the essence of a particular type of character. For soap operas, casting directors seem to be partial to a more upscale and beautiful look. In any case, the photograph should *always* look like you. But remember, you can change your look for different situations, and that is what you want to do when getting headshots made for specific casting situations. The "happy-go-lucky" you should be in your commercial headshot, the "real" you in your theatrical headshot, the "beautiful" you in your soap opera headshot.

You can always start off with a conservative, all-purpose headshot to use for all of your audition situations. Later, you can get more headshots for your specific audition needs. We suggest taking this route for beginners who may not yet be familiar with the different types of headshot, or may not yet know what their different looks are going to be.

> When [newcomers] come to me, they have to have photographs they can leave with me. The headshot is the single most important thing. You'd do a little better if you have more shots, but [the headshot is] basic.
>
> *Peter Lerman*

> I usually give people the same basic advice. You can get started in this business with even one shot. If you don't want to invest a lot of money but you want to circulate your picture around, you can use a commercial-type shot as an all-around shot. Straight on with a nice smile.
>
> *James Kriegsman, Jr.*

> The photo should be fairly neutral. The clothing should not be typecast—large earrings, headband, any sort of wardrobe that gets in the way of the photograph, because that's what we start looking at. It's the same thing when someone comes in to audition—you don't want to wear clothing that makes too much of a statement. You want to wear something that makes your personality identifiable. If the photo makes too much of a statement, you can't see the person.
>
> *Annamarie Kostura*

Headshot photographer Elizabeth Lehmann feels that the type of photo shooting you choose can also help identify your target market. Elizabeth feels studio shootings with artificial light sources are very controlled and tend to work for conservative, commercial-type photos, where natural sunlight projects a stark, more realistic image for television and film castings.

There should be nothing in the background to distract from your face. A plain, light-colored backdrop is best. If you are shooting outdoors, the background should be clear—make

sure there's nothing sticking out from behind your head likes houses, cars, and trees. Don't wear distracting clothes, and don't cover your face with hats, scarves, jewelry, or hands. If you have good teeth, show them off with a big smile, but beware of showing too much of your gums.

> Common mistakes—using a hairstyle they don't walk around with. Hair is very important. Overdoing their expressions can really mess up a shooting. They can wear the wrong thing. Also, they should come in on a day they feel right. Be "up" for the shooting and feel good about yourself.
>
> *James Kriegsman, Jr.*

Before approaching a headshot photo shooting, an actor should ask himself the following questions to avoid making costly and careless mistakes:

What is the most realistic age range I can project? By deciding beforehand what your target age range is going to be, you can avoid taking pictures that do not match your appearance as you enter an agent or casting director's office. Your photos should reflect the way you look. Never try to add or subtract years from your real appearance. This becomes confusing during the casting process, and you will be remembered for presenting a falsified presentation.

With what types of characters am I most identifiable? Have you ever had anyone tell you you look like a teacher? Could you play a convincing doctor or nurse? Are you more comfortable looking "artsy," like you could be a musician? These are important considerations if you are preparing a range of character types to be photographed for a composite photograph. Make your portrayals simple, yet realistic. If you have access to professional uniforms, use them. During the casting process, your composite photo may be just the edge you need to convince a casting director that you can play a variety of character types.

Do I look the way I want to look for my pictures? Do I need dental or cosmetic work to enhance my appearance? If you plan to make any major changes in your overall appearance, make them before you take your photographs. A bad picture will make you feel self-conscious and apologetic at casting sessions. By correcting your flaws ahead of time, you ensure a more relaxed photo shoot and better pictures.

How should I groom myself for my pictures? Until you learn the best tricks for your own individual grooming, seek out a professional makeup artist and hairstylist who will decide the best ways for you to look. Ask for advice and recommendations from performers whose photographs you like. Cut pictures from magazines when you see a look that captures your eye. Practice in front of the mirror with different expressions, clothing, and hairstyles before the actual photo session. Seek the advice of a professional image consultant.

Lehmann offers the following advice about hairstyling:

Hair tends to be the biggest problem during the shoot. Your hair frames your face. The arrangement and balance that are essential to photos are achieved through the styling. Good hairstyling is an integral part of the finished product. If you have a regular hairdresser, you may use that person the day of the shoot. Unless your hairstylist has experience specifically styling for photography, please use one of my stylists during the session. If your hair tends to be temperamental and/or you want to make more than one hair change during the session, you should have the hairstylist come with you to the shoot. At a minimum, you should have your hair professionally styled prior to the session. If you're planning to have your hair cut or processed, do so at least a week before the session, to give your hair a chance to adjust.

Practice applying your makeup before the photo session if a makeup artist will not be present at the shooting. Makeup should be natural-looking but applied a bit heavier than every-day makeup for the contrasts caused by stark lighting in black & white photography. You could conceivably waste a great deal of money on pictures if your makeup photographs improperly; if you are unsure, always seek professional help. It will save money in the long run.

Regarding clothing choices for photography, Lehmann offers these suggestions:

In general, bring shirts/blouses that are lighter or darker than your skin tone. Rich pastels photograph well, as do dark colors. Black is okay, but white is not, unless layered under something. The goal is to have tone separation between your skin, clothing, and hair. Sweatshirt gray, khaki, and salmon read the same tone as skin tone. Avoid bold prints and busy patterns. Also, try to choose clothes with texture. For commercial shots, think in terms of casual but neat. Crisp cotton blouses/shirts and crew neck sweaters are good for a commercial look. Blouses with simple, elegant necklines and textured fabrics such as angora wool, silks, and leather are suggested for women's legit/soap/film shots. Sweaters, nice shirts, sports jackets, and street jackets are suggested for men. Ask yourself: How do people in the business see me? What types of roles am I likely to be sent out for? How do I usually dress for an audition? Make clothing choices accordingly. Bring more clothes than you think will actually be used. It is better to have too many choices than too few.

Keep your look plain and simple. Don't wear anything distracting—earrings in your nose; cornrows, braids or beads in your hair; or elaborate ethnic headwraps and clothing. These items will typecast you and limit your marketability and appeal. Why? Advertising agencies spend millions of dollars on consumer surveys, which are circulated throughout the United States. Each survey questionnaire contains questions that identify the most familiar and nonthreatening commercial images. The "P&G" (Procter & Gamble[14]) look is a conservative advertising

[14]Procter & Gamble is a major manufacturer of soap and household products which has financially backed many ad campaigns, soap operas, and television programs.

image based on a cross-section of American cultures and dress styles. Boring as it may be to you, the P&G "whitebread" look gives advertising clients versatility. This image can be shown anywhere without offense. Safe? Yes! But as your career escalates, you may become more individual and unique.

Should I have my photos retouched? This is a tricky question. Yes, you should have minimal retouching done to make your photo appear clean and crisp, especially for duplication. Sometimes the camera can exaggerate imperfections in skin color and texture. These imperfections should be softened or removed. However, be careful not to change or alter your physical appearance too drastically. You should leave laugh lines, wrinkles around the eyes, and any prominent signs of character or age. These markings make you the person you are. Marks of character make us look human and show just how normal we appear to be. Today, the emphasis is on real-looking people who possess the average, wholesome qualities of healthy American life.

How do I choose a photographer? In choosing a photographer, we suggest that you first ask agents and other performers for their recommendations. If you can't get any recommendations, look through the trade papers. *Backstage* and *Show Business* in New York and *Dramalogue* in Los Angeles are the regular weekly trades that photographers advertise in. Don't use a friend to take your headshot, and stay away from amateur photographers. Make sure that a professional headshot photographer is taking your picture. A professional headshot photographer knows the market and the images that are best for you. He is also equipped with the proper lighting, backdrops, and character props to enhance your photos.

Make an appointment to visit the photographer in person to see his work. Any competent photographer will have samples of his current work. Before making any decisions, see the portfolios of several headshot photographers. Make sure you look at all of the photographer's samples of actors, both black and white. Lighting and backdrops should flatter our darker skin tones, and lighting should be adjusted to bring out the warmth and highlights of our complexions. Notice the amount of care taken with his photos, and try to get a feel of the atmosphere you'll be shooting in. It is at this time that you will find out if you feel comfortable and at ease with the photographer. You want to make sure you have a positive and friendly rapport with him. If you don't like something about the photographer or his work, don't feel pressured to hire him, don't commit to anything. If you feel uncomfortable, this will be reflected in your pictures.

Decide beforehand exactly what type and how many pictures you want so that you won't be pressured and swayed by the photographer's suggestions to have extra character photos taken at your headshot sitting. Many performers use composite photos to supplement their 8 x 10 headshot. These composite photos can contain anywhere from two to six different photo-

graphs of the performer in various character situations. Even if you decide you want to get composite photos, have your headshot photo taken separately. Save the character photos for future shootings so you can focus your attention on your headshot photo. The photographer, of course, will always want you to purchase their most expensive photography package.

Before you make your final decision on a photographer, find out the answers to the following questions:

- *How much does the photographer charge for the initial photo session?*
- *What does that price include?*
- *Does this price include makeup and grooming services?*
- *Do these services fit my special ethnic needs?*
- *How much deposit is required?*
- *When is the balance due?*
- *How many shots will the photographer take?*
- *Will I be able to keep the negatives at no additional charge?*
- *How long after the photo session will the contact sheets be ready?*
- *How long after I select the pictures will I receive the actual prints?*
- *How many, if any, 8 x 10 prints are included in the photo session price?*
- *If 8 x 10 prints are not included in the price, how much will each print cost?*
- *Is retouching included in the photo session price?*
- *If I am dissatisfied with my photos, do I get a reshoot? Is there an additional fee for this?*

Lehmann offers these questions in her "Checklist for Evaluating a Headshot Photographer":

- *What is the session fee?*
- *What is the average length of a session?*
- *Does the photographer do Polaroid test shots before going to film?*
- *How many shots are included in the cost? How many 8 x 10s? What do additional 8 x 10s cost?*
- *How long does it take to get your proofs? Your 8 x 10s?*
- *How far in advance do you need to make an appointment?*
- *What does the photographer do/suggest about hair, makeup, and retouching?*
- *What if, for valid reasons, you're really not happy with your shots?*
- *Do you like the photographer's book?*
- *Do people in the book look like individuals, or do they tend to conform to the photographer's style? Do they look real or glamorized? Do you think these people could walk into an audition and be recognized on the basis of their picture?*

- *Do you like the use of light? Is there detail in the faces, or do they seem over-lit (washed out) or over retouched?*

- *Is the background distracting, or does it enhance the photograph? Is there tone separation between the face and the background?*

- *Does the photographer seem to photograph one sex better than the other, one type better than another ("pretty" people better than "average" people) or a type of shot better than another (commercial shots better than soap/legit or vice versa)? Some photographers have a broader range than others. It's a matter of what kind of shots you particularly want and finding someone who does those shots best.*

- *Did the photographer take time with you, and does he seem to enjoy doing headshots? Did you sense that perhaps he is burned out or into a numbers game of high volume, high turnover?*

- *How would the photographer be working with you while actually shooting?*

- *And probably most importantly, how do you feel about the photographer? Can you imagine working with this person and feeling comfortable? There is no one photographer for everyone. So it's up to you to find the one whose work you like and who you think you could best work with.*

Headshot photo sessions can vary anywhere from $50 to $5,000—really! Prices also vary from men to women. For women, makeup, hairstyling, and wardrobe styling require extra personnel, which will either be included in the photo session price or charged separately by each individual person.

You should have a makeup artist apply your makeup at your very first photo session. Makeup artists charge anywhere from $25 to $200 per sitting. Women require more elaborate makeup; however, men and children also require basic foundation and contouring. For men and children, prices may be significantly lower than those for women. Many photographers have makeup artists and stylists with whom they prefer to work. Ask the photographer about having a makeup artist and hairstylist present at your sitting, how much it will cost, and how long they will stay during the shooting. Some makeup artists apply the makeup and then leave, while others stay throughout the entire shooting, constantly checking your appearance for last minute touch-ups. Be sure the makeup artist is familiar with black makeup techniques. This is not the time to experiment.

After your film is developed, you will select your headshot from a contact sheet. A contact sheet (also known as proof sheet) is a film strip photo reproduction of a roll of film. From each contact sheet, you can make your final selection from a series of miniature photographs.

When you receive your contact sheets, take a few days to decide on the pictures you want. Ask your friends, both professional and personal, for their recommendations. If you know an

agent, manager, or casting director, solicit his professional recommendations. You can also ask the photographer which photo he thinks most clearly represents the image you are seeking to project.

You should be extremely objective in choosing your headshot. Use common sense. What will show you off in the best possible light within the guidelines of the image you want to project? Forget about how you *personally* want to look. It seems everyone secretly fantasizes about being the beautiful, model type. And we can all glamorize ourselves with the right makeup, hair, and clothing. But you should be impartial and realistic in choosing the photograph that is going to market you the best.

Once you decide on your picture selection, you'll once again need to contact the photographer, who will have the original prints made from the negatives. When you receive these original prints, take them to a photo duplication service to have quantity copies reproduced. You'll use these copies to distribute at interviews and auditions and through mailings.

In having quantity copies of your headshot made, look through the trade papers for information on theatrical photo duplication services. Prices vary significantly, depending, from company to company, on the reproduction quality. For the initial duplication, you'll need to make an 8 x 10 copy negative from which your quantity prints will be made. You can choose to have your photo negative made with or without a border. You'll also need a negative for your name, which will be printed on the front of your photo. You can choose to have your name printed within the border or inserted onto the photo image. Ask to see samples of the most current and popular styles of photo printing. When you reorder your photos, you will pay only for the actual duplications, since you will have already gotten the copy and name negatives.

Be sure to take care in storing your negatives—they are fragile and sensitive to heat, moisture, and light. Your negatives can last a long time if properly cared for, and you will avoid additional expenses, too.

Photo postcards are smaller size versions of your headshot. You will use these postcards to establish and maintain regular contact with your agents and casting directors in follow-up mailings. The standard size for these postcards is approximately 4 inches by 6 inches, with one or two photos.

Depending on the type of work you're trying to do, you may use a photo postcard with one or two different headshots on it, or several different postcards each with a single headshot photo. If you have a commercial and theatrical headshot, you may want to put both photos on your postcard. Or you can get a postcard made for each headshot. In any case, your photo postcard should have your name, union affiliation, and answering service phone number printed on the same side as the photo. You may opt to have your agency logo imprinted on your postcard as well.

Make sure that your headshot is exactly 8 inches by 10 inches and that your postcard is 4 inches by 6 inches—this is the industry's standard size for filing photos. Your photographs can be duplicated with a glossy, semi-matte, or matte finish. These protective finishes sometimes can alter the appearance of your photograph. We personally recommend that you choose borderless, semi-matte photos. Keep in mind that glossy finishes on your photos can yellow and dull over time. Semi-matte finishes are often more flattering because they don't glare and they soften the stark contrast of black & white photographs. You should also have your photo postcards duplicated at this time.

Don't be satisfied with anything less than first-rate, quality photos. If your photos were not reproduced properly, insist on having them redone at no additional charge. If a mistake was made that wasn't your fault, stand firmly in your desire to have your photos redone. You're paying for your calling card—your entree into a show business career.

There are photo duplication services located in most major cities, but New York and Los Angeles have services specifically geared towards performing artists. These services specialize in doing only theatrical photos, and they are specially priced for quantity reproductions. If you go to your local photo shop, you may end up paying several dollars for each duplication, whereas if you use a service for performers, each photo can cost as low as 30 cents for runs of 100 or more. Outside the major cities, you can order your photo duplications through mail order services. Many of the top photo duplication services in New York and Los Angeles offer mail order as well.

On the following pages you will find examples of various pictures of working actors, both black and white. This section is intended to give you ideas in creating your photo package. Your choice of a photographer, your wardrobe, your cosmetic styling, and your expressions may differ from these examples, but over time you will discover there are certain photographic standards that will apply to any great headshot.

The Photo Gallery

Introduction

Your photo image is sometimes the only representative you have to send or leave behind with a casting director or a producer. Whether it is an 8 x 10 black & white photograph, a model composite, or even a business card, it is important that your pictures are clear, targeted, well-executed, and styled within the current trends of photography, lighting, cosmetic styling, and printing. Remember, you can book major jobs without ever being seen in person. Your photo will go places you cannot and will be seen by many people over the course of the casting process. Actors have been known to book jobs without even knowing the casting people or the production staff. If your photo presentation is striking, clear, and dynamic, doors will eventually automatically open.

There are no concrete rules for taking and reproducing photographs, but, after reviewing hundreds of actor's presentations, we have found actor and model guidelines and suggestions that have been tested through years of experience and work the best for a number of different auditioning situations. Once you have done an initial mailing, you will know if your photograph is working. If there is no positive response to your mailings over a period of time, you should consider taking and sending a new photograph.

We have chosen a range of actors from New York and Los Angeles, the largest markets for actors in the United States. Photo presentations are somewhat different in these two regions of the country and, surprisingly, most experienced casting directors can identify which coast actor is from by the styling of his or her publicity materials. Your materials may have to be slightly different for different events and different markets, and we want your overall financial investment to be a wise one.

Today, most working actors choose to work in more than one area of the busines. Theatre auditions, film castings, commercial and industrial auditions, commercial print go-sees, video and voice castings—all these different casting situations still require photographs. For ethnic actors, freelancing with several different types of agencies can be financially profitable because no one agency is going to receive all the daily calls for African American actors.

In order to fill the needs of several different agencies and the different types of auditions they attend, most actors now work from several different headshots. In some instances, some actors have even used model composites to obtain work. This process can be quite expensive, time consuming, and overwhelming because you are now sending out and keeping record of several different images of yourself. However, by increasing your output of publicity materials, remember you are increasing your ability to work. Whatever the investment, be sure to keep

accurate financial records and receipts for your photo services and duplication. For the professional actor, most of this expense is deductible at tax time.

Over the next few pages, the pictured actors and actresses have donated their professional presentations so we can illustrate the different types of photography used when seeking show business employment. The photos displayed here are selected from a wide range of professional headshot photographers. Most of our examples are of actresses; however, the variables for personal grooming and good clean photography remain the same for both actors and actresses of any age. If you are seeking advice on photography, check the advertising pages of your local trade paper and ask other professional actors and models for references.

Photo by Richard Bombersheim

Los Angeles actress/director **Denise Dowse** projects a mature, serious attitude in this lush, dramatic Afrocentric portrait headshot. Notice the careful wardrobe styling and Denise's well-groomed, locked hairstyle. This look presents Denise as a talent with a definite image, an actress with political convictions and an interesting lifestyle. We can also get a sense of Denise's strength of character and her confidence. The photographer has chosen to highlight the complexities of Denise's intense personality by placing her against a richly textured background. The contasting texture of the wrapped silk scarf breaks up the stark white top, adding a feeling of costumed formality. Darkly lit photographs lend an air of mystery and drama to the subject being photographed which is great for television and film castings. These types of photos also appear to be more traditional and conservative in nature.

Model/actress **Brenda Joyce** chose to highlight three different looks she can easily portray in 8 x 10 photos. These pictures were all taken on the same day during the same photo shoot, with a simple change of wardrobe, hair, and lighting. This way, a casting person can see Brenda the way she chooses to submit herself. Here we see Brenda as a conservative, upscale businesswoman; a romantic woman in a flirty, vampish evening dress; and a casually elegant woman on the go. Because of the three-quarter length of her photographs, we get an idea of her body type and language.

In reproducing her photographs, Brenda chose to have her bordered 8 x10 photos surrounded by a black frame for emphasis and contrast. She also had her name printed within the white border on her photographs. If you look at the pictures together, you can see the similarities in the way Brenda posed herself, yet when you look at the photos separately, they represent three diffent characters. Because she works as a commercial print model and actress, she keeps careful records on what she sends to each casting, to not confuse her image in the minds of the casting directors. This can be a complicated process and requires careful monitoring of your photos and the response they evoke from castings.

Photos by James Kriegsman

Actress/writer **Toni Ann Johnson**'s engaging three-quarter length portrait shot presents a body language that suggests an air of femininity and fragility.

Three-quarter length photography has become quite popular in recent years because it allows the viewer more of an insight into the subject's personality and lifestyle. This is the perfect opportunity to show movement, to suggest mood, or to create an atmosphere that will reveal who you really are.

Toni appears to possess a friendly and engaging personality, someone we would want to know.

Photo by Sandy Spears

Photo by Susan Goldman

Light, open photographs give the viewer the impression you have a pleasing, forward personality and can give your photograph an air of freshness. California actress/dancer **Neisha Folkes** has placed all the emphasis on her face in this beautiful, casual, three-quarter photograph by surrounding herself in light backgrounds,wardrobe, and colors. The photography is excellent here because we can still correctly identify Neisha's skin texture and coloring, despite the reflective nature of the bright colors around her. Neisha's makeup and hair are well executed yet natural, adding a casual feeling to this framed 8 x10 photo. We still get a subtle suggestion of Neisha's well-toned dancer's body without it being revealed to us. When reviewing a photographer's portfolio, check his samples for lighting and contrast. It is important to choose a photographer who can light the many different shades of Afican American skin properly.

Photo by Eric Stephen Jacobs

An air of confidence and success are displayed in the three-quarter length business headshot of **Emilie Gaskins**. Emilie personiifies the maturity and dignity of a sucessful corporate executive. This photo works well for industrial and commercial print bookings. The direct eye contact, the sincere, pleasant smile, and the contrast of the dark suit against the gray textured background helps to highlight her business formality. Here, we see a good balance between darks and lights that complement Emilie's natural skin tones. This shot is one of several Emilie selected from a photo shoot in which she also changed her hair and wardrobe to get three distinctly different looks.

Samaria's photographs are a dramatic study in contrasts. Her engaging personality and strength of character are evident in her presentation, and we feel a sense of her youthful appeal and energy.

Samaria's session allowed her to take more than one photograph, which made her session valuable in terms of her time and money. She can alternate her shots, or she can use them independently as different marketing tools.

Photo by Lauren Burley

Commercial actress **Shirley Jordan** chose to highlight her individuality in her friendly headshot. Shirley, a Los Angeles-based talent, is highly energetic and personable. Her pixie-like haircut, beautiful broad smile, and gold hoop earrings give us an insight to her charm and provides us a glimpse into her fun, easy going, and sassy personality. This is the perfect commercial headshot, full of personal warmth and style. Shirley's textured background also lends an air of sparkle to her photo personality. Remember, in pictures, less usually is more. This photgrapher captured the essence of his subject on film through textures and the relaxed nature of this shoot, which helps get you noticed in the casting process.

Photo by Sandy Spears

Lynná Davis

Photo by Dan Doghtery

Film actress and stuntwoman **Lynna Davis** wanted her headshot photo to capture her natural beauty, her athletic ability, and her glamorous Afrocentric sense of style. Her direct focus and the graceful use of her arms suggest her sense of her heritage, her confidence, and physical vitality.

Remember, your photo is your calling card. You should leave behind a descriptive photo image, a photograph that will accurately suggest who you are, a glimpse into your personality, your talent and your abilities.

Photos by Richard Dunkley and Frank White

Yvonne Tucker decided to show her versatility and her natural good looks with her commercial print composite. On the front, we see two different headshots of Yvonne as she has appeared in national print ads. On the back, we get another sampling of Yvonne's work from different ads. For an agency model, showing the range of your work without identifying products can suggest your experience in the business. This is a standard model agency composite, produced in association with an agency model book. On Yvonne's page in the agency book, the same photos may be reproduced in a slightly different format. Yvonne also must maintain a standard 8 x 10 résumé and photograph for any acting assignments that come her way.

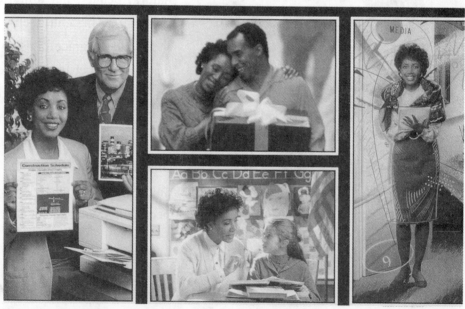

Photos by Jeff Cadge, Dennis Chalkin, A.J. Sandone and Howard Breitrose

Selma McPherson decided to produce her own materials for commercial print auditions. After testing with several different commercial photographers, Selma collected enough different looks to manufacture her own color composite. Even though this process can be quite costly, it allows the model to have control over the publication of the image. Sometimes, we see ourselves diffrently than our

Selma McPherson

agencies do. This self-produced composite will allow Selma to direct her agency to the work she is seeking in a particular category. This type of composite will work extremely well for people who do a lot of freelance work between several different print agencies.

Composite photographs by Manning Gurney (cover),
Michael Keel and Michael Keller (inside spread), Adrian Adams (back cover).
Selma McPherson's composite printed by Impact Graphics.

Photo by Michael Helm

Veteran actor **Justin Lord** represents the dashing leading man with moody, dramatic lighting, suggesting his masculine power and strength. Justin's photo is an accurate depiction of his age range and his emotional and physical chronology.

Justin's image looms impressively in this photo, giving the viewer a sense of his performance power and intensity. Again, notice the interesting contrasts in the lighting and background.

Bicoastal actor **Kerry Ruff**'s corporate three-quarter length headshot captures him looking successful and approachable. His wardrobe styling is subtle, yet effective, suggesting his suitability to be cast as a young executive, a dad, or as a handsome, conservative spokesperson. His wardrobe and the suggestion of an outdoor background do not compete or take away from the subject, but instead they complement Kerry's natural good looks.

Kerry also had his name and a thin black border stripped into this photgraph. Kerry duplicated and lithographed his photo, so he could mail out larger quantities of his original black and white photograph at more reasonable prices.

Photo by Leslie Bohm

Soap actor **Timothy D. Stickney** uses this color postcard in his press kit presentation along with his black & white headshots. The casual styling and relaxed nature of his simple pose gives us an insight to his intensity and his on-camera personality.

Timothy had this shot printed in a 5 x 7 color format, and he uses this postcards to give to his fans and in his network press kit mailings. Color is a little more expensive but can give a dramatic look to your presentation.

Photo by Jim Warren

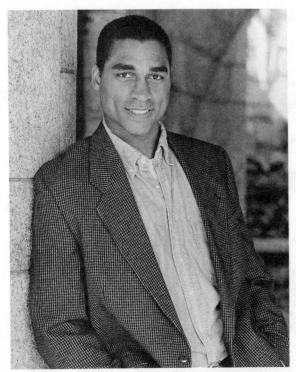

Photo by Tim Lampson

New York actor **Tom Day**'s three-quarter length portrait shot gives us a good example of how a photograph can give a casting director an overall glimpse into your personality and suitability for castings. Tom's photo has an outdoorsy, modern, and fresh feeling to it and presents him as a casual, friendly, conservative guy. Notice how the textures of the background and the fabrics all blend in the photograph to flatter Tom, as opposed to distracting from his photographic presence. It is important that your pictures subtly show you are approachable, the kind of person who has an open personality and is willing to be friendly and cooperative.

Photos by Noel Sutherland

Where an actor wants to display his suitability for a particular role, a print model wants to show versatility and experience in front of the camera. New York model/actor **Alvin Williams** new model composite is a printed color booklet that shows us the many different ways Alvin can look, his photogenic versatility in front of the camera, and his vital statistics. As shown here, a good model composite has a closeup or head shot, photos posed with other models, and pictures showing the model in a number of different situations and wardrobe looks. The important thing here is to look as good and relaxed as you can in front of the camera, while also showing the range of characters you can realistically portray.

Photos by Fadil Berisha, Michael Goldman, and Susan Oristaglio

Character actor **Prince Hughes** knows his looks are his selling point. Rather than try to change his looks, Prince presents himself very simply and naturally without complicated lighting, props, or wardrobe. For the character actor, this is the best route. Without distracting photograpic elements, it is sometimes easier for a casting person to imagine how talent is to be used. If you look different, always play up your difference. The chartacter actor's use of emotion and character intensity categorises him. There is work for all types of people in the industry, and character actors have a tendency to work more regularly because they always represent real life people and situations.

Prince Hughes

Joseph Heldfond & Rix, Inc.

Photos by Leslie Bohm

Résumés

Your résumé is attached to the reverse side of your headshot. It should be neatly typed, one concise page only!

Agents and casting directors aren't interested in your secretarial, sales, talent contest, or beauty pageant experience. Forget listing anything but professional performance credits on your résumé. If you don't have any professional credits, you'll, of course, have to earn some. If you are a beginner, your résumé will look pretty empty, but as time goes by, you will begin to accumulate more and more professional credits. Don't specify extra work. Agents and casting directors only want to see "speaking" roles and any other significant parts you've played.

For starters, make sure your name is prominently displayed on the top of your résumé. We recommend that you have your name typeset in large, bold type. You want your name and phone number to be remembered!

Next, in bold type, list your phone number, preferably an answering service number. If you have to use your home phone number, keep in mind that your photo and résumé will be circulating all over town and you can't be sure of who will get their hands on them. If you're lucky enough to have an agent or manager, be sure to list his name and phone number. You can also type your résumé on his letterhead or affix his agency sticker or stamp.

Your union affiliations are listed next, followed by your physical statistics—height, weight, dress or suit size, hair and eye color. If you have a demo video or audio tape, be sure to mention that on your résumé as "Video and Audio Tapes Available Upon Request." Many performers, due to requests from casting directors, list their Social Security number and SAG number. That's up to you. We suggest that you refrain from listing an age range or birth date (unless you are a child or teen under 18 years of age) because it categorizes you and automatically limits your audition opportunities. For example, if a casting director is looking for a 30-year-old male, which you can play, but you've listed your age range as 23-29, it's likely the casting director will consider you too young for the role, and you lose out on a golden opportunity. This is especially important when casting directors are casting strictly from photos and résumés.

In listing your professional credits, we suggest that you list your stage credits first if you're a New York performer. New York is a stage town, and theater credits carry a lot of weight. Professional theater credits are impressive, even when you're pursuing film and TV work, because they imply that you've attained a certain degree of professional training and experience. Don't list understudy roles unless you actually performed the role—and in that case, list the credit as a regular role. Don't ever downplay any of your credits by lessening their significance. If you don't have any professional stage credits, then it's okay to list your college and community theater credits. Los Angeles performers should list their film credits first and their televi-

sion credits second. Los Angeles is a film town, and film and television credits carry the most weight.

For theater credits, from the left to right margin, list the name of the play in capital letters, the role your played, and the name of the theater or production company. For all credits on your résumé, be sure to highlight any impressive billings—"star," "guest star," "co-star," "featured"—and any well-known performers, directors, and theater companies that you've worked with.

Next, under the category of "Television and Film," if you have no professional credits in this category, list your industrial, student, and non-union TV and film work. They show that you've had experience in front of the camera. From the left to right margin, list the title of the movie or television show in capital letters, the series or episode title, the role you played, any impressive billing, and the movie studio, network and/or production company.

Next, under the category of "Commercials," it is customary to write "List Available Upon Request." This lets the casting director know you have commercial performance experience without specifically identifying any products. If you want the casting director to be aware of your extensive commercial experiences, you can add descriptive phrases such as "Numerous National Commercials" or "List of Over 50 National and Regional Commercials Available Upon Request."

Under union rules, actors cannot appear in commercials for two or more competitor products at the same time. That means that you can't do a Burger King commercial while you're still under contract to McDonald's. If you list the names of the commercials you've done, some of which may not be running on the air when your résumé is reviewed, you may lose the opportunity to audition for any conflicting commercials. If an advertising client or casting director sees that you've done a commercial for a competitor's product, they may be less inclined to audition or cast you in their commercial.

The next category on your résumé should be "Training." Don't list your high school drama courses, but college training is appropriate to list, especially if you are a degreed drama major or were trained at one of the more prestigious colleges like Yale School of Drama, Julliard, or Carnegie-Mellon. List your professional coaches, workshops, and all of your professional acting, commercial, dance voice, speech, and specialty training.

Next, under the category of "Special Abilities" or "Skills," list everything that you can do well—sports, musical instruments, hobbies, office skills, etc. Also list any languages and dialects in which you are fluent. It is important that you can expertly do everything you claim. If a casting director calls you because of your special abilities, you'd better be able to deliver on cue. Many an actor has lost a job and spoiled a reputation when he arrived on the set and was unable to perform the skills he was hired to perform.

Sample Résumé

YOUR NAME IN BOLD CAPS
Phone Number
Affiliations

Height Social Security Number
Weight SAG Number
Shoe Size Agency Affiliation (name and phone)
Dress (women) or Suit (men) Size

THEATER
| Name of Play or Musical | Billing and/or Character Name | Theater or Company, Name of Theater |

TELEVISION
| Name of Show, "Episode Name" | Billing and/or Character Name | Producer, Production Company, Network, Director's Name |

FEATURE FILMS
| Name of Film | Billing and/or Character Name | Film Company, Producer, Director's Name |

COMMERCIALS
"List of Commercials on Request"–Tape Available

TRAINING
Acting: Name of acting coaches and drama schools
Commercials: Name of commercial workshops
Dance: Name of dance teachers and schools
Voice: Name of voice coach or teacher

SPECIAL SKILLS
List any sports you participate in, musical instruments you play, hobbies, and special abilities or interests.

Other categories that may be listed on your résumé include "Variety," "Music Videos," "Dance," "Nightclub," "Recordings," and "Specialty Acts." These credits should be listed above the "Training" section or can be listed on a separate résumé.

After you've typed your résumé or had it professionally printed on a computer, have duplicate copies made. Some photocopy services have 8 x 10 paper specifically to fit standard 8 x 10 headshots. If not, cut your résumé down to 8 x 10 size and neatly glue (rubber cement and glue sticks work great) or staple them onto the back of your headshot. Paper clips should always be avoided because they let your headshot and résumé become separated in filing and mailing.

Make sure to reproduce your résumé on good looking, quality paper. Eggshell, off white, ivory, or light gray paper makes for an impressive-looking résumé. Stay away from loud-colored paper (bright pinks, oranges, and yellows) and colored inks—it makes the résumé look too busy, it's hard to read, and it's not businesslike. Offset printed duplicates look better than xeroxed copies.

Video Résumés

A video résumé (also referred to as a demo tape) is a videotape of an actor's performances. Essential to the California actor, it is becoming increasingly attractive to the New York actor. They serve several purposes. Video résumés can show an actor's range and abilities. They often can be the deciding factor for an agent deciding to take on a new client. And a casting director may make preliminary casting decisions by screening actors from their video résumés, shortening the process of live auditions.

Video résumés are most often used by experienced, veteran performers who have compiled a nice body of performance work to present on videotape. Newcomers may also put together a video résumé. If you are just starting out and have gotten a few non-union jobs in student films, industrial films, or commercials, you can use those performances on your video résumé.

In putting together a video résumé, consider that it is an introduction to your talents—another tool of your trade. It should market you and your talent in a positive and favorable light. Broadcast material—excerpts of actual performance work—is most effective on a video résumé. We recommend that you not invest in a tape made from rehearsal scenes or acting class performances.

Most agents and casting directors seem to prefer 1/2-inch VHS tapes, although 3/4-inch, broadcast-quality tapes are sometimes requested. Have several copies of both sizes made just in case.

Your video résumé can be anywhere from 5 to 10 minutes in length. Most agents and casting people don't have time to watch more than about 10 minutes, considering that your tape is probably not the only tape they will be watching.

Consider the choice of material you show on your video résumé—make sure it's your best work. Good material can often get lost in the midst of poor editing. The quality of your acting, directing, lighting, sound, costuming, makeup, camera work, editing, and videotape are also important in putting together your video résumé. Cheap tapes often appear blurred and distorted. Remember, your video résumé is a professional representation of you, your looks, and your talent.

You should be clearly recognizable. Agents and casting directors don't want to spend time trying to figure out who you are in a large group of people. Don't put extra work on your tape. You should be marketing yourself as a leading or featured performer, not as a background player.

A mixture of close-ups and full-length shots, scenes, and monologues is the ideal combination. We favor opening your tape with a close-up shot to identify yourself instantly. Music tracks and titles also add a touch of professionalism to your video résumé.

Fliers

When an actor or group of actors want to advertise their appearance in a stage production, they can use printed mass produced paper announcements, or fliers. Fliers can be put on bulletin boards of theatrical organizations, union offices, theatrical bookstores, and performing arts schools. They can also be mailed to agents and casting directors to announce an actor's part in a play, the theater, and the date and time of the performances.

Fliers can be especially useful when they include photographs of the cast. Your picture could help interest an agent or casting director in seeing your performance, if they are looking for your type specifically. You can also attach your postcard to the flier to remind the agent or casting director who you are.

Like all of your promotional tools, fliers should look as if they were professionally produced, even if they were not. The paper quality, type size and style, and reproduction quality are important factors to consider in putting a flier together. Check the trade papers and industry directories for printers and photo reproduction services that are experienced in producing fliers for performers. Ask them for samples of their work.

Performers can also use fliers to supplement their regular mailing campaigns and to break the monotony of their photo postcard mailings. Be creative and innovative. Put together a flyer outlining your recent credits with a catchy headline. For additional interest, use two-color ink or colored paper.

Press Kits

Celebrities and veteran performers often use press kits to highlight their vast and diverse careers. These press kits are usually put together by their press agent or publicists for distribution to various media outlets, talk shows, and news programs like the *Ebony/Jet Celebrity Showcase* and *Entertainment Tonight*. Until you hit the big time and start making the big bucks, you probably won't be able to afford the monthly fees of a public relations firm. Publicists normally charge anywhere from $1,000 up to tens of thousands of dollars per month. Still, the beginner or less established performer need not wait to put together a professional press kit.

What should you include in your press kit? Anything that calls positive attention to your talents and credits—reviews, magazine and newspaper feature articles from your local papers, press photos from actual performances, your biography, résumé, and a variety of photos. Don't include anything that is unflattering to you, no matter how prestigious the publication may be. You can also include an 8 x 10, your photo business card, audio and video demo tapes.

All of your printed materials can be organized in a two-pocket folder, available at most stationery stores.

7

PROMOTING YOURSELF

In the beginning of your career, you'll spend a great deal of time and energy establishing yourself with agents and casting directors. Often, getting past secretaries and casting assistants can be a difficult job, especially for the actor with few credits. Regular mailings and "making the rounds," targeted to specific industry professionals, can help establish your career. Including your photo in one of the major talent directories will automatically put your photo in the hands of hundreds of agents, casting directors, directors, and producers. And cold reading workshops, scene nights (also known as prepared scene showcases), and showcase productions can also help increase your visibility in the industry.

With fewer jobs available to black performers in proportion to the jobs available to all performers, many African-Americans will often find themselves constantly losing jobs to the same performer over and over again. It may seem like every job gets booked by one or two of the same actors. This theatrical industry is quick to jump on the bandwagon. Once a performer becomes "hot," word spreads quickly, and actors usually find themselves booking a great majority of the jobs they audition for. Why? When an agent finds out there is particular demand for an actor, he is more likely to "strike while the iron is hot," circulating photos to everyone who may know about this actor's recent successes. Everyone loves a winner, and it usually takes one good job to generate several more. Though it may seem as though these lucky actors have a monopoly on employment, you, too, can put yourself in this envious position by capitalizing on opportunities when they present themselves to you. Take full advantage of every new role. Use good politics, diplomacy, a smart business sense, and a strong public relations campaign to catapult yourself to industry and public popularity. Unfortunately, many actors don't even see opportunity when it is staring them straight in the face.

One young black actress recently did a number of choice roles in television, film, and commercials. Being unprepared, and not knowing how to exploit these roles to their fullest

potential, this actress sat back and literally did nothing. She should have seized the opportunity and capitalized on her roles. Sending out fliers, press kits, and photographs from jobs could have helped increase her visibility within the industry, and she could have been approached by more casting people for auditions and jobs. This is a prime example of how ego and naivete can destroy a career. If you expend great amounts of energy in promoting yourself, it will eventually pay off. Take advantage of every opportunity you have to publicize yourself when you are working.

Other performers with fewer professional credits often publicize and promote themselves daily, creating the impression that they're constantly working and in demand through photographs, postcards, fliers, and other publicity materials. Use every role, no matter how insignificant or small it may seem, to promote yourself to higher grounds. Don't sit back and wait for your phone to ring. You have to get out there and make your phone ring.

Mailings

Mailings perform an important function in building your show business career, but they are not a replacement for making the rounds. Nothing can even come close to the value of seeing an agent or casting director face to face. However, agents and casting directors don't always permit drop-in interviews, so even if you do get your foot in the door, you probably won't be interviewed. It's not possible to see everyone in a position to hire you because of time and opportunity limitations, so mailings become the next best thing.

> The mail is very important. We've actually cast contract roles through the mail. It's one way of meeting new people.
>
> *Annamarie Kostura*

The purpose of mailings is to spark the interest of an agent or casting director when you cannot appear in person with a good 8 x 10 headshot, résumé, and cover letter. These materials should be interesting enough to get you an interview. At the interview, the impression you make will determine if, when, and for what roles you will be considered. Mailings can be done in several ways. Most performers maintain computer files or a specific index card file that contains the names, addresses, phone numbers, and other information of agents, casting directors, advertising agencies, and production companies. You can get this information from several sources, including pre-addressed mailing labels, books, networking with fellow actors, industry directories, and trade publications.

Pre-addressed mailing labels can be purchased from most theatrical bookstores. There are a number of books and industry directories that list the union-franchised agents, casting direc-

tors, advertising agencies, and production companies as well as their office hours and additional information. You can also add names to your mailing list from reading the "trades."

The "trades" are weekly (and monthly) theatrical publications produced to inform the industry of current casting information and activity. They list legitimate auditions according to union standards and guidelines, with other sections dealing with non-union job opportunities. Sometimes you can find the name of the casting director in the audition notice to add to your mailing list. The trades also give performers the feeling that they are part of the show business community, giving them a sense of participation and helping to surmount the feelings of alienation and loneliness that newcomers often face. For some, reading the weekly trades is the high point of their week. *Backstage* is for East Coast performers and *Backstage West* is its West Coast counterpart. *Black Talent News* is a trade publication by, for, and about African-Americans in the entertainment industry and is published ten times a year. It includes casting notices, production charts, how-to information, interviews with industry professionals, important contact names and numbers, and a calendar of industry events. *Black Talent News* is available by subscription from Black Talent News, P.O. Box 7374, Culver City, CA 90233-7374.

Ross Reports Television is a pocket-sized guide that lists agents, advertising agencies, casting directors, and the major production companies in New York, with descriptive information helpful to the performer. There is a West Coast section that lists the networks, studios, and major casting personnel. *Ross Reports* is available by subscription from Television Index, Inc., 40-29 27th Street, Long Island City, NY 11101, or at most theatrical bookstores.

Breakdown Services publishes the *CD Directory,* which lists Los Angeles casting directors. This directory is updated and published every two weeks. Breakdown Services also sells lists of both Los Angeles and New York agents, casting directors, and advertising agencies. Breakdown Services is located at 1120 So. Robertson Blvd., 3rd floor, Los Angeles, CA 90035, (213) 276-9166.

The weekly *Theatrical Index* and bimonthly *Theatrical Calendar* both list current Broadway, Off-Broadway, and Off-Off-Broadway productions, including contact information. They are also available at most theatrical bookstores.

Once you have established a list of names and addresses for your mailing list, do an introductory mailing. The introductory mailing should include your 8 x 10 headshot, your résumé, and a cover letter of introduction. The letter should be short, concise, and to the point. Remember that you are a business professional. Your correspondence and mailings should reflect your professional qualities of organization, style, and intelligence.

Mailing your headshot and résumé alone is useful, but an interesting cover letter will make the mailing more personal, informative, and memorable. Your cover letter should be brief and typed on attractive stationery. Personalized letterhead and envelopes make the mailing package

even more impressive and businesslike, and it shows that you take pride and a professional approach to your career.

In your cover letter, mention any previous encounter you have had with that particular casting contact. Draw attention to anything on your résumé that you want to receive special attention. Mention favorable notices you have had in previous work, and let them know if you will be appearing in anything that they may want to see you in. After the initial mailing, it is important to do a follow-up mailing. This time you'll send only your photo postcard. This will keep you fresh in their minds and let them know that you are serious about looking for work. Always send a follow-up thank you note or photo postcard a couple of days after an interview or audition. You want to make sure that they don't forget you. We recommend that you write a brief couple of lines on your photo postcard instead of just sending a blank card. Keep your messages short, sweet, and right to the point. This will further personalize your mailing. Continue regularly mailing your photo postcards at monthly or bimonthly intervals to remind them of your availability.

When mailing your photo postcards, remember that the more a casting director sees your face in print, the more likely you are to be called for auditions and work. This is why good pictures are important. Not only are you presenting yourself, you are creating an image to be remembered for future castings.

Another common function of mailings is to announce your professional appearances or any type of showcase performances in which you work can be seen. Announcements, invitations, and tickets should be mailed a couple of weeks in advance of any performance. Remember, agents and casting directors have busy itineraries, so they need advance notification to make arrangements to schedule seeing your performance.

> I tell people to send me notices when they're doing something rather than to just
> send me a card that says "Hi." I think that it's such an expense to be an actor trying
> to get work. And if you're sending out mailings and then you're also sending out
> "Hi, how are you?" postcards, don't. Save it until you have something to tell me.
>
> *Jaki Brown-Karman*

Lou Myers, who played the lovable "Mr. Gaines" on *A Different World*, talked about how mailings have worked for him:

> I never had a manager. I wasn't making that much [in my early years in the business]
> and didn't have that much to manage. I just got an agent when I started doing
> Broadway. Other than that, I did it myself. I would mail out pictures and if I got a
> review in the paper I'd have that run off [photocopied] and I'd mail out hundreds of
> them. And I might get an answer from 20 of them. Out of those 20 I might get 10
> jobs. That's the way I've done it.

Mailings are also sent anytime there is a major change in your status, such as when you become a union member, whenever you have a substantial new credit on your résumé, or when there is a significant change in your physical appearance and you get new photos.

The timing of your mail is very important. It is best to try to time your post office activity so your mail hits the desk on the most productive casting day. Most casting activity is generated midweek after production meetings when casting people receive their casting breakdowns. Most casting calls are placed midweek so agents can ensure confirmations before the end of the business week. It would also be wise to target major mailings in July at the beginning of the television production season, and in January at the beginning of pilot season.

If you are financially able to mail regularly, do it. This is not a wasted discipline. The performers who are working consistently have mailings that are almost scientifically developed and perfected. They realize their pictures continue to work for them, especially in situations where it is difficult to be present in person.

Your 8 x 10 headshot and résumé will cost about 60 cents to mail in an envelope. Postcards usually cost 20 cents if mailed separately and 32 cents if mailed in an envelope. And if you're doing a major mailing to a couple of hundred people, the costs can add up. However, save all postal and photo reproduction receipts, because they are tax deductible. Remember, you'll need a few hundred photo reproductions, résumé and cover letter copies, and mailing envelopes in addition to postage. So, for those of you unable to afford a major mailing on your own, consider doing a group mailing with several other performers. Each performer can submit his headshot and résumé under one unified cover letter. With everyone chipping in to share the cost of envelopes, postage, and paper, you can do a mailing at a fraction of the cost. Sometimes a casting director will be impressed by the group effort and will use everyone from a group mailing—it has happened!

You should keep track of the mail that is returned to you by the post office. This will help you update your mailing list when people move. Immediately update the information on your computer or index cards to reflect the new addresses and personnel. This is a transient business—producers switch advertising agencies, casting directors go out on their own as independents, and still photographers become television commercial directors. Part of your job as a professional is to keep up with the changes within the industry.

Again, new pictures, an updated résumé, and a change in your physical appearance are reasons for an immediate mailing. It is your responsibility to keep agents and prospective employers aware of your ever changing professional status.

Beware of writing mushy, personal, or patronizing messages. Love letters, flowers, and personal gifts only make casting directors uncomfortable. Casting directors have received sweaters, shirts, office decorations, perfume, wine, champagne, cookies, cakes, homemade meals,

dinner invitations, and every other conceivable kind of gift. One casting executive received two free round trip airline tickets to the destination of his choice from an actor with whom he had never worked! After that incident, the casting director lost respect for the actor and refused the actor's calls and postcards. Usually, you can't buy or bribe a casting director—any reputable casting person will recognize a bribe for what it is.

Your mailing should be used as a sales tool. Interesting, offbeat mailings can brighten a person's day and will stand out among the 200 to 500 photos offices receive daily. Your objective should be to make a strong, lasting, and positive impression.

Consistent mailings will broaden your visibility within the industry. It's a constant reminder that you're out there, available, and looking for work. Remember, mailing is a promotional campaign. It is important to introduce yourself around, meet people, make wise career choices, and establish solid career connections.

Making the Rounds

Once you have saturated the market with your headshot and résumé through mailings, you are ready to take another step in promoting yourself, "making the rounds." This expression, used by actors, explains another valuable way of soliciting work. When an actor makes the rounds, he physically travels around from door-to-door visiting prospective agents, casting personnel, and other industry employers. Many people who do regular casting interviews have open hours when actors may visit to register. These open hours allow a casting person to not only see an actor face-to-face, but also allows him to collect specific and detailed profile information that can be fed into casting files and computer terminals.

> What I find is there's something kind of scary about an actor saying he's waiting for his agent to call. I think that it's too much to assume that the person who is supposedly your representative is going to be working throughout the day, or on any given day, for any amount of time, in pursuit of helping you find work—especially knowing the realities of the fact that opportunity can knock, but nine times out of ten it's not going to come to your house and knock. Where it knocks is when you're at the door and you're out there making the rounds. Certainly, I think making the rounds is a lot easier in New York because you find its a little less intimidating to go to an office as opposed to going to a studio gate and getting on the lot. Once you start getting that rhythm going and know you're going to go out and make rounds and just try to meet people, you never know when you go if you're going to have anybody open the door for you, or if you're even gonna get it, but you made the effort. You never know—the day you show up at somebody's office could be the day that you are the person that they need that day. And here you are, on a fluke, and you walked

into an audition that you didn't anticipate because you were just dropping off your picture and résumé.

Jaki Brown-Karman

Making the rounds is a much easier proposition in New York than it is in Los Angeles. In New York, 99% of the talent agencies, casting offices, production houses, networks, and film companies are concentrated within the city of New York. There is a theater district that houses a large number of the places you'll visit. You can easily spend a few days canvassing this area by foot. Making the rounds in other areas of the city is easy by foot, bicycle, subway, bus, or taxicab. The places you'll want to visit are, for the most part, located in unlocked public buildings. You can easily walk into any building and slip your picture under the door. One actor we know was ushered into a casting session and booked into a commercial from doing consistent mailings, then making the rounds, because the casting director was already familiar with his face and credits and actually acted as if he knew the actor personally, although their only contact had been through the mail. Discipline eventually pays off.

Los Angeles, on the other hand, is a vast metropolis that covers over 70 miles and consists of many small communities connected by boundless freeways. Talent agencies, casting offices, production houses, networks, and film companies are located in office buildings and bungalows and on studio lots all over the Los Angeles County area. And remember, in Los Angeles, a car is a necessity.

Los Angeles is also the land of the studio lots. MGM, Paramount, Universal, The Burbank Studios, and 20th Century Fox, to name just a few, house a majority of the casting offices you'll want to visit. Herein lies the problem. The studio lots are not easily accessible. Entry onto the lots means first getting through the heavily-guarded security gate. Without an appointment, access onto the lots may be virtually impossible. And if you try to bluff your way in, the security guard will call to confirm your appointment since it won't be listed on his daily visitor list. But if you do get on the lots, you can quickly cover a lot of ground and drop off dozens of pictures and résumés.

While it may take 15 minutes to walk from one office to another in New York, it can take upwards of an hour to drive from one of the Hollywood studios to one of the San Fernando Valley studios in Los Angeles. And the directions are often rather complicated. It's a good idea to get a copy of the *Thomas Brothers Los Angeles County Popular Street Atlas*, available at most bookstores, supermarkets, and newsstands. New Yorkers should purchase a street, subway, or bus map to guide them around. These maps are available in wallet sizes. Subway maps are available free of charge at most subway token booths, subject to their rare availability. Ditto for bus maps, which you can sometimes get from bus drivers.

The best way to make the rounds is to take addresses from your mailing list and arrange them according to geographical location. You can also purchase geographical casting guides from the theatrical bookstores. Once you have pinpointed a specific area that you want to cover, map out a plan to distribute your pictures and résumés.

Sometimes while making rounds, you will find people who are not receptive to you. If you get into this situation, politely ask if you may leave your picture and résumé. Most casting people discourage actors from dropping by. Don't take it personally if they don't have time to talk to you. These people are often under pressure and are trying to make last-minute casting decisions and deadlines. Your objective should be to simply leave your picture and résumé with as many people as you can.

In the beginning, you should target your rounds towards the major sources of casting activity. The more frequent the casting activity at an office, the more often you should mail and make the rounds. Some casting offices cast weekly, some seasonally. Soap opera casting directors cast numerous actors on a weekly basis, as do the weekly prime time TV shows. Try to stay abreast of the casting activity so you predict when a casting office is going to be busy.

Become friendly with casting receptionists and assistants. These are the agents, producers, and casting directors of tomorrow. You are always onstage, from the moment you enter the door. One famous casting director often plays like an office worker so he can make a closer observation of your personality. You really never know when or how you are being evaluated. Try to be friendly to everyone. Find another performer with whom you can make the rounds. A group effort can make this sometimes difficult situation more bearable.

If no one knows you're out there, you'll never work. So get out there and make yourself visible.

Talent Directories

There are four major talent directories that feature the photos and short bios of performers. Agents and casting people often use these directories in search of new talent.

The *Black Players Directory* is the only talent directory exclusively for African-American talent. Published by *Black Talent News*, the *Black Players Directory* features African-American actors, actresses, singers, and dancers. The directory is distributed free of charge to agents, managers, casting directors, and producers. The cost of being included in the directory is $50. Contact the Black Players Directory, c/o Black Talent News, P.O. Box 7374, Culver City, CA 90233-7374, (310) 642-7658, for more information.

> *Players Guide* is important for me, as is *Academy Players Directory* out on the West
> Coast. It's a reference more than anything. What happens is, as I'm thumbing through

it, I start to think about people that I don't remember. I think it's good for people who don't have representation, if nothing but for the reason that, as I'm looking, I may see a face that I don't know. If they don't have an agent, well, then I wouldn't have known about them if I hadn't looked through the guides.

Jaki Brown-Karman

The *Academy Players Directory* is the directory for West Coast performers, though many East Coast performers also list themselves. This directory is widely used by all industry personnel. You must have a franchised agent or personal manager or be in a union in order to be included. The directory is broken down into four categories—Children, Leading Men/Younger Leading Men, Leading Women/Ingenues, and Characters and Comediennes/Characters and Comedians. The cost is $45 per year per category for inclusion in all three issues, or $15 per issue per category. Contact the Academy of Arts and Sciences at 8949 Wilshire Blvd., Beverly Hills, CA 90211, for further information.

For information on the *Whitmark Directory*, contact Whitmark Associates, 4120 Main Street, Dallas, TX 75226.

A recent addition to the talent directory market is the *National Black Talent Directory,* which lists union and non-union African-American talent across the United States. The *National Black Talent Directory* is located at 6223 Sunset Boulevard, Hollywood, CA 90028.

Cold Reading Workshops

Cold reading workshops are unique to Los Angeles. You pay anywhere from $18 to $25 to attend a three- or four-hour workshop with an invited guest, usually a casting director. During the workshop you are handed actual casting sides (audition scenes), which you will perform for the casting director. They are called "cold readings" because, like in many actual audition situations, you are given very little time to rehearse and practice your lines.

> Many New Yorkers aren't good at cold reading. Cold reading in New York is not important. But here in California, you must be a good cold reader. In fact, if you can't cold read, you probably will never get a chance to show how good an actor you really are.
>
> *Jack Rose*

When you get right down to it, what you're actually doing is paying to perform a simulated audition. And yes, some actors are horrified at having to pay to audition, questioning the ethics of such a practice. But we're not here to be judgmental, just to give you the facts.

These cold reading workshops are a good opportunity to meet and be seen by casting directors and to get their honest feedback on your audition skills. But, like anything else, there

are advantages and disadvantages to these workshops. If you're not yet skilled at acting and doing cold readings, it may not be a good idea to showcase your talents in front of a major casting director. You may need to attend classes specifically designed to teach the cold reading technique before actually participating in one of these workshops. On the other hand, if you've got your act together, these workshops are an excellent way to showcase your talents. There are no guarantees, but these workshops often lead to future auditions and casting consideration.

Like in a real audition situation, be sure to project a polished and professional image when attending these workshops. Just because the workshop may be held early on a Saturday morning does not mean you should show up in a casual jogging outfit with your hair in disarray and no makeup. You are still in a professional career environment, and you'll do yourself a world of good by looking, feeling, and being at your best. Don't forget to bring your picture and résumé.

In order to participate, many cold reading workshops require that you be a "professional" performer, a union member with agency representation. This requirement is intended to deter non-professionals and beginners.

Scene Nights

Scene nights are similar to cold reading workshops. For a fee, you can perform for an invited panel of industry guests (agents, casting directors, producers, etc.) Unlike cold reading workshops, scene nights are planned and rehearsed prior to performance night. Some scene nights are elaborate and well-produced productions that include printed programs, an intermission, and refreshments, and they are performed in a professional theater space. Others are sloppily put together and can be performed anywhere—a church basement, casting studio, etc. Shop around for the most professionally-produced scene night productions.

The scene you choose to perform should display your strongest talents and should reveal the types of characters you're suitable for. Don't make the mistake of choosing a character too far out of your acting reach or age range. Your audience wants to see you in a favorable and realistic light.

The same advantages and disadvantages used to decide whether you should participate in a cold reading workshop should be weighed when deciding on participating in a scene night.

Showcases

Showcases are just what their name implies—a vehicle to display a performer's talent. In New York they're called Equity-Approved Showcases, and in Los Angeles they're called Equity-Waiver Productions.

Showcases are staged dramas or musicals that offer the performer the opportunity to perform in a small-scale professional stage production. On the plus side, showcases are a great

opportunity for the performer to be seen by agents and casting people. The more reputable showcases often attract a large number of agents, talent scouts, and casting directors because they carry the reputation of being a great place to find new talent. Showcases can also help pad the résumé of a beginner, showing actual stage performance experience. On the down side, showcases usually pay little—some pay only for your transportation, others pay nothing at all.

Any new actor who sits back and waits for an agent to get him work probably will never get that first job. He must do everything he can to help himself and his agent. He must look at his career as a business by doing such things as further educating himself, promoting himself, and showcasing himself. What I mean is that, first, you must get the very best pictures you can and, second, get into as many classes as you have time and can afford. You also get into showcases, Equity and Equity-Waiver plays, so that industry people can see what you look like and what your talent is. You socialize.

Jack Rose

8

MAKING PROFESSIONAL CONTACTS AND NETWORKING

Tapping into "who you know" can be a significant part of a show business career. Unfair as it may be, having a family member, parent, or friend in an inside position can do wonders for your show business career and get you in doors that are otherwise inaccessible. Non-actors getting television and film roles because of their personal connections are typical occurrences within the industry. Even if a personal contact of yours is not directly involved in the business, any remote associations they may have can help you.

As you see, it's not always so much *what* you know, but *who* you know. This age-old cliche proves especially true when it comes to job hunting and career advancement. Contacts within the industry can easily help further your career and, more often than not, are essential for some upward mobility, especially in the beginning stages of your career. Developing contacts with industry insiders should always be high on your list of priorities. Now, we're not saying that you have to develop deep social relationships with your fellow performers, agents, technicians, and casting directors. A solid, professional working relationship based on mutual respect will do just fine.

Some performers are lucky to be born financially independent or socially advantaged into families that can successfully provide the entrance into a show business career. Performers like Janet Jackson, Rain Pryor, Shari Belafonte, Guy Davis, Joie Lee, Mario Van Peebles, and Rae Dawn Chong come from successful show business families, yet they all had to prove their own merits based on their individual abilities and talents. The point is, a parent, friend, or relative can open the doors for you, but you have to make sure you're not ushered right back out. If your talent is not up to par, regardless of your contacts, you will quickly find your picture at the bottom of the pile.

African-American performers have the added problem of being in an industry where the doors are not always open to them. In order to succeed in the entertainment industry, a performer must become involved in more than the artistic side of the business. Social liaisons at all levels of the industry will help you get into doors that are otherwise shut.

Writer-producer Travis Clark talked about the importance of relationships in the upward mobility of an industry career:

> This whole town [Los Angeles] is about relationships. It really is. And people tend to work with people that they know and that they feel comfortable with. Even when they staff a show, people tend to use the people they used on other shows, that wrote an episode for them, or that a friend recommended. And if you look at the credits on television shows, if you see one particular executive producer, you'll tend to see that in whatever show he does, the same list of names starts coming up, whether it's in hairstyling, makeup, or whatever. So they use these people over and over again. Then these people bring in their friends as assistants and then those people move up. For example, if I'm producing a show, I'll bring on story editors, and then those story editors move up to become producers the next year. Then they spin off and produce their own shows, and they bring in the people they worked with on my show. So you see those same names over and over again.

Travis went on:

> I'm going to tell you what I tell all of my clients: Talent gets you nowhere. Relationships get you everywhere. Talent will *keep* you there, but it won't *get* you there. And unfortunately, most of us think that if we're talented, we're going to make it. That's not what it's about. That's why it's so important to get the right agent, the right manager, the right relationship by playing volleyball, basketball, and softball with the right people. That's why you don't find ethnic people behind the scenes—because no one hangs out with us. So when the president of CBS decides to hire a staff, he goes to those people he hangs out with. I'm saying most blacks don't hang out at those social gatherings because we don't have the invitations. We don't hang out in Malibu on the weekends with the vice presidents of development or the vice presidents of the studios. We're not a part of that. So when job openings come up, we're never considered only because we're not in that relationship.

Professional friends can be especially important because, in addition to being someone to give you job leads, friends can act as a buffer to the ego-busting trips that you'll encounter. Friends also act as your support network for information and advice. A friendly relationship with a supportive agent or casting director can do wonders for your career. A supportive agent will be more likely to be enthusiastic about representing and introducing you around and will

push harder to get you auditions. In a situation where a casting decision can go either way, casting directors who are familiar with you and your work habits are more likely to go out on a limb for you, pressing harder for you to be cast in a role.

The unions have ethnic committees and advocacy groups that will expose you to a wider circle of professional colleagues. Take advantage of these networking channels. These committees often work hand in hand with the major networks, production companies, and casting companies to develop better standards for ethnic hiring policies. What better way to meet and develop a working relationship with an industry insider?

Take the initiative and begin building a network of associates and friends. After acting class or an audition, introduce yourself, talk to other performers, and exchange phone numbers. Get involved in a cause that interests you and will help your networking efforts. There are a number of cultural organizations for African-Americans in the entertainment industry you might be interested in joining—Kwanza, Black Women in Theatre, AUDELCO, and the Black Filmmakers Foundation, to name just a few.

> This is a very social business. You can meet industry people at parties, social events, dinners, showcases, and charity events. One person will introduce you to another person, who will introduce you to more people. Each of these is a contact and a way to network into the business.
>
> *Jack Rose*

> You're going to have to start networking with one another to do your own projects. In conversation with another actor or if you see someone at an interview, get that person's telephone number, and then tell that person to tell somebody else, and start meeting once a week, or once a month, or once every two months. Discuss something positive to do and stop complaining. We [African-Americans] have to stop complaining and start doing.
>
> *Travis Clark*

Power Networking Tips

We all know how difficult it is to break into this business without a helping hand. Today, more than ever before, networking is one of the most important factors in furthering a career in the entertainment industry. But effective power networking isn't just about making contacts and social chitchat. What you should be doing is developing meaningful relationships based on trust. Build trust in your industry relationships, and from that trust you'll get more work. People employ, send business to, and do business with people they trust. Yet, to trust someone you must know someone. Get to know others in the industry by sharing your knowledge, expertise, and

experiences in a nonmonetary environment (meaning, you're not getting paid for sharing!). Your willingness to share will earn the friendship and loyalty of others.

Besides working in your chosen industry profession, you should work on being part of the "in" crowd, the inner-circle of African-Americans in powerful and decisionmaking positions. Why? Because people tend to look to those closest and nearest to them when jobs are being handed out. Even though there are no African-Americans heading major movie studios or television networks, there are quite a number of African-Americans with decisionmaking power in the upper ranks of the television and movie business. Knowing who these people are can put your name on their "A" list when they've been given the go-ahead to hire someone and are looking for someone just like you. Certainly, there are African-Americans with the power to cast you in a role. You should know who these people are. In the music business, African-Americans are faring better and now number among some of the industry's most powerful and respected people. You should know who these people are and what they do. Don't find yourself in a conversation where someone mentions a well-known industry person and you have no idea who they're talking about. Do your homework! Find out "who's who" in the business. You should definitely know who the people are that are in a position to hire you for a job. Your goal is to meet and socialize with these people in order to forge a long-lasting business and quasi-social relationship. In the entertainment business, the people you regularly socialize with in your business life also tend to be the people you socialize with in your personal life.

A bit of warning is in order—don't be overzealous in asking for help or assistance. Relationships take time to build, and it is recommended you wait at least a year before you enlist the aid of any new industry contact. A year is enough time to build trust, which is the cornerstone of any productive business relationship. No one likes being put in the position of having to go to bat for someone they are not too familiar with. After a year's time, you should have established a rapport and relationship where they will be more than happy to put in a good word for you. Remember, their reputation is also at stake if they stick their neck out for you, and you want to make sure they feel absolutely comfortable helping you out.

Promoting Yourself and Networking On-Line

The world has the Internet (the "Net"), the U.S. has America OnLine (AOL), Prodigy, and CompuServe, and the entertainment industry has its own on-line presence. On-line services have become a way people can network with one another from around the world, and the entertainment business offers its own services for industry professionals who want to connect, converse, and network. Many services also offer you the opportunity to showcase your photo and résumé, musical work, and video demo tape on-line for others to view.

We conducted a one-on-one interview with Tucker Parsons, cofounder of The Vine, a leading entertainment on-line service for the entertainment industry. Tucker gave us a primer on what it means to be on-line and what benefits it offers the entertainment industry professional.

What is an on-line service? What equipment (hardware) do I need to go on-line? Being on-line means, basically, being connected. In most cases, it means that your computer is connected over a modem and phone line to another computer. That other computer can be at your friend's house down the street, or it can be part of a large networked service. An on-line service is a business whose primary reason for existing is to provide useful information and an easy and enjoyable environment in which people can make contact with each other to forward their own interests, projects, or careers.

Is much of the entertainment industry really "on-line"? Yes. I wish I could claim they were all on The Vine, but we are still small compared to what we intend to become. Our goal is to grow to be the single on-line home for the entertainment industry. As of right now, we have about 1300 active members—producers, directors, agents, writers, casting directors, actors, crew, multimedia designers, and others.

How can going on-line help me in my career? Can't I get the same information from reading newspapers and books? First of all, many people have found work on The Vine. One of our primary functions is to help people get the word out about who they are and what they do, and to connect the people who need work done to the people who can do it. And it's not just production jobs. Just a couple of weeks ago, there was a story in *The Hollywood Reporter* about the sale of a screenplay that was initiated on The Vine. We have résumé conferences for all crafts and skills and active conferences where job opportunities are posted.

In terms of information, you can't beat the timeliness that an on-line service can deliver. For example, we carry a feed of entertainment industry press releases that we get at the same time as the trade papers. For some people, that's very important. But information is only part of what we offer. The on-line environment we have created is ideally suited to "schmoozing." You can chat with people on-line or leave messages in conferences that concern topics in which you are interested. Having conversations with people in this way is an effective method for establishing them as a contact and building a relationship that can help your career grow.

It's also a lot of fun. But what happens when you have a lot of people doing that on a single service like The Vine is that it begins to develop a personality of its own.

The Vine is now a community of people, many of whom know each other pretty well, even though they have never met. We are now beginning to have live get togethers so the relationships aren't limited to cyberspace.

What type of services does The Vine offer? The Vine is a network of people who all share a common interest in communicating with each other to expand their contacts, increase their knowledge, and make successful projects happen. We have all kinds of members, from writers to gaffers, producers to composers, directors to set decorators. We have a broad cross-section of above-the-line and below-the-line professionals from the film, television, music, and multimedia industries forming an exciting and supportive community on-line.

The Vine has a long list of services. First of all, we offer Internet E-mail. Any full member can mail to anyone on any Internet-connected service and receive mail from them from your mailbox on The Vine. We carry general news (Associated Press, USA Today), trade news (Studio Briefing, Entertainment Wire, Hollywood Hotline, Transient Images, AP Movie, music and entertainment news, and more), and special databases like The Vine's Industry Directory, with over 3,000 production companies, agencies, and production resource contacts, and The Vine's Production Slate, which tracks studio and independent films from development through post-production. We are in the final stages of development on a comprehensive movie credits database, a wonderful resource for people in the film business. As I mentioned before, we have all kinds of other conferences and services. We even have other organizations on-line with their own "office suites" where they are free to promote themselves or sell goods and services or have special conferences of their own. The reason we offer a free 30-day trial membership is that it's really too much to describe quickly—you should just log on and see it for yourself.

Do you have many African-American users? We don't track the race of our members, so I don't know what proportion of our membership is African-American. However, I suspect that the proportion is pretty low right now, but growing. The Vine wants to have a rich and diverse on-line culture, and we invite anybody and everybody working in the entertainment industry to join. With the division between the races now seeming so great, I feel that the on-line environment is a perfect place to help work some of these issues out because you actually cannot tell—unless someone tells you—what race they are. Cyberspace is truly colorblind, and if we want to evolve toward a colorblind society, it would seem a great place to start working on it. The Vine is currently offering a free 30-day introductory membership. You can call (213) 957-1990 to receive your free starter kit.

In addition to The Vine, there are number of other on-line services geared specifically for people in the entertainment industry. ACTcomm BBS, "The Actor's Net-

work," is an on-line service for the acting community, affording actors the opportunity to meet other actors, join theatre groups, upload pictures and résumés, send and receive E-mail, participate in forums and on-line chats, and access file libraries. You can even download mailing lists of casting directors, agents, and theaters. To access, call (818) 766-0510, type "new" at the log-in prompt, and follow the directions on the screen.

Artist Files Online (AFO) is an on-line system developed by the Non-Traditional Casting Project (NTCP) in response to directors, casting directors, and producers who want to hire artists of color and artists with disabilities but are not familiar with the general talent pool. The largest resource of its kind in the country, AFO contains current résumés for actors, directors, producers, choreographers, designers, stage managers, technicians, and other members of the production team. Artist Files Online allows users to access résumés and high-resolution photographs from anywhere in the country. A fax option is also available. To date, Artist Files Online has been consulted for nearly 1,000 stage, television, film, and commercial productions. Send AFO your pictures and résumé. If you work in more than one area (acting, writing, and directing, for example), send one résumé for each occupation. Make sure you keep your information current. Any time you change your phone number, update your résumé, or get a new photo, send it with a note indicating the new changes to update your files. Send information to Artist Files Online, The Non-Traditional Casting Project, 1560 Broadway, Suite 1600, New York, NY 10036, (212) 730-4750 (voice), (212) 730-4913 (TDD), (212) 730-4820 (fax).

Arts Wire (*artswire@tmn.com*), Online Communications for the Arts, is a national, computer-based communications network for the arts community. It allows artists, individuals, and organizations in arts communities across the country to communicate, share information, and coordinate their activities. The main features and services on Arts Wire include "Hotwire," a summary of arts news; "AWNews," a central area for users to disseminate news and information, and "Money," a searchable resource of grant deadlines and other opportunities for artists and organizations. For more information contact Arts Wire, Front Desk Coordinator, 824 South Mill Avenue, Suite #93, Tempe, AZ 85281-5603, (602) 829-0815.

Hollynet (*http://www.usc.edu/dept/etc/hollynet* using Mosaic, or *cwis.usc.edu* using Gopher) is an outgrowth of the University of Southern California's Entertainment Technology Center and is sponsored by Viacom, Paramount, Warner Bros., Pacific Bell, Apple, and USC. HollyNet provides on-line access to casting and production information. The Motion Picture Academy's Players Directory has provided lower-resolution black & white images of every actor in its directory. The service is free for now since it's still in the prototype stage.

The Independent Filmmakers Forum is the H.O.M.E. (Hollywood Online Meeting Electronically) of rising professional media people. The service provides a full range of on-line services including forums, where users can read and post questions and information about their projects and interests; the Filmmaker Directory for networking; multiuser chat in Teleconference; Private Chat; more than 5,000 files of programs, electronic literature, and graphics in the download libraries; and a user community of multimedia artists, film producers, directors, actors, editors, composers, videographers, sound people, makeup artists, graphic designers, and musicians. For more information, contact The Independent Filmmakers Forum, P.O. Box 8112, Long Beach, CA 90808-0122, voice/fax (310) 425-5331, modem (310) 425-0012

Kaleidospace (*http://kspace.com*) offers independent artists the opportunity to showcase, sell, and distribute their work to an international audience on the Internet. Kaleidospace was founded by Jeannie Novak and Peter Markiewicz, who wanted to empower independent artists who have been ignored by major record labels, publishing houses, and large film companies. There are 10 areas in Kaleidospace where you can showcase, sell, or distribute your work. For example, in "Center Stage," performers and actors can showcase clips of their shows; comedians, choreographers, and performance artists can advertise clips from their performance videos. In "Music Kiosk," musicians and independent record labels can showcase excerpts of their music. And "Screening Room" offers animators, filmmakers, and independent film-video production companies the opportunity to showcase film clips or trailers. For more info contact Kaleidospace, P.O. Box 341556, Los Angeles, CA 90034, voice (310) 399-4349, fax (310) 396-5489.

9

GROOMING YOUR
PROFESSIONAL APPEARANCE

Your physical appearance is one of the most important elements of your overall professional image. How you choose to wear your makeup, hair, and clothing can make or break your career. Your physical appearance is always visible, and every performance puts you in the position to act as a representative of African-American beauty. Unfortunately, White Hollywood is not always particularly interested in the realistic expression of the beauty of black culture. Therefore, as a black performer you must decide whether you want to participate in the existing standards of the industry the way it is—accepting the industry-wide guidelines for makeup, hair, and clothing—or choose to be the person you are, even if it means losing out on jobs because your look is unacceptable in the mainstream of the entertainment industry.

If you decide to participate in the industry the way it is, you should know that the entertainment industry is forever changing. What is popular today is passé tomorrow. Fashion trends change quickly. However, the perception of the general American public changes much slower than the trends, and their fashion changes stay within a certain frame of conservatism (which can often be rather boring!). The styles we have chosen for this section are based on a cross-section of opinions gathered from black professional stylists.

While there are no set rules about how you should look, there are certain specific guidelines to be followed for a clean, healthy appearance. What really counts are your style, individuality, and versatility—within pre-structured limits. It's quite easy for the novice performer to get caught up in designing a fashion image that is outlandish and faddish in the pursuit of developing his own unique identity. Well-known performers like Lisa Bonet and Whoopi Goldberg are often identified by their unique style identities. But until you've reached the point in your career where you can more or less control your own destiny, stick to a more conserva-

tive fashion image. As you become increasingly employed and known, you can begin to carve out the unique image that will ultimately become synonymous with your name.

An actor should always appear physically healthy and well-rested. Even though a role may require an actor to appear as if he were ill, no commercial advertiser wants to give the impression that his product will be associated with illness or physical disfigurement. Your *acting* should make you appear ill if that's what the scene calls for; your physical presence should not. Your health is reflected in the general condition of your skin, hair, eyes, fingernails, teeth, and body condition. If you're overweight and dissatisfied with your physical appearance, go on a diet. If you have acne or other skin problems, see a dermatologist. The idea is to correct as many physical flaws as you can. When the competition is keen, you don't want any physical defects to lessen your chances. As a black performer, you are a representative of your community and you want to project an example of good grooming.

Veteran supermodel Sheila Johnson talked about her grooming routine as a fashion model:

> My model routine was a few glasses of water a day, no fried foods, no salt. I ate no dairy, no caffeine, no sugar, and I exercised absolutely every day. The discipline was phenomenal. It was beauty treatments twice a week, it was massages, it was manicures, it was everything. I had to—there was no way I was ever going to walk into a booking and have them say I can't believe her nails, her hair, or her skin looks horrible. There was no way this was ever going to happen to me. This was a personal thing for me, and as a black model. You [the black model] had to be as good, if not better—I do believe that. Whether it's how you take care of yourself or your attitude on the set. You have to be interestingly better. Grooming was major. You have to have the perfect body. You have to be one size smaller than the perfect size. The clothes do not look good on a full women—if she's full in the bosom, that's different—but her waist, legs, and butt have to be able to carry those clothes. Designer clothes are a size 6.

The Afrocentric Choice

Cosmetically over the last decade, African Americans have found new beauty territories to explore, our own niche. With the discovery and acceptance of new and better grooming products and techniques, the black performer now has more of a choice when it comes to grooming a professional image.

New, innovative fashion stylists and performers have finally brought representation of our Afrocentric culture into mainstream American focus. Our new style boasts of self-pride, racial consciousness, and personal confidence. Over the past few years, you may have noticed a trend by advertisers to present more realistic and authentic portrayals of African Americans in the

commercial marketplace. Due to our ever-changing demographic and economic picture, there is now a hot, new industry trend towards extreme ethnicity and multicultural images.

No longer is the black performer forced to adhere to the conservative "whitebread" images of middle American culture. We have found our own style, rooted in our history and the countries from which our ancestors emerged. With the advent of more reality-based programming, actors have personalized and modified the all-American fantasy images of their characters to create realistic cultural portrayals of everyday citizens.

It is not unusual for performers to have Jamaican locks and wild ethnic hair, tatoos, pierced ears and noses. Our hairstyling techniques have reached new hair texture and color horizons. Facial hair has now become acceptable commercially, and the setting of our own neighborhoods are also reflected in character attitudes and wardrobe. Even the most conservative roles are now being played with our own twist. Nurses, doctors, lawyers, school teachers, and other conservative public servants can now reflect the cultural identity of the African American community.

Makeup

You must first master the basic skills of makeup application. Even men and children will often find themselves applying their own foundation, powder, and contour for both auditions and jobs. Makeup gives the skin a healthy and natural appearance to combat the distorting, harsh studio lights and sensitive camera lenses. For black performers, makeup can only enhance our often uneven pigmentation. Use a cover-up to camouflage facial discoloration, dark, under-eye circles, and scars. Use contour shading to enhance your bone structure and translucent powder to tone down shiny areas caused by oily skin and perspiration. If you have limited knowledge about makeup application, visit a makeup counter at your local drug or department store. The salespeople are usually trained to help you make the best selections for your needs. Don't be hoodwinked into buying a complete line of beauty products. Stick to the basics: foundation, powder, liner, lipstick, and mascara. You can also learn by reading the beauty, grooming, and make-over sections of magazines like *Essence, Ebony Man, Sophisticate's Black Hair Care,* and *Styles Guide.*

Many performers complain of harsh makeup application on the set. If you know your skin's sensitivities, it is a good idea to keep a supply of your own makeup on hand at all times. Bringing your own makeup along on set is also a good idea for sanitary purposes. You can easily get conjunctivitis (pink eye) or other skin infections from using makeup that has been applied on a lot of other faces. We suggest that you only use your own mascara and replace it every six months. Mascara often carries bacteria that could trigger an eye infection.

On most large-budget productions, a makeup artist is usually present on the set to apply your makeup. Makeup application for television and film is different than your everyday makeup application technique. The makeup artist knows what will make you photograph your best, yet he will probably be willing to compromise. In most cases, you should trust the makeup artist's professional judgment. But if you find yourself in a situation where you feel you look strange, consult the other stylists and wardrobe people. They can usually arrange to have your makeup reapplied or changed. However, since you are dealing with another professional's ego, try to be as diplomatic and tactful as possible.

> I was listening some years ago to Della Reese on one of the late night talk shows and she said that the makeup artist made her up and, when she looked in the mirror before she went out on stage, she immediately grabbed a wad of towels and wiped her face completely clean before because she said she looked ghostly. I have heard that kind of story many times. It's an incompetent makeup artist who really doesn't take into consideration the issues of light absorption. I would suggest that there has to be some understanding between the performer and makeup person. I have traveled and had to do makeup shows and television programs and I've had makeup artists make me up. And when I see them reaching for the wrong colors, I simply say, "Excuse me, but I know the type of makeup that looks best on me in terms of making me look the way I'm accustomed to." I have known people who have pulled out photographs of how they've been made up before to show to a new makeup artist how they look in certain colors. It's correct for a professional performer to let a makeup person know how they want their face made up.
>
> *Alfred Fornay*

There will be times when the makeup artist on the set may not be familiar with applying makeup for black skin. And there will be times when the makeup artist won't have foundation colors for our skin coloring. Nothing is worse than a handsome, ebony-skinned actor wearing a too-light, gray-toned foundation. It's to your own benefit to always bring your own specially formulated makeup, especially foundation.

We asked beauty expert Alfred Fornay what black performers should do about skin care and makeup. His response was this:

> I'll address my answer towards men. Men who are now sportscasters, athletes (in commercials), actors, models have to be very careful about the type of foundation that is applied to their skin, especially with the different skin colors that we have. We've come a long way since Max Factor's Negro foundations. There are professional companies now who have dark shades for black skin coloring. And black men now have to feel comfortable going through the rudiments of makeup application. It has

nothing to do with ego, it has nothing to do with being effeminate. All this comes with the territory. I've had a very difficult time convincing men to wear makeup under electronic lighting. Makeup makes a big difference. Black skin bounces light differently than white skin. A white person absorbs and reflects light differently than a black person. So you have to take all of that into consideration. A white person can sweat in front of the camera, and you can't really see the shine or the glare or the glistening. A black person will sweat in the same type of environment and he will look oily and greasy and shiny. And it's because of the reflection of light and the way light is absorbed. So that has to be taken into consideration. So what am I saying? I'm saying that a black male should consider putting a cover stick on the dark circles underneath his eyes. If he has pimples, blackheads, or even wide pores, then he ought to use a cream, souffle-type of foundation and translucent powder that will give the appearance of flawless skin under electronic lighting. Those men who are in opera productions discovered this years ago. Simon Estee, for example, a black baritone, endures several hours of makeup before going on the Metropolitan Opera stage and others stages of the world, and he has a makeup application that has been tailored for him and looks suitable for print as well as on stage—and he looks great. I would urge males to find a professional makeup artist to consult with before the actual makeup session and find out what colors the makeup artist will be using and what foundations he has. If the makeup artist doesn't have them, then he should go out and purchase them and introduce the makeup artist to them. And that's not difficult to do now with the different black companies that are specializing in these types of makeup.

Once you've mastered the skills of basic makeup application, you're ready to apply them to designing your own image. The colors you choose should complement your coloring and complexion. Your hairstyle should be manageable and flattering to your face. Here again, check out one of the many black hairstyle magazines to get an idea of the current hair styles and lengths. A trendy style may be all right for your everyday activities, but as a performer you will be representing a broad cross-section of black Americans, and trendy corn rows, jeri curls, and geometric hairstyles are not always advisable. Women should definitely stay away from extreme, drastic cuts—these trendy styles are limiting in versatility and they may also be offensive to conservative advertising clients and mainstream Americans.

Character people tend to be a little more kooky and eccentric than their upscale counterparts. They are hired because of their unusual looks and mannerisms. Their appeal may be based on age, a peculiar appearance, or attitude. Character role playing is widely used with comedic appeal, which lends itself to personal physical stylization. This is one area where personal ethnic style is a plus!

However, in most cases, it is important that a performer not overshadow the product or part he is playing. A performer must be believable doing what he is doing, and his clothing and makeup must complement without distracting from the product or performance. If a role requires unusual makeup, hair, or wardrobe choices, the production company will hire trained styling professionals to create the necessary physical imagery.

Makeup should be at a natural bare minimum, just enough to complement your features rather than change them. Some people think it's "professional" to wear lots of makeup, but it's not. A natural look is popular in today's industry. Hair color should conform to what would be appropriate for your natural coloring. Hairstyling should be kept modest and free from ornamentation. Certain ethnic hairstyles—braiding, dreadlocks, cornrows, beading, and large Afros— are frequently used to illustrate certain ethnic products, but, remember, you are presenting mainstream America as seen through the eyes of a successful business person. In order to work, personal preferences must take a back seat.

Hairstyle

The trends in black hairstyles change fairly rapidly. There was a time when natural Afros, plaits, cornrows, and jeri curls were "in." Today, the trend is towards chemically-straightened (permed), textured hairstyles, mid-length, with a classic, versatile cut. In any event, make sure that the hairstyle you choose suits and flatters you and your facial structure. Trendy and gimmicky hairstyles should be avoided because your natural hair should be versatile enough to be arranged in many different styles. Haircuts like extreme fade-aways, flat tops, and asymmetrical styles are sometimes too limiting because they will not afford you with the ability to arrange your hair in different styles.

Alfred Fornay had this to say about choosing a hairstyle:

> I think a performer really has to be concerned about hair. I'm speaking of a hairstyle that really complements the facial structure—especially if the person is going to be in print or in front of an electronic type media such as television or videos. Hair is very, very important. Hair can overpower features, overpower a face structure, and interfere with lighting in terms of how light hits the face. It's important to make sure that the hairstyle complements the jaw line, the width of the face, and, of course, the features. For example, if you have a very flat face, a broad nose, and very thick lips, and then you have a lot of hair cascading towards the forehead, you're look is going to be top-heavy. It can be distracting and uncomplimentary. So hairstyle is a very important consideration. A professional performer has to start thinking about personal grooming services. That means that you can no longer give yourself the homemade manicures, the homemade pedicures, the homemade hairstyle. You have to go to a professional hairstylist or a professional barber who's

going to look at you and the lifestyle that you are anticipating in a professional light and try to design a look that's going to complement bone structure and skin color. I don't subscribe to trendy hairstyles, especially for black folks.

Black hair requires special care, as we all well know. As a black performer, this special attention should be intensified, as your hair should be healthy with a natural sheen and luster. The effects of constant blow drying, hot curlers, curling irons, hair conditioners, and pomades used by hairstylists can produce devastating effects and severely damage your hair. And chemical preparations such as relaxers, perms, and coloring can dry your hair even more. Therefore, you should keep your hair well conditioned and visit your stylist at least once a month for deep salon conditioning and the repairing of split ends. Permed and relaxed hair should be touched up on a regular basis and given deep conditioning treatments to replace moisture. If possible, it is a good idea to avoid hair coloring. Once you begin coloring your hair, you will have to maintain it on a regular basis. Not only is this expensive but, over a period of time, it is damaging to your hair. Nothing looks worse than a light head of hair with dark roots. At all costs, stay away from unnatural hair colors—blondes, bright reds, burgundies, and oranges that are unrealistic for our skin tones. Remember, what may be perfectly acceptable in your everyday lifestyle may work against you in show business.

Alfred Fornay talked about hair coloring for black performers:

> Changing hair color is a consideration, because if you have very dull, lackluster, dark hair and you are appearing in a very lively-type show like a soap opera or as a guest on "Arsenio" or something like that, you want to be in a happy mood and present a cheerful kind of presentation because people want to listen and look at you approvingly. [Dionne Warwick's] hair is dark but she wears it light sometimes, with blondish streaks. It's complimentary and it shows she cares about her looks, and she creates new images.

Black men can use hair colors to enhance the color of their hair as well. Fornay had this to say on the subject:

> Men need to get into lightening their hair. Red highlights can add and develop a more approving type of appearance is terms of adding sheen and luster to the hair.

Black performers often use wigs, wiglets, hairpieces, and hair weaving to supplement their own hair in times of need. Wigs allow a performer versatility—one can change hairstyle and color in a matter of minutes. Michael Weeks' It's A Wig and the Naomi Sims Wig Collection

have a large variety of wigs designed especially for African-American women. The styles are contemporary and lightweight and the wigs' fibers are very natural looking. If you wear a wig, the cap should be securely attached to your head with hair pins or bobby pins. The wig's lining should be made of a wide mesh netting to allow your scalp to breathe.

When it comes to hair weaving, make sure that you have thoroughly investigated the stylist who is going to do your weave. Hair weaving is a process by which a beautician sews and attaches strips of artificial hair to your own hair, adding volume and length. There are a lot of so-called hair weaving professionals who really don't know what they are doing, and if you are the unlikely victim of one of these people, you're headed for serious trouble. Hair weaving, if done improperly, can literally tear the real hair out of your scalp.

For men, hair should be natural and neatly groomed. Facial hair is usually unacceptable; however, for black men, a short, neatly-trimmed moustache can be worn. Beards have not yet reached complete acceptability, but if you decide to wear a beard, as in the case of top black model Rashid Silvera, it must be as neatly groomed as your hair.

Don't forget to keep your hands presentable at all times. Both men and women should have their nails neatly manicured. Women should wear a neutral-color polish and fingertip-length nails. Long, claw-like fingernails are distracting from your overall on-camera appearance.

Eyeglasses, wigs, hats, or other pieces of clothing or costume are often used to suggest a change in age, character, or time period. The wardrobe stylist will provide these accessories for the effect that is needed. As a professional performer, you should carry your own supply of accessories that best suit your face and various personalities. These special effects can also aid in your being cast during the audition process, but remember to keep all gimmicks to a minimum. In commercials, the product is always the star, and your image is secondary—elaborate dress, makeup, and mannerisms will only lessen your chances of booking the job. You are representing middle America—keep your persona separate.

Your Professional Working Wardrobe

If you can afford it, you should have an extensive personal wardrobe to complement the wide range of roles for which you will be auditioning. You will also need to bring some of your own clothing on many of your actual jobs. Low budget films, industrial films, television under-fives, and even smaller feature film roles and extra work often require the performer to provide his own wardrobe. (You will be compensated on your paycheck in the form of a cleaning and rental maintenance fee). You, therefore, need a well-planned wardrobe.

How do you develop this wardrobe? Experiment! Check out the latest fashion magazines to monitor the current trends in dress, makeup, and hairstyle. (Notice we used the word "trend" instead of "fad.") It's okay to be contemporary in your appearance and in tune with current

fashion trends. Watch television commercials to see what looks the performers are following. Then make an honest and objective assessment of your fashion profile. Now you're ready to focus your image and establish an individual style identity that is right for you. When preparing to attend audition calls, a performer should always have a variety of wardrobe choices at his disposal. Many audition calls come in at the very last minute, and you won't have much time to prepare your wardrobe. So it's a good idea to have various outfits ready at a moment's notice. Go through your closet and group together outfits that will represent the different types of roles you are called in to audition for. This way you'll be ready whenever the audition call comes in. A good versatile, conservative wardrobe can make the difference in a close audition. Remember, agents and casting directors make many decisions based primarily on appearance and grooming, so you want to have your professional wardrobe outfitted correctly.

In dressing for any specific audition or role, be sure to inquire about character specifics. Ask about the age range, occupation, product, or role specifics when obtaining information about your audition. It is your responsibility to obtain this information from your agent or manager. Likewise, it is their responsibility to furnish you with accurate and detailed information. You should not call the casting director to request information about the audition. These clues will allow you to determine what, if anything, in your closet can best evoke the character you are to portray. Be subtle in your choices. You want only to suggest the character and his appearance, not define it outright. Just as important, don't dress inappropriately for the type of role you are auditioning for. For example, if you are auditioning for the role of a young mother, wear a simple skirt and blouse. You certainly wouldn't dress in a skimpy dress (á la Tina Turner) or in new wave rock 'n roll attire (Vanity). If you're auditioning for the role of a construction worker, wear a pair of jeans, a rugged-looking shirt, and boots. You could even carry a hard hat to further suggest the character.

Simplicity is always the key. An outfit that is too stylish may impress the fashion-conscious viewer but may also offend the sensibilities of the average American consumer. Roles that require outlandish costumes are carefully planned by special fashion designers with theatrical costuming experience.

> I believe that when you go for an audition, short of trying to assume whatever you can of the role, dress accordingly. Particularly men. If it's summertime, I don't want to see you in shorts and t-shirts unless it's the type and the character is a really casual guy. Short of that, don't come for a general interview and not be in slacks and a shirt. I think of me as being like a person who is looking at you and you want a job. You don't have to wear a tie and a suit, but wear slacks and a shirt. And please don't rent a uniform to show me how much you prepared. Leave some room for imagination.
>
> *Jaki Brown-Karman*

Also, in choosing wardrobe, remember that color is of extreme importance. Certain colors that may appear pleasing to the naked eye may change and become unflattering under studio lighting. Some colors, when photographed by the supersensitive lens of a film or video camera, can change in intensity and texture. Stay away from wearing white or black—they throw harsh reflective light and shadows and are extremely difficult to photograph properly. Extremely patterned fabrics (including big checks, plaids, and multicolored geometric prints) cause distracting photography problems. Avoid these patterns and colors. On camera, medium-toned colors photograph best and are more appealing to the average skin coloring. Light-colored pastels will sometimes photograph as white and distort your image on camera. The same applies to loud, bright colors, bold prints, and checks and stripes, which often appear harsh and contrasting. Do not wear clothing with obvious designer labels or logos visible on the outside. This may create conflicts or legal problems for a potential advertiser. Keeping your wardrobe simple and conservative gives a production a more classic, timeless look.

Having the right wardrobe to complement the image you're trying to achieve is important. But equally important is the way you coordinate your clothing in terms of outerwear, mixing and matching, fabrics, and colors.

When you first walk through the door of an agency or casting office, you will be immediately assessed according to your physical appearance. Sloppy, ill-fitting, unseasonable outerwear will not leave a positive casting impression. If you've taken the time to put together a well-coordinated outfit, put the same amount of time into choosing an overcoat or jacket that will add to your overall appearance. Shirts and sweaters that hang beneath the bottom of your overcoat will look like you didn't put much thought into your overall presentation.

Wearing good undergarments is also important. You know your mother's old saying, "Make sure you wear clean underwear, because you never know when you'll end up in the hospital!". Well, the same holds true for the performer. You never know when you'll be asked to try on a special costume or the client's product clothing. This is especially true on fashion calls where the production staff wants to see how their costumes will appear on camera and how the performer fits the clothing. Sometimes you may be asked to change in a room with several other performers present. Do yourself a favor and save yourself from embarrassment and gossip—always wear clean and neat undergarments.

Even if you've gone to a lot of trouble choosing your professional wardrobe, you haven't finished your wardrobe choices until you've coordinated your clothing with your accessories and footwear. Mixing and matching separates for cameras and lighting is not as easy as it appears. That's why television and film productions employ specific wardrobe people as well as a professional costume stylist who are responsible for creating the desired fashion image. Coordinating outfits and accessories is a tricky business, and if you're not sure how to go about

it, it would be wise to invest in a consultation with a fashion or image consultant. Not only will they help choose complete outfits, including accessories and footwear, but they'll also instruct you on how to properly wear your clothes and how to maximize your wardrobe through mixing and matching. It would also be a wise idea to play close attention to the dressing do's and don'ts featured monthly in most of the leading fashion magazines.

In choosing fabrics and colors, quality clothing will wear better in the long run. Cottons, linens, rayons, and wools are your best bets. A few good pieces are better than a whole wardrobe of poorly-made clothing that will fade and shrink after continued wash and wear. But better-made clothing is often "Dry Clean Only," so keep in mind that your cleaning bill is going to go up.

You don't have to spend a lot of money on your wardrobe. Discount outlet stores are a gold mine for inexpensive accessories like jewelry, scarves, belts, bags, and hosiery that can do wonders to expand the look of your wardrobe. For those of you on the East Coast, street vendors sell all kinds of goodies. Set aside a Saturday afternoon and take the bus to Secaucus, New Jersey, where you'll find the designer warehouse capital of the New York metropolitan area. The warehouses are, of course, nothing like walking through Bloomingdale's and Saks Fifth Avenue, with all of their fancy store displays and luxury dressing rooms—but warehouse prices are definitely on the money. You'll find designer label clothing at prices up to 75% off the department store prices. And for those of you on the West Coast, you'll find similar bargains at the California Mart, throughout the Santee Street shopping district, and on the boardwalk at Venice Beach.

Be imaginative. Experiment with your clothing, shoes, and accessories to create a versatile, professional wardrobe.

If you can afford it, try to maintain separate wardrobes for work and personal use. In selecting something to wear, remember your appearance represents your character and your character's use of a specific product. Advertisers want talent to appear attractive, happy, confident, and healthy, as if the product is responsible for the talent's well-being. A sloppy, unkempt, casual appearance will only limit your chances for getting work.

On the next few pages are sample lists of wardrobe pieces that will get you off to a good start in building your professional wardrobe. Try to accumulate as many of these as you can.

Guidelines for Professional Working Wardrobe for Women

A women's professional wardrobe depends on her type and the age group she fits into.

For the *young performer in her teens to early 20s*, a pair of good-fitting blue jeans (without holes and patches), a polo shirt, an oxford shirt, and a sweater will go a long way. To that list add a dress, jumper, skirt, and blazer for even more variety. You can interchange and accessorize

these pieces to display different character types. For example, for the preppy look, jeans, a shirt, and a blazer with eyeglasses and necktie would work. For the role of a countergirl, a jumper and top will work well to suggest the countergirl character. Add a few brightly-colored accessories for some pizazz if you're auditioning for the typical, trendy teenager of today. Women can get away with outfitting themselves in some of the current fashion styles. Steer clear of extremely trendy fashions. Flipping through fashion magazines should give you a good idea of what middle America is wearing. You're bound to notice that the current mainstream fashion trends rarely coincide with the current fashion trends within the black community. Like we said many times before, black culture has not been taken into account in the white media. Keep in mind that, on the West Coast, clothing tends to be a little bit shorter, skimpier, and sexier than it is on the East Coast.

Mother and housewife types, both young and old, should display a soft, casual appeal. Opt for basic styles and colors in casual separates—skirts, slacks, blouses, and tops work best. You can add a cardigan or pullover sweater for more versatility. This is definitely not the area where you should appear too trendy. You should look like you could do housework, play with the kids, or go shopping in the same outfit. You will be addressing a broad spectrum of American households, and the fashion consciousness of big city areas is not the same in the Midwest and rural, small town environments.

Corporate women (such as the business executive or secretary) should choose conservative business styles. A tailored suit consisting of a skirt, blazer, and pants is a good start. This can be interchanged and accessorized with blouses of different color and style. Flashy, provocative clothes are usually out of the place for the office environment.

Working women (such as a teacher or flight attendant) can opt for a slightly more casual look than the white collar executive types. Separates—pants, skirts, blouses, sweaters, and jackets—can be mixed and matched to create a professional career look.

Women of all ages will at some time or another find a need for formal wear and uniforms on actual jobs. High school proms, nightclubs, discos, and elegant restaurant scenes will often require tea-length party dresses and evening gowns. Nurse, airline stewardess, and policewoman uniforms are also frequently used. Investing your own money in these uniforms may be a wise decision. Many casting directors regularly employ certain performers because of their specific uniforms. Be sure to check with the various costume shops in your area to make sure your police uniform is accurate in keeping with the regulation, seasonal police dress codes.

Athletic wear and sports equipment—sweatshirts and sweatpants, sneakers, tennis rackets, bicycles, ice skates, and roller-skates—can also be a valuable asset. Casting directors will often request these items for certain working situations. A young black New York actress did five jobs

during one winter season because she owned a pair of old ice skates. She made so much money from the five jobs that she treated herself to a brand new pair of professional ice skates.

Jewelry for women should be plain and simple—no large earrings and necklaces to distract from your look. Stick to simple hoop or post earrings and maybe a small, simple neck chain. Remember, most production companies provide wardrobe stylists on the job who will add and subtract pieces from your wardrobe.

Guidelines for Professional Working Wardrobe for Men

Male performers should have a combination of suits, shirts, sweaters, denim pieces, and formal wear to complete their working wardrobe. The styles and colors will vary, depending on your age range. Performers in their teens and early 20s can get away with a slightly trendier look, more colors, and accentuated styles. Everyone else should basically stick to the classics.

A variety of well-fitting business suits are of great importance. Select only classic cuts and colors. Most actors prefer a basic black or navy banker's suit; a gray or dark brown suit to cover the middle of the color spectrum; and a beige or tan, light-colored suit.

Tuxedos and formal wear should be part of your working wardrobe. Especially around the holidays or festive occasions, there usually seems to be a great need for men in formal attire. Rather than paying costly rental fees, most actors purchase their tuxedos and accessories.

Shirts and sweaters can completely change the look of a pair of jeans or khaki pants. With the evolution of the black urban professional ("buppie," as opposed to "yuppie"), there is a great demand for the elegantly casual polo shirt and cable knit sweater. These pieces can either be interchanged, coordinated, or made to be dramatically contrasting. Dress shirts should include classic button-downs and wing collars, with conservative collar sizes and patterns.

For the male performer, a good denim jacket and slacks can be versatile and add a youthful, non-conformist air to his appearance. Stay away from excessive detail, studding, and embroidery that cause lighting problems and become distorted on camera. Also, extremely ripped, overly-faded, and patched denim is definitely out! Depending on the role, you could add a t-shirt, oxford shirt, or sweater to complement the look. For a rugged, outdoorsy look, jeans and a big sweater work. For a more studious look, try mixing the same jeans with a plain oxford shirt and blazer. For a more athletic look, skip the blazer and put on a baseball-style jacket and sneakers.

Other wardrobe pieces to consider would be a pair of khaki pants and sweatpants and a matching sweatshirt. These pieces can be mixed with shirts and sweaters to create an array of different looks.

Uniforms are necessary for policeman, doctor, and athlete roles. If these clothes are already a part of your lifestyle, include them as part of your professional working wardrobe. If

you are considering taking this step, check your costume and its accessories for accuracy and detail. Where the standard business suit cannot suffice, many actors find owning the standard blue-collar uniforms increase their marketability.

As we've repeated many times before, Hollywood is not always interested in the realistic expression of the beauty of black culture. Advertising agents, their clients, photographers, and casting directors often feel threatened by looks and mannerisms that are too ethnic. Earrings in the nose, traditional African clothing, and Afro picks in the hair or sticking out of a back pocket are not seen as acceptable in today's show business industry. Certain cultural trends in fashion should also be avoided. Large gold names on necklaces (typical of young black teens of the hip hop and rap culture), a zillion bracelets on your arm, more than one hole in each ear for earrings, and untied, oversized shoestrings on your sneakers will often limit your overall casting potential. Leave these types of choices to the wardrobe people once you get the job. Although these trends may be fashionable and acceptable in the black community, remember you are pursuing a career in the mainstream of White Hollywood where these trends are often misunderstood and looked upon as threatening and offensive. It is important to mention here that there are a number of African-American performers who in recent years have embraced their ethnic culture with great success. *All My Children* actor Keith Hamilton Cobb, *One Life To Live* actor Timothy Stickney, and *The City* (formerly *Loving*) actor Darnell Williams all proudly sport dreadlocks.

Like it or not, the reality of casting is this: black performers are often asked to play stereotyped, street-type characters. Black castings often call for pimps, prostitutes, drug dealers, gang members, criminals, street dwellers, and characteristic low-income neighborhood types of all ages. This is the one area where you should disregard the basic wardrobe guidelines outlined above. Unless you market yourself as a specific character type, these costumes are not part of your everyday, professional working wardrobe.

Following is a breakdown of the clothing representative of street characters.

Specialized Costumes

Pimps often wear flashy and overly-colorful jackets, ties, hats, platform shoes, and dark sunglasses.

Street prostitutes usually wear sleazy and tight-fitting shorty shorts, mini-skirts, spandex pants, fishnet stockings, high heel stiletto pumps, and, in cold weather, a short fur jacket.

Criminals should be outfitted in dark, nondescript pants, shirts, and jackets and a ski cap or ski mask.

Gang members wear pants and jacket and carry a bandana in a certain color (usually red, black, or blue). Don't forget the characteristic toothpick to stick in your teeth. The production

staff will provide you with any weapons you need. Never carry firearms or weapons into an audition or for a set. There are legal and insurance regulations governing all firearms, weapons, and ammunition.

Street dwellers such as bag ladies, bums, drug addicts, and winos wear tattered, torn, dirty-looking old clothing worn in many layers, including a dingy, oversized overcoat and cap.

Low income neighborhood types are your everyday, ordinary blue-collar people—the people seen hanging out of windows, rappin' on street corners, sitting on front steps, and playing doubledutch or basketball in the park. Stick to whatever clothing trends are current in the black community. Usually it is downscale, casual clothing.

10

POLISHING YOUR CRAFT

I think studying today is really important. Gone are the days when the dear Bernie Rubenstein's, who were agents, would take you under their wing, and tutor you, and tell you, and sit with you, and take you out to lunch when you'd cry "I'll never work again" Gone are the days when they'd tell you what to wear and how to do it. There's just too many people out there today. You've got to find people who will help you, and in most instances, you have to pay for that.

Joan See

Training is one of the most essential elements of your professional career. In all areas of training, the performer should concentrate on building a solid foundation based on skill and technique on which to broaden his talents.

Most of today's leading performers still participate in structured training. And for good reason. A performer should never stop practicing. In order to maintain a certain level of skill, all performers—dancers and singers in particular—must continue their training.

I believe that one needs to train, because if you're able to hone your instrument and gain the skills that you need to become a marketable and a fine actor, then you've got something to offer at the table. That ties in very closely with having a sense of security when you go into read. So train, train, train. And that also means along with that training, read, read, read. Read books about the craft, read biographies and autobiographies on role models, read them. Because you'll learn what their journey was like. Everyone's journey is different, but you can certainly learn from others.

Adilah Barnes

Finding adequate instruction is not difficult. New York City, Los Angeles, and many other major cities offer an abundance of training opportunities. Your job is to decide which areas will

be most beneficial to your overall career development and which teachers would be best to study with.

There are many ways to find good instruction. First, inquire with your fellow performers. Usually they'll be able to give you the scoop on who's good and who's not. You can also ask a friendly agent or casting director who they would recommend. They will often be more than happy to give you a list of their favorites. But don't make a blind selection based on recommendations alone. Before investing your money, you still need to evaluate the teacher and class on your own.

You should feel comfortable with the instructor and the classroom student composition. Most schools and teachers will allow prospective students to audit (view a class for free). By auditing a class before enrolling, you have the opportunity to participate in the actual workings of the class. This will give you an insight to the temperament and knowledge of the instructor. Some schools will charge a nominal fee for auditing, which is usually deducted from the enrollment fee if you decide to participate in the class.

> First of all, you should always meet and audit with the person you're thinking of studying with because there is a very real chemistry between teacher and student. I think your teacher is as personal as your shrink, because there comes a time when you have to trust that person. If you don't, you shouldn't be studying with them. Number two, they should be able to answer your questions, fully and completely.
>
> *Joan See*

The following checklist of questions can help you evaluate a class before you enroll:

- *Is an interview or audition a prerequisite to joining the class?* Many teachers require an interview or audition before allowing a student to join a class. This helps the teacher place you with students who are at the same level of ability.

- *Is the class divided into different levels of ability (beginning, intermediate, advanced, or professional levels)?*

- *How is the class run?* Classes are usually run on an ongoing or month-to-month basis.

- *How much does the class cost and how is the tuition paid?* For month-to-month classes, tuition is usually paid on a monthly basis. For semester study, you will usually be required to pay in advance. Some schools offer financing, flexible payment schedules and even partial scholarships. Also inquire if a registration fee is charged.

- *What is the teacher's policy on missed classes?*

- *How many students are in the class and is there a limit to class size?* Most acting classes are limited to 10 to 12 students. Dance classes can have as many as 40 students. Vocal classes should be taken on a private, one-on-one basis with the teacher.

Acting Training

All actors should begin with a basic acting course to learn fundamental acting techniques and build a strong foundation for more advanced studies. In a basic acting class, the student will participate in acting exercises geared towards freeing emotional expression and learning how to constructively use his body, voice, and emotions (which are commonly referred to as his "instrument"). In most beginning acting courses, theater games, on-the-spot situation play acting (known as improvisation), and character studies are used to create a foundation for intermediate studies. Intermediate acting study concentrates on developing monologues and scenes between two or more actors. These more advanced studies allow the acting teacher to specifically work on a performer's problem areas through constructive scene criticism and direction. Advanced acting courses may include the exploration of different styles of acting (such as Shakespeare) and specialized areas of movement and speech.

In addition to the different techniques taught in acting, there are a number of specialized commercial acting areas an actor might consider investigating. You may decide to enroll in a class that teaches the soap opera, film, sitcom, commercial, or voiceover acting technique, scene study, or improv class.

Soap opera acting requires the actor to memorize large numbers of pages from a script overnight. At the same time, the actor must be skilled, creating a complete performance by himself—taking the script, quickly determining his actions in the scene, and honestly playing the script from moment to moment. The actor has to be trained to listen, think, and then react to the other actor in the scene. In addition, soap operas allow for little rehearsal time. A soap opera acting class will teach you how to quickly get the most truthful emotional camera reading.

Feature film and television acting requires the actor to be familiar with camera techniques. In film and television, the camera is right in front of you, and the actor must learn how to subtly communicate deep emotions. You will learn these techniques in an on-camera film or television class.

Commercial acting explores the fundamentals of acting in television commercials. These lessons include script analysis, product handling, cold reading, and grooming for the camera. Advanced studies in TV commercial acting include lessons in cue card reading and audition

technique. You may also participate in an Agent or Casting Director Workshop where you'll showcase your TV commercial acting talents, live, on-camera, for invited commercial agents and casting people.

An improvisation class will emphasize the use of spontaneous response to situations and help you develop confidence in impromptu casting situations. As a performer, you should become "quicker on your feet" as the result of studying improvisational acting, because the skills you will learn will be extremely helpful in audition situations when you need to make quick and creative character choices.

Cold reading technique study is particularly important for the West Coast performer where cold reading auditions are commonplace. Cold reading is when an actor reads lines from a script "cold," or without any preparation. You completely depend upon your instincts and script reading abilities.

You might also consider taking a class in speech. Black performers tend to have distinct regional accents and ethnic voice patterns. These accents and voice patterns have a tendency to typecast the black performer and limit his marketability. A speech class will teach ethnic performers how to disguise their accents and voice patterns when necessary. A dialect such as Southern, West Indian, African, or "street black" could help increase the range of work for which a performer can be considered. Black performers are often sought with authentic Southern speaking accents. Similarly, the typical typecasting of African-American performers in stereotyped black roles calls for a performer who can "talk black."

Choosing an acting school or teacher is a decision that should be thoroughly investigated. There are hundreds of acting schools and teachers in New York and Los Angeles, and several different teaching styles and acting techniques. Strasberg, the Stanislavski Method, and the Meisner Technique are probably the most popular acting styles taught. Because there are such varied teaching principles, the beginning student should audit as many classes as he can to decide which teaching styles and acting techniques he prefers.

Dance Training

Black dancers should concentrate their studies in four basic categories of dance—ballet, jazz, ethnic, and tap. Specialized areas of dance such as modern, folk, and contemporary or "street" dancing may also be desirable depending on your career aspirations.

The serious dancer should take at least two or more professional classes every day to keep his body and performance skills in top condition. Most schools of dance offer schedules that enable students to choose their classes according to their available time. Dance studios usually allow students to audit. It is here that you can decide if the class reflects the type and style of dancing you want to master.

In selecting a dance instructor, read the information and biographies pertaining to your class. Find out your instructor's credentials, and make sure these credentials include legitimate, professional performing experience. If your teacher has attained some of the goals you are seeking, he will be more helpful to you.

Once you have set up a schedule of classes, you will be expected to attend class regularly and be disciplined, properly attired, and ready to learn. Each class unit is usually comprised of 6 to 40 students who train with an instructor to live or recorded musical accompaniment. These classes can run between 45 minutes and 2 hours per session.

A good dance class will usually be divided into four sections: warm-up exercises, floor studies, combinations, and warm-down exercises. The warm-up exercises are designed to align the body and stretch the muscles; they also strengthen the dancer's body and prepare it for strenuous dance performance. More technically advanced movement is explored through "floor" studies. Floor studies can be done either seated on the floor or standing; they prepare the dancer for progressive movement. The combination section of the class allows the student to learn to incorporate several movement phrases into a single dance routine. At the end of the class, in order to physically allow the body to return to its normal state, many teachers will give a series of warm-down exercises.

Each dance discipline has its own regulations about classroom attire, etiquette, and performance attitudes. It is important to follow the specific instructions of the teacher and dance studio. In the dance world, there are certain set regulations established for the safety and maximum comfort of all involved. The following is a list of rules that should be followed in the dance class.

- Most studios print a schedule of classes which includes faculty information, dress codes, and rules of conduct. Follow the instructions on suggested attire. Don't bring your street clothes or belongings into class if lockers are provided. Do bring a lock.

- Most established studios have locker room and shower facilities similar to your local health club.

- In ballet class, strict adherence to the dress code is required. Dress codes in classical western dance were established to allow instructors to properly view and correct posture and movement of the body.

- Bare feet and more casual dance attire are okay in modern and jazz dance class. Jazz shoes, character heels, and boots should be worn in jazz class when required. If you have questions, consult your instructor.

- Leave your ego and personal style of fashion and mannerisms at the door. Find out your classroom requirements and abide by them.

Choosing an instructor is a personal decision; however, your choice should also be based on professional reputation. Has your instructor produced students who are constantly working within the industry? Are professionals taking the class?

The average dance class now ranges in price from $7 to $15 per session. Some studios offer registration where dancers can buy class discount cards. Class cards entitle dancers to a series of classes, usually 10 or 20, at a reduced price. Most class cards are only valid for one month, with extensions for professional, working dance students. Many dance studios offer professional discounts to students who hold active union membership cards. Check these specifics with the studio management before attending your class. (For more information on dance, see the chapter entitled "Dancin' Divas.")

Vocal Training

When deciding to study singing, be sure to study with a teacher as opposed to a coach. A voice teacher will emphasize the basic of classical vocal technique, breathing, expanding vocal range, speech, tonality, and placement. You will need a solid foundation of technique on which to develop your vocal style. Coaches are generally for the most advanced vocal student, since they focus largely on style. A vocal coach works on musicality and interpretation, production, and performance. It's wonderful to be able to work on singing songs, but it's important that you first master the basics of singing.

> I got into performing arts high school on voice. I stayed there only for a year and I got kicked out because I wouldn't go to school. The only reason I wouldn't go to school was because when I got in I got very disillusioned because I thought I was going to learn how to sing like James Brown. Instead, they taught classical singing.
>
> *Paul Laurence Jones*

You should discipline yourself to work on your vocal exercises on a daily basis. Most teachers and coaches will tape your vocal class and exercises so you can study them at home.

11

THE UNIONS

In order to work as a professional performer, you must be a member of the union that covers the type of work you do. The unions function like the police of the entertainment industry. Among the many career benefits unions offer are the following:

- They keep amateur performers out of the professional job market.

- Through collective bargaining agreements with talent agencies, casting companies, advertising agencies, and production companies, they regulate and safeguard the wages, residual payments, and terms and conditions of your employment.

- They provide medical, dental, and group life insurance, welfare, and pension plans for eligible members and their immediate families.

- They provide a valuable network of information on casting and production opportunities.

- Through the union-sponsored credit unions, members can open savings and checking accounts and apply for major credit cards and low cost loans. Credit requirements are specifically designed to take into account the performer's lifestyle. For example, unemployment insurance may be considered as regular income in some instances.

- They offer career counseling and support groups.

- They provide low-cost video classes in commercials, voiceovers, monologues, and scene study, run by professionals.

- They provide admittance to professional auditions.

Connie Best, New York Field Representative for the American Federation of Television and Radio Artists (AFTRA), had this to say about AFTRA's role in a performer's career:

> The [AFTRA] representatives are here to take any complaints from actors. We are
> here to serve the actors, if there are any problems. We have to visit the sets to speak
> to contract players who are unable to call or visit the office. Whenever a producer

violates a portion of the AFTRA Network Code or whatever code they operate under, we have to file claims to get penalties paid, to get payments made or to get conditions bettered on the sets. So we're there to attend to whatever is going on.

On a more personal level, the unions act as a support network and vehicle for the development of social relationships through regular interactions in membership meetings and committee activities.

With the everchanging economy, producers, more than ever before, are cutting back their budgets and working out specific negotiated trade agreements with the unions to ensure more artistic and financial control over production. This causes the performers' unions to have to bargain to ensure work and standard fees for all their members. As a performer, you must keep abreast of the yearly changes in the union codes and rules, and, if you want to be a part of the decisionmaking process, you must become actively involved in the political structure of your union. These changes will determine your working fees and benefits and, ultimately, your professional future.

For example, in the case of a production that will use large crowd scenes, only a small daily percentage of the background artists will now be union members, which allows production companies to hire larger numbers of non-union actors at a reduced flat rate. This is helpful financially when large numbers of extras are hired over a long period of production time. These non-union actors receive no guaranteed insurance or unemployment benefits, no meal payments, and no overtime, and they are required to work the same hours and to make the same work commitment as union actors.

Casting directors now maintain specific non-union files and special talent registration for those actors seeking non-union extra work. The opportunities for work are plentiful for the beginner, and, after working on several productions at union scale, the non-union performer, under a special waiver clause, is eligible to join the union.

It's another one of those "Catch-22" situations—you can't do professional work if you're not a union member, and you can't become a union member unless you've already had professional experience. Sounds difficult, doesn't it? Well, you're right—it ain't easy! Remember, no one was born with a SAG card, so it's not a hopeless cause. The bottom line is that there are many ways to become a union member. Keep in mind, though, that if you're not ready to compete with professional performers, and you still need more training and experience, don't get all bent out of shape because you're not a union member. You can gain a great deal of on-the-job training and experience working in non-union productions where you won't be competing with union performers.

Union members are forbidden to work in non-union jobs. They can only work for companies that are signatories to a union contract. Signatories are employers who contractually agree with the union's guidelines. So if your skills and talents are not quite where they should be, get as much as you can out of the non-union job market before competing with thousands of union performers.

Deciding what union to join depends, of course, on the type of work you're pursuing. As a professional performer, it is to your benefit to be a member of more than one union. But there is one basic rule of thumb: New York is primarily a theater town, so it's best to have at least an Equity card. In Los Angeles, which is considered a film town, make sure you get an SAG card.

The Associates Actors and Artistes of America (commonly called the 4A's) is a federation that includes the following unions: Actors Equity Association (AEA), the Screen Actors Guild (SAG), the American Federation of Television and Radio Artists (AFTRA), the American Guild of Musical Artists (AGMA), the American Guild of Variety Artists (AGVA), and the Screen Extras Guild (SEG). These unions are called affiliate, or sister, unions among each other, since they have made reciprocal agreements relating to membership, dues, and pension and welfare requirements. Under the reciprocal agreement between these 4A unions, the initiation fee is discounted and the dues are cut in half for each affiliate union you join.

You always pay the full initiation fee and full dues to the first union you join, commonly called your "parent union." Membership dues to your parent union are based on a sliding scale related to your gross yearly income. In other words, the more money you make in a calendar year, the higher your dues are the following year.

You can sidestep into a union affiliated with the 4A's by a process known as "parenting." To join an affiliate union from your parent union, you must be a paid-up member in good standing for at least one year, and you must have worked under your parent union's jurisdiction. The type of work required varies according to each affiliate union. To join an affiliate union by parenting, you must supply a letter from your parent union certifying that your dues are paid and indicating your joining date and the amount of original initiation payment. In addition, you must supply proof that you have performed principal work under contract within the jurisdiction of your parent union. This information can be obtained from your employer or from the union's pension and welfare department, which keeps track of all your employment within union jurisdiction. You can also join an affiliate union if you have been promised a union job from a signatory and have secured a signed union contract.

Actors Equity Association (AEA), commonly called Equity, is the union for all stage actors, and its jurisdiction covers all live theater performance. There are three ways you can get your Equity card:

1) by joining with a contract if you are offered a job under a bonded (insured) Equity production;

2) by joining through the Equity Membership Candidate Program. This program allows nonprofessional performers to credit their work at Equity resident theaters, dinner theaters, Chicago off-Loop theaters, and resident and nonresident dramatic stock theaters towards Equity membership. After 50 weeks at a participating accredited theater, the registered membership candidate is eligible to join Equity. The candidate registers by completing a nonprofessional affidavit provided by the theater and paying a registration fee, which is credited against initiation when you decide to join Equity; and

3) by joining without a contract through parenting. You receive a credit of up to $250[15] towards Equity's initiation fee, depending upon how much your initiation fee was when you joined your parent union.

The current initiation fee is $500. Basic dues are $42 per year, payable in two installments of $21 on the first of November and the first of May. There are also working dues, which are 2% of gross earnings from employment under Equity's jurisdiction (unless you earned less than $5,000 or more than $100,000, in which cases the percentage of working dues will change).

The Screen Actors Guild (SAG) covers filmed motion pictures for television or theatrical release and filmed commercials. The current initiation fee is $800. SAG does not offer discounts to new members joining from an affiliate union. You can join SAG by 1) parenting or 2) performing in a union-regulated production. You can also get a Taft-Hartley Waiver to join SAG by securing a signed union contract. Under this law, once you perform in a union-regulated job, you have 30 days in which to join SAG. You can continue to perform in SAG productions until that 30-day period is up, at which time you must join if you wish to continue working under SAG's jurisdiction. The Taft-Hartley provision applies to all of the 4A unions.

The American Federation of Television and Radio Artists (AFTRA) covers live and taped radio and television work, including soap operas, live sitcoms, game shows, newscasts, sportscasts, videotaped commercials, and industrials. AFTRA has an "open door" policy, whereby anyone can join the union simply by filling out an application form and paying the initiation fee, which is currently $700. The dues range from $28.75 to $525 semiannually, depending on your gross income.

The American Guild of Musical Artists (AGMA) covers professional dancers, classical singers (both soloists and choral), and instrumentalists who perform live in concert halls and theaters. You are eligible to join AGMA if you have an offer of a job and a signed union contract, or by parenting. The AGMA initiation fee is $500, with semiannual dues of $26.

[15] All monetary figures are based on information compiled in March of 1990 and are subject to change.

The American Guild of Variety Artists (AGVA) represents live theater entertainment that does not come under the jurisdiction of Actors Equity. These variety shows are not considered plays because of their lack of a scripted book. This includes traveling ice shows, circuses, and cabaret, night club, and Broadway acts. Initiation is $300, with dues ranging from $72 to $795 three times per year.

12

THE POWERBROKERS: AGENTS

You can be innovative and use your ingenuity to pursue acting jobs without representation; however, *most* quality acting work is secured through an agent. You will get more quality auditions and you will be ensured better contracts and payment benefits and have a better chance of being cast if you have some form of professional talent representation. Without an agent, you won't always know what roles are being cast, and you will frequently miss out on lucrative job opportunities. Except for a call directly from a casting director or an occasional hot tip from a contact, actors without representation don't always have access to the most complete casting information available.

New York independent casting director Pat Golden echoes this same sentiment:

> An actor can't do it by himself. It's difficult. Basically, you have to know what's going on and submit yourself. It means a lot more legwork than it would be with an agent.

We asked commercial actress and teacher Joan See how important agency representation was. She had this to say:

> Absolutely vital—as vital as for the white performer. There is no difference. Agencies are as hot to find good black performers as they are to find good white performers. There is no way to make it, in a big way, without being represented by an agent. I think you'd better make your mind up to that. That doesn't mean that there's not a great deal of work that you can find on your own and develop on your own. But when it comes to getting out for the big stuff—even if you get your first job on your own and suddenly everyone's saying "Oh! Bruce, I want Bruce!"—at that point you need an agent to take what you've done and to then start getting you into places where you need to be.

What is an Agent?

An agent is the person who will find employment prospective opportunities and handle contract and salary negotiations for you. He will guide your career and hopefully help you make the right career choices. An agent should be someone who is on your side, who believes in you and your talents. An agent vouches for your reputation and your professional credits, legitimizing you in the eyes of the casting director as a professional performer.

An agent is paid only when you book a job. For booking a job, your agent will receive a percentage of your salary, their commission. From a union actor, franchised agents legally receive a 10% commission. Make sure you get a union-franchised agent. This way, you will be protected by union rules and regulations and will be less likely to get ripped off by an unscrupulous agent. Steer clear of an agent who require registration fees or any type of up front money—he is not legitimate!

An agent can best be described as a booking service. He finds out what auditions are being held and tries to get you an appointment if he feels you're right for the role. Casting directors explain the character specifics to the agent and, if the agent feels the actor does not fit the call, the actor's name doesn't get submitted. When casting directors call the agent with information about an audition, the agent then calls the performer, who then goes to the audition and does his best to get the job.

Personal Managers

Because agents have many clients to be concerned with, many do not have the time to give you the personal attention that you need. This is where a personal manager fits in. A personal manager is responsible for guiding your career on a more personal level, advising you on your hair, clothing, makeup, public image, and promotional materials. He often gives you more personal attention than an agent does, and for this, he also charge a commission. Because managers are not franchised by any union, they can charge any percentage commission they want to. The average commission for most managers is in the area of 15% to 20%.

We asked personal manager Travis Clark about the role of a manager is a performer's career. He responded with this:

> A manager is a facilitator. He's also an orchestrator—he orchestrates what you do. More importantly, while everyone else is giving you adulation, a manager tells you when you're wrong, like a parent. The management office is also the nerve center for you. In other words, everything comes in and out of the management office. And it's not that clients aren't intelligent. But if you're a successful client, you don't have time to do those things. So there has to be something, some entity, to

take care of those things and sift them out. And those things entail everything—you name it, we take care of it. Whatever concerns the career, the management office will take care of it—finding an agent, prescreening and reading your scripts, making sure that you have the right business managers and the right attorneys. It's making sure that the total person is protected—that your money is invested well, that you choose the right projects, that you're on time, that you do your interviews, all of those things.

The problem with managers is that good ones are hard to find. Many reputable managers will not take on newcomers—the feeling is that there really is no need for a manager at the beginning stages of your career. Managers are usually reserved for performers with successful careers who need specific guidance. At that point in your career, a manager is necessary to coordinate the activities of an agent, publicist, business manager, and accountant. Be careful—there are countless so-called managers around town looking to take advantage of the novice performer.

Personal manager Travis Clark takes a different point of view. We asked him at what point in a performer's career he should shop around for a personal manager. Travis had this to say:

> It depends on whether or not you, as a newcomer, want to start your career off totally in sync with the industry— whether you want to be just a working actor or a major star with longevity. If you want to be a major star with longevity, then, yes, you should start off your career with a manager. That should be your first sales job—convincing a manager you're in this for the long haul, that you have possibilities, that you're going to give it at least 300% if they give it 100%, and to take that shot with you. So, sure, I take newcomers. Why wait? Your manager should be a part of the starting process to make sure you're on the right track and should take a shot with you to make it happen.

Finding an Agent

Actors often knock themselves out and bend over backwards looking for professional representation. To the novice, an agent is a prized possession. If you are a union member, one of the most important things to remember is to make sure that any agent you work with is franchised by the unions.

How should you got about finding an agent? First, you've got to get a list of agents. If you are a paid-up union member, the Screen Actors Guild will give you a list for free. You can also purchase one of the many talent directories that include agent listings. Do your homework!

Until you have a working knowledge of the industry, it will be hard to figure out what agents you should contact. There are hundreds of franchised agents in New York and Los Ange-

les. Not all of these agents will be right for you. You'll have to do some research—find out which agents handle your type and which agents take on newcomers.

> For the person who is just starting out to become an actor and/or is new to California, I would suggest he contact the Screen Actor's Guild and get a list of all the agents that are signatory to that Guild. He should then send the agencies his picture and whatever kind of résumé he can compile.
>
> *Jack Rose*

> Breakdown Services puts out a little book for a couple of bucks that lists all the agents. Or you can get a list from Screen Actors Guild. Then you should send out your picture and résumé—do a mailing. Explain to the agent that you're new in town. Keep your letter short. If you have a typewriter or access to a typewriter, that's best because not everybody has readable handwriting. Try to keep your letter as neat and concise as you can. And then keep a list of all the agents and follow up your mailing with a follow-up call. If you can invest in a little more updated book, there are some books that list who the agents are, if they do general interviews, etc. You can usually go to Samuel French bookstore and look at the different guides on agents.
>
> *Jaki Brown-Karman*

Once you've narrowed the list down to 10 to 20 agents, mail them your photo and résumé with a short cover letter requesting an interview. It's best to address these to the agent by name. This way your photo and résumé won't sit on the receptionist's desk waiting to be distributed among the agents in the office. Normally, when an envelope comes into the agency without an agent's name on it, the receptionist decides which agent might be interested in the performer. The receptionist can also decide that no one will be interested and toss the entire envelope in the garbage. If you address your photo and résumé to a specific agent, it's more likely to go directly to that agent's desk, sidestepping possible elimination by the receptionist.

The three most important things to consider are 1) the agent's reputation, 2) the size of the agency he works for, and 3) his personal access. Ask around about the agent's reputation. Is the agent known to get a lot of audition calls? Does the agent's talent have appointments at most auditions? Does the agent get his talent out on auditions on a consistent basis? Is the agent honest? Do the casting people like the agent?

Decide what size agency you want to work with. There are several schools of thought on this. The large-sized agencies like International Creative Management (ICM) and William Morris primarily handle star and celebrity talent, and, if you do work with them, it can be a great ego-boost; however, you probably won't get the personal attention you can find in the smaller or mid-sized agencies. The novice can easily get lost in these big agencies, which can have as

many as 100 active talent agents with their client lists. The large agencies are not as concerned about their overhead because they have the big money-making stars paying their bills. The smaller agencies are often more hungry for money and will push harder to get you work. The large agencies may take you on if they see star potential in you, waiting to reap rewards at some later time. Bottom line: don't call them—wait for them to call you!

Breakdown Services is the primary source of casting information for many agents. Almost all agents subscribe to the service. Casting directors call Breakdown Services with information on their project and roles to be cast. Breakdown compiles this information on a daily basis and sends it out to the agents who read it and then prepare talent picture submissions. Most agents mail their picture submissions to the casting director. But if the agent has a personal business relationship with the casting director, he will call the casting director personally if he hasn't already gotten the casting information.

In choosing an agent, this is another important question to ask: Does the agent have access to casting information other than through the Breakdown? In other words, does the agent have direct access to casting directors?

What Agents Look For

Once you've mailed your photos and résumés, wait a few days and follow up with a phone call. Ask to speak to the agent as if you are already a client of the agent and wish to speak to him. Don't let the receptionist know you recently mailed your photo and résumé and are following up.

Once you've got the agent on the line, introduce yourself, and let him know you sent him your photo and résumé several days ago. Don't ask the agent if he's interested in seeing you. Tell him you're interested in making an appointment to meet him and ask when it would be most convenient. Try not to let the agent say "no." Be persuasive and professional.

You can't make a connection every time you try to get to see an agent, but with some luck and persistence you will get appointments. If you don't get any appointments on your first attempt, go back to the drawing board. Find another group of agents to mail to and repeat the process until you get several appointments.

At your first meeting with an agent, you should present yourself as a talented professional. Never apologize for your lack of credits—everyone has to start somewhere. Be confident and speak positively about yourself. If they ask if you're a good actor, reply with a resounding "Yes!". Let the agent know you'd be a pleasant person to work for. Show them that you're responsible. If you're not on time for your appointment with the agent, he'll automatically assume you'll be late for your auditions. No one will put his reputation on the line for a tardy performer. CP time is out!

Show some enthusiasm for your career. Let the agent know you're the type of performer willing to go the extra yard to make things happen. Show interest in your career by asking intelligent questions. You might ask questions like:

- Do you represent any other performers of my type?
- How would you market me to the casting directors?
- Can you arrange general interviews for me with casting directors?

At most of your interviews with both agents and casting directors, you will also be asked these two questions:

"Tell me about yourself"—This is the time to let the agent see who you are. You can tell him where you were born. Talk about your travels and interesting hobbies. Interject some humor into the conversation. Relate a funny experience in acting class or during a job. Let the agent know what you want to accomplish, but don't run down your list of credits. He'll ask you about your credits; if he doesn't, he can read it off your résumé. Don't say "I want to be a star"—he's heard this a million times. Everyone wants to be a star.

"What have you done?"—Now it's time to talk about the business. Don't just recite your résumé. Talk about a recent job and a related experience. If you don't have any credits, don't say, "I haven't done anything." Talk about your acting class instead. Let him know you've been studying for a while and are now ready to go out on auditions.

Talk with the agent on a friendly basis. Don't just talk about yourself. Be a likable person. Let the agent know you're the type of person he would like to work with. We asked several agents what they look for in potential clients:

> First, I decide if they'll be right, or if I'm working with too many people that are their type. Normal attitude without a chip on their shoulder. What I look for is having a proper résumé. Someone who is relaxed. See the person's personality. If they're getting started, being somewhat honest in that they don't have a lot of experience. Some people make things up and then, when you pinpoint something that's a lie, it backfires. At least they should have taken some basic training. A lot of experience in commercials is not essential to do commercials. It's not a requirement. For commercials, honestly, it's the look.
>
> *Wendy Curiel*

> Our criteria is very straightforward, very single-minded. When anybody comes in, black or white, man or woman, the decision we're making is, can we make money with this person? We look at the person sitting opposite the desk and say, Will we get calls for this person? That's our A-1 criteria. Will we get calls that this person is right for? Will they satisfy our clients? After that, we start thinking about things like,

are they intelligent enough to show up on time? To do the right things? To groom properly? To pick out the right clothing? Are they well-spoken enough? Do they have good hygiene? You can go on and on. You start to notice everything about the person. But the initial reaction is, will they satisfy my clients?

Peter Lerman

There is a limitation to the number of black talent that we add to our client list. The reason is that there are simply fewer roles for blacks than there are for whites, and we only take on the number of people that we feel we can find work for.

Jack Rose

Freelancing vs. Signing with an Agent

For New York performers, deciding whether or not to sign exclusively with an agent is another big decision. An agent usually works harder for his signed clients than he does for his freelance talent. Freelance performers are not exclusive to any specific agency. Signed talent, by their own choice, is limited to one exclusive agency. You may think that freelancing will offer you greater opportunities, but this is not always the case—except for commercials, where freelancing will multiply your chances for getting auditions. You have a choice in New York: you can either freelance with several agents or sign with one agent. In Los Angeles you must be signed—more on that later.

You have to have an agent because all of the [casting] information goes through the agents, and, if you're gonna work in the business, then you have to work through agents. You can't freelance but so much. You might stumble upon something, but you don't even know where the jobs are if you don't have an agent.

Lou Myers

People in New York freelance with a lot of different agents, and I find it becomes a real problem for me when I'm casting and an actor is submitted by three different agents. Then it's a question of which of the three agents do I call? I've had this come down to a real issue when someone actually got a job. In California, you don't freelance with agents—you are signed. When you have an agent, you sign with that agent. Freelancing is only a problem to me for the performer who doesn't have an agent to really get to a point where he or she can really build their career. Because the reality is, you're not gonna find out about what's going on even if you have friends who have agents and they tell you things. You're still not gonna get in because there's a sort of elitist thing for, I would say, 99% of the casting directors—with me probably being in that 1% of the exception, who doesn't hold it against

actors who don't have agents and who submit themselves. They'll just see an unso-
licited photo and toss it in the trash. All they want to see is there's an agent's name
on that résumé or picture, somewhere. And if they don't see it, it's the can. It's too
difficult, I think, to get past the under-five-lines in soaps, or one-liners in movies, or
walk-ons with one line in television shows if you don't have an agent. Because
they're the ones who are getting the supporting roles, the co-starring roles, and the
starring roles. I just don't know how an actor can function without an agent. I think
if anything, it's a hindrance. But then it's the "Catch-22"— it's easy to say you need
an agent, but how do you get an agent if you don't have the experience or you've
only done theater?

Jaki Brown-Karman

We asked talent agent Wendy Curiel whether a New York performer would be better off
working as a freelance talent or signing with an agency. She offered this commentary:

They should [freelance] when they first begin in this business. Keep it limited to
about three agents who are going to get the majority of the calls, simply because,
when you start working with everybody, it gets to a point where people who've
worked with me are also working with five, six, seven other agents. If the other
agent happens to get the [audition] call before I do and has submitted the [actor's]
name, regardless of the fact that the actors wants to work with me, the casting
director says they've been submitted and there's nothing I can do, at which point
the name comes off my list of submissions for that particular audition. They should
try and keep it limited. They should really take into consideration the amount of
work they're getting from a specific agent—how many times they're being sent out,
how many times they're right for the job. It depends if they're willing to lose, because
you do when you've restricted yourself, and not every agent gets every call. You
should be willing to take a couple fewer auditions a week and possibly maybe lose
a few bookings, but you're getting better representation as an exclusive client. You're
getting the attention. You know that you're supposed to be submitted "priority" as a
signed client, that you're one of the first names on the [submission] list.

Being non-exclusive, or operating through a number of different agents, will often allow a
black actor to get more varied submissions or audition calls. Casting is highly opinionated and
subjective in nature, and an actor who misses a submission from one agent may call another
agent who is more familiar with his range and abilities and get the audition. Since ethnic cast-
ing is considered a specialized area, not all agents are going to get called for specific jobs. This,
again, can be tricky, and the actor must be tactful and try not to step on the toes of other agents.

For the California actor, choosing an agent is quite different. Actors do not freelance in Los
Angeles. You must be signed to an agent or work with one agent exclusively. The actor can sign

with one agent in all areas—television, film, theater, and commercials. Or the actor can sign with one agent for commercials, another for television and film, and still another for theater. In this way, the actor has the benefit of multiple agents who specialize in the areas they handle.

California talent agent Jack Rose explains why performers sign exclusively with agents in Los Angeles:

> This California procedure of requiring signed exclusive agents actually works out better for actors. Here in California, agents build a very strong personal relationship with actors. Agents become concerned with the development of the talent and their careers. The booking of an actor in a job is, of course, of the utmost importance, but it becomes secondary to what is best for that actor's overall career. In California, an actor is only allowed to be represented by one agent. That actor must have an exclusive contract with that agency. The reason is that the guilds—SAG and AFTRA—state that, if an actor is not exclusively signed to a specific agent, he has no obligation to pay agency commissions.

Los Angeles talent agents can be classified according to the type of talent list they have. At the top of the totem pole are the large, departmentalized agencies—William Morris, ICM, Creative Artists, and Triad Artists. These agencies represent the stars and other celebrities such as athletes, noted lecturers, top writers, producers, and directors. Newcomers should wait for these agencies to approach them. These agencies usually don't have enough time to invest in a newcomer, who will make little or no money, when they can make thousands of dollars representing their star clients.

There are also a number of bi-coastal agencies that represent actors who work on both the east and west coasts. These agencies are known to represent top theater actors in New York and Los Angeles, although they are not limited to only theater actors. These agencies are also prestigious, with well-deserved reputations for representing top talent. The Actors Group Agency, Henderson/Hogan, The Lantz Office, Smith/Freedman & Associates, William Morris Agency, ICM, Triad Artists, and STE Representation are some of the larger bi-coastal talent agencies.

The majority of talent agencies fall into the category of "mixed level" agencies, with client lists of stars, established talent, and newcomers. Some agencies may only represent top established talent, while others represent newcomers as well. Agencies that are on the rise as being well regarded for representing top talent will often take on newcomers that show great promise.

At the bottom of the totem pole are the new agencies that are hungry for talent and are most willing to take on a newcomer. Remember that these agencies are also newcomers, and it may be a while before the agency establishes valuable casting contacts within the industry. This is where the beginning actor will probably find his first agent.

Talent agencies are known to change personnel rapidly. Agents often leave large agencies to form their own agencies, taking top talent to the new agency. These agencies are also hungry for newcomers to add to their already established talent roster. New agencies also have a built-in reputation from working with a large agency and can offer the newcomer ready-made casting contacts.

Because agencies are ever-changing, the actor should keep up-to-date with the comings and goings of agents on a daily basis. Although the actor signs a union contract with the talent agency, he is really represented by the individual agent who took an interest in him and asked him to sign with the agency. Your agent may leave his agency to merge with or form another agency. If you are not aware of this, it is highly possible you could call the agency and find that no one in the office knows who you are.

Agents and managers can open doors, but it's up to you to get through the door. Your talent, personality, and professionalism will determine how far you'll go from there.

It is important for black actors to showcase themselves to be seen by prospective agents. If you work in a black theater company, or if most of your theater experience is within the African-American community, it is highly possibly that a mainstream agency will not be familiar with your work. You have to publicize and take whatever means you must to get all the agents, both black and white, to see your work.

The Agent/Actor Relationship

The agent/actor relationship is like a marriage. The agent and actor are partners in a business marriage. Each partner has to fulfill his responsibilities in order to make the marriage work. Each partner depends on the other. The agent works for the actor; it is the agent's responsibility to secure prospective job opportunities for the actor. If the actor is successful in securing the job, he, in return, pays the union-franchised agent a salary in the form of a 10% commission.

The agent's responsibilities are:

* to get the actor auditions, the *right* auditions;
* to give the actor accurate, concise casting information;
* to negotiate salary and contracts on behalf of the actor; and
* to ensure that the working conditions are correct on behalf of the actor.

The actor's responsibilities are:

* to keep the agent supplied with photos and résumés;
* to let the agent know when he's going out of town—"checking or booking out";
* to go on all appointments the agent sets up for him—to be on time for the appointments, to call if he's going to be late—the agent's hard-earned reputation is on the line; and

• to pay the agency commission on all work performed according to union contract.

Commissions are also taken from all residual payments. Residual payments are fees paid to an actor for a re-broadcast of a filmed or taped performance. These fees are paid per showing on a sliding scale established by the unions.

Our agent interviewees commented on the agent/actor relationship:

> You work for each other—I don't like performers who say "my agent works for me." Your incomes are symbiotically connected—they make money when you make money and you make money when they make money. If you indeed are professional, disciplined, communicative, and open, you generally will find yourself having a good relationship with a good agent. If you are sloppy, haphazard, undisciplined, there's nothing that an agent can do for you, nor will choose to do for you, because he can't go the whole nine yards alone. He can only go so far if you're not doing what you need to be doing. And he can't do anything more for you unless you're doing that. So to turn to the agent and say, "The agent isn't doing his job for me," the performer has to sit back and say, "Is it the agent, is it me—or is it a little bit of both?". Because you work for each other. Everybody's happy when everybody's making money. They're happy with you and they're getting their ten percent. And they're even happier when they negotiate for you overscale, which means now you're really a hot shot, and you're happier, too.
>
> *Joan See*

> I like complete honesty—I like to know what's going on. Respect the fact that I am an agent, that I know what I'm doing, that I've been in this business for a long time. Don't go over my head. If you're running late for an audition, call me and let me know. Establish an honest relationship. If there's a problem, let's talk about it. I think actors have to realize that, number one, agents are human beings. We are under as much pressure as everybody else in the business. Everyone in this business has pressures of some kind, and everyone is answerable to someone. We're [agents] at the mercy of casting directors. It's a matter of understanding that agents are not against actors. We need to work together hand in hand in order for it to work. The new breed of actors needs to realize that this is a *business*. Approach it in a very professional way, and if you don't know, ask. Ask me before you take a step and make a big mistake.
>
> *Wendy Curiel*

> This is your career, your profession, your business. You help yourself and help your agent to develop that career/business. If you do all that, and you're patient and persistent and have a little luck, you have a good chance of being the star you came to California to be.
>
> *Jack Rose*

12

AUITIONING

In auditioning, the objective is to make yourself the most obvious choice for a particular role. This involves planning, discipline, and, sometimes, luck. It is important to always be well-prepared in any instance, narrowing the probabilities and making you successful.

Whenever you are approaching an audition, always remain patient, relaxed, flexible, and willing to try new ideas on a moment's notice. Your audition should and can be well thought out before you enter the actual audition room; however, many directors will purposely throw challenges at a you to see how quickly you can respond and how well you handle pressure. (This is where your improvisational acting class really comes in handy!) You are constantly being evaluated and observed. It is better to be able to roll with the punches—your interpretation may not be wrong, it just may not fit the particular casting requirements.

The performer who books the job is the one who combines all the right elements better than everyone else. It's not all about looks, although you should always appear groomed and well-dressed. Personality is always an asset. Be sure to capitalize on your own uniqueness, within the framework of your audition requirements. Smile! Be yourself at your best, and everyone will appreciate you. Even if you fail at your first audition, you may be called back to audition again for another bigger job, and your chances of booking may even be greater the second time around.

If you have developed a friendly rapport with a casting director, find out what your strong points are. Ask for constructive criticism on your auditions, then use the information to strengthen your auditioning technique. Take all criticism with a grain of salt. There are those unfortunate individuals who like making everyone's life as miserable as their own. Don't allow yourself to take anything personally. Rejection, unfortunately, is a very real part of show business. The professional performer is strong and knows how to use rejection constructively.

The first step in approaching any audition is doing your homework on the content of the project. Try to find out the basic storyline, the theme of the project, and the variety of roles being offered. It is best to investigate the entire production, including the casting director. Find out what other projects the casting director has worked on, and comment on what a great casting job he did during your conversations. Gather as much information as you can about the project and the people connected with the project so you can speak intelligently about the production and its values.

Always remember that show business is built on illusion. Your dress, mannerisms, and attitude should reflect, even in the early stages of the game, what you are trying to create. You are being observed constantly, and any sign of insecurity or hesitation translates as panic and fright in front of a casting audience.

Actors should try to attend as many auditions as possible, especially in the beginning of their careers. By practicing auditioning techniques, you can acquaint yourself with presenting your talents in the most favorable light. You should learn how to dress, the amount of time you need to prepare your materials, and, most importantly, how to handle that last-minute case of nervous energy. Remember, everyone hates auditioning, and everyone wants the job. Consequently, everybody, including the people you are auditioning for, feels the pressure.

Auditions may be scheduled over a series of days, or even weeks, for stage work. For television and film, work the auditioning process can last several months! At the end of each casting session, the field of candidates is narrowed down by a process of elimination. Your first casting appointment will probably be a general interview. During the general interview, the casting director usually will review your credits and categorize you according to your type. They want to get to know you as a person and get a sense of your personality and degree of professionalism. In auditions for stage work, there is a process called "typing out" in which the auditioner automatically eliminates actors before being auditioned based on their physical appearance. At each successive audition, commonly known as a "callback," the casting director will gather more specific information about the performer through an actual audition performance and make further eliminations. Keep in mind that performers are not necessarily eliminated because of talent deficiencies. The elimination process is based on many factors, including type, height, weight, hair color, facial features, personality, attitude, and anything else the casting director may see as not fitting the specific requirements of the role.

Getting the Audition

Auditions can be solicited through three basic routes: (1) the trade papers, (2) networking, and (3) your agent or manager.

In the first method, an actor finds out about auditions from the *trade papers*. In theater especially, casting and production personnel on occasion attempt to do nontraditional casting of ethnic actors in roles written for white actors. Many audition listings in the trade papers will specifically encourage that minority actors attend. This may be due to an unfamiliarity with minority talent, or a specific casting director or producer may be reviewing new ethnic talent for upcoming productions. Even though the listing may be specific, you will still be expected to follow certain guidelines in auditioning that pertain to all work, both union and non-union.

Networking is the second way of getting audition information. Meeting casting directors, directors, choreographers, production personnel, and even other performers can be helpful in obtaining audition information. Sometimes, smaller auditions will be held when a director or casting director has seen the work of certain performers, eliminating the need for large-scale audition calls. It is important to make acquaintances at every level of your profession. Your career will be influenced by your friendships and your personal code of ethics and business. Since the ethnic market is still growing and is relatively small, it is important to remember the actor or production staffer you are working or auditioning with today, because he could well be tomorrow's producer or director. Word of mouth travels very quickly in this business, and your reputation will always precede you. Very often because of word of mouth, a performer who has just completed a successful project will suddenly find himself in great demand because the industry is quick to jump on the bandwagon. If someone of importance thinks you're good and wants to cast you in his project, it is likely that others will soon follow.

The third source of audition information is your *agent*. Agency representation is not always necessary, but a good agent can command higher fees for the talent he represents, better working conditions, and fringe benefit luxuries such as dressing rooms and limousine service. Having a good agent can also psychologically help a director, casting director, or production staffer decide who will be cast in a specific role. When there is tight competition and it is difficult to decide who the best choice for a role will be, your agent can make the difference. The agent vouches for your reputation. He has either seen your work or heard about your performance and he is willing to support your theatrical credentials. Usually, when your pictures are sent into a preliminary casting by an agent, for what is known as a "picture submission," your agent will first review the roles offered in a project and send your picture because he feels you are one of the best representatives in his stable of talent. It is important that you have a good working relationship with your agent because he is there to work in your best interest. You may question your agent about a submission, but never argue when he sees you differently than you see yourself. Your agent's reputation is on the line when dealing with casting people, and, sometimes, the agent will be held accountable when a particular casting session goes sour.

A lot of casting is done through agent submissions only; consequently, it may be best to have more than one agent on your side.

It is also important for black actors to realize that all of the ethnic audition calls do not go to any one specific agency. If you are able to freelance with several different agents, do so. By working with more than one agent, you can increase the number of auditions you can attend, hopefully increasing your actual job bookings. However, in some areas of the country, you must be signed contractually with only one agency.

The Casting Process

Your actual audition will probably be done in front a panel of any number of people. For television and film auditions, you will probably audition from "sides"—pages from the actual script. Your initial preliminary audition will normally be in the presence of a casting director or his assistant. In subsequent auditions, the casting director, director, producers, advertising clients, sponsors, and sometimes even the star performer of the project will be present.

In classical theater auditions, you will probably perform your classical monologue or read aloud from a script in front of a casting director, director, producer, author, and/or stage manager. In musical theater, the panel may expand to include the musical director, choreographer, accompanist, and several assistants who will also want to explore your singing and dancing abilities.

Often, the casting process is complex, and many people may be involved in the decisionmaking process, although the ultimate decision is usually made by the producer and/or director. Impressing the casting director is only the first step.

JB Sutherland, casting director for Ogilvy and Mather Advertising in New York, had this to say about the casting process:

> I call agents. They give me a list of names. Sometimes, if I know an agent from working with him on a regular basis, I can simply call him and request his signed talent. These are usually the people who are in their books. If I trust his judgement (from past experiences), I will suggest he send one or two new faces. Since I don't like "cattle calls," I request a certain number of people from each agent that I contact and give a specific block of time for his talent to audition. I use this method regardless of the number of people I need per ad.

Independent casting director Winsome Sinclair talks about how she finds actors:

> There are so many different ways I find actors. I like to get into the director's head and figure out what his vision for the film is and how I can help him to achieve his goal. Then I look for ways to find the talent. All directors are different. For example,

if Spike Lee is going to shoot in Harlem, he wants his open call held in Harlem. The first time we did this, we had to fight with SAG over whether Harlem was a place we should be holding an open call. But Spike is like, if he's using the neighborhood, he wants to use the people. So I do find people through open calls.

Pat Golden, a leading independent black casting director who has cast actors for *Krush Groove*, *Beat Street*, *Ragtime*, *Platoon*, *Blue Velvet*, and *The Killing Fields*, had this to say about how she casts a project:

I read the script and send out the casting information to Breakdown Service or put an ad in the trade paper to solicit pictures and résumés directly from performers if necessary. I sometimes do both—particularly if it's a show that needs black or Hispanic actors. I put an ad in *Backstage* as well as in Breakdown so that people who may not have agents can know about it as well. We ask for pictures and résumés. We get pictures and résumés from the ad and from Breakdown. Breakdown is in California, New York, and London, and I think they also hit Chicago, too. Agents pay for the service. Agents get the breakdown and send back responses in the form of pictures and résumés of their clients, along with submission sheets, which are lists of who they picture for what character. We proceed to meet and interview people that we don't know, both from the independent submissions and Breakdown. If somebody is right, we call them in for an audition for just me. At that point, if I really think they are right, I'll bring them back at some later date to audition for the producer and/or the director. This is for features. For television, it's the producer; for commercials, it's the advertising agency. If there are people we already know, we start making lists, assigning people's names to which character they might fit, and then get their agent alerted that we want them to come in when the director is in town so we can get them a script, if a script is available, which isn't always, or at least sides, so they'll be prepared to come in and give an audition. Some people incorrectly assume the casting director's power and control. Casting directors are sort of a clearinghouse. Directors don't have the time to see everyone, so they want the field of talent narrowed down to who's right, to who the casting director thinks are the right people. I guess that can be interpreted as control, but it's just part of the job. In television, the producer ultimately decides, not even the director. Everyone is a go-between to the producer. In features, casting directors are hired on reputation. They'll generally listen to our opinion. The director is the one who ultimately makes the decision, and most of the directors want our opinion, our input, particularly if they're not familiar with the talent. The casting director's job is really an organizational job, a traffic job. It's like fishing. You cast the line, reel [the talent] in, and show [the producers and directors] what you've caught.

The final casting decision will be based on a combination of your talent presentation, your physical presence, and your ability to work with others and follow specific directions. You, as the performer, are expected to be punctual, alert, and ready to accept any and all challenges at any given moment. Also, remember that auditions can last over a period of days, weeks, or months, with general interviews, callbacks, and finals. You must *always* be at your best.

When preparing for an audition, remember to portray the essence of the character. Dress in a manner that will make people identify you with the role you are auditioning for, including makeup, hairstyle, and suggestion of costume. Make a favorable impression and your efforts will be remembered.

When asked what impresses them about an actor, our interviewees had this to say:

> Somebody who would impress me is someone who's taken the time to look over the scene, decide what's going on in that particular scene, and then comes in with a point of view and sticks to that point of view throughout the scene. It may be the wrong point of view, but if it's done well, that's very impressive. Then you start them all over. You say, "That was very nice, but I'd like to see something else in the scene. Would you please go out and think about it and then come back in?".
>
> *Betty Rea*

> The most gifted actors make me watch them, listen to them, hang on to every word they're saying. They make me forget we're in a small room, that my desk is cluttered and the phones are ringing off the hook.
>
> *Pat Golden*

> What impresses me about an actor? If his personality has something that makes me want to spend five minutes talking with him. The best thing you can do is to come across as yourself. If you're not being yourself, I'll read into that.
>
> *Winsome Sinclair*

At television and film auditions, actors are usually provided with sides in advance. The actor is expected to read with the casting director.

> I look to see if the actor will take chances in making a choice, in putting himself out there for that choice. I can tell by how an actor reads for me, in making a choice, how directable he's going to be. And generally, I can tell how broad he can be, where I can take him, and how far he can go. You can tell a lot about his range in a casting session. A lot of times actors get [character] information. The casting direc- tor will tell them, "This character is a thief and he's been brought up in the streets"— just that little information, because they don't get that much information, nor do

they get a full script. So for an actor to come in and really make a choice and really make me believe that he's a thief and from the streets, each actor will have to take a chance and make a choice. Some actors will go way out—too far—and come in dressed like a thief. It's really how they read it, how they hit certain words. A choice like that, a subtlety, a nuance, is what makes me decide if I want to work with that actor or not.

Tony Singletary

For theater auditions, you will need prepared audition materials, including monologues and scenes that display your theatrical versatility. For musicals, your repertoire of audition materials should include several songs, including contemporary, rock and roll, gospel, and jazz, with an assortment of up-tempo tunes and ballads, as well as show tunes from Broadway shows. You may also be asked to improvise a dance movement phrase on the spot. Audition pieces are usually handed out in the form of scenes that you will be expected to read with other actors, the casting director, the stage manager, the star performer, or even a member of the production staff. Remember that, when reading with a non-actor for any type of audition, it is important to be energetic, communicative, and responsive. Listen, think, and then react to the lines you are being fed.

Dance auditions are usually held in a separate call, with the choreographer or his assistant teaching movement phrases, called "combinations," which will probably be incorporated later in the show.

At some auditions, to test your spontaneity, you may be asked to improvise a scene or dance or to change the key of your music. This often happens when someone feels you are possibly right for a specific role but further specific information about your skills and talent is needed. Gracefully accept all challenges, but never lie about your abilities. Casting directors are more inclined to choose the most well-rounded performer, so be sure to display all of your wonderful talents and abilities.

Prepared Audition Material

On the East Coast, actors are expected to have prepared monologues in their repertoire of audition pieces. A monologue is a one-character speech from a drama or musical. You should have two contrasting monologues. One should showcase your comic abilities; the other should create a more emotional and dramatic mood. Keep all your monologues under three minutes each.

On the West Coast, actors should have prepared scenes in their repertoire of audition pieces. Choose two contrasting scenes, one comedy and one drama. You should select a scene partner who will usually be available to accompany you to auditions at the last minute. Your scene

partner should be a performer (not an amateur friend of yours) who is reliable, trustworthy, and responsible. You should thoroughly rehearse your scene with your scene partner, working out all the kinks, so that it's ready when the audition call comes in. Make sure your scene partner is not a scene stealer!

Good sources of material for your prepared monologues and scenes are current films and television shows. You can rent many of the latest features on video cassette. Keep your tape recorder handy when watching, and record monologues or scenes that you can identify with and see yourself playing. Then transcribe the material from your tape recorder, and you've got an audition piece—probably one the casting directors haven't heard before. The casting directors often complain about seeing the same monologues and scenes over and over again. This is because, when the performer goes to the theatrical bookstore to look for an audition piece, the sales people often refer them to the same material. Be different and choose material new to the casting director. This will keep them attentive during your audition.

Audition Do's and Don'ts

There are certain basic guidelines, tried and tested, to adhere to for all interviews and auditions. All an agent can do is get the call and send you out—you have to sell yourself. As a performer looking for work, you are a salesperson selling your abilities and your personality as your product. Sales is indeed a tough job in any line of work. Don't expect to get cast every time you audition for a role. But, as with other sales jobs, if you are persistent—without being pushy—you will get auditions. After that, talent, personality, and polite persistence will get you the job. Keep in mind that most successful sales are made after numerous attempts, so you should never stop trying just because you don't initially succeed. For the most part, there are no overnight successes. By the time an actor makes the "big time," he usually has spent *years* studying, training, auditioning, and performing in local and regional arenas. With millions of dollars riding on every single performance, few production companies are going to take a chance on a real novice.

We asked casting director Pat Golden what an actor should do in an audition situation. She had this to say:

> The best think any actor can do is come in prepared— otherwise, you're wasting your time and my time. People who are unprepared often blow it for themselves. It's better to just be centered and calm. Some people like to put on airs that they think are necessary—I want to see that in your acting, not in your personality. The best way for an actor to approach a casting director is as honestly as possible. The picture should be an accurate reflection of that person, not airbrushed to death, or conversely, underlit. It should be as accurate a picture as possible, as honest a

reflection of that person as possible. And when actors come in, they're there for the business at hand. It's not really to socialize. You have to be prepared for some sort of chitchat generally, meaning very short. Some actors come in and are so twisted up into the character they're reading for that they can make a bad impression, particularly on a [casting] director or producer that doesn't know them. This makes it impossible for them to have the little pleasantries beforehand, which are especially important in California, though it's just a formality. That's really detrimental.

When asked what turned her off about actors, Pat went on to say:

What can an actor do to turn me off? Come in and tell me all their personal problems, take up far too much time, and be unprepared. That would do it. No-shows without an explanation get on my nerves as well. I prefer a phone call, even after the fact; otherwise, I'm just sitting around waiting.

First and foremost, you must be prepared. Your talent must be polished, and you must be confident. Don't go out on auditions until you're ready.

Actors are always talking about how they want to work, so, to me, the most amazing thing is when you give them an opportunity to come in and get the materials early so they have the edge, they have excuses for why they can't come beforehand. I don't want to hear it. You have a friend or somebody who can go get the materials for you. If you have to get up an hour early, that's the reality. You give to get. And if you really want to work, what is the problem with making your life work around it? I understand that a lot of actors have to work full time. So when someone says to me they work and it's really a problem when they leave their job before 5pm, I'll try to get them an audition at 6 o'clock. But then don't come in unprepared when I've given you a chance to get the materials early and you're not prepared because of work. That's when you get up a little early.

Jaki Brown-Karman

You should be in a positive mental and emotional state of mind. This is your big chance, and you want to be sure that you have it all together. You should go into your appointment with a positive attitude and feel good about yourself. Feel comfortable and attractive and know that you have your act together.

Don't worry about the competition—that just breeds nervousness and feelings of inadequacy. Don't let the presence of other actors auditioning for the same role "psych" you out. Think of it this way: you are not auditioning against anyone but yourself.

One of New York's top black commercial actors had this to say on the subject of competition:

Competition: the only competition I'm in is with myself. Period. When I walk into an audition, it's my time to audition, to do my thing. You'll have a lot of people saying "You're not going to make it today, I'm going to get this one pal, you might as well not show up" or "I got the last one." Fine, good—someone's working. Great, excellent. But I'm here to audition. They're throwing garbage at me. Fine, throw it at me. But I have to drop the garbage as it hits me and let it go.

Kerry Ruff

Body language is important. Sit relaxed but attentive. Don't slouch in the chair. And ladies, remember to sit properly if you're wearing a skirt or dress. Smile and be happy!

Punctuality is also crucial, as it is the mark of a true professional. Always arrive on time to your appointments. Forget about arriving on CP time. Again, if you are late, it will be assumed that you will also be late for the actual job.

Within reason, you should follow your agent's instructions on how to dress. Get as much information about the role as you can. Research the casting director and find out as much as you can about the project that you are being considered for. In every other industry, prospective employees (which is what auditioning performers are) are expected to know a little about the company they are interviewing with. Our industry is no different.

Express an interest in the job and be enthusiastic. You want the job. But don't act as if you need the job, because the desperation will show. Ask questions about the job that may reveal information —probe!

Don't be too afraid or too timid to speak up. When you are in the casting office, flatter them a bit. Let them know that you enjoyed the casting in their past projects and that you hope to get cast in one of their future projects. Be honest with your praise, but don't overdo it.

You can always ask for feedback on your audition or suggestions or techniques for future auditions. Sometimes, though, it may be best to solicit feedback through your agent. It's your call on this one!

Think of the audition this way. You are at the audition to solve the casting director's problem. The casting director needs to cast someone in a role. They don't want to hear about your personal and professional problems. They want to solve their problem, and you are there to present yourself as the solution. Don't be negative and belittle yourself. And don't apologize for your lack of professional credits. Be proud of what you've done, no matter how small or insignificant if may seem. Stress your good qualities, and be positive about yourself and your accomplishments without bragging or boasting.

Cockiness is something that turns me off. If you come in and tell me about how wonderful you are and I don't know it, you have to prove it. But don't spend your

entire interview telling me you're so great and you do this and you do that. Either I'm gonna know it, I've seen it, I've read it, or I'm gonna know something about you because you're that hot.

Jaki Brown-Karman

Stay away from discussions that may make the casting director feel uncomfortable. That means no racial statements or questions! Don't put the casting director on the spot by asking something like, "So, what do you feel is the reason that talented black actors like me are not working today?" Don't laugh—it's been asked before!

Common courtesy dictates that you don't smoke in the office. Don't chew gum, eat, or drink, and be sure to take off your dark sunglasses indoors. You are being analyzed the very minute you walk through the door, and you want to be sure to make a good first impression.

Make sure your portfolio is in good shape—no junk in the pockets. Have enough pictures to distribute. Agency stickers should be affixed to your pictures before you walk into the casting office.

Follow these guidelines, and you'll be sure to present yourself as a professional package.

14

PILOT SEASON

Hopefuls with stars in their eyes arrive in Hollywood by the thousands, hoping to "get a pilot" during pilot season. A pilot is the initial sample episode of a show producers and writers want to sell to the network for the fall schedule. The period from mid-February through the end of April, generally referred to as "pilot season," is when the industry is at its busiest and everyone—agents, casting directors, writers, producers—are scrambling to get a piece of next fall's prime time television schedule. Writers and producers are trying to get their ideas turned into pilots, hoping their show will make it on the fall prime time schedule. Actors are hoping to get cast in a pilot.

During the past few years, many people in the industry have been moving towards less risky and costly ventures in the form of "presentation tapes" which, unlike pilots, are not a full-length representation of complete episode but rather a shorter sample of the writing and casting for the potential show. Because pilots are so expensive to produce and because so few are actually picked up and aired, some in the industry see traditional pilots as a huge waste of money. Presentation tapes require less money and give the network the essence of the potential show without the large monetary investment. Some producers are also opting to do live, staged readings of their show ideas for network executives as a way to cut costs even more. Either way, pilots offer actors an opportunity to get work.

If you work on a pilot, you'll receive union pay (SAG or AFTRA). If the pilot is a presentation tape, you'll make less money but will normally be released from your contractual obligations earlier, around June 15th, so you can pursue other projects. Actors who sign on to pilots are normally held under contract until December 30th, because, even if the show doesn't make the fall schedule, there's still a chance it will make the mid-season schedule.

To increase your chances of getting considered for a pilot, make sure your photos are up to date and are a true representation of what you look like when you walk in the door. Being seen

in showcases is also a plus because casting directors attend showcase productions to cast new talent for the pilot season.

Adilah Barnes, a veteran actress who has been cast in several pilots, commented on how you should negotiate a pilot role:

> If the role is initially written as a regular, you want to fight to have it remain a regular once they make the offer. If you're unsuccessful at that and you still want to do the pilot, for whatever reasons—for the exposure, because it's a role you like, because they're people you'd like to work with, the money, whatever—then you want to negotiate in other ways. If the role is recurring, you want to negotiate around billing. In a sitcom, if your name is not billed with main titles (as regulars are at the top of the show), then "first position" in the endtitles (the tag at the very end of the show) is what you want. Having a dressing room with a bathroom, a refrigerator, a telephone—all that can be negotiated. You might want to negotiate having a parking space that's exclusively yours with your name on it. If it's recurring, you can negotiate the number of guaranteed episodes your character is involved in. You can possibly negotiate at least one storyline for your character. There are a lot of ways you can negotiate and get what you need even if you don't get a regular role. You can even negotiate around publicity. There is personal power if we use it. You may not get everything you want, but you can get some of what you want. I came to discover all of these things. Some of them you just learn as you go along. With my experience on "Blue Skies," I wanted to make sure I could got everything I wanted to get, so I sat down and thought about every area in which I might be able to ask for what I wanted—that's when I began to think of things I hadn't even thought of before. If they really want you, they'll be willing to negotiate and, being negotiators themselves, they'll expect that you're going to negotiate. Actors have to move beyond that place of fear about asking for what they want and into what they believe they deserve. Because if you don't ask, you don't get.
>
> *Adilah Barnes*

ON-THE-JOB PROFESSIONAL ETIQUETTE

Now that you've been hired for the job, what comes next? Your performance on the job! And we're speaking not only about your actual talent performance, which we'll assume is excellent—we're speaking about your professional performance, your on-the-job professional etiquette.

There are a number of general guidelines you should follow on the job. Always remember you are a professional and you should speak and carry yourself in a manner befitting a professional.

First of all, be on time for your work call! Keeping everyone waiting is a sure way to get off on the wrong foot. Time is money in this business, and no one will look kindly upon a performer who holds everyone else up while the clock is ticking.

> I'm a stickler for promptness. I hate actors that come in late. So, for an actor to be on time, ready to go to work when the call time is, is very important to me.
>
> *Tony Singletary*

Under certain circumstances, you may be able to interject your creative ideas about your character or staging, particularly if your director or stage manager ask or are open to suggestions—although you'll find that, most times, they will not be open to any input from you. They have their professional egos to protect just as you do. If it seems your unsolicited suggestions are unwelcome, don't go any further with them. That's not your job anyway. Never openly challenge another professional's authority or directions. Trust his professional judgment. He knows what he's doing, just as you know what you're doing. You wouldn't want him to tell you how to act, dance, or sing, would you?

When asked what turns him off about actors, network sitcom director Tony Singletary had this to say:

> Actors who are overzealous in giving their ideas—it gets pretty annoying. But there's a fine line there, too. I'm not the type of director that's so close-eared. A lot of times I want to hear what the actor has to say. If an actor has a good idea, I will use his good idea, but I don't want to constantly hear actors' ideas. I think their job is, "Here's the material, the director would like it done this way, can you perform that material the way the director wants it?" In sitcoms, I only have a week—five days. It's not like a play where I can kick [the script] around, really talk and get into long conversations. I can't isolate myself with one person for any length of time. So the actor really has to knock it out really fast. There's no time for all these ideas because it really throws [the director] off course. I sit home every night and go over my script and know exactly what I want to accomplish that next day. Not that I'm so rigid, because I want to keep a looseness of creative ideas flowing and coming out—but there has to be a direction that [the director] is really set on going. Otherwise, in those five days, you won't be ready. If you set your direction, then you can make changes. If the actor wants to try something, I'll let him try it. If it works, I'll let him keep it. If it doesn't, I'll say no. I would like the actor to feel from me that he has the freeness to bring up ideas, but not to go crazy with it.

You were hired to perform, not to direct, give stage directions, or rewrite the script. Even if you disagree with the director's interpretation of your character, do not argue about it. Just go ahead and do whatever is asked of you. That's what you are being paid for. And it's his job to direct you. If the director sees your character differently that you, it's within his authority to do so. You are a professional performer and should be able to work with any interpretation given to you. Questioning a director could get you fired and replaced by another performer. It could not only cut this job short, but, in extreme cases, could cut your entire career short. Word gets around quickly in this business; don't let the word on you be "troublemaker."

When asked what impressed him about an actor, television director Tony Singletary had this to say:

> Coming in and reading without changing words. Scoping out the situation and seeing the kind of director he is. At some point, making a choice and, if that choice is wrong and the director changes it, being able to switch around and be able to change that choice and do whatever the director needs you to do. The actor should get the words [memorize lines]. A lot of times, I won't say learn the words for a period of time. But once I say go get the words, and I want the words tomorrow, then I think that actor, as a pro, should be able to come back and be off the script and have the

words down. Generally, that's done for a reason, so I can see better movement, flow, and give him props to put in his hands. At some point, I'll need that. Depending on the show, I'll ask him to get the words earlier or later. But the ability to get the words down—I hope an actor can take a script home and in one night get the words down—I like that a lot.

Not only is it improper conduct, it is also against the union regulations for anyone, except delegated stage hands, to touch or move sets and props without permission. Never use foul or abusive language, and never openly criticize anyone, especially around sound stages with open microphones! Follow all directions explicitly. An ability to listen and respond to directions quickly and efficiently is crucial.

There is usually a lot of waiting, and waiting, and more waiting on the set. Between takes and scenes, you have to wait for makeup, hair, and wardrobe changes, props to be moved, lighting to be readjusted, cameras to be moved, locations to be changed, and meal breaks. Be cool. You can wait anywhere from a few minutes to a few hours. And as soon as it's time for you to perform, someone from the production staff may yell "take five" or "lunch." "Take five" refers to taking a five-minute break. Under union rules, performers and production personnel are allocated several break periods throughout each work day at predetermined time intervals.

Patience is crucial. Bring something to keep you occupied while you're waiting. When they are working on sets, inevitably actors talk and exchange all kinds of acting and casting information. Stay alert, with pen in hand, and jot down important names and addresses. Through sharing, make some new industry friends. Network. This is also a great time to do a mailing. You could also bring a book, a crossword puzzle, or some stationery to write those letters you promised to write ages ago. In other words, use waiting time constructively.

16

MONEY MANAGEMENT

Do these scenarios sound familiar? Waiting tables at some crummy little diner with poor tips. Collecting a measly $100 a week from unemployment. Two months behind in your rent and several eviction notices from your landlord. Three months behind in your telephone and utility bills, with several disconnect notices. Six months behind in your other bills. Bill collectors knocking at your door daily. Sick and can't afford to see a doctor. Haven't had a decent meal this month. Made less than $2,000 this year in your profession.

These are commonplace occurrences in the life of a struggling performing artist. Because income is unpredictable and often rather sporadic, most performers in the early stages (and for some, in the latter stages) of their careers will have a hard time making ends meet. With basic living and career-related expenses, performers should take great care in managing their money.

At the beginning of your career, unless you are extremely lucky, there will be little or no income from performance jobs. As you gradually begin to book more jobs, your income may increase, but it will continue to fluctuate. There are always bound to be slow times—we all have them. Even major stars and celebrities have slow periods when they don't work as much as they're accustomed to. Stars and celebrities often tell stories of how, after a major role, they found themselves on the unemployment line or selling real estate just to make ends meet. It happens to the best of us—so be prepared for it and save!

One of the most important things you can do for yourself is to manage your money—start a savings plan. Be sure to save a portion of any money you earn.

Better yet, sit down and outline a money plan. With a money plan, you can get more satisfaction from your hard-earned dollars by directing them where they're needed most. The *CIRcular (Consumer Information Report) Personal Money Planner* advises that "a good way to begin a money plan is to define your goals and set up timetables for achieving them." Your list of short- and long-term goals might include:

- paying all bills on time;

- keeping your credit card and charge account spending within predetermined limits;

- establishing an emergency savings account, such as 10% of your total account pay or from two to six months' take-home pay;

- saving for specific large purchases, perhaps the down payment on a car or home;

- setting up an investment program for more income now or retirement income later.[16]

Take a look at your list to see whether all your goals actually can be met through a budgeting system. You may decide that many of your present money problems stem from using your charge accounts too much. In this case, perhaps you'll need to supplement your budget with other self-discipline tactics. Your decisions about how quickly you want to reach your goals will affect the figures in your budget. Try to be as realistic as you can when setting timetables so you'll be able to live comfortably within your choices and be less tempted to stray from your plan.

If you need professional help, contact the Consumer Credit Counselors (CCC). The CCC is a nonprofit organization specializing in helping people with budgeting and debt management problems. For more information, contact the CCC office listed in the white pages of your telephone directory.

Making Money

After years of earning less than carfare as an actor, suddenly you hit pay dirt. You land a national commercial estimated to gross over $25,000 within the year. So you immediately go out and splurge. You buy all the things you've wanted but couldn't even think about buying—an updated wardrobe, jewelry, a color television, a VCR, and a compact disc player. But wait! Think before you buy. You know the old saying, "Here today, gone tomorrow"? Your $25,000 commercial could be pulled off the air, your product could become obsolete, or your performance could end up on the cutting room floor. Your lucky break can disappear as quickly as it appeared. Then what do you do? You could end up back in the poorhouse sooner than you think.

If you are lucky enough to immediately hit pay dirt, these are some of the things you should consider doing. Put some cash into a money market account or CD that you can't touch without penalty for at least six months. Pay off all of your outstanding debts. Hide your credit cards. Stock up on canned food. Visit the hairdresser, barber, and manicurist for grooming. Invest in that acting or dance class you wanted to take but couldn't afford before. Get new headshots. Save! Do a major photo-résumé mailing. To sum it up, reinvest some of that money into your career.

[16](Bank of America NT & SA, 1977).

You go out and make $10,000, get a commercial that runs, but that might be the only one you get. After taxes and paying your agent, you might net $4,500. And you go out and buy a brand new car that costs $10,000, trying to be cool. You might end up getting the car repossessed in two and a half years, but for those two and a half years that you had the car, you were big time. You have to be careful—real careful.

Bill Overton

It's okay to satisfy one or two whims. But overall, if you come into large sums of money, manage the money wisely. Extravagances will come later, once you become financially established and begin working on a more regular basis.

Let's be frank—no one who made it to the "million dollar club" should ever find themselves broke. But how often do we read headline stories about celebrities filing for bankruptcy, being investigated by the IRS for tax evasion, or taking their advisors to court for embezzlement and mismanagement of funds? Money problems have even led a handful of the once-rich to take their own lives. Too often, these problems stem from poor financial management and planning. Money matters! Don't go for broke. Take care of business and be smart about how, why, and when your money is being spent. If you handle your own financial affairs, you should have a pretty good handle on how much money you have and how it's being spent. If you don't, sit down with your bank statements and other financial information and have a heart-to-heart. If you have a financial advisor or business manager whom you've charged with handling your financial affairs, that doesn't mean you should sit back and relax while they handle your money. It's *your* money!

No one cares about *your* money like *you*. That's why you should always keep on top of what your advisors are doing with the hard-earned money that is yours. Ask about where your money is, how it's being invested. Ask *lots* of questions.

If you've landed a record deal, television series, or plum feature film role and you find your income suddenly skyrocketing, don't overextend yourself too quickly. Be as careful with those millions as you would be with your last dollar. Until you are sure you are making enough money to live on without having to work another day in your life, plan carefully. Do you have a contingency plan if your record sales plummet, your television series is cancelled, or the movie bombs, and there are no new offers in sight? How will you pay your bills, mortgage, car note? How will you maintain your standard of living? Have you put some money away for a rainy day? Have your put money away to pay taxes you may owe at the end of the year? Too many people take the money and spend it without thinking about taxes, savings, and, most importantly, the future. These are all things to consider as you take control of managing your money. Your money is your future. Wise financial planning can offer you a comfortable or miserable future, depending on how you handle your money now.

Banking Services

If you're moving to New York or Los Angeles, keep your out-of-town bank accounts open for reference and credit profiles. Many large-city banking institutions require previous banking experience when applying for loans, credit cards, and even checking accounts. Your out-of-town bank account will continue to gain interest premiums as your savings increase.

Explore the Actors Federal Credit Union in New York and the SAG-AFTRA Federal Credit Union in Los Angeles. (You have to be a paid-up union member in good standing in order to join either of these credit unions). These credit unions function as full-service banking institutions, offering draft checking and share savings accounts; personal, car, and homeowner loans; money market accounts; and IRAs and Keogh plans. The Actors Federal Credit Union offers VISA credit cards and 24-hour automatic teller machine (ATM) banking cards. Because performers are self-employed independent contractors, most financial institutions and credit companies will avoid granting credit to you because you lack what they consider to be a stable income. Our credit unions understand the performers' lifestyles and accommodate for it. They will sometimes even consider your unemployment insurance as part of your income!

Taxes

All performers should hire a good theatrical tax preparer or CPA (certified public accountant) to keep them abreast of the everchanging tax laws and to prepare their yearly tax returns—someone who specializes in theatrical tax returns. The best method of obtaining an accountant is to ask around. Ask your theatrical friends for references. Check the trade papers for advertisements during tax season. If you're a member of SAG, AFTRA, or Equity, you may want to check out VITA (Volunteers Providing Income Tax Assistance). VITA is a program that provides free professional assistance for union members in good standing on their income tax preparation.

Performers' tax returns are unlike those of most other professions. Besides theatrical work, your tax return is also based on the various maintenance jobs you may have worked during the year. These returns require specialized knowledge of income tax preparation and deductions on the part of the tax preparer.

In order to file your taxes as a performer and deduct your performing arts-related business expenses, you must meet the deduction income requirements as outlined by the Internal Revenue Service for a Qualified Performing Artist. Otherwise, your performing-arts-related business deductions may be subject to the 2% limit that applies to most other employee business expenses.

According to the Internal Revenue Service:

A Qualified Performing Artist is an individual who (1) performed services in the performing arts as an employee for at least two employers in the tax year, (2) had allowable business expenses attributable to the performing arts of more than 10% of gross income from the performing arts, and (3) had adjusted gross income of $16,000 or less before deducting expenses as a performing artist."[17]

There are certain deductions performers are allowed, within limit. You should check with your tax preparer for additional information on the deduction income requirements. These deductions include:

Advertising & publicity	Agent & manager commissions
Answering service	Business equipment[18]
Business-related gifts[19]	Classes & training
Costume rental	Demo tape production
Entertainment (movie & theater tickets)	Gasoline[20]
Grooming (hair, skin, nail care)	Headsheets
Home telephone[21]	Mailing envelopes
Office supplies	Records, cassettes, CDs
Photos	Postage
Scripts	Sheet music
Stationery	Tax preparer fee
Theatrical books	Trade publications
Transportation fares (subway, bus, taxi)	Unusual wardrobe
Wardrobe upkeep (cleaners, shoe repair)	

If you travel out of town to look for work, your airfare, lodging, and meals are also deductible. Some of these deductions have specific time and monetary requirements. Check with your tax preparer for specifics.

You should keep all of your receipts, especially if they are over $25. Cancelled checks are also receipts of your purchases. If you happen to get audited by the IRS, you'll be expected to show all receipts to substantiate your expenses. You should also keep detailed, handwritten, daily records in your appointment book of all phone calls from public telephone booths, subway, bus and taxi fares, parking fees, and tolls.

[17]Dept. of the Treasury, Internal Revenue Service, Instruction for Form 2106, Employee Business Expenses.

[18]The cost of business equipment is often depreciated over a period of years. Business equipment would include computer, typewriter, answering machine, videocassette recorder, television, etc.

[19]Limited to $25 per individual.

[20]Keep a record of how many miles you traveled; the IRS allows you to deduct 25 cents per mile.

[21]The IRS does not allow you to deduct a portion of your basic monthly service fee.

17

OPPORTUNITIES AND AVENUES OF PURSUIT

Most beginning performers go to New York or Los Angeles to pursue work in one of the major areas of the entertainment industry—feature films, prime time television, Broadway, commercials, print work, and dance. They are often unaware of the many other opportunities available to them in the smaller and more specialized areas of stunt acting, industrial films, educational films, student films, live industrials, theme parks, voiceovers, commercial jingles, comedy, and the nightclub circuit.

You can find this work in New York and Los Angeles as well as in many of the larger cities across the country. If you're working in New York or Los Angeles, most talent agents do not handle work in these areas, particularly because most of this work is non-union and they are busy working on more lucrative major projects in feature films, television, and commercials. In most instances, you will have to go out and find this work yourself.

If you're working in one of the large cities—Philadelphia, Baltimore, Washington, D.C., Boston, Chicago, Dallas, Miami, Atlanta, Las Vegas, or San Francisco—the talent agents in these cities will handle these areas because that's where the bulk of the work is. Because the markets are smaller in these cities, the talent agents book their talent on all kinds of jobs.

If you don't live near one of the larger cities, you can still find opportunities right in your city or town. For example, your local television station airs local commercials and programming that always need performers.

Working in these areas affords you the opportunity to work at your craft, gain valuable experience, earn professional credits, accumulate videotape and film, and earn money all at the same time. Some performers find enough work in these areas (particularly in voiceovers and singing commercial jingles) to give up their maintenance jobs altogether. Many performers

even find whole new careers in these areas. Top producer and recording artist Luther Vandross helped launch a lucrative singing career doing jingles for, among other products, Kentucky Fried Chicken.

The same principles regarding professionalism and work ethics apply in pursuing work in these smaller, specialized, yet still highly competitive fields. In most instances, you'll need to send out photos and résumés, follow up with photo postcards, and attend auditions, just as you do for feature film, television, and commercial work.

Stunt Acting

What is a stunt actor? We asked Eric Mansker, a well-known and highly respected stunt performer, who had this to say:

> A stunt actor is an individual hired by a production who possesses the ability to both act and perform his or her own stunts. Unlike a stunt performer, a stunt actor is usually hired under an actor's contract and is paid based on the production company's budget under union salary guidelines. After acquiring a number of years of experience in the business, most stunt actors are apt to become stunt coordinators.

A stunt actor hired under SAG contract on a low-budget film (less than $1.75 million) earns $448 per day or $1,671 per week; on a film budgeted at over $1.75 million, it's $504 per day or $1,880 per week. The flat daily rate for a stunt coordinator on a film project is $617 (or $504 + expenses) or $2,300 per week (or $1,880 + expenses).

Most stunt performers usually have some kind of athletic background such as gymnastics, track & field, or skydiving, but it's not required. There's nothing better than on-the-job-training when it comes to performing stunts. If you're in school and want to learn more about the field, think about taking as many courses as you can about the laws of physics, which will help you understand the dynamics of speed, accuracy, and timing. You might also consider studying acting. Acting skills will help you become more sensitive to an actor's character, facial expressions, and body movements if you work as a stunt double or stunt actor. Some knowledge of photography is also helpful. When you're executing a stunt, you'll want to know what the camera is capturing and what the audience is going to see. Finally, knowledge of the design, construction, and operation of machinery will help familiarize you with some of the equipment you might use during a stunt. For example, if a stunt sequence calls for you to collide with another vehicle, you will need to know how both forces will interact and what impact it will have on the drivers.

Know who the players are. Pay close attention to film and television credits and familiarize yourself with the names of the stunt performers and stunt coordinators. Try to get a chance to

visit movie sets and television shows in production. Talk to the stunt coordinator and stunt actors on the set and ask to be included in their training sessions. You'll have to convince them you have what it takes to make the cut. Be determined and persistent.

> Be prepared to meet a lot of resistance. They might try to throw you off the set. Your best bet is to make it difficult for them to turn away your talents. If you stick around long enough, eventually someone will notice you.
>
> *Eric Mansker*

Remember that every time a stunt person performs a stunt, he is putting himself and his co-workers at risk. So expect everyone to be on their guard. Newcomers are not instantly welcomed on "the team"—you'll have to earn your place. Train and learn as much as you can, because there are many different kinds of stunts. You can establish your credibility by working as a stunt double and an extra.

> As you might not know, the representation of minorities in the stunt business is considerably low. Although the average person may be deceived by the ethnic diversity seen on everyday television, Hollywood cannot ignore the painful reality that every minority professional faces, the inability to find work.
>
> *Eric Mansker*

Every year, the Screen Actor's Guild compiles an ethnic breakdown of the stunt performers hired for the current year. Of the 50,344 performers hired in 1994, black males accounted for 3,786, black females 2,224.

For more information on the stunt business, check out a book called *The Stunt Guide* by John Cann. You can also contact the AFTRA/SAG Coalition for Stunt Performers of Color, P.O. Box 4227, Panorama City, CA 91412, (310) 518-5203.

Specialized Films

For the film and television actor lacking professional credits and a union card, the areas of specialized films is especially attractive. This field offers the newcomer the opportunity to gain valuable experience in front of the camera. It's also a good way to get copies of your filmed performance on videotape that can later be used on your professional demo tape.

A performer can look for work in these areas the same way he looks for work in feature films, television, and commercials. Send your photo and résumé with a cover letter to the casting contact. The trade papers and trade directories are the best source for this information. The *Madison Avenue Handbook* lists and describes production companies, video companies, advertising agencies, and film companies in the New York area. It also has sections on many of the

regional areas as well as a section on Los Angeles. The *Studio Blu Book* covers the Los Angeles area production companies, video companies, advertising agencies, and film companies. You can also call the Screen Actors Guild and American Federation of Television and Radio Artists if you are a member and request their complimentary list of signatory production companies. And *Back Stage* publishes an annual directory that lists production, film, and video companies.

Industrial films are produced by major corporations as in-house training and information films. They act as sales aids, demonstrating how products are made and how a particular job should be performed. For example, when Johnson Products Company develops a new black hair care product, they may produce an industrial film for their salespeople to excite them about the product and to highlight the product's selling points.

If you live in New York, you have the opportunity to work in Philadelphia, Baltimore, Washington, D.C., or Boston, all of which are within four hours or less by car, plane, or commuter railroad. That isn't a long way to travel for a $700-a-day industrial job. There is quite a bit of industrial film work all along the East Coast. Find an agent in the area and submit your photo and résumé. Because you live a distance away, you can often bypass the audition stage and book jobs right from your photo and résumé. Many of the industrial casting people, upon the recommendation of an agent or manager, often take the chance and book experienced professional New York talent directly from their photos and résumé.

Narrations are the prerecorded voices heard on film. They are the voice tracks that describe the action of industrial films in a storytelling manner.

Slide films are usually produced by smaller companies because they are more cost-effective than large-scale industrial film productions. This film strip is a series of still life photographs with a complementary voice track or film narration describing the action of the film.

Educational films are most often produced by institutions, high schools, colleges, hospitals, libraries, and museums. They are used in classroom instruction and to inform the public of available services and programs. Remember falling asleep in class watching that film about drug abuse or birth control methods? Well, that was an educational film, and usually the people on the screen were actors! In hospitals, educational films are often used as a training aid for new medical personnel. In libraries and museums, these films inform the public of services available to them and of upcoming events and activities.

Student films are produced by college students studying communications and filmmaking. These low-budget, non-union film productions rarely offer a salary, but most do provide transportation reimbursement, free food, and, sometimes, a copy of your filmed performance. The trade papers are full of casting notices for student films throughout the year, especially from November through April when students are preparing their films for the end of the semester.

Keep in mind here that today's directors of major feature films were once student filmmakers, and these films may offer you a good way to make contacts for the future.

As you can see, there is a great deal of work in the area of specialized films. With the exception of union-regulated industrial films, most of these films are non-union. And the pay is pretty good. In the New York metropolitan area, actors can sometimes make $300 to $700 for a one-day shoot on an industrial film. These films are a great training and proving ground for the novice actor. If you're a member of AFTRA, you can request their list of union signatory production companies that hire union actors for industrial film work. When exploring listings of film and videotape production houses for the non-union actor, check out the production directories (like *Backstage's Annual Production Guide*), available at the theatre bookshops. Distribute your photos and résumés to the production houses and follow up regularly with photo postcards.

For industrial film work, the look is usually an upscale, conservative, and corporate appearance. This is because most roles in industrial films are those of executives, secretaries, office managers, and receptionists—typical jobs found in most office environments.

The competition is keen for work in specialized films, and all actors should be fully prepared for the same stringent casting and talent requirements found in union television and feature film jobs.

Live Industrials

Live industrial production can best be compared to doing a live commercial. Its purpose is to publicly sell the image or products of a company. These productions are big-budget extravaganzas usually held for in-house gatherings of large corporations and national organizations. The appearances of Michael Jackson and Alphonso Ribiero at the international gathering of Pepsi-Cola executives was a live industrial. Companies who use well-known celebrities and athletes to endorse their products will use these personalities to make live appearances at their corporate functions. These productions praise the product image corporate contributions and salute the products that the company makes.

The talent requirements for these productions are stringent due to exorbitant costs and short-lived life spans. They are usually performed over a one- or two-day period, although they may demand one to two weeks of heavy rehearsals. Performers in live industrials must have commanding speaking voices and top notch musical theatre abilities and be able to learn extensive song and dance routines in a short period of time. You should be a "triple threat" performer—actor, singer and dancer—to perform in live industrials. Union jobs in live industrials fall usually under the jurisdiction of the Actors Equity Association (AEA).

Theme Parks

Theme parks such as Great Adventure, Six Flags, Disney World, and Disneyland also use performers in their live musical revue productions. Theme park performers must be versatile, well-trained singers, dancers, actors, and musicians. The hours are long, and you are likely to do several performances each day in all types of indoor and outdoor weather conditions. Performers must be able to perform many styles and periods of song and dance. Theme parks employ many contract performers with all types of musical abilities—contemporary, pop rock, rock & roll, R&B, country, and jazz—depending on the theme of the production. The performance season varies, but, except for year-round warm weather climates, most parks operate during the spring and summer months, ending right after Labor Day.

Voiceovers and Jingles

The voiceover field is one of the toughest fields to break in to because performers are heard but not seen as characters in commercial voice tracks and cartoons. Regional accents, dialects, and unusual voice characterizations are often used in pursuing voiceover work. If you don't have any experience in this highly specialized area, make sure you take a workshop to learn the technique of doing voiceovers.

This field employs a small number of proven professionals that are constantly in demand, such as *Coming to America* and *Claudine*'s James Earl Jones, singer-actress Lena Horne, and the late Adolph Caesar, last seen in the feature films *The Color Purple* and *A Soldier's Story*.

Many of the same principles apply to obtaining voiceover work as for on-camera commercial work. The voiceover talent uses a demo audiotape to get work. Keep in mind that an amateur audiotape is to the voiceover industry what a bad photo is to the acting industry. Demo tapes should be professionally produced in a recording studio only after you've studied the voiceover technique. There are numerous workshops that include the production of a voiceover demo tape at the end of the session. Check the trade papers and shop around for the best deal. But beware of amateur workshops and rip-off scams! Your master demo tape should be a 5-in. reel-to-reel or cassette tape recorded at 7.5 rpm. It should be no longer than 3 to 4 minutes in length and contain 6 to 10 different vocal characterizations. Check the trade papers and the Yellow Pages under "Recording Services" for companies that duplicate tapes once you have made your master. You should distribute them to advertising agencies and voiceover producers. This process is similar to the actor mailing his photo and résumés to casting personnel.

Jingles are the song tracks that accompany television and radio commercials. Like voiceover talent, jingle singers are heard but not seen. They sell the product to music. Vocalists in this field must, of course, be well-trained and versatile and able to sight read music flawlessly.

When you audition for work as a jingle singer, you will be given original sheet music to perform and you must usually be able to sing the jingles with little musical rehearsal. Ashford and Simpson, Roberta Flack, Aretha Franklin, Phoebe Snow, Patti Austin, Paula Abdul, Gladys Knight, Whitney Houston and Luther Vandross all have and continue to supplement successful recording careers with writing and singing commercial jingles.

Doin' the Comedy Thang

More than ever before, actors are using stand-up comedy as a stepping stone to film and television careers. Smart move! Why? Because comedy is "in." There is more comedy than ever at the movies, on television and cable, in video and music stores. As a result, producers, talent scouts, and casting directors are constantly on the lookout for new faces with comedy backgrounds. So, if you're funny, have lots of courage, and dare to take the risk, stand-up comedy might be the launching pad to a successful television and film acting career.

But don't rush onto the stage just yet. Being funny at work or in the shower often doesn't just naturally translate on the stage. Comedy is an art that requires training and practice.

Comedy acts usually begin with short routines or monologues that give the audience an insight into the philosophies and day-to-day life of the performer. These routines are sometimes quite elaborate and can be acted out in a minimal space, often in front of a curtain. The comedian uses basic skills of acting and pantomime to relate his experiences, and often uses simple props, costumes, or musical accompaniment. Beginning comics usually take their material to a showcase comedy club where their jokes and routines can be tested in front of a live audience. Like theatre, the spontaneity of performer vs. audience can tell the comedian whether his comedic material will be consistently funny.

Bill Cosby, Whoopi Goldberg, Richard Pryor, Eddie Murphy, Redd Foxx, Sinbad, Danita Vance, Phyllis Yvonne Stickney, and the late Robin Harris are just a few of the many comedians who have parlayed successful stand-up comedy careers into commercial film and television careers. Eddie Murphy's dynamic and outrageous style started with performances in youth centers, local bars, and high school auditoriums. He went on to perform at The Comic Strip, a Manhattan showcase club, and then moved on to appear in television's *Saturday Night Live*, which brought him to national attention. Several blockbuster feature comedy films, live concert shows, two comedy records, an all-music record album, and an exclusive, multimillion dollar movie deal followed.

Many times, in order to keep an audience entertained and primed for a star attraction, producers will hire the stand-up comedian as an "opening act." The comedian, using his knowledge of timing, will act as emcee, introducing the main attraction once he has persuaded the

audience to be receptive. Working as an opening act can introduce an unknown performer to recording artists, producers, and the international public.

In the early stages of a comedian's career, his material will introduce him and his series of experiences and characters. As the comedian grows and develops new material, the subject matter will become more topical, controversial, and even political. There are even stand-up comedians, such as Bill Cosby and Dick Gregory, who handle the tongue-in-cheek art of social and political satire. This allows us the opportunity to laugh at the workings of our families, governments, and social and political systems. It should be noted that, to make large groups of people laugh, comedians must be accomplished technical actors with a knowledge of current events, theatrical stage presence, and split-second timing in presentation.

Comedienne Myra J advises comics to keep the doors open:

> Keep working. If you work, work will come to you. All the work is not in front of the camera. Just keep focusing on different jobs in the comedy field and you'll master the business. I think it's important for comics starting out to think of this as a business and never put all your eggs in one basket. There are many different aspects of comedy. It's not just about getting up and telling jokes. There is writing, production, management, comedic singing, poetry, political satire. Don't get in a rut—be creative. Be like Nike—just do it! If you keep doing comedy and you're good, people will come to you.

Warming Up

Viable, lucrative, and growing—that describes the warm-up comedy field. The warm-up entertains the live studio audience at sitcom tapings. Unlike the stand-up who does a 10- or 15-minute set, the warm-up works a crowd anywhere from two to five hours per taping. His job is to keep the audience energized, involved, and interested in the show. Most warm-up regulars work two to four shows a week. And the pay is good—AFTRA scale pays $136 for a 15-minute warm-up and $224 for 30 minutes.

But breaking into the warm-up circuit isn't easy. It's a "Catch-22" that goes like this: most producers won't take a chance on you unless you've done it, but you can't do it until you've done it at least once. So how does a comic break into this field? The usual way is by the recommendation of a known warm-up or producer. Like everything else in this business, contacts are essential.

Live Showcases

To really make 'em laugh, you need a stand-up routine, stage presence, and an uncanny knack for timing, all which you can develop with practice. And you can get this practice by

working the comedy showcase circuit. Showcases afford the comic an opportunity to get up on stage and try out his material. If you're a beginning comic, you should perform wherever and whenever you can. Some of the country's biggest comedians, such as the ever-popular Martin Lawrence, can, to this day, be found regularly trying out new material at local comedy clubs. They know that the only way to really polish their routine is to try it out in front of an audience and use the reaction and feedback to fine-tune their act. Also, talent scouts, agents, and casting people are known to regularly attend comedy showcases on the lookout for fresh new talent for their television sitcoms and feature film projects. Many television and film stars began their careers on the comedy circuit. Eddie Murphy, Martin Lawrence, and Sinbad are shining examples of stand-ups who triumphantly made the transition to television and film success.

You can get started doing stand-up work by getting up on stage and performing at one of the many showcase clubs throughout the country. These clubs present showcases or audition talent before a live audience. There is usually no pay involved, but that's not what you're looking for, at least in the early stages of your stand-up career. Performing in front of a live audience is the only way to work out the kinks in your act, find out what does and doesn't work, and gain valuable experience and exposure. If at all possible, have your set videotaped so you can go home and evaluate your performance. Parts of the video can also be incorporated into your demo tape. You have to continuously work at perfecting your act. If you don't know any of the showcase clubs in your locality, pick up the Yellow Pages and call the nightclubs and restaurants. Ask for the manager, and inquire whether they offer showcase opportunities for new acts. If they don't, you might even offer to put together a showcase night. Ask lots of questions—Is the audition live or taped? Who handles the advertising and promotion? Is it an "open mike" or showcase? Many clubs hold amateur night contests as well.

Training

Training is important. A comic must develop stage presence, vocal quality, movement, timing, and other useful techniques for sitcom, dramatic comedy, and stand-up performance. You need to develop and refine your material and concentrate on strengthening your comedy acting abilities. Improv is an excellent way of learning to develop believable and memorable characters, impressions, and sketches.

Representation

There are a number of managers and agents who exclusively represent comedians. All of the big agencies—CAA, ICM, and William Morris/Triad—have entire comedy departments, and many of the smaller "boutique" agencies have an agent who specializes in representing comic talent.

Television and Cable

African-American comedians are making major inroads into the comedy field and gaining national attention. Much of this is a result of Russell Simmons' *Def Comedy Jam* explosion on the comedy scene three years ago. This HBO late-night showcase has propelled the grass-roots popularity of black stand-up comedy into the national mainstream. *Def Comedy Jam* is so hot there's even a Def Comedy Tour playing to SRO audiences all across the country. Comics are also makin' it big time in network TV—Martin Lawrence on Fox's *Martin* is one of today's most popular African-American comics. And, of course, there's Bill *We're in the House* Bellamy makinh 'em laugh all across the country.

Besides the opportunity for experience and exposure on the showcase club circuit, there are also myriad opportunities on television and cable. *Sunday Comics* (Fox), *Stand-Up Spotlight* (VH1), *Comic Strip Live* (Fox), *Up All Night* (USA), *Comedy on the Road* (A&E), *Caroline's Comedy Hour* (A&E) and *Live at the Improv* (A&E) are just a few of the many comic programs. There's even an entire network—Comedy Central—devoted exclusively to comedy programming. *Showtime at the Apollo* and *Star Search* offer fledging comics the opportunity to strut their stuff on national television in the form of a talent contest. New on the horizons is funnyman Bernie Mac's new comedy show on HBO late-night television, *Midnight Mack*, which Mac created and produces. *Midnight Mack* includes stand-up and sketch comedy as well as musical jams and dance routines.

Like everything else in this business, a career in comedy requires perserverance—keep on struttin' yo' stuff!

Resources for More Information

The *Comedy USA Trade Directory* features lists of clubs, bookers, TV production companies, talent coordinators, agents, managers, publicists, cruise bookers, comedy competitions, festivals, and classes. For more information, contact Comedy USA, P.O. Box 990, New York, NY 10156-0990, or call (212) 532-0171.

The Nightclub Circuit

Nightclub work has provided many an unknown artist an entree to film and television work. The nightclub circuit finds singers and musicians invaluable. For as many categories as there are in contemporary music—pop, rock, soft rock, hard rock, rock & roll, R&B, Big Band, jazz, folk, country, and rap—there are clubs to accommodate live audiences.

Singers may find work in a number of different ways. There are "house" singers, those who work in clubs that feature the musical talents of one steady performer. Then there is the "featured" singer, who may be part of a band or orchestra and is given material representing the

sound and direction of the group. There are also solo acts that depend solely on the range and talent of the individual musician or singer. This artist frequently plays small jazz and supper clubs and guarantees a certain faithful audience following. Club owners hire these specialized singers to guarantee sales of liquor and food. Then there are performance groups, where a number of singers and musicians will perform *en masse*. In clubs where there is little space or manpower, artists will perform their specialities to specially prerecorded musical accompaniment called "tracks." Tracks contain elaborate orchestrations and background vocals and sometimes feature the performer's voice so he can evoke a call and response with his own recorded voice.

The nightclub musician works unusual hours, and his work is divided into two or three timed intervals, known as "sets." Each set will be different to accommodate the tastes or feel of a certain crowd. It is here, in front of a live audience, that a singer or musician must really prove his worth, for he is far from the engineering tricks of the recording studio. Also, a singer or musician must be in top physical condition, since the hours are long and most club shows begin late in the evening, with many performers completing their last sets just before daybreak in establishments where drinking, smoking, and eating are encouraged. In order to maintain a quality performance, the musical artist must be extremely disciplined.

Nightclub work is experiencing a resurgence as more and more performers are using it as a stepping stone to furthering other careers. The number of nightclubs and comedy clubs in Manhattan alone is astounding. Many clubs will give the newcomer an opportunity to perform on showcase nights, while other clubs only present established performers with a strong following. Most newcomers will perform one-nighters at many different clubs until they've developed a reputation and can get booked into one prestigious club for an extended run. Payment policies vary from no pay to a percentage of the door, bar, or cover charge, flat fees, pay per set, and sliding pay scales, depending on the drawing power of the act. Established acts usually negotiate their salaries through their management.

18

EXTRA WORK

Accepting extra work can be a touchy subject. Acting as atmosphere or background talent means exactly what it says. In order to give a feeling of activity or movement to a particular scene, a casting director will select a secondary group of actors, without dialogue, who will appear behind the major source of action. These actors, commonly referred to as "extras," are usually indistinguishable on-screen and can appear in a number of different scenes as different people, simply with a quick change of wardrobe. Extras are employed in television, film, video, commercials, and even print.

Many established actors refuse to do extra work. Psychologically, some actors feel that, once a casting director has used them for extra work, they will be labeled as extras and will be overlooked by the casting director for major roles. In addition, agents often frown upon extra work, feeling it undermines their career-planning strategies. Most agents like to present their actors as leading players and are often afraid that if the actor does extra work he will be labeled as a supporting player and won't be considered for featured and starring roles. Also remember, under union regulations, agents cannot collect their 10% commission from extra work, except in "overscale" payment situations. Normally, an actor receives a flat rate—"scale" payment for extra work—which is determined by the governing union's minimum wage regulations. In some cases, an actor will receive an "overscale" payment, which is an additional 10% or more over "scale." Agents can only collect commission from jobs paying the actor scale plus 10%. So don't be surprised if your agent isn't overjoyed with your extra work credits. The bottom line in this situation is this—your agent can't make money on your extra work.

There is an unspoken rule of thumb that "real" actors shouldn't do film extra work because their reputations as serious actors will be tarnished. A certain stigma is often attached to extras. This is true more so on the West Coast than the East Coast, where extras are often referred to as "background actors." In California, extras are often thought of as non-actors who do film extra

work on the side to earn additional money or who do film extra work to make an easy living. It has become somewhat taboo to do film extra work in California.

Because money and jobs are hard to come by, many professional actors still do extra work in California. They just don't tell anyone about it—especially their agent. They often work in disguise, wearing wigs and other accessories to conceal their real identities.

In order to ensure more union production in what appears to be more desperate financial times, the unions now offer production discounts in the hiring of background actors as part of their contract negotiations. These negotiated discounts are known as waivers. Waivers allow productions to now hire fewer union atmosphere actors in order to cut daily production costs.

Many actors who accept extra work do so to supplement their income. This "bread and butter" employment affords the actor the opportunity to work at his craft and gain valuable paid observation experience, rather than working a 9-to-5 job in a restaurant or temporary agency. One of the biggest incentives for doing extra work is the possibility of an actor moving into a larger role. In industry jargon, this is known as being "upgraded." For example, in movie productions, if an actor is asked to perform a special talent—sing, dance, ice skate—he will be upgraded to the role of special ability actor or day player.

Daytime and episodic television are a bit different. If your role requires you speak less than five lines, you are called an "under-five." If the role requires more than five lines of dialogue, you become a "day player." Each change in a performer's status changes his earnings. Check your union's guidelines for specifics.

Upgrading usually occurs on the set when the director or production staff decides, on the spur on the moment, that he needs an actor to do or say something that was not planned in the script. Because of time constraints, production staffers can't always afford to contact the casting director and wait to cast the part through the normal casting process. The director and the production staff then make an on-the-spot casting decision from among the extra talent.

Being upgraded is usually a matter of luck—being in the right place with the right look and skills at the right time. This is one reason an actor should always be prepared. Often times, an actor, knowing he will be doing extra work, will be less likely to put his best foot forward—not putting on full makeup, hair, clothing. Always keep in mind that you never know when you will get moved into the forefront.

The process of upgrading is seldom done in reverse ("downgrading"). However, when a client or an agency executive is unhappy with his creative decision, his casting decision, or an actor's performance, an actor could be the victim of downgrading. This is contractually complicated, and usually the client or advertising agency has to come to some sort of financial settlement with the performer.

When seeking work as an extra, your standards of preparedness and professionalism should equal any other attempts you make at employment. The casting director's casting selection is based upon the same criteria used when casting an actor for a major role. This is not an arbitrary casting decision, as most of your competition will lead you to believe.

Often, you may audition for a major role in a production for which you may not be cast. Remembering you from your audition, the casting director may even offer you extra work on the same production.

Extra work is the area where a performer's reliability and accessibility to uniforms, sports equipment, and other props will often decide whether he gets the job. Police and medical uniforms, bicycles, ice-skates, roller-skates, luggage, cameras, knapsacks, pets, automobiles, and yellow cabs are frequently requested props. Most casting directors who cast extra players keep detailed files on performers' skills, working habits, and available costumes and props. Today, with the advances in computer technology, casting directors can keep more complete and accurate casting records for thousands of performers. This enables the casting director to find the performers he needs at a a moment's notice. Remember, for every prop and every change of clothing you are asked to bring with you on a job, you will receive an additional payment.

To the outside observer, extra work may seem like a glamorous job. Who wouldn't want to rub elbows with the likes of Danny Glover, Denzel Washington, Alfre Woodard, Bill Cosby, Bobby Brown, or Janet Jackson on a film, television, or music video set? Don't be misled! Appearances can be deceiving. There are times when extra work can be a comfortable and pleasurable experience, especially on commercial and television shoots, which are often done in studios—indoors, where there are more environmental controls. Studios are air-conditioned and heated seasonally, and there are often rooms (even dressing rooms!) for the extras with comfortable furniture, television and sometimes even a telephone, while you wait to be called to the set.

On the other hand, when working outdoors where the weather is unpredictable, you never know what to expect. There will be hours of working in the snow and rain (with a little extra pay!), but long and tedious hours without shelter can be far from glamorous. When the stars retire on their breaks to luxury, catered trailers with all the comforts of home (air conditioning, heat, television, car, bedroom, bathroom, makeup/dressing room, and personal assistants to attend to their every whim), one of the production assistants, who has also been working for little or no pay in the elements, will direct the extras to their public room, the "holding pen." Once all of the extras have assembled onto buses, where they are given directions and instructions and are allowed to use the only bathroom in a 50-mile radius, they are shipped from location to location, changing wardrobe and often working till the wee hours of the morning. And on top of all this, the principal actors, staff, and crew still eat first at every meal break!

In order to be fair and impartial, we have developed the following to relate the pros and cons of accepting extra work.

Pros:

- Certain types of extra work can, at times, provide career advancement and familiarization through upgrading.
- Union actors can qualify for and maintain valuable union benefits, and unemployment and insurance coverages.
- For the novice actor, extra work can provide paid, on-camera training and experience.
- Agents cannot collect commissions on money earned on "scale" extra work.
- Extra work provides a great network for sharing information between professional actors about castings, classes, etc.
- For the black actor, extra work can provide the opportunity to meet industry personnel who, in other situations, may be unapproachable. Some of these people move to more powerful industry related situations and can be beneficial in aiding ethnic talent to gain a foothold in establishing show business careers.

Cons:

- Casting directors and producers with limited intuitive scope will consider only background actors for extra work.
- Hours can be long, demanding, and tedious. If an actor is not prepared, these days can also be unproductive.
- Doing too much extra work can effect an actor's sense of self-esteem.
- Some production staffers may take a condescending attitude towards extras. Extras are considered "low man on the totem pole."
- Extras do not always receive the on-the-set benefits of make up, meals, and dressing rooms.
- Extras do not benefit from residual payments.
- Non-union extras do not benefit from any overtime, scale payment, meals, or dressing facilities. Most non-union actors are hired at a flat, daily rate for long hours and are held in separate waiting and eating areas from union actors.

19

THE COLORFUL WORLD OF COMMERCIALS

Prior to the birth of black-owned advertising agencies or "shops" in the 1960s and 1970s, white advertisers and their clients virtually ignored the potential spending power of the ethnic consumer market. Black talent has historically been "locked-out" of national television commercial acting jobs. Advertisers didn't think national commercials featuring black talent would appeal to the overall viewing public, and they didn't think African-Americans, as consumers, had any buying power. National television commercials were usually targeted to influence the purchases of the general American viewing public, depicting predominately white actors. Black commercial performers were relegated to commercials and products specifically targeted to the black community and were shown only during black-oriented broadcasting. Ever notice the overabundance of black record and hair care commercials during the station breaks for *Soul Train*?

In recent years, advertisers have become more interested in using ethnic talent in their national commercial spots. As the advertising agencies have become more aware of the black consuming public's buying power, African-American talent has become increasingly marketable. Today, the trend in advertising is to communicate with the ethnic consumer market by using black talent in national television commercials. Our family, work, and social situations have become commonplace fixtures on national television commercials. Black talent has also become increasingly popular in general market advertising campaigns and is seen in social and work situations relating to white actors—for example, a black Avon lady selling cosmetics to a white housewife, and racially-mixed social situations for Miller and Budweiser beer commercials.

As our country's demographic picture changes and the commercial industry opens more doors, black family life becomes more visible, and the image of blacks in advertising becomes

more prominent. This, however, is not always fair in proportion to the actual number of commercials broadcast in the United States.

The major ethnic commercial market used to be New York City, where the large advertising agencies are located and where the majority of commercials are produced. Due to cheaper production costs and more predictable weather conditions, in recent years, commercial activity has moved to the West Coast.

The total yearly income professional union actors earn from commercials is greater than the total yearly union income they earn in the areas of television, film, and theatre combined. With the many recent changes in union contracts, it is difficult to predict what exactly an actor will make on a commercial. However, this is indeed still a very lucrative area. Millions of dollars are riding on every 60-second performance.

Actors are paid according to the type of commercial in which they appear. Commercials are broken down into six different types: national or "network," regional, wildspots or "buyouts," dealer, seasonal, and test commercials.

Program usage commercials or *network commercials*, as they are more commonly known, are commercials that are aired on interconnecting stations known as networks. This is where all actors earn big money. Network commercials are broken down into class A, B and C usage. Class A commercials air in over 20 cities and are commonly referred to as "national" spots. Class B commercials air in 6-20 cities, and Class C commercials air in 1-5 cities. Class B and C commercials are commonly called "regional" commercials in industry jargon.

The first money an actor gets for a commercial is the session fee. A session fee is a payment made to an actor to compensate for his original daily performance time. The majority of actors receive a scale payment, which is the union's minimum wage for a day's work on a commercial. Celebrities, athletes, and well-established commercial performers are often paid overscale due to their recognizability and their personal management's salary negotiations. When an actor signs a commercial contract, he becomes exclusive to that product for a 21-month period, known as the "maximum use period." Contractually, being exclusive means that you can not do a similar commercial for a competitor product. The maximum use period is broken down into seven 13-week, fixed cycles. At the beginning of each 13-week cycle, you will be paid a holding fee, which equals the amount of your initial session pay. The holding fee is a payment that is designed to keep you contractually exclusive to the product's projected commercial air time of 13 weeks, even if the commercial doesn't run. At the end of this maximum use period, the advertiser has the option of renegotiating your contract or releasing you completely from the commercial contract.

Every time a network commercial is aired, you are paid a usage fee, known as a "residual" payment. This is where performers earn big money. Every time the commercial airs, the actor

earns money.

Wildspot commercials usually run on local stations. The performer is paid a flat fee for unlimited use of the commercial for a 13-week period. The fee is based on the number of cities that air the commercial and their projected population. Wildspot commercials can be renegotiated every 13 weeks. The performer earns no residuals.

Dealer commercials are usually produced by auto dealers. They not only promote the auto dealer's cars, but they also promote the dealership. Performers are paid a flat fee for six month's unlimited usage. The performer earns no residuals.

Seasonal commercials run 13 to 15 weeks, and the actor is paid a flat fee. These commercials are often seen during special holiday or promotional seasons. Performers can earn residuals, depending on the negotiated contract.

Test commercials are normally aired in limited markets for 13 to 26 weeks. Advertising agencies produce test commercials to get the public's reaction to a particular product or product campaign. These commercials can run the entire maximum use period of 21 months. If the commercial gets a good public response, the advertiser often decides to go national with the commercial. If the test spot goes national, the actor will be paid according to the network commercial contract and will begin receiving residuals. Most times, however, test commercials have only a temporary run. Advertising agencies will usually reshoot and recast the test commercial for national airing. It is important to note that the actors who appear in test spots have no guarantee of representing the product in a national commercial. Many veteran commercial actors will often decline work in test spots because, contractually, it can cause product conflicts and limit their chances to do other commercials.

Public service announcements are commercials designed to inform the viewer about social and health issues and support services that don't invoke the selling of a product. These commercials often deal with controversial, topical issues such as race relations, public health, child abuse, alcoholism, driver safety, sex education, and birth control. The actors hired in these spots usually receive a daily session fee for their shooting time. Their residual payments are automatically donated to the sponsoring organization as a charitable contribution..

Types of Commercials

Commercials can also be broken down into "hard sell" and "soft sell" categories. Hard sell commercials slap you in the face with an aggressive demand to go out and buy the product. The New York area's local "Crazy Eddie" commercials are the perfect example of the hard sell. Soft sell commercials demonstrate the advantages of the product without demanding that you go out and buy it.

There are also various types of soft sells. There are spokesperson, slice-of-life, and vignette commercials. Spokesperson commercials are like mini-documentaries. The actor usually talks seriously and directly to the camera about the product, speaking on behalf of the sponsor. Many celebrities and athletes endorse products as spokespersons, and sponsors rely on these well-known names to sell their products.

Slice-of-life commercials are like 60-second melodramas. They are short stories with a beginning, a middle, and an end. They often depict domestic scenarios. At the beginning, there is usually a dilemma over what product to use or how to solve a problem; in the middle, there is a confrontation with two or more people over what product to use. This is where the product's advantages are discussed. And at the end, there is a resolution in which the sponsor's product (of course!) solves the problem. Slice-of-life commercials can be funny, romantic comedies or even serious, tragic dramas.

Vignettes are a series of short, silent commercial situations flashed across the screen in succession, where several different actors are photographed using the product or explaining visually the positive effect the product has had on their lives. There can be musical accompaniment or voiceover announcing, or both.

Effective Commercial Marketing and Presentation

Performers in commercials often become so closely associated and identified with a particular product that they can catapult themselves to stardom. Emmanuel Lewis's commercial success rocketed him to international television stardom. Can we ever forget that tiny, childlike voice on the Burger King Whopper commercials?

The purpose of a television commercial is to sell a product. Commercials are talent vehicles for the actor, but the product is always, clearly, the star performer.

The advertisers develop commercial campaigns that are made to appeal to the "target" market, the market that the sponsor wants to reach. An advertising campaign is a series of commercials and ads that revolve around one singular product. Great expense is taken to make the product look favorable to several different audiences. A campaign may include print advertising and radio voiceovers as well.

The commercial performer's job is to sell the sponsor's product in 60 seconds or less. Because there is not time to develop complex acting characterizations, commercial performers must instantly look like a believable user of a product. Performers must have a look and appeal with which the purchasing public can instantly identify.

In your pursuit of a career in television commercials, you must decide what "type" you are going to represent. Type refers to the instantly recognizable, effective, physical projection of an image.

In the world of television commercial acting, there are types that are most often requested in casting—children, teens, young adults, collegiate types, "buppies," housewives, mothers, husbands, fathers, spokespersons, senior citizens, grandparents, comedians, neighbors, blue-collar workers, and models, as well as celebrities, athletes, and other well-known personalities.

Your type will depend on many factors, including the age that you appear on camera—not necessarily your biological age. It will also depend on your clothing, hair, makeup, skin color-ing, figure, ethnic features, expressions, attitude, and personality. These elements, taken to-gether, will determine the type you most closely resemble. In choosing your type, make an honest assessment of yourself. Watch television commercials and decide which characters you most resemble. It is imperative that you can recognize your type. Commercial casting decisions are often based on predetermined typecasting.

A good rule of thumb is this: if you realistically appear to be younger or older than your actual age, remember to incorporate the attitude, wardrobe, and mannerisms of that age into your photo presentation and your overall commercial image.

There are many different types that you may be able to portray. Pinpoint your type. For example, if you happen to be an 18-year-old who can look 18 to 25, narrow your market—stick to the younger roles for now. You have plenty of time for more mature roles. But, if you are intent on playing a wide age range of roles, remember that you'll need to invest even more money on pictures that reflect your maturing look, as well as clothes and accessories. We be-lieve it is far better to concentrate on pinpointing a specific and comfortable type, establish yourself in that market, and get your name well-known, and then, gradually, broaden your range and show them all you can do.

When you hear talk of someone being cast "true to type," they are referring to a performer who always appears to represent the image he has chosen for himself. The smart performer knows he may be seen by a prospective employer anywhere, at anytime, and he always repre-sents his type. The smart performer carries his photo-résumé, picture postcard, photo business cards, or some form of photographic representation with a current business phone number at all times! You never know who you may run into at the corner store—so be prepared! One actress we know had been trying to see a prestigious casting director for weeks. She finally saw him— but she was in the supermarket complete with curlers in her hair, bummy clothes, dark glasses, and nowhere to hide! Luckily, the casting director found this situation funny. But did she get work? No.

As a black commercial talent, don't limit yourself further by projecting an image that may seem threatening and intimidating to commercial talent buyers who will make their decisions based on what they think will appeal to the overall buying public. Any look that you choose for yourself should represent a wide cross-section of the African-American public. In most cases,

current ethnic fashion trends in hair, jewelry, and clothing (earrings in nose, cornrows and braids, beads in hair, sneakers with oversized shoe strings, large gold names on neckchains, traditional ethnic clothing) will often keep a talented performer from being considered for a mainstream role. Universality and versatility are the key. Once you have established your image as a successful commercial performer, you may then be able to change the minds of talent buyers and become a trendsetter. As a commercial personality, advertisers are more likely to give you the license to express your heritage and display the beauty of black American culture.

Let's take a look at the descriptions for the different types listed earlier. Decide what image most closely resembles you and create the look for yourself

Children

This category includes infants, toddlers, and preteens ranging in age from birth to 13. Children should be personable, full of vitality and energy, open, and communicative. Naturalness is the most important quality that a child can have. Because the greatest amount of growth and change takes place during childhood, advertisers are endeared to the natural, slight imperfections that children have. You don't have to go out and get your five-year-old's missing front tooth capped!

Twins of any age are always in demand. This is especially true in the case of child actors. Due to strict union regulations regarding the on-camera employment time of a minor, twins are often hired by production companies to play a single role. The twins are alternated in 20-minute time intervals, allowing the production to save valuable filming costs.

Children will most often be featured in commercial situations that relate to their normal, everyday lives: playing in the schoolyard or playground, in the classroom, eating at the kitchen table, playing with dolls in their rooms, playing games in the living room with their families. Typical products that children are likely to endorse include cereals, fruit juices, candy, games, toys, dolls, and of course, diapers!

The big-eyed and charming Emmanuel Lewis's look of complete and trusting innocence won him roles in Campbell's Soup, Elmer's Glue, Fisher Price Toys, Colgate, Jello, and Burger King Whopper commercials. His commercial successes parlayed into his own prime time comedy series, *Webster*.

Teens and Young Adults

This category ranges in age from 13 to 21, the typical junior high or high school student.

Commercial performers who fall into this category will find themselves playing roles that are an extension of the children's commercial market. As the child grows, he becomes the young counterperson in fast food commercials, a student in classroom and locker room situa-

tions, a member of a peer group in social and leisure activities, an athlete on the school playing field, a girl gossiping at a sleepover party, a typical rebellious teen in parent confrontation situations. Typical products that teen and young adult commercial performers are likely to endorse include fast food restaurants, soft drinks, grooming aids, video games, records, cosmetics, athletic and stereo equipment, and sporting goods.

Since the teenage commercial performer represents a change in age and social responsibility, his commercial situations revolve around more controversial subject matter. Teenagers today are politically involved and aware of current events. Their commercials usually present the current trends in wardrobe and music. Teenagers can be seen in commercials about drunk driving, drug and alcohol abuse, birth control, premarital relations, abortion, venereal disease, literacy, and higher education.

Collegiate Types

This category refers to those of you who appear to be of college age, in your early 20s. United Negro College Fund and U.S. Armed Forces recruitment commercials are typical of this category. Commercial types called for in this category include the college student, young salesperson, student nurse, receptionists and junior secretaries.

"Buppies" or Corporate Types

"Buppies" (black urban professionals) are upscale, professional, white-collar workers ranging in age from the mid 20s to early 40s. They are the image of the new college-educated African-American in the business world who is successful, well read, and financially upwardly mobile. Typical commercial types that fall into this category include the teacher, doctor, nurse, lawyer, banker, and business executives.

Housewife, Husband, Mother, and Father Types

This category has the broadest age range, from the early 20s to mid 40s. Some commercials call for young mom and dad types for new family and newlywed couple situations, while other commercials call for the mature mother and father type. One thing remains constant for all women and men who fall into this category: a sincere and likable personality is essential since you are likely be selling groceries and household and family hygiene products to all families across America. American families want to believe that you are the typical product user and that you are being truthful about the product and confident that it will work successfully in every family household.

Spokespersons

A spokesperson is a mature and conservative representative of the image of a corporation or business. The spokesman (or spokeswoman) single-handedly delivers factual information about a company or product.

A spokesperson appears to be upscale, authoritative, intelligent, and knowledgeable. The performer's vocal delivery should be conversational, not emotional, instilling confidence and trust in the viewer. The spokesperson's appeal usually covers a middle age range. Bill Cosby is currently one of our most visible spokesmen for Kodak, Jello, and E.F. Hutton.

Seniors Citizens and Grandparents

When advertisers want to give an air of sentiment and family heritage or show the reliability of a product over the passage of time, they will frequently cast performers in the more mature age ranges. Senior citizens and grandparents in advertising usually are allowed the freedom to be a little eccentric and odd-looking, and their lovable qualities can represent family tradition and familiarity with a product. When you see a senior citizen or grandparent in a commercial, an advertiser usually wants to imply that the product has been used by generations and has always been proven to be reliable. Kodak's True Colors graduating grandmother and Luv's Diapers' grandfather commercials show black senior citizens as active, loved, and integral parts of the family unit. Seniors also sell a variety of insurance, retirement, and health care products targeted to a more mature audience.

Comedic People, Neighbors, and Blue-Collar Workers

These people are the essence of the American public. They are the funny neighbor next door, the construction worker, and the bookworm. These performers often represent commonplace products in everyday situations, cover all ages, and make us laugh at our own shortcomings and insecurities.

Models

Models are hired in commercials for their look—their exceptional physical beauty. Models are often hired because of a particular physical attribute—their hair, skin, eyes, lips, legs, or hands, or their overall fashion appearance. Commercial acting ability is often of little importance. Models are hired to glamorize the look of a product or to make consumers believe using the product will make them more attractive. Models generally work in commercials that sell cosmetics, soap, beauty products, perfume, cars, liquor, and fashion.

Celebrities, Athletes, and Other Well-Known Personalities

This category speaks for itself. There's Michael Jackson for Pepsi and L.A. Gear, Arsenio Hall for Sprite, Magic Johnson for Slice, Bill Cosby for Jello and Kodak, Dr. J (Julius Irving) for Coke, Spike Lee and Michael Jordan for Nike and Coke, Shaquille O'Neal for Pepsi, and Whitney Houston for Diet Coke.

Commercial Agents

Casting directors want to see the best available talent at auditions, so they announce the audition and assign a specific number of auditions or "slots" to the talent agents. In turn, the agents will send, at predetermined time intervals, the talent they think most closely resembles the description of the roles being cast.

Some commercial agents have large client lists to cover the wide range of types requested for commercial auditions. Other agents have relatively small lists or may specialize in one or more specific types. There are a number of talent agents that specialize only in commercials, and others have what are known as commercial divisions or departments within the larger agency.

Choosing the agency you want to represent you depends on your type. You should find out how many similar types the agency represents before you sign any contractual agreement. This will give you the option of being exclusively under contract to one agency, or it will allow you to freelance, working without contractual stipulations for any talent agency. Because there are fewer commercial calls for ethnic performers, it may be wise for the black actor to freelance with several agents until he has established a commercial reputation. All agents do not get the same commercial casting calls. Casting directors often rely on agents with whom they have a successful business relationship and who they can always depend for sending the best possible talent. If you are freelancing, the chances of your auditioning for many different casting directors will be greater. If you decide to sign a contract and work with one exclusive agent, your chances will be narrowed because you will be auditioning only for commercials being cast by a relatively small, select number of casting directors.

A contract signed between agent and talent is a legal, written agreement. This supposedly, guarantees that the agent is working to ensure talent a certain amount of income over a specified period of time. This income is subject to agency commission fees in return for talent promotion. Promotional services include salary negotiation, mailings, clerical services, and even acting as an answering service. If your exclusive agent is not successful at sending the right talent to auditions, the casting directors may stop using your agent to find commercial talent, and your chances at auditioning will become more limited.

There are some talent agents who are well known in the industry for representing a large pool of ethnic commercial talent. Casting directors will often call these agents first, because they know they'll be able to get a wide variety of African-American commercial types. Do your research and find out which agents have good reputations for representing quality black commercial talent. If there are too many actors of the same or similar type as you in an agency, look for another agent, especially if you are freelancing. Keeping their contractual and financial interests at heart, agents will always send out their signed clients first.

The procedure for finding a commercial agent is similar to finding a theatrical agent; however, commercial agents rely more heavily on your look and your ability to handle commercial copy. They are more concerned with your on-camera personality, how well you resemble your type, and how closely your headshot resembles you. This is because you are selling products to a large consumer audience. Agents look for glamorized versions of the average American citizen.

Character photographs are often used by actors in their pursuit of commercial acting jobs. Character photos show your ability to realistically project different looks within the framework of your type. Let's say you're the secretarial type. You should have postcards made up with two shots—your standard headshot and a photo of you in glasses leaning on a typewriter with a desk in disarray or talking on the telephone. If you're the blue-collar type, you can show your versatility with photographs depicting you in different commercial situations—cabdriver, fast-order cook, construction worker, or supermarket clerk. You must still have a good, standard 8 x 10 headshot, but the addition of character photos will show the agents and casting directors just how versatile you really are.

Commercial Auditions

The same professionalism is required for commercial auditions as is required for television, film, and theatre auditions. You must be fully prepared. Your look—makeup, hair, and clothing—should be right for the role for which you are auditioning.

Commercial auditions can also be held at the offices of the production company who will film or tape the commercial.

The Screen Actors Guild dictates the procedure for commercial auditions through everchanging collective bargaining agreements with the advertising agencies and production companies. At your initial audition, you will enter your name on the "sign-in" sheet provided. The sign-in sheet usually sits on the receptionist's or secretary's desk, and you should see it as soon as you walk in the door. Write your name, social security number, and your agent's name on the sign-in sheet. You may also have to check a box for your race, age range, and which audition you're attending (the 1st, 2nd, 3rd or 4th). There should also be a "conflict sheet" for

you to sign, stating that you are not under contract to any other commercials for competitive products. The conflicting products will usually be listed on the sheet. For example, if you are auditioning for a Burger King commercial, all fast food restaurant commercials will be listed as conflicts.

Many auditions are held in small office spaces within casting or advertising agencies. There is usually a waiting area with a separate room attached, which acts as a videotape audition room. This room is usually equipped with portable lights, a small video camera, a playback monitor, and a desk for the casting staff. Upon your arrival in the waiting area, immediately find a bathroom or dressing room where you can check your appearance. Time is limited. Once you have signed in, you may be called to audition almost immediately. If you ran to catch the bus or got disheveled in a wild taxi ride, you need this time to pull your act together. Remember, you'll only get one chance to show your best work.

After you sign in, the casting director or his assistants will take a Polaroid snapshot of you. This snapshot is only for identification purposes. Everyone in the business hates taking Polaroids. Don't make this an issue. Once you fill out an information card with your vital information, your Polaroid will be attached so you and your agent can be identified. You will be given your audition script material, known as "commercial copy" or "copy." Sit down, make yourself comfortable, and, while concentrating, create an imaginary wall around yourself. Don't let anything or anyone distract you. You will probably see many familiar faces and friends with whom you audition regularly. Don't chit-chat or get into lengthy social conversations. You are there to get the job, so you need to concentrate on your audition.

Take a look at the copy and read it over several times. Don't memorize the copy except for the first and last ("tag") lines. Usually during the audition process you will read your scripted material from large placards called cue cards or from a mechanical script forwarding device known as a teleprompt. Be careful not to over rehearse your reading because you want your commercial reading to be fresh and spontaneous.

Being nervous is normal. It's a simple case of mind over matter. To ease the tension and nervousness, focus your concentration to the copy, and you'll forget about how nervous you really are.

In analyzing your commercial copy, decide what your point of view is. Who is the character you're playing, where is he coming from, what situation is the character in, what does he want, and what is he feeling? Decide how your character speaks—the feeling will determine your vocal projection—tone, pitch, tempo, and intensity—as well as your facial expressions. Create an environment using familiar gestures that instantly communicate a point of view or state of mind. Locate the hook, the attention-getting sell words or phrases. They are usually qualitative and/or quantitative and describe the special features of the product—for example,

more sheets per roll, one-half the time, no sugar. Further convince the audience by demonstrating the use of product or explaining information. If you've solved a problem, state the solution with total confidence. Show how great the product is with a strong and positive final statement.

If there is time after studying your script, visit the restroom again to check your appearance. Make any last minute touch-ups to your hair and makeup. Use the bathroom mirror to quickly practice your lines and gestures. If your clothing, makeup, or hair seems inappropriate according to the script, now is the time for changes. Make sure you look good—your best!

When you are finally called to the audition room, take a deep breath and smile! Have your photo-résumé in your hand when you walk into the room. Always bring your photo-résumé, even if you've seen the casting director previously and you know they already have a copy.

Television commercial auditions are almost always videotaped. Be sure not to wear busy patterns, distracting jewelry, or bright-colored clothing. If you have the chance before your audition, check your outfits on a portable video camera for truth of color. Some clothing will change drastically under harsh studio lighting and primitive video techniques. Stick to solid, conservative-colored clothes.

You will be asked to "slate," which means to give your name. "Hi! I'm [your name]." Most casting directors will let you rehearse once before they actually tape your audition. And they will usually give you at least two chances to give your best videotaped audition performance. For the first take, go for it. Be as up and energetic as possible. Focus your eyes directly into the camera, smile, be animated, and communicate in a conversational way. Make sure your voice is not monotonous. Make changes in your voice and facial expressions throughout your delivery. As a rule of thumb, make these vocal and facial changes after each change of thought. For the second take, the casting director will probably give you more specific direction and clues on interpretation. Follow these directions explicitly. You are being tested on your ability to quickly make character choices and to take direction.

After the audition, try to remain calm, say your "thank you's," gather all of your belongings, and leave. Nothing is more embarrassing than giving a great audition, then leaving the room hurriedly, only to return to collect your pocketbook, umbrella, car keys, or portfolio. Remember, your audition impression is a lasting one. You must appear confident and in control of the situation at all times, even under pressure. Even if you are not right for the commercial, you may be remembered for another spot or for commercial extra work. Either way, we are talking about a great paycheck.

Commercials are more likely to be cast today by committee. Your videotaped auditions and callbacks may be viewed by a panel of casting directors, photographers, advertising executives, clients, and stylists, which can number up to 20 people. Unlike in years past, the casting director is now responsible only for the first round of eliminations, narrowing the talent pool to

specific types. Any one of these people can render their objective opinions about your look and performance, which will affect your chances to work. It is important that your talent presentation is always polished and professional.

Many commercial agents are now handling commercial extra work as part of a casting package to ensure continuing work for their signed clients. Commercial actors who are not right for the role for which they originally auditioned can now be offered commercial extra work from the audition tape. After viewing the audition tape, this process allows the production company more visual control over who is actually chosen for commercial extra work and offers the talent agency more financial incentive for securing quality talent.

In certain situations that require a large number of commercial extras, it is not unusual to be put on videotape in an audition situation. These auditions usually require the actor to slate as usual and then to speak conversationally into the lens of the camera. You are still required to dress and act appropriately for the casting process.

In your next mailing, be sure to send a thank you note to the casting director and your agent. This follow-up will keep your memory fresh in their minds.

20

VIDEO SOUL

Music videos are visual promotional vehicles for recording artists. They are fast becoming a good way for performers to catapult themselves to national attention and help move them into new careers. Cable television is largely responsible for the popularity of music videos. BET (Black Entertainment Television) features music video format programming several times throughout the day, while MTV and VH-1 are all-music video cable stations. In some areas of the country, several new music video channels have recently popped up on cable television where the viewer requests his favorite video and pays a small fee to have it aired.

Former *General Hospital* and *One Life to Live* soap opera star Laura Carrington became highly visible in the media as a result of her introductory acting performance as the blind girl in Lionel Richie's "Hello" music video. And top fashion model Maria McDonald was featured in two of Freddie Jackson's videos, "Rock Me Tonight" and "You Are My Lady," moved on to appear in a television episode of *Miami Vice*, and then made numerous appearances on the soap opera *One Life to Live*. Already well-known performers are also featured in music videos. Debbie Morgan, formerly Angie of the soap opera *All My Children*, and now co-starring as a cast member of *Generations*, appeared in Cameo's "Single Life" video as leading lady. Even megastars like former talk show host Arsenio Hall have appeared in music videos. Arsenio appeared in Paula Abdul's "Straight Up" video.

Music videos employ large numbers of performers of all types, ages, and sizes. Beautiful and exotic model-types and ethnic actors seem to be most frequently employed. Dancers who are well-versed in jazz and street dance are also regularly used for the big dance music numbers often featured in the videos of Michael Jackson, Janet Jackson, and Paula Abdul.

Video talent was originally cast primarily by a staff person from the production company that produced the music video. Because of the increase in the volume of music videos being produced over the last several years and the record income the videos generate, agents and

casting directors have become involved in the process of hiring music video talent. In fact, several talent agencies have popped up that, for the most part, represent only talent for music videos.

If you're interested in working in the area of music videos, you might ask your agent if the agency get calls for music videos. If not, find out what agents are involved. Because these videos hire a large number of model types, modeling agencies are frequently used to hire talent for music videos.

It would be a good idea to have a photo taken that represents your music video image. For example, for dance music, the look is very contemporary—upbeat, energetic, and funky. You should also include a section entitled "Music Videos" on your résumé and list the recording artist, song, record company, and production company, as well as the role you played, such as "leading lady," "featured dancer," etc.

You can also send your photo to the many production companies that are involved in music video production. *Backstage* publishes a special music video issue twice a year and lists all the major music video production companies in the United States.

At the present time, music videos are not regulated by the unions, but union members can and should get a special union waiver if they want to work in a music video production.

21

BLACK BEAUTIES

If you've got what it takes, a modeling career can be one of the most exciting, glamorous and financially rewarding professions—but it's not for everyone. Modeling is fast-paced and highly competitive. Modeling is also extremely demanding, as models are always called upon to perform under any circumstances. They must smile, pout, and look pretty and happy even if they are sick. In addition to specific physical requirements, this profession requires a highly-disciplined, flexible, reliable, and physically-prepared person in top condition who is dedicated to hard and tedious work.

Success in modeling is not guaranteed by looks alone. Even if you qualify physically and are one of the chosen few accepted by a modeling agency, the odds are still heavily against you supporting yourself through modeling alone. Many factors—having the "look" in demand, luck, current fashion, and political trends and having the right agent can make the difference between success and failure. Currently, the modeling industry is experiencing an increasingly "colorful" saturation of black models. Beautiful African-American models are virtually flooding the pages of today's top fashion magazines and print advertisements, while veteran black supermodel Beverly Johnson, the first black model to appear on the cover of *Vogue* (1974), and one of the prestigious Virginia Slims models, continues in her luminous career.

Each year, hundreds of young black men and women come to New York to pursue modeling careers, with grand illusions of fame and fortune. But be forewarned: even if you were the number one "top" black model back in Atlanta or Chicago, you still have to meet New York's tougher and more stringent standards. What might have been perfectly acceptable in Atlanta or Chicago might not pass in the fashion mecca of New York, where certain fashion requirements must be met and where the competition is the toughest. It's a simple case of supply vs. demand: the number of models looking for work far outnumbers the supply of available jobs for qualified black models.

The competition is fierce because there are few jobs.

Kidane Sayfou

Commercial print models—the average everyday looking models used to demonstrate product use—are never too young or too old. Their careers can span from infancy to old age. But high-fashion modeling agencies have a specific age cutoff. New female models should be about 14 to 15 years old to be accepted into high-fashion modeling agencies. Traditionally, the black fashion model has outlived her white model counterpart. White fashion models usually have short-lived career spans, reaching the end of their careers as they approach age 30. To the contrary, many black fashion models, often due to their high visibility and community role model status, continue modeling well into their late 50s and early 60s.

The prospects for modeling are, of course, very appealing. Among the many fringe benefits are public recognition, traveling all over the world meeting fascinating people from all walks of life, and large financial rewards. And if you're one of the lucky models to land a major product endorsement contract, the financial rewards and security are even more lucrative.

Veteran supermodel Sheila Johnson talked about how much money a model can expect to earn:

> I did so much catalog work. I made so much money on catalogs. Ads and catalog— that's where the money is. Editorial is absolutely no money but is all the prestige you need to get print advertising and catalog work. That's the way the industry goes. You'll come in the industry as a new model and, hopefully, you'll do as much editorial as possible. Editorial is all the fashion magazines. You want to do that as much as possible. White models get pushed to go to Europe to establish themselves and get the style and flair of a fashion model. Black models don't usually get pushed to go to Europe because we have that style and flair when we walk into a room. So the route is to do as much editorial as possible and then ask your agency to see the catalog people. Catalogs take you all over the world, and you make tons of money. You make day rates and travel fees. Day rates start out at about $1250 for a beginning model and then your rate can go up to $2500 a day. You can get up to $8000 a day, plus bonus fees, plus point of purchase for print advertising. You get a usage fee when the ad comes out. The ad is used for three months. If the advertiser decides to use it for anything else [another print medium], you get paid again and again. So the ideal career would be to mix print advertising with catalog work. Modeling is lucrative.

Keep in mind that a model's earnings will fluctuate throughout his or her career. The trends in modeling change fairly rapidly, and there are times, like today, when black models are especially in vogue.

The modeling industry is a multimillion dollar business tied into some of this country's largest industries, including fashion, cosmetics, consumer products, publishing, and television. As a model, you run your own business—your product is your image. You must use a well-rounded marketing strategy to sell yourself to the "model buyers".[22] Because you are selling yourself as a self-employed business-person, known as an "independent contractor" in industry jargon, your product should be in the best condition possible, and your marketing tools and presentation should equal that of a full-fledged advertising agency. You must develop an interesting marketing plan to sell your image, one that will encourage people to use you as a model. This marketing plan will include your overall physical appearance, your personality, your attitude, and your portfolio photos and composites.

Even with great potential to become successful black models, many newcomers fail to make it, because they lack the business "know-how," which is a crucial aspect of a successful modeling career. As a model, you will often have to make major decisions that can affect the future of your career, and, without a solid understanding of the modeling business, the wrong decisions can ruin your career. It is advisable that you learn all that you can about the modeling business through reading books and magazines and talking to people knowledgeable about the modeling industry. It is unwise to begin any career without an education. The same goes for modeling careers. You have to know how and where to look for work.

Models are "role models" to adults and children all across America who see them on commercials and in magazines. As a role model, you should always present yourself at your best. Remember that anything that you do in public will be scrutinized by the public and the media.

When dealing with other professionals in the modeling business—agents, photographers, magazines, and other clients—you will be judged from the moment you walk through the door. You should, therefore, always carry yourself as a professional. Professionals do not wear Walkmans when they walk through the door, and they do not chew gum or wear sunglasses in someone's office. Professionals always speak positively about themselves, never bringing personal problems with them to their business appointments, and never apologize for their lack of business credentials. If you are a beginner, do not apologize because you do not have many photographs in your portfolio, or because you have never professionally modeled before. If you are at the appointment, then someone, possibly an agent, thinks that you are worth being seen for the job.

Attitudes can make or break a career. Many models complain that their "artistic temperament" is too often misunderstood as having a bad attitude, and indeed, they are right. Unless you are one of the most successful and sought after "top" models in the country, indispensable

[22]Model buyers are those in positions to hire models—for example, advertising agencies, photographers, cosmetics companies, and fashion designers.

to the industry (which is rather impossible, in any case), leave your artistic temperament at home and do your complaining to your family and friends, if you must. Remember that you can always be replaced by one of the thousands of would-be young, gorgeous models just waiting to step into your place.

Modeling can be broken down into two different categories, with varying requirements: (1) fashion and high-fashion modeling, including editorial, catalog, print advertising, runway, showroom, and specialty-size modeling; and (2) commercial print modeling.

Before you decide on the type of modeling you want to pursue, you must evaluate your potential and decide on your qualifications, and you'll have to determine the areas of modeling in which you feel you have the best chance of succeeding.

Fashion Modeling

The physical requirements for fashion and high-fashion photographic modeling for women are rather specific:

- at least 5'8" tall
- size 6 to 8
- wide-set eyes, free of dark circles and puffy bags
- good teeth
- good complexion with skin free of blemishes, scars, birthmarks and stretch marks
- good facial and bone structure with high cheekbones and a long neck
- healthy, well-groomed, manageable hair that flatters the proportions of the face
- long, shapely legs
- a well-proportioned, trim body (the camera will visually add 10 to 15 pounds!)

The fashion modeling industry absolutely requires these very specific physical requirements, and you must fit the bill in order to work as a fashion model. The height requirement is the most important one, and there are few, if any, exceptions to this rule.

> I'm 5'8". Ten years ago the cut off was 5'7-1/2". Today, I would think 5'9" would be the cut off point. I'm considered short for modeling. When they book me with some of the girls who are really happening right now, I find myself stretching a little and asking for the heels.
>
> *Sheila Johnson*

If you fit these requirements, you'll need to determine your "look" to further decide what your fashion modeling options are.

Your "look" is your physical type. Forget that you've always wanted to look like the chic, sophisticated, high-fashion model that wears couture clothes. To determine your look, compare

yourself to the models in magazine ads. If you analyze yourself realistically, you'll be able to utilize your full modeling potential by presenting yourself in the direction of that look through your clothing style, hair, makeup, poise, charm, attitude, and personality. You don't have to be the most beautiful person. If you use all your assets, you can create an attractive marketable style for yourself.

The most popular looks for black fashion models are the "glamour," "ethnic," "exotic," "racially-mixed," "all-American," and "classic."

The *glamour* look is the sharp, chic, elegant, sophisticated look of veteran high-fashion models like Naomi Campbell, Beverly Johnson, Iman, and Sheila Johnson. These models appear regularly in magazines such as *Vogue* and *Harper's Bazaar.*

The *ethnic* look is typical of models like restaurateur Barbara Smith, former *Vogue* cover girl Peggy Dillard, and Wannakee. This look typifies the standard black American female image—the "girl-next-door" look. She could be your neighbor, your friend, or your cousin, but she is, of course, very beautiful. It is within this area that black fashion trends are most acceptable.

The *exotic* looks of veteran models Bethann Hardison, Mounia, and Billie Blair don't fit the standard American female image. The exotic look includes eccentric hairstyles and sculptured African-looking features and coloring. Recording artist Grace Jones first set forth fashion and artistic trends with her unique, exotic looks as a runway model.

Pat Cleveland, Shari Belafonte Harper, and Kersti Bowser have the crossover appeal that typifies the *racially-mixed* look.

The *All-American* look of teen and junior model Shari Headley appears regularly in mainstream junior fashion magazines and fashion ads. This look is fresh and wholesome, with a vibrant, energetic, and alive face. All-American-looking models should project a positive, "up," and fun spirit, with an irresistible smile. Grammy award-winning songstress Whitney Houston started her illustrious career as a teen model on the editorial pages of *Seventeen* and in beauty ads for Max Factor's Maxi Cosmetics and Noxema.

Classic senior models exemplify the beauty of the mature woman over 40. Actress Ethel Ayler, *Life* magazine cover girl and beauty expert Naomi Sims, and '50s superstar models Helen Williams and Dorothea Towles, forerunners of the contemporary black modeling industry, still represent the spirit, beauty, and dignity of mature black womanhood.

Editorial Modeling

Editorial models are hired by a magazine staff to present a clothing statement that the readers will want to emulate. This type of model is more like an actress, creating in photographs, different moods and expressions that will persuade the consumer to go out and pur-

chase clothing. No expense is spared in promoting the garment industry. Through interesting, faraway locations and elaborate grooming, editorial models develop a creative interpretation of the fashions and their origins. The competition for appearing in the editorial pages of the leading magazines is keen. However, the actual salary commanded for editorial work is usually very low because magazine editors feel this type of modeling is very prestigious and is often a publicity forum for increasing a model's visibility. Editorial modeling is also crucial to portfolio-building through the collection of "tear sheets." Tear sheets are the printed magazine pages from an actual job the model uses to generate more work. The model must be photogenic and come alive in front of the camera. Depending on the magazines and the fashions, all types of model looks are used, including the most exotic and extreme.

The magazine cover model's job is to sell the magazine. Her face represents focus of the publication—she should have intense eye contact, beauty, and physical appeal. black models have frequently appeared in the leading general-market fashion magazines, as well as in black fashion and consumer publications like *Essence, Ebony, Emerge, Ebony Man, Modern Black Man, Black Enterprise, Emerge, Elán, Class, Sepia, Tan,* and *Black Elegance* magazines.

Catalog Modeling

Catalog modeling is by far the mainstay of the modeling industry. There are virtually thousands of companies that hire models to specifically sell their products and clothing through mail order publications, called catalogs. Sears, Spiegel, J.C. Penney, and Montgomery Ward produce the largest catalogs, and the smaller catalogs—Tweeds, J. Crew, Victoria's Secret, and the like—are put out by department stores, boutiques, and specialty stores. This is where the experienced model makes their "bread and butter" money, but it's restricted to the modeling pros. A catalog model must be able to withstand the tedious job of modeling many different outfits in a single day, assuming simple variations in posing, and being photographed from a variety of angles. Catalog shoots are fast-paced, high-volume productions that require consummate modeling professionals only; beginning models will rarely be selected for catalog modeling. The model must be an expert at applying her own makeup and styling her own hair, because makeup artists and hairstylists are rarely present. Catalog photo shoots are usually very conservative with no fancy locations, sets, or lighting. The model's only job is to sell the garment. Very few shots are taken of each garment, so the model must know exactly what to do with collars, pockets, belts, and hands. Black models are regularly seen in many of the leading fashion catalogs, as well as in the black-oriented catalogs *Essence By Mail* and *Ebony Fashions.*

Print Advertising

Print advertising is also a prestigious and portfolio-building facet of the modeling world. Fashion, product, cosmetic, and beauty advertising fall under this area. For a magazine's advertising pages, the model is usually hired by the advertising agency or photographer who represents the fashion firm. The model is selected according to the "look" needed to sell the fashions. In beauty advertising for cosmetics and jewelry, the model may be used for a particular part of her body. All parts of the body are used: lips for lipstick ads, eyes for eyeshadow eyes, and necks and shoulders for jewelry ads. Beauty advertising is where the model can earn megabucks, especially if she is lucky enough to be signed to an exclusive contract to endorse a product. This is also the area where model personalities are developed, because of their high visibility and identification with personal beauty products. Black hair care, makeup, and beauty products like Flori Roberts Cosmetics, Fashion Fair Cosmetics, Posner, Ambi, Classy Curl, and Soft Sheen Products use black models exclusively for their print ads. General consumer market companies like Revlon, Avon, and Noxema use black models in their black-oriented, foreign, and general-market ad campaigns. Although black models have made many inroads infiltrating the print advertisement industry, they still find most of their print work in black-oriented product and print ad campaigns, which appear in the United States, the Caribbean, and Africa. For example, Virginia Slims ads can be seen in most of the leading magazines with White models, but in black-oriented publications, Beverly Johnson, Iman, and Sheila Johnson are featured. Beverly Johnson has graduated to become the spokesmodel for Capri Super Slim Cigarettes. The same applies to the prestigious Monet and Napier Jewelry ads, which feature black model Sheila Johnson.

Runway Modeling

Runway or "ramp" models are employed by fashion designers and fashion couture houses. Black models have traditionally fared extremely well in this area. Iman, Pat Cleveland, and Mounia are among the most sought-after black runway models in the world.

The physical requirements for runway modeling can be different from the requirements for fashion print modeling. Because these models are wearing specifically-tailored designer garments in front of a live audience, designers tend to choose models who look more physically statuesque and dramatic. Aside from height differences, runway models can also be chosen because of interesting personality and movement qualities.

The runway model can be as tall as 6'1". Broad, "coat hanger" shoulders on which clothes can fall freely, long legs, and a delicate, swan-like neck are often among a runway model's assets. The model must move with confidence, appearing to love what she is wearing while looking graceful and relaxed. It is essential that a runway model masters the fine art of displaying garments.

Four times a year, designers preview the direction their line is going to take for the upcoming fashion season. A designer will show his "collection," an assortment of styles, which will eventually determine what types of clothing you will see in the stores. These shows are international fashion extravaganzas held in New York, Paris, Milan, and Japan. Each collection may feature between five and thirty top runway models who are employed by the designer's fashion houses, also known as "couturier" houses. Runway models travel extensively throughout Europe, Southeast Asia, and the United States.

Dance training is very helpful to the runway model who must move with long, graceful strides. It is not important that a runway model possess the general American image of a pretty face. Exotic, eccentric, and unusual looking models are often sought for runway work.

Showroom Modeling

Showroom models are employed by fashion manufacturers to model a succession of clothing for visiting store buyers, while sales representatives interpret the line's selling features. Along New York City's famed 7th Avenue ("Fashion Avenue") garment district, manufacturer's showrooms hire models either full-time, seasonally during "buying" seasons and "market week", or on a daily, freelance basis. It is helpful that these models also possess secretarial and office skills. These models, when not showing garments, often do double duty as receptionists, secretaries, and sales assistants. Showroom models must fit sample garments perfectly and must be a perfect sample size. Often times, a designer will use a perfect-sized model to "fit" garments made for consumer purchase. These models often are used to make sure an entire designer collection is sized and worn properly by the public. Some agencies carry two or three "fit" models on their head sheet. These models often run from designer showroom to showroom trying on sample clothing, making thousands of dollars in a single day. They usually never have contact with the public or the advertising media.

Trade Show, Promotional, and Convention Modeling

Trade show, promotional, and convention models must look pretty. This is first and foremost because they are often used for live industrial sales promotion—to hold up a sign near a product and smile. They may also have to distribute fliers or make sales pitches.

Trade shows and conventions are held throughout the country in most major cities. New York's annual Boat Show, Auto Show, Black Expo, Toy Fair, Fashion, Sportswear, Shoe, Fur, Jewelry, and Beauty shows hire large numbers of models. This type of modeling is very tiring.

It requires long hours of standing on your feet. At the same time, you must smile and appear pleasant and full of bubbly personality. The pay for this type of modeling is the lowest in the field, and a model usually cannot make a career of trade show and convention modeling. There are, however, some models who are hired year 'round as spokespersons for a particular product. These salaried models travel with the company all across the country as product representatives.

Full-Figured and Petite Modeling

Special-size models have, in recent years, moved into the mainstream of fashion modeling. Society has finally begun to respond to the fashion needs of the millions of full-figured and petite women in America who were excluded from the mainstream fashion world.

Once fashion outcasts, doomed to old granny and matronly-styled, tent dresses, flowered housedresses, and polyester pantsuits, the full-figured woman is experiencing the emergence of a whole new fashion industry, which caters exclusively to her size 12+ fashion needs. The full-figured model has discovered a new market for her modeling talents in fashion, print, catalog, showroom, and runway work. The growth of this field is evidenced by the scores of specialty clothing stores and magazines that feature full-figured models exclusively. Lane Bryant, Roman's, Bloomingdales, Saks, and other leading stores feature these models regularly in their print advertisements and store catalogs. Magazines like *Big Beautiful Woman* (*BBW*) and *The Allure Woman* are geared to the full-figured woman and use full-figured models exclusively on their fashion, editorial, and beauty pages.

As a result, the top fashion model agencies now have full-figured fashion divisions. Ford Models has a division called "12 Plus." There are also many specialized modeling agencies springing up that represent only full-figured models. In New York City, there are Big Beauties and Plus Models. Cuington Model Management is owned and run by one of the industry's veteran black full-figured fashion models and fashion photographers, Phyllis Cuington.

Closely related to full-figure modeling is the specialty size modeling field for petite models. Women under 5'4" are seeing the emergence of a fashion industry that is catering exclusively to their small-sizes. In New York City, there are several modeling agencies that represent petite models: Petite Model Management (a division of Elite Models), Little Women (a division of Big Beauties), and Judith's Models.

Modeling Abroad

Many beginning models are encouraged by their agencies to get exposure modeling abroad. Tokyo, Milan, Munich, London, and Paris are great proving grounds where new models can

build their portfolios. Black models have fared extremely well in these overseas markets, particularly in runway modeling.

Sheila Johnson talked about travelling abroad:

> If I had to say anything that was the most difficult thing about modeling, I'd say it was getting to be able to depend completely on yourself. When you're traveling, your agency will give you your itinerary. You have to have absolutely every detail written down in blood because that driver might not be there in Milan, Italy. That driver might not make it to bring you your petty cash. For a young model in a foreign city who doesn't have her itinerary and thinks someone is going to be there to pick her up, you need to find out tax lines. You don't ever want to run out of money. Don't ever want to not know where you're going. You want to know the home numbers of people on the shoot—the photographer, the makeup people, the hair people—and your agency. If you find yourself in a hotel in the middle of the night without a credit card and the hotel needs a credit card imprint, you'll have to give them all of your cash, your driver's license, your passport, everything that you have. Though that should never have to happen, it does.

Commercial Print Modeling

Calling all ordinary people with "real" faces! There's a "real people" revolution going on in the world of modeling. Product advertising is being flooded with character and comedy-type faces. Gone are the days when a commercial model had to be exceptionally beautiful, thin, tall, or strikingly handsome. Look at magazines and billboard advertisements. Today's models are also "real people," the type of ordinary people you see everyday—bus driver, car mechanic, supermarket clerk, and secretary.

Commercial print models can appear plain, frumpy, or glamorized, but they always maintain their "real people" quality. Many actors and actresses who do not fit the requirements for fashion modeling can supplement their acting income by appearing in ads that sell liquor, cigarettes, household products, home remedies, fast foods, and soft drinks. Personality and acting ability are the keys here. It is important that the commercial print model represent the real consumer. Because there is such a wide variety of products in the consumer market, commercial print models can work outside the youthful images presented in the fashion arena. Being slightly imperfect can often be an asset for a commercial print model. Character types can be young or old, tall, short, thin, or overweight. Men can be balding. Glasses, dentures, and braces can actually be an asset. Even allergy, arthritis, and rheumatism sufferers can find work in commercial print modeling. Advertisers want to hire models that actually suffer from these typical physical ailments to demonstrate the effectiveness of their products.

As a commercial print model, you need to develop an image that represents a believable product user. These models encompass every conceivable type, shape, size, color, and age.

Although the commercial print model does not necessarily need the elaborate portfolio carried by fashion models, it is sometimes profitable to carry a simple composite showing a variety of characters and a good black & white, 8 x 10 headshot. The commercial composite should show you using products, but the products should not be commercially identifiable.

Once the commercial print model has these tools, she can make the rounds, visiting photographers and advertising agencies. It is wise to affix an agency sticker or label to all photos and composites you leave behind because pictures have a tendency to move around quite a bit. You want to make sure your photographs can always be identified and that your agent can be contacted.

Industrial models illustrate business usage of office machinery and tools in company brochures, in-house company bulletins, and films that advertise and describe company services. Industrial models usually have a very corporate appeal, the "spokesperson," upscale, professional type look. Models must appear educated and capable of supervising employees, office machinery, and even business management. Because industrial modeling work usually stays within the confines of a corporation or business firm, models are less likely to be recognized and exposed to the general public.

There are modeling agencies that deal specifically with the commercial market. These agencies are less likely to handle fashion models and, today, large agencies now offer a commercial print department as a subdivision of the fashion agency. Many advertising agencies and photographers casting for a commercial print ad will steer away from using a fashion agency, knowing that the commercial agencies will deal more specifically with character and industrial types, models with acting ability.

Male Modeling

The image of the American black male in print advertising still has not reached its proper status; however, in recent years, the market has improved significantly. Many magazines and catalogs have now embraced the idea of the black male being able to buy and afford the same clothes and accessories as the white, middle-American male and are including handsome African-American models in their catalogues, editorials, and publications. Black male models such as Renauld White, Alan Cephus, Rashid Silvera, Alvin Fernandez, James Vest, and Kidane are recognizable faces, appearing regularly in the leading fashion and consumer magazines and catalogs. Even black male celebrities have gotten on the print bandwagon. Check out Michael Jordan's campaign for Coke, Billy Dee Williams' campaigns for Colt 45 Malt Liquor and, most recently, Avon Cosmetics' new women's fragrance, Undeniable.

Sizing requirements are basically the same for all male models. Men should comfortably fit a size 40 regular suit, with a height ranging between 6'0" and 6'2" tall. This is because, many times, a fashion editor or stylist has the clothing for a particular photograph long before the models are hired. The fashion industry recognizes a 40-Regular suit as the standard male sample size, representing the average American male build, according to fashion industry statistics.

The male model must also possess a body that is proportional to his height without an excess of body weight. The all-seeing eye of the camera automatically adds between 10 to 15 pounds to the average frame, and a body that is too heavy or too muscular will appear distorted and awkward.

Good skin, hair, and teeth are also important for any male who chooses to model. Whatever your coloring is, your skin should be as blemish free as possible and should reflect good health. Hair can also be worn in a variety of styles, from chemically straightened to natural growth, and, in some extreme cases, as in the case of model David Kennedy, dreadlocks are acceptable. However, it is best to assume that the more extreme your hairstyle, the less likely you will work. Certain ethnically-based products and fashion designers favor ethnic looks to capture the essence of a particular heritage. In the mainstream commercial market, the emphasis is placed on the image that is non-offensive and suitable to the needs of middle-America. This is a long-standing rule that has been tested by hundreds of black models, and this is a very serious statement about the way things are perceived in the fashion industry. There are still changes to be made in raising public awareness to the beauty of foreign cultures. In the meantime, if you sincerely want to work and be successful as a black male model, you must modify your look to be nonthreatening to advertisers and their clients. Once you have broken down a few doors, you can then try to influence people that your particular style and culture is worth emulating.

Black America needs male role models playing the young collegians, husbands, fathers, the fashionable "GQ" type, the "buppie," and the more mature, character type that covers older relatives and spokespersons. The mid-20s to mid-30s age category has the broadest fashion appeal for black male models.

The longevity of a male model depends upon his type and his general physical condition. Male models tend to work a little longer than female models in the fashion modeling industry, if they are in top physical condition.

Parts Modeling

If you possess unusually beautiful hands, feet, legs, or a well-defined and proportional torso, you may want to consider also working as a body parts model. Known for their perfection, a good body parts model can command extremely high working fees and must promote her career just like a regular fashion model.

For example, a hand model may be specifically trained to handle products for commercials and print and most possess well-manicured and proportionally well-sized hands for extremely tight camera close-ups. Hands must be free of scars, blemishes, and body hair, and the skin texture and color should be event and uniform. Nails should be clean, well-groomed, and free of hangnails and dry, overgrown cuticles. Women's hands should be well-manicured with conservative nail length and color.

Just like character actors, hands can be romantic and fashionable as used in cosmetic and health care accounts, or they can appear rugged and blue-collar for working class people as used in beer commercials and men's sports products. Body parts models also cover the color spectrum and vary in size and proportion. Body part models may also be hired to double for popular celebrities when an advertising client wants a product handled cosmetically and professionally in a commercial situation.

Parts models have their own special audition process and work through regular fashion and commercial print agencies. The fees and commissions are standard in the industry, and, aside from collecting residual payments, the pay is usually above scale as a principal performer. Today, there are also special agencies that only deal with these specialized artists.

The Model's "Tools of the Trade"

There are three "tools of the trade" that are essential for the model:

- a portfolio (commonly known as a "book")
- a composite (also known as a "model card")
- a model's tote bag, ready to go on a moment's notice

Your book should include photos from many different sources. No one photographer should produce your entire portfolio. Your portfolio should contain a variety of settings, moods, and clothing and photographic styles. To avoid having a book that appears repetitious and one-sided, beware of photographers who offer package portfolio deals. Photographers who offer package deals usually make their income by convincing newcomers that they can put together their entire presentation on a shoestring budget. They will often profess to offer everything in one shooting. The professional model compiles many years of photo shootings, test pictures, and work to create a winning portfolio. Each roll of film a photographer shoots can offer you between 20 and 36 picture choices. If you consider that it takes three to four rolls of film (144 choices!) to get just one presentable portfolio shot, then it follows that it would take 30 to 40 rolls (1,440 choices!) to get 10 presentable portfolio shots. Remember, we are not accounting for changes in hair, makeup, wardrobe, lighting, setting, and location. Even if the photographer makes no mistakes, how can one afternoon's work by only one photographer guarantee you 10 to 12 quality pictures?

Developing and maintaining a good portfolio is a never-ending battle. Models are always growing and evolving, and their pictures should represent this process. Instead of setting a time limit on a finished portfolio, collect your pictures one or two at a time, choosing only the most perfect shots. It is better to show four dynamic pictures than a volume of mediocre photos.

There are several different sources from which you will assemble your portfolio.

If you're a newcomer with no modeling experience, all you need is a good photograph of your face and a full-length body shot to begin with. It isn't necessary to invest in a full-fledged portfolio at this stage of the game. Have a friend take some photos of you, and use those pictures to find an agent. Wait until you get signed by an agency to begin putting together a portfolio. Your agency will provide you with a list of photographers who are testing. In a testing, the photographer may be building his book or experimenting with new equipment and will shoot pictures of you with little or no charge for his labor. The model normally just pays for the cost of the film and processing.

> People come up to me all the time, especially young girls, and they say they'd really like to but they can't afford a [portfolio]. It's a crime that there are a lot of photographers out there that can't even get one job in the advertising world as a photographer, but they'll take these girls' money for these ridiculously horrible pictures. I would have your friends take pictures of you. Take Polaroids. It's absolutely ridiculous to pay a photographer like that. The thing is, if you're not in an agency, then you don't want to spend the money to establish yourself to get into an agency because you're probably wasting your money. I didn't spend one dime on pictures, not one dime. No girl has to. That's what a test is. These photographers need you as much as you need them. That's why I'm saying, if you're not in an agency that's going to tell you that and do it for you, it's not worth it.
>
> *Sheila Johnson*

If you don't have an agent to arrange testings, you will have to begin developing your book on your own. You can sometimes find testings on your own. If you know someone with modeling experience or if you know someone who has industry experience or connections, ask for recommendations. With some luck, this may give you a nice list to start with. If you can't find a photographer who is testing, investigate professional photographers who charge for photo shoots. In the beginning, don't spend a lot of money on pictures. A good headshot and body shot will do. Don't sacrifice quality for low cost.

Another way of building your portfolio is by including tear sheets of work from your modeling jobs. A tearsheet is the actual product of a print job's photo shoot. It is often a page from a magazine or catalog. You can get your tear sheets from the photographers you have

worked for, your modeling agency, the advertising agency that places your work in the various publications, or from the publication itself.

A good and inexpensive way of showing additional color shots without going through the expense of duplicating color prints is with 35mm color slides. After a shooting, a photographer will normally edit all of the photo selections taken during a particular shoot. After removing one or two of the best shots for duplication, the photographer will give the model the remaining film in the form of 35mm slides. You choose your best shots and arrange them in a plastic, 35mm slide sleeve, which is available at most photo supply stores.

Be sure to take precautions with all of your portfolio materials, especially slides. Slides are easily scratched and damaged due to exposure to heat, moisture, and excessive handling. Always play it safe and have your slides and prints duplicated. This way, if something happens to your book, you will have replacements.

Your portfolio should contain a full length body shot, a formal evening wear shot, a good fashion and commercial headshot, perhaps photographs of hands or feet, and photos with other models, both male and female, black and white, young and old, in the background and forefront. A good beginning portfolio contains between eight and ten shots from different photographers, conveying changes in mood, environment, lighting, and wardrobe. It is also good to show physical activity in your photographs, displaying athletic abilities or hobbies. The trend for posed, still photographs has changed abruptly over the past few years. Check out the major fashion and consumer publications to get an idea of the styles of photography that are appropriate for your market. It is important to show yourself to your best advantage at all times. Have your portfolio seen and reviewed at once. Getting other opinions will keep your book from being one-sided and uninteresting.

> No more than 20 pictures. It's boring. After the 10th or 15th picture, [the clients will] be looking out the window while they're flipping the pages. It's very redundant. Only your best pictures. Better five good ones than five good ones plus five bad ones. There's nothing shameful about being a beginner. It's only supposed to show how good you can look, not how bad you can look. That's the single biggest mistake people make—they put in four or five good pictures, a tearsheet or two, and then junk, because they want to make it look more impressive. But it makes it look worse. Don't put a tearsheet in if it's not flattering to you. That's another mistake people make. But people consistently do it. It's common, it's very common.
>
> *Peter Lerman*

Aside from your portfolio, you will need a model card or "composite" to leave behind at go-sees and interviews. It also represents you when you cannot be physically present, keeping you fresh in the minds of potential employers. Models have even been known to book work exclusively from a good card.

Your first model card will display between one and four of your best portfolio shots. Your card can be in color or black & white, printed on one side, both sides, or on many different pages. Because of expense, it is advisable to have a black & white card printed when you are first starting out. You can have a more elaborate color card with numerous foldout pages made up later, when you acquire tear sheets. New models need not spend a lot of money for elaborate cards initially; however, your card should represent you in the most flattering way possible. Along with your portfolio, your card is the most important piece of information about you. It is what you leave behind.

The standard 6-in. x 8-in. model card is currently experiencing a renaissance in New York City, as models are distributing graphically-appealing 6 x 8 cards that are designed in all different formats. More experienced models who have actual work and tear sheets usually produce color model cards with more elaborate foldouts to show their range and experience. Have printed on each card your physical statistics (measurements, sizes, and coloring) and the name, address, and phone number of your agency.

The following chart outlines what physical statistics should be printed on your model card:

For Women:	*For Men:*
Height	Height
Weight	Weight
Bust	Waist
Waist	Inseam
Hips	Suit
Dress	Shirt
Shoe	Shoe
Hair	Hair
Eyes	Eyes

Your card should be left at every firm to which you are sent. It should also be mailed to photographers and advertising agencies. Model cards have been known to be filed for years. It is to your advantage to make sure your card is always circulating with current agency representation, service phone numbers and information clearly printed on it.

When you're ready to have photographic prints made for your book or composites printed for distribution, be sure to shop around and compare prices and quality at the different photo shops.

Color prints (also known as "c-prints") should be custom-made. As an alternative to c-prints, especially when you need photos printed in a hurry, you can have Cibachrome or color stats made. These prints are made by a machine in about one to three hours, at a price consider-

ably less than c-prints, and are of comparatively the same quality (depending on where you have them printed). Color photocopies have also become an affordable alternative for emergency printing. Composites should be printed on a medium-weight stock with either a laminated glossy or matte finish.

Modeling Agencies

We asked veteran supermodel Sheila Johnson how a beginner gets into a modeling agency:

> What usually happens for most people is that they have to call around to the different agencies. Where they get names from—well, they can get them from the newspapers, and a lot of the publicity the models get in the magazines say what agencies they're with. Most of the agencies see prospective models once a week, and you should make those cattle calls. There are girls and guys from all over the country that are sitting there waiting for the same opportunity that you are. And if you don't get in during that day, you'll have to come back the next week. It's really a madhouse. I would say 40 to 50 people usually show up for these cattle calls. It's a little different today [than it was when I started 13 years ago] because most of the agencies have talent scouts. The agencies realized that if they went to the different pageants, the proms and pep rallies to scout the girls out, they could find the girls from Omaha and small towns across the country who are pretty healthy and gorgeous. So that's what the agencies do now. The talent scouts are a division of most of the big agencies.

You should call the agencies to see if they have open interviews where you can just walk in and be seen. If the agency doesn't have special times where new models can walk in and be interviewed, you should send your photos with a short note requesting an interview appointment. Keep in mind that modeling agencies are only going to be concerned with your money-making potential as a model. They are not going to be concerned with how long you've dreamed of becoming a model, a story they've heard countless times already. You must prove to them that you have the attributes and potential of becoming a successful model. Physical appearance, clothing, attitude, and mannerisms are all important.

We asked top New York print agent Peter Lerman about a model's career responsibilities. He had this to say:

> The model's responsibility is to maintain their looks—don't put on tremendous amounts of weight or lose tremendous amounts of weight. Don't go get a mohawk without me knowing about it. Don't shave off your mustache if you work with a mustache. If all I have in the files is shots of you in a mustache, you'd better be able to show up in a mustache—that's the responsibility of the model—that if you have

it shaved off, you have one you can paste on. Same with hairpieces. Keep your agent informed of any radical changes. Maintain your health and good looks.

When asked what turns him off about a model, Peter had this to say:

[What turns me off is] when you get someone who is talented, who has what it takes to work, and is too lazy or disorganized. A lot of models are really their own worst enemies. We call them up, we say we're out of pictures of you in the file. Then they don't come around with the pictures for another three or four weeks, and if that, they mail them in. We don't want models coming by every day. We don't want them checking in every day. But if you stick your face in once in a while, you're more in the agent's mind. Know when you stick your face in—you just may have walked into a hurricane, and nobody will have time to say anything but hello and good-bye. It's okay, the people that come around just once in a while, every few weeks, to say hello, to see if I have enough pictures of them in the file—the people who aren't too lazy to drop off the vouchers themselves instead of just mailing them in. The people that are so lazy that they look to avoid coming to the agency are doing themselves a disservice. The people that piss me off are the people that don't keep me supplied with their shots when I want them. I'm hamstrung—half the jobs they're simply not going to be considered for. And after a while, I'm just going to get mad at them. The people that don't return their calls in a timely fashion are even worse. Those are the two big things—keeping me supplied with pictures and returning calls quickly.

Once you've been accepted by a modeling agency, they will advise you on all aspects of your career—your look, your dress, your pictures. You will discuss the photos they want you to represent yourself with and, if they don't like the pictures you already have, they will arrange new "test" shoots.

There's a promotion division for new models who don't know much about the business. In the promotion division, the agency tell you how to dress, how you should look, where you should shop, where you should go out to dinner, and what people you should know. They take pretty good care of you. They'll introduce you around so that when you get pushed into the Model Management division, you'll be all ready to work. And then in the Model Management division, they manage your career. They're still pushing you while you're working. In the Model Management division, there are the girls who are working and the girls who are just about to take off. In the Elite division, where I am, you don't need anyone pushing you at all. You have made it, you're a name, they call and ask for you. And that's where I am now.

Sheila Johnson

You will probably be asked to go on your agency's "headsheet." A headsheet is a collection of pictures, names, and physical statistics of the models who work through one particular agency. It is distributed to prospective clients. Virtually all agencies charge their models to be included on a headsheet, but costs vary widely. Some of the top agencies charge their models fees up to $2,000 to be included on the headsheet, while some of the smaller agencies may only charge $45. Be sure to determine the fee before you agree to be put on a headsheet. An agency should obtain your consent, usually in writing, before including you on its headsheet. The design of each agency headsheet will vary, from elaborate spiral bound books with full-color pages to small books with black & white headshots of several models per page.

A model should also have an answering service or some type of reliable phone number through which she can always be reached by her agency booker. Your agency booker is the person with whom you will be in contact with daily. They are the people who actually handle your day-to-day go-sees and bookings.

Models who have not yet been accepted by an agency or who prefer to "freelance" (work through various different agencies) will have to do their homework, and do it well. Remember, most modeling work is secured through agents. You'll need to go through the *Madison Avenue Handbook* and the *Creative Black Book* and take down the names of all potential employers— advertising agencies, photographers, cosmetic companies, department stores, magazines and newspapers, fashion houses, designers and showrooms. Call and find out what their policy is on seeing models.

A new national local union called The Models Guild was formed in 1995 by the Office and Professional Employees Inter-National Union. Designated as Local 51, The Models Guild has exclusive jurisdiction in all non-film aspects of modeling such as runway modeling, print and catalogue modeling, retail modeling, freelance modeling, editorial modeling, illustration modeling, and specialty modeling. Quoting from a recent press release:

> The profession is far from glamorous, with the majority of working models being subjected to long hours, without the basic protections such as Worker's Compensation coverage, pension and health insurance coverage, and basic safety and health protection on the job. Modeling careers are often all too brief, frequently shortened through unscrupulous practices by false agencies who foster gross exploitation of young and unprotected models. The legitimate and reputable agencies cannot provide the united voice models need in such an unregulated industry.

For further information contact Ms. Amie Bongay, President, OPEIU Local 51, ALF-CIO at (800) 346-7348.

Model Extras

Model's Mart

It is also wise to read the major fashion and consumer magazines including *Essence*, *Ebony*, *Ebony Man*, *Esquire*, *Blactress*, *Sophisticate's Black Hair Care and Styles Guide*, *Glamour*, *Mademoiselle*, *Harper's Bazaar*.

Beginning models are often easy targets for rip-off agencies and scam practices. If anyone approaches you on the street about modeling, take his business card and call the Better Business Bureau to see if any complaints have been filed against him for unscrupulous business practices. Ask your fellow models if they have ever heard of that person or agency. Phony agencies are rampant. Never pay an agency a registration fee. Agencies make money only when you make money, in the form of a commission. Reputable agencies will never ask for any front money. Also, stay away from agencies that recommend you get your portfolio done only by their photographer. These are usually rip-off arrangements where the agency is getting a "kick-back" payment from the photographer, and the photos you receive will usually be unprofessional and totally useless in the professional modeling world.

It is often very tempting when someone says that they can make you a "star," but keep in mind that successful careers are not made overnight and no one can make you a "star." No agency can guarantee you a job. No legitimate modeling assignment will pay thousands of dollars to a beginning model from a classified newspaper ad. With the thousands of professional models looking for work, there is no need for a legitimate agency to advertise in the paper. Stay away from those agencies that specify "no experience necessary" or "all types and sizes." These agencies usually take anyone who walks in the door and wants to be a model. They are just out to make easy money from naive aspirants who want to be models.

Modeling Schools

Modeling schools are yet another area plagued with rip-off operations. Some modeling schools have been known to promise models jobs once they've completed a costly modeling course. No reputable modeling agency will ever promise you a job. All a modeling school does is provide you with basic instruction on makeup, hairstyling, grooming, nutrition, model posing, and walking. Don't let them fool you. Most modeling schools can't do anything to advance your career. Individual modeling seminars and courses are more productive investments in your career, as they are usually given by professional models and industry personnel. Many of the top modeling agencies offer special courses and seminars for beginning models which are quite informative and helpful.

The [modeling] schools are not going to make a model out of someone who couldn't normally be a model. If you have the talent, the ability, the looks, the disposition and the smarts—if you really have what it takes—there will probably be an agent somewhere who will help you mold yourself into a model. The modeling schools will give you confidence, and they'll show you some basics. I don't write them off as a total waste of money. I just don't think they are what people think they are. They really are what they generally present themselves to be, a place where they'll teach you how to coordinate your outfits, put on your makeup, etc. If you need that, do it. I don't think it's going to make a model out of a non-model. It's self-improvement. You can't just put someone into modeling school and let them leave [as] a model.

Peter Lerman

Today's top black models like Wannakee, Coco Mitchell, Louise Vyent, Karen Alexander, Alvin Fernandez, David Kennedy, Brett Walker, James Vest, Naomi Campbell, Mounia, Sheila Johnson, Gail O'Neill, and Kersti Bowser are prime examples of the type of success that a black model can reach. You, too, can be as successful if you make the right decisions in your career and never give up believing in yourself!

22

DANCIN' DIVAS

First of all, you've got to think, 'Why do I want to be a dancer?' It takes a lot to be a dancer. It takes a lot to be anything. It's more than just classes. It takes all this politics. You've got to know you really want to dance because it isn't an easy thing. Most people think it's easy—they just jump up and down. It takes 99% brains, and the body will do the other if you train it. Many people think it's just the opposite.

Louis Johnson

In recent years, dance has become a viable business, with dancers taking a more active role in television, film, and commercial production storylines.

Dance training is broken down into the areas of style and technical study—ballet, modern, jazz, tap, folk, ethnic, African, Caribbean, forms of "street" dance (including break dancing, and video dance), disco dancing, ballroom, gymnastics, and aerobics. Dance training is not difficult to obtain in major cities; however, specialized dance forms are more difficult to find once you get away from large urban areas with large multi-ethnic populations.

Professional dance means a life of sacrifice and physical conditioning. More than ever, dancers train like athletes, with strict physical and mental disciplines. One class a week for 90 minutes each is certainly not enough for the working dance professional—dancing improves only with consistent daily study. A professional dancer should dance every day for at least three or four hours. This encourages mental agility, trains the body, and allows the dancer to gain physical strength, endurance, and flexibility. It is also essential that a dancer master the dance elements of style, character acting, and timing with split-second precision and accuracy. Dancers are frequently called upon to physically narrate a staged theatre work. This requires acting ability and personal grooming suited to storytelling and physical exposition.

A dancer needs all kinds of knowledge. A dancer doesn't just need dance knowledge. In order to dance, you need knowledge of life, living, and everything, because when you start to dance, that's what you're interpreting—life!

Louis Johnson

Dance has been known as a vehicle that catapults theatre chorus talent into the spotlight. In the early history of the prestigious Cotton Club, a teenaged Lena Horne stepped from chorus dancer to featured singer. Gregory and Maurice Hines' tap dancing careers started as part of a family nightclub act. Now Gregory commands star salary and top billing in feature films like *White Nights, Wolfen, Running Scared,* and *Tap*. Gregory's brother Maurice has appeared with him onstage in the Broadway biography *Eubie,* and their relationship was further explored as tap dancing hoofers in the feature film *The Cotton Club*. Maurice went on to own a successful dance business and helped produce and choreograph the black Broadway musical revue *Uptown, It's Hot!*

Debbie Allen parlayed a successful dance chorus career into real show business success. Having appeared in the Broadway shows *Ain't Misbehavin',* *Purlie,* and *Raisin* as an ensemble dancer, Debbie went on to headline revivals of *West Side Story* and *Sweet Charity*. During this period, Debbie was awarded the opportunity of creating the role of dance teacher "Lydia Grant" in the original movie version of the hit television series *Fame*. The remarkable Ms. Allen now produces and directs major television series and film projects, including the *Cosby* spin-off series *A Different World*. Debbie's sister, Phylicia Ayers Rashad, left the chorus of the Broadway musical *Dreamgirls* to appear in the TV soap *One Life to Live* and to win the coveted role of "Claire Huxtable" on the hit television series *The Cosby Show*.

The black dance community is quite small and is most active in the training grounds of New York City. For today's competitive dance market, a black dancer should have a definitive knowledge of ballet, modern, jazz, tap, and ethnic dance. Tap dancing in particular is experiencing a rebirth in the United States. Former Los Angeles Lakers cheerleader Paula Abdul went from choreographing Janet Jackson's music videos to staging and choreographing the production numbers for Fox networks' *The Tracy Ullman Show*. Paula, known for her slick combination of tap, jazz, and modern dance styles, became an international Grammy Award-winning recording and video artist and choreographer and staged the prestigious 1990 Academy Award presentation.

Even though, in the mainstream arena, they are considered specialized dance, it is wise for the black dancer to know the ethnic, African, and street dance vocabularies. Remember, it is important to know your heritage in the commercial market. You are being hired because you represent a segment of the general black populace. It is important that you are able to capture the flavor of your ethnic group and present it with dignity in a positive, respectful way.

Unfortunately, there is still little work for dancers in television and film, except for dance-oriented theatrical productions and music videos. Gene Anthony ("Leroy") Ray of *Fame* and former Solid Gold Dancers Darcel Wynne and Dance Cooley were among the black dancers that found work on national television programs on a regular basis. "Soul Train" regular Damita Jo Freeman danced her way into prime time television, commercials, and feature films as an actress.

Unlike years past, the demands on dancers are pretty universal and both female and male dancers are required to have the same types of physical training. Gone are the days when males only partnered females. With the advent of choreography and the continuing improvement of the commercial stage presentation, male and female dancers are expected to have similar training and abilities. Whether dancing as an object of our fantasy or simply to beautifully and visually illustrate an accompanying musical interlude, dancers are required to be in top physical condition and style, looking ever youthful and desirable.

It is also important to realize that more stars are dancing in their musical presentations. Madonna, Michael and Janet Jackson, Paula Abdul, Salt N' Pepa, and MC Hammer are among the recording artists who first heavily relied on their dance training and the dance community to add new, visual dimension.

There is also money to be made on the production end as a choreographer, dance captain, or dance teacher. Choreographers illustrate music and storylines in the language of dance. Choreographers are hired as part of the production team. They are responsible for inventing original dance combinations for videos, shows and films.

The dance captain or dance assistant is a respected dancer with advanced teaching skills, responsible for teaching another person's choreography to replacement dancers and for keeping production movement fresh, spaced, and accurate. The dance captain is usually hired by the choreographer because of his/her dance ability and familiarity with the choreographer's personal style of movement.

The dance teacher, also commonly known as a movement coach, actually instructs artists in techniques in the art of movement. The dance teacher is usually a movement specialist and can dissect and break down movement phrase by phrase to teach dancers how to actually execute steps.

One thing is certain—competition for dance has become quite stiff for the black dancer. Over the past decade, the black dancer has added more mainstream dance styling to his urban repertoire. Many black dancers, with the onset of integration, were able to attend ballet conservatories, thus expanding their repertoire and allowing them to compete with their Caucasian dance counterparts. At one time in the United States, African-American dancers were considered unable to adapt to the rigors of the ballet world. We were told our bodies were improperly

formed and were led to believe that our physical limitations could not elevate us to the regal stature of the ballet world's classical princes and princesses.

With the advent of the sixties, the civil rights movement, and the influence of black music on the American populace, African-Americans began to challenge the commercial dance images White America had created. Arthur Mitchell founded the Dance Theatre of Harlem, one of the country's finest classical ballet training schools and international dance companies, geared specifically towards training black dancers in the classical ballet forms. The late Alvin Ailey pioneered American modern dance while maintaining a critically-acclaimed and internationally-structured performance company. These two American dance pioneers, along with fellow veteran black choreographers and dancers Katherine Dunham, Geoffrey Holder, Carmen De Lavallade, Donald McKayle, Billy Wilson, Louis Johnson, Talley Beatty, Honi Coles, Eleo Pomare, Rod Rogers, George Faison, Pepsi Bethel, Lester Wilson, Claude Thompson, Mike Malone, Fred Benjamin, Henry Le Tang, Pearl Primus, Frank Hatchett, Michael Peters, Judith Jamison, Clive Thompson, John Jones, and Otis Sallid, have fought to preserve the commercial image and integrity of the black dancer. These are names *all* black dancers should know.

In the routine theatre dance audition, dancers go through a series of elimination processes. Most choreographers begin making their eliminations according to specific physical requirements. Many dancers will be eliminated from the audition process because of their physical looks before they get a chance to actually dance. This is known as being "typed out." Dancers are then given progressive choreographed material to see if they have the physical ability to quickly master specific dance movement.

The process of elimination involves many different factors; however, most commercial auditions use ballet to determine the degree of formal training and posture of a dancer. To be familiar with ballet means a dancer understands certain basic dance terminology and has studied the dancer's craft with a certain amount of classroom training and discipline.

The second round of eliminations comes after dancers learn and execute a longer, more complicated dance routine, known as a "combination." The combination uses movement phrases the choreographer intends for show use.

Once an audition gets to final callbacks, dancers are also asked to display their specialty areas of dance. This gives the choreographer specific information about the scope of the dancer's experience and training. For a black dancer, our indigenous dance forms are extremely important.

Dance has evolved into a lifestyle all its own. Today, dancers and dancing have become a part of mainstream recreational activity, and dancewear is worn both in and outside of class. Dancers walk, talk, and act unlike any other performing artists. This is probably due to the strong emphasis on a disciplined lifestyle, group effort, and dynamics.

Hip-hop dancing has become an increasingly popular dance style and financially rewarding career avenue for African-Americans. Take a look at the videos airing on BET, MTV, and VH-1. The dancers are a far cry from the days of the New York City Ballet and the Solid Gold Dancers. Many of today's hip-hop dancers perform moves with the tenacity and at a pace inconceivable to the average person. Gone are the days of traditional leotards, tights, and dance shoes. Hip-hop dancers often appear clad in the trendiest wears—oversized pants and shirts, scanty biker-style unitards with combat-style military boots, and headgear of all shapes and sizes.

The hip-hop and rap music industries have opened doors for talented African-American youth. For years, we have talked about all the "undiscovered" talent our children possess, and the time has finally come for these kids to strut their stuff. Think about how many young black kids and teenagers have meaningful employment and the opportunity to travel all across the world, and make an excellent salary. Hammer's entourage at one time totaled well over 100, and he proudly publicized the fact that he employed many ex-gang members. So, not only is this a 1990s-style dance career a new avenue of employment, it's also become a way to get kids off the streets and into something constructive that they can be proud of.

If you have a natural-born ability to perform these dance steps without any formal dance training, you're one step ahead of the game, but you still need formal training. Most large dance studios offer hip-hop dance classes in addition to the traditional dance styles.

There are many rewards associated with a career as a hip hop dancer. Probably most attractive is the travel involved. American rap and hip hop groups are extremely popular overseas and extensive travel abroad on international concert tours is often involved.

23

SOULFUL SOUNDS

You've probably heard the legendary stories of how singers and musicians are discovered and become rich and famous stars. But it takes a lot more than luck or a chance encounter to bring success if you're pursuing a career as a vocalist.

There are literally thousands of aspiring singers just like you, dreaming about a singing career. What will propel you in the professional music business, ahead of all the others, is a solid understanding of how the music industry operates. Like the acting and dance professions, the pursuit of a singing career requires very specific knowledge. All aspiring singers should understand all the intricacies of vocal preparation, recording contracts, album production, artist representation, publicity, and promotion.

Jacqueline Rhinehart, Director of R&B Publicity for Arista Records, had this to say about the importance of being educated about the music industry:

> Often, I may have an artist who has no idea what he wants to be. But then, quite frankly, if you were really that out of touch with what artists were about, what the whole environment, in terms of the music industry was about, and had no idea of what image you wanted to project, I would really second guess your viability as a recording artist. Because to me, you have not really been studious in terms of really being serious about the business. You haven't really taken it upon yourself to educate yourself about the music business—and you should, because there's nothing worse than a stupid artist. I don't care how talented you are. You should read the publications that are geared to the music industry. Get a *Billboard* each week on the stands. You should buy the teen fan magazines and see who is being publicized, how they're being publicized, and why they're being publicized. And you should know some of the industry players. For example, it would be dumb for an artist to come [to Arista Records] and not know who Clive Davis [the president of Arista Records] is. Basically, it's best if the artist has an idea of what he plans to contribute to the

music industry, because there is no demand for new music. You have to be needed. I mean, we don't run out of music like we run out of toothpaste. It's like you can play the same ole' stuff over and over and over. So, if you are now feeling that you should have a music career, that it's your dream and goal, then what new do you have to contribute that makes it so imperative that you have to sing or to be a musician? You should have kind of figured that out already.

Associate Director of A&R at SBK Records Blossette Kitson adds:

I think it's very important when a person decides he wants to be an artist and he enters the mainstream of music to pretty much map out what it is that he wants, to become very knowledgeable of the business—all aspects of the business, primarily the legal aspects and what the bindings are, the marketing, the promotion, the publicity, all of these things—and then he should become educated in his field just like in anything else that he does. You have to know the whole spectrum to see how you fit in the scheme of things.

The following is an excerpt from a question-and-answer session we held with record producer and recording artist Paul Laurence Jones. Paul offered some of his personal insights into the recording industry. He prefaced this discussion by pointing out that there are no tried and tested formulas for success in the recording business. Mr. Laurence's comments were reiterated by several other prominent recording industry professionals, including Blossette Kitson, Ian Davis, and Jacqueline Rhinehart.

What is a recording contract?

Paul: A recording contract is a deal between the singer and the record company whereby the record company allocates a budget for the artist to produce an album. The budget for a new artist usually falls in the range of $50,000 to $150,000. Out of the budget, all of the album production costs are paid—the musicians, the studio engineers, and studio time, as well as promotion, publicity, and advertising costs. The producer is also sometimes advanced money out of the budget. Depending on the circumstances, the artist may or may not get a signing bonus. This signing bonus is an additional amount of money paid to the artist for living expenses. On average, an album takes about three months to produce.

Blossette: An advance, of course, is worked out for the artist. They usually get about $10-15,000 from $125,000 contract. But it depends on the contract agreements. It's not cut and dried because, of course, contracts vary from artist to artist and deal to deal and it depends on the parties involved, what kind of deal they're cutting, and their ability to cut a deal.

Paul: The artist will get paid by the record company only after the record company has recouped all the money it invested in the album, including the album budget and signing bonus. After the record company recoups its investment, the artist gets royalties from the album sale profits. The amount of royalties the artist gets is based on the artist's rate. The artist's rate is the negotiated percentage he receives from the album sale profits. This percentage is based on 90% of the album sale profits; the remaining 10% goes to the record company's administrative costs. An equitable rate for a new artist is around 5-6%.

Jacqueline: The record has to sell. If it doesn't sell, then you remain in the red for that particular album. You normally sign a contract that is for 3-6 albums or for a single and the option of an album. The last two LPs are normally completed at the option of the label, which means it is the record company's exclusive option to go ahead and produce two more albums. The artist doesn't have the option of walking, but the record company does. An LP being in debt to the label is on an album-by-album basis. So, if you didn't sell enough LP's to recoup the $100,000 production budget on the first LP, that red ink will remain, regardless of whether you receive the same budget for the second LP and you sell two million albums. So, even if you have an excess on the second album, you still owe on the first album. It comes down to seeing if, at the end of the contract, the LPs that did sell offset the cost of the LPs that didn't sell. If you accumulate the type of record where each LP does less than anticipated, then, at the end of your contract, the record company may take the option not to continue producing your albums. That's what happens a lot when an artist demands advances greater than the revenues he brings in—he remains in the hole.

What steps would you advise a singer take towards securing a recording contract?

Paul: The ultimate goal is to get the record company to sign the artist to its label and secure a deal to produce an album. How the artist approaches the record company varies. The artist can approach the record company directly, through a manager or producer. If the recording artist goes directly to the record company, he will need to present a demo tape. A demo tape is a audiotape with two to three salable songs. Original music is preferred. The tape should be directed to the A&R (Artist and Repertoire) department. If the artist approaches the record company directly, he should have an attorney represent him in the negotiations.

Blossette: The best way for someone to approach me is through an attorney or through a manager because, on the average, record companies don't accept unsolicited tapes. Why? Because you can get into trouble for that. For instance, how many lawsuits have you heard about where people have said they've submitted their tape

to a record company and then another artist comes out with a song and the original artist claims the material is similar to his? Now, if the tape comes through an attorney, at least they'll be some legal representation, so chances are no one is going to try anything. In addition, it's more professional to go through an attorney or manager—A&R people don't like to deal with artists. Also, entertainment attorneys take it a step further to negotiate the contract if you get one. So you pretty much need to have someone who knows everything that's necessary to get the whole deal done. A lot of times, you have managers who don't really have the know-how about what should and shouldn't be included in a contract and how to get their artist the best deal. So it's advisable to get an attorney or a manager with a good background in the industry.

Paul: The artist can also seek out a manager or producer to represent them to several record companies and then cut the best deal he can get. A manager normally takes about a 15-20% commission. A producer is paid by the record company.

Ian: The record companies don't take unsolicited material. They'll only take it from a management company or from an entertainment law firm who can bring it through the door as well. That's the only way to get to the record company unless you know someone who works there and is going to recommend you, take the tape to the right person, and have them listen to it. They used to get thousands of demo tapes. That's why they stopped taking unsolicited material. It takes them a long time to listen to it. Finally, when they do get around to listening to it, if they like it, then they'll call you or send you a letter saying they like it and would like to hear some more. If you get a response that they'd like to hear something else, that's point when you need a manager to go in there and negotiate a record contract. That's one way of going about it. The other way is basically having a manager walk it through the door because we [managers] have relationships with most of the record companies or already have an artist on the label, so we can walk through the door and have someone listen to it.

Blossette: I don't always follow that policy of unsolicited tapes because a lot of times kids off the street don't have the money to get things together, they don't have contacts, they don't have the know-how—but they have talent.

Does a music video get produced from the album budget?

Paul: No. The music video, if negotiated in the recording contract, is paid from a separate budget. The music video budget for a new recording artist can range from $5-20,000.

Who is the artist's contact at the record company with on a day-to-day basis?

Paul: The A&R (Artist and Repertoire) department is in charge of the recording artist's career. A product manager is usually assigned to handle daily affairs.

Blossette: The A&R department is responsible for finding acts and groups that are on the cutting edge of business and making them stars. It's not that simple, though. We have various ways of going about finding talent: tapes are sent in, people are referred to us, and we go out and see shows. We might just hear someone singing and think they're fabulous and then we put their repertoire together, though this rarely happens.

What are the major record companies?

Paul: The major record companies are CBS, EMI/Capitol, Warner/Elecktra/Asylum, Polygram, MCA, RCA, and Atlantic. Within these record companies are different record labels. For example, Epic is a Columbia Records label, and A&M, DeLite, and Wing are labels under Polygram. There are a number of smaller record companies—Island Records, Arista, Defjam, Virgin, QWest, and Solar. But before you go out to begin a singing career or to look for a recording contract, you should spend some time training your instrument, your voice.

Vocal Training

For anyone interested in a professional singing career, vocal training is essential. There are few professional singers who are able to sustain the rigors of singing full voice five to eight shows per week on the professional stage or on the concert tour circuit. Vocal training is a discipline that a singer practices throughout his or her career. Most of today's most popular recording artists practice their vocal exercises and other vocal techniques on a daily basis. Because their voice is their instrument, they must keep it finely tuned and in top shape.

By learning proper placement, breathing, and other vocal techniques, you should be able to enjoy a lengthy singing career.

You find a lot of different artists come and go, but you find that the ones that sustain their careers and are going to be there throughout the years, like the Stevie Wonder, have solid training. Nowadays, you have a lot of machines. The new generation seems to rely on machines, like drum machines, and the older generation believes in the musicians, the real drums, the real saxophone, and they don't depend on machines. I don't know where the trend is going to go, but I think artists need to get back to basics. It's weird where the music business is going as far as the youngsters coming up are concerned. They don't have the training—for instance, piano lessons

and studying and training and practicing. Nowadays, it's so easy, because you can do everything with machines. The focus is moving away from real music, and the recording companies throughout the years tend to shift to the easy money. The record companies aren't into artists who are going to last. They take the quick money, the quick turnaround, but that's why they're in business.

Ian Davis

With the advent of high-tech recording equipment, it's no longer uncommon for singers with little or no vocal training to enter the music business and have successful careers.

You can take someone with little or no talent and make them [successful]. They use a lot of voice modulators and things like that. I see a lot of that happening in the industry and I hate it. I like the good ole' days when people could really sing.

Blossette Kitson

Many of today's top recording artists who don't have the training have to rely on recording machines when they perform live because their voices are untrained and unable to sustain the rigors of strenuous singing. Rumor has it that some recording stars don't even perform their own vocals or instrumentals on their albums.

There's another thing that's going on right now—certain well-known singers can't sing, and they're going out on the road and they all have backin' tracks. Backin' tracks are basically a pre-recorded tape playing backstage that the singer "lip syncs" to. A lot of people go in to see a show and think they're seeing a live concert—the artist is performing but all the artist is really doing is lip synching to the backin' tracks. They're out on the road for 10 months and their voice can't handle it. So, to preserve their voice, there's only a few cities where they actually perform—they may play Los Angeles and New York and sing live. The sound people will turn up the mike and bring the mike back live like at the end of the show so the performer can talk and then everyone thinks it's a live show, but it's not.

Ian Davis

The average professional voice lesson lasts between 30 minutes and one hour. Usually the first half of a voice lesson is dedicated to the singing of one-syllable exercises, called "vocaliz-ing," designed to prepare the voice for performance and to strengthen and stretch the tonal capacity of the singer's voice. These one-syllable vowel and consonant sounds are the musical components of spoken words. The better voice teachers demonstrate exercises to musical one-note piano accompaniments, known as ascending and descending scales. When attempting to sing a complete line of music, the singer is then aware of how to sing anything comfortably without strain or damage to the vocal chords. Extreme humidity, temperature changes, aller-

gies, illness, and personal vices all affect a singer's overall performance. The good vocal instructor exercises a student through the student's individual problem areas so he can sing proficiently under adverse conditions.

The second half of the lesson is devoted to the practical application of vocalization with ear training and breathing exercises. The exercises are now applied to more complex scales and actual song performance. Most students record their weekly voice lesson so they can practice the theories and vocalization exercises at home on a daily basis.

> Learn your instruments. Train your voice if you're a singer, and just keep going and never stop. You have to believe in what you want and keep going. A lot of obstacles are going to be in the way. It's just not going to happen over night. Keep pushin' and learn your trade. Learn your instruments at home at an early age. Like anything else, you have to study, learn your music. It's best if you can go to a school of the arts. Unfortunately, a lot of doors aren't open to minority people to go to such schools, but there are still good teachers around that you can find. Find a good voice, piano, or guitar teacher that you can afford.
>
> *Ian Davis*

Most colleges and universities offer musical curriculums with vocal training, basic piano music theory, and performance classes. Private instructors usually teaches from their homes or from small rental studios with pianos. Professional voice lessons can cost between $20 and $200 per classroom hour, depending on the popularity, reputation, and experience of the instructor.

Vocal Coaching

Where a voice teacher trains the voice to physically be able to accommodate the rigors of singing, the vocal coach teaches musical style and interpretation. For the advanced vocal student, a vocal coach often picks up where the voice teacher leaves off. It is here in the studio with the coach that you learn to express yourself musically and develop your own musical style and sound.

In a coaching session, you are practicing and interpreting singing with an emphasis on performance technique. The singer chooses a song from his repertoire and dissects the vocal placement for phrase-by-phrase interpretation and the hidden meaning of the spoken text. This musical text, often sung in a poetic form, is known as "lyrics." At the end of several class sessions, a student should have mastered enough song material to prepare for auditions and actual performances.

A good vocal coach listens to your voice and makes suggestions on how to best showcase your individual singing talent. In a one-hour coaching session, you may explore the dynamics of several different songs. A vocal coach may also help you interpret the hidden language of a song with phrasing, breath control, and musical punctuation.

There is a separate cost for professional vocal coaching and the costs, like those for voice lessons, vary according to the experience of the instructor.

James Thomas, promoter of Los Angeles's Hollywood Music Showcase and owner of his own independent record label and management firm, talked to us about the role of the manager in the career of a recording artist:

> The Music Industry Hall of Fame is filled with talented individuals who are "po', broke, and lonely" because of bad management. Just because your brother-in-law owns a neighborhood record store does not mean he can negotiate a spot for you on a major concert tour. Nor can your sister, who danced on *Soul Train* in the '70s, handle the day-to-day duties of managing your career as a dancer in music videos. If you are to have a successful career in the music industry, you must have a manager who not only believes in you, but is competent and hard working, and possesses some (if not all) of the following skills and qualities: A manager should be interested in more than how much money you can generate, and he should be willing and able to commit a "reasonable" amount of time to the development of your career. With that in mind, let's look at what the duties of a manager are. Most good managers give advice and counsel to the artist in the following areas: the selection of musical materials; all matters relating to publicity, PR, and advertising; the adoption of the proper format for the best presentation of the artist's talents (demo tapes, photos, etc.); maximum employment of the artist; the types of employment the artist should accept; and the selection and supervision of accountants and attorneys. Managers supervise, at your expense, business matters related to your "on the road" expenses and serve as a buffer to insulate you from unattractive offers, requests for charitable gifts, free appearances, and the like. Your manager will play an important role in your relationship with record companies, talent agencies, and producers. Certain managers will also assume control over their artist's business and even personal affairs. Although a good manager will shoulder the above responsibilities, he should also possess these qualities: 1) a respectable reputation—choose someone who has been in industry practices; 2) knowledge in your field of music—if you are a rapper, don't choose a manager that has only worked with R&B artists. The more he knows about your field of music, the more valuable he is to you and your career; 3) financial honesty—never give money to someone up front. Most managers are paid on a commission basis of 10 to 25%. If someone says he can help your career but he needs up front money, run—far and fast! A legitimate manager will have connections

to provide you with all of the necessities; 4) trustworthiness—choose a person you trust wholeheartedly. Your manager should be your best friend. This person literally has your life and career in his hands; and 5) a business mind—choose a manager who knows and is willing to teach you all aspects of the business. Many artists see the fame and bright lights of Hollywood and forget about the business side of the entertainment industry. If you don't know, *ask*. If you don't understand, *don't sign*. Make sure you are in control of your business. Sign every check and know where and why every penny is being spent. If you apply these points to your search for a manager, not only will you increase your chances for success, you will avoid many sleepless nights.

Showcasing Your Talents

Jacqueline Rhinehart of Arista Records recommends showcases as a way of getting seen by the industry decisionmakers:

> The best way to be seen is in showcases. Showcases can be done either by the artist himself, or he can have it done by his management company. Right now, a lot of artists who don't have managers do have attorneys that are almost acting as managers. The attorneys go around and try to solicit interest in the demo tape of an artist. They may actually finance a showcase at a local club and invite people to come out and see the artist. There are other ways to do that. ASCAP and BMI often have showcases of writer-producers that they have signed for licensing, and they will underwrite all the costs for presenting the artists and inviting the industry out to see them. So there are other ways you can get signed to a label.

Another way of showcasing your talent is to put together a demonstration or "demo" tape. Manager Ian Davis offers this advice on putting together your demo tape:

> You need to go into a studio—8-track or 24-track—where you can get a good deal. Go in and put down [record] two or three songs. First of all, you'd have to get musicians together. It's really easy to get musicians if you're in the business. Pick up a union book and see what players are listed and try to get someone at a good rate. You go into the studio and make music and hopefully find a producer that can help you out.

The next step you should take towards realizing your dream of becoming a recording artist is to decide what record companies to approach.

Choosing a record company is a very personal decision. Like choosing a mate, both you and the record company should be on the same wave length with similar goals and be able to communicate.

> Certain companies are better equipped to promote and market certain types of music than others—like rap music. Smaller and independent labels seems to do better with them than majors [record companies]. Majors are usually looking at the Top 40, and the smaller and independent companies don't have such a big roster. So, therefore, the smaller and independent companies have more time to meticulously go through the A&R process, whereas the major companies don't.
>
> *Blossette Kitson*

Have your manager, producer, or attorney shop your demo tape around the different record companies. Once you get your demo tape to the record company, the waiting game begins.

> Once you get to the record company, it will take them forever to make a decision. Once they make a decision, the lawyers take even longer to put the contract together—so it's a long process and it's not something that happens overnight. I'll say that, from the time you get your tape to an A&R person and have him listen to it, it will probably take them two to three months just to listen to it.
>
> *Ian Davis*

The Record Deal

Getting a record deal is not all it seems to be. We've heard many stories of singers who have signed record deals and find that it's not a promise of success. The reason? Producing the album is just the beginning. If the record company doesn't push to promote the album, the album is likely to fade into oblivion. Usually, by the time an album is finished, the A&R executive who was initially responsible for signing the artist is promoted or moves to another record company. The new A&R person normally gets a percentage of the royalties of the artists he signs, not the artists signed by his predecessor. Therefore, the new A&R person may not be as motivated to give the album the promotional support it needs. If the company doesn't promote the album, the public doesn't hear the song on the radio airwaves, and the record buyers never know the album is available to be purchased.

> A lot of people think, because they have a record contract—or a more widely used term in the business is a "deal," a record deal—that they've arrived. It doesn't mean anything, because you can go in and sign a record contract with a company, and if you don't have certain things in there like guaranteed releases, you can make the album and then it can sit on the shelves and never, ever go anywhere. So there are

certain things that you need in a contract. You also need the right company. You need the people and the company that are going to believe in what you're doing—from your A&R person all the way down to the promotion people—people that really believe in your project and what you're doing and that are really going to stand behind you. Because a lot of times what you have is you get signed to a company and nothing happens, or they put your record out and you don't have the right promotion, you don't have the right publicity behind it, and the record dies. It never gets off the ground, and that happens so much. Because some of the record company rosters—a "roster" is the people they have signed to a label, the different artists—some of them are so jam packed, and half of these people never even heard about it. They keep putting out their money—it's a tax write-off for some of these major corporations, and some of them genuinely think it's going to work. The guy who signs the artist may love him, but, once the record gets upstairs, the boss may not like it, may not believe in it, or radio may not like it. So it's just so many obstacles. First, you have to get the record company to like it. Once they like it, that's fine, but then you have to get radio to like it, and the promotion people who are really gonna work it and get it to all the radio stations to listen to it. Radio has everything to do with it, because that's how you're going to get your music to the people. If you don't have radio, you don't have anything. Radio plays a big, a major, major part in this whole spectrum of things. So, once you get a record contract, the headaches have just begun.

Ian Davis

To alleviate problems, you should always consult an attorney experienced in entertainment contract law before signing any contracts. Ian Davis also stated:

What a lot of people have to be careful about is signing contracts. Always have an attorney review all contracts before you sign them. That's one of the biggest problems I have found. Every other person who walks into my office needs to get out of a bad situation that he's signed to because he didn't have proper counsel. Never sign anything unless an attorney looks at it. But a lot of people get sucked in because there are a lot of people in this business who are only concerned with making money—they don't care about anyone else, and they'll sign you for everything—your publishing, merchandising rights, etc. They'll have you locked up. So you get into a bad situation, and once you're in it it's very hard to get out. It'll cost you twice as much money to get out of it than it does if you go in to it, so pay an attorney to look at it before you sign it. And that goes for production people, too. What you have nowadays is different production companies that put up the money to make the record. They shop it to record companies and, if they get a deal, they negotiate a record contract with the record company, and then they just take everything. There's pretty

much nothing management can do at that point, or anybody else. It's a legal situation. I would strongly urge everyone out there to always seek legal counsel before signing any documents.

How long does it take to cut an album? It varies. Sometimes you go in, lay down the tracks, do the mixing, and it's fabulous and you don't want to change anything. Or it might take a week to lay down just one song.

Blossette Kitson

When you sign a recording contract, you'll be given a budget to produce your album. We asked Jacqueline Rhinehart if the amount of money available to an artist varies between black and white artists Ms. Rhinehart replied:

Budgets rarely vary, particularly at the beginning stages of an artist's career. Of course, as time goes on, Dionne Warwick and Aretha Franklin get more stop points than a newer singer because they have a track record that would allow the record company to spend a greater amount of money, because the company knows they're going to recoup a greater amount of money since the artist is already tried and proven. So that's the only real difference in what money is available to an artist. The publicity department uses money on who has the most lavish record release party, who has the most expensive photographer on their photo shoot. It's the artist who can afford it in terms of what budget monies are given. The higher budgets are given to those artists the record company expects to make the most money out of. So it's really not a black and white issue. It's a return-on-investment issue. There's a higher expectation from certain artists to begin with, only because of their track record. In the beginning, they all start out pretty much on the same level. Or maybe the record company has researched the market on what your potential is, and your potential may be higher than another artist. An artist that has a more general appeal should make more money than an artist that has a more limited audience—for example, a rap artist vs. Aretha Franklin. The rap music audience is going to buy Aretha just as the general audience of the United States is gonna buy Aretha. Well, who's gonna buy the rap artist's album?

Your A&R person will assist in finding the right producer and musicians to work on your LP.

The marriage between producer and artist is so important to the success of a project. That's a large part of an A&R person's job. Because once you get an artist and you sign him, then you have to find the right type of producer. Obviously, you wouldn't use a heavy metal producer for an R&B act. The chemistry has to be there. A lot of

times the two [artist and producer] get in the studios, hate each other, and want to scratch each other's eyes out.

Blossette Kitson

Promotion and Publicity

After your album is finished, the record company's publicity people step into the picture. They prepare your sales image for the record marketplace.

Jacqueline Rhinehart explains the role of promotion and publicity in the career of a recording artist:

> I listen to your music, I meet you, find out if there's anything interesting about you that I can use as an angle or that may not have been highlighted in your music. If there is nothing there, possibly we'll confer and make something up or highlight something that you are not aware of. But, primarily, although the music is the focal point, the artist should have something to say. Hopefully, he's an interesting personality, but that comes in and of itself. You should strive to be interesting for yourself. You go up to the Creative Department and they assign a stylist to work with you and give you a look. Then I take a look at your look and see if that look is applicable to what I want to do in terms of publicity. If it's not, I send you back to Creative and you do it over. And from there I choose what images I'm going to use from the photo shoot for your publicity shots and set you up in different situations, such as taking you around to different affairs and events so you'll be in the right scenes, and photo opportunities will then arise—like you could be seen with Kool Moe Dee. Those pictures would then be mine, and I would be able to use them to publicize the new artist and have you placed that way, maybe even before interest has taken off in your record. If you have any particular interests in a cause or an organization or a particular belief in something, then I try and put you in a position to be working with that type of organization on a public affairs basis in terms of you doing public service announcements and being made available for any type of benefit situation they might have.

Many artists opt to hire their own publicist in addition to the record company publicity department. Jacqueline continues:

> The label handles your publicity—that's part of the overhead in terms of marketing you. However, often an artist will get to a certain level and desire an independent publicist because he has an ongoing need for publicity, because he, as an image, as an entity, has grown larger than just the record—say, for example, Whitney Houston, who has endeavors other than what's happening here [at Arista Records]. She's

busy even when there's no record out. She has an independent publicist whom she pays for with her own money. So, in effect, she has two publicity companies working for her. She has the record company publicists, and she has her own publicist who takes care of all those in-between things that she does, be it her television engagements that have nothing to do with a record or her involvement now that she's started a film company and is buying production works. And so they work on those things, although the record label could do that, would do that. But if you can afford it, then you may wish to hire an independent publicist.

Clearly, the performer who succeeds in the music industry must be talented, well trained, and have defined career strategies.

For more information on careers in the music business, check out the *Mix Bookshelf*, a leading resource for information on the music industry and recording technology. Mix Bookshelf's 65-page catalog contains pages and pages of information resources for music industry professionals. You'll find a wide variety of how-to books, career guides, industry directories, reference manuals, textbooks, instructional videos, and sample CDs on the music business, career development, music publishing, recording, live sound, audio references, electronic music, multimedia, compact discs, composition, and performance. To get a free catalog write to Mix Bookshelf, 6400 Hollis Street, Suite #10, Emeryville, CA 94608, or call (800) 233-9604.

24

THE LITTLE PEOPLE:
KIDS IN SHOW BIZ

Infants, toddlers, and children ranging in age from birth to age 13 are considered child performers. As a parent, you may feel that your child possesses the qualities that would make him perfect for show business. It seems all parents feel this way. In making your decision of whether you should get your child into the business, consider the following thoughts.

Lynda Johnson-Garrett, style editor of a leading children's fashion publication, had this to say about what makes a child marketable:

> What makes a child marketable? The child that is expressive, has a lot of personality, is friendly, and isn't shy. Kids with interesting looks, a little quirky, maybe with freckles or missing teeth. Kids that look like real kids as opposed to a kid who has been groomed to be a model. Those are the kids I tend to lean towards when I'm hiring children as models.

More important than any particular physical attribute is the child's on-camera personality, which should be extroverted and outgoing. The child should be enthusiastic, eager, and excited about his career. However, a child should be real—the typical kid from the neighborhood, not too polished. Other important attributes that a child should possess include independence, self-motivation, attentiveness, confidence, patience, and curiosity. A friendly and happy child with lots of interests, who is happy at school and engages in extracurricular activities, usually interacts well with other children in commercial situations. Infants should be good-natured and should warm up quickly to strangers. Toddlers should also have good temperaments. All children should be able to take direction well, but remember—a child performer should be a child first, an actor second. His family and social life should be kept as close to normal as possible—a child should not miss out on enjoying the wonders of his childhood years because of his career.

Lynda offers some advice to the parents of babies:

> One of the most difficult things is when you have to work with babies and toddlers. You have to have a lot more patience than usual. And you also always have to book a back-up baby. So, for you parents, when your child gets booked for a shoot, and if it's a baby, anticipate there being a back-up baby in case your child falls asleep or just happens to be cranky, which is to be expected. Don't take it personally, and don't take it out on the kid, because the kid, in most instances, doesn't know what he's doing.

She had this to say about the problems she has encountered working with children on the set:

> What do I do when kids get temperamental on the set? Well, it depends on the age and the child. When they're young, there's nothing much that can be done. Sometimes, if you have a really good photographer and most of the staff is there, you can start playing or interacting with the kid. Or the photographer and the kid are the only ones allowed on the set and you remove everyone else. It depends on the kid and what it is that is distracting them or making them get cranky or temperamental. Sometimes when the kid is older and he's acting up on the set, I'll just sign his voucher and release him from the shoot. Then I'll call the agency and tell them the kid didn't work out and to send me another kid. When they're older, they know what they're doing, and they know better, and they're either testing their parents for something, or they're trying to prove that they're in control. And when you're on the set and you're paying models by the hour, you don't have time to play those little games with the kids. I don't have time to tolerate it. I just sign their vouchers and say good-bye, and I'll never use that kid again.

A Word on Parents

Every parent thinks his or her child is the best. When deciding whether your child should get into the business, be objective. The children's market is just as competitive as the adult market. Withdrawn, shy, or temperamental kids do poorly under the daily pressures of auditions, rounds, go-sees, work situations, and school. Make sure your child has what it takes.

Consider the welfare of your child before he enters the business. There will be long hours, extensive travel, rehearsals, and performance time, which will often cut out formal school and social activities. If your child is successful, even though he is young, he will be expected to deliver and perform as an adult.

Parents can either be a hindrance or a source of encouragement for their child. The parent's attitude is crucial to the child's success. Parental support is encouraged, but most agents and managers will not tolerate the pressures and anxiety that many parents place on their kids. Pushy and overbearing parental support often inhibits a child's spontaneity and creativity, making it

more difficult for the child to concentrate on acting. Parents should also be prepared and willing to cope with the many inconveniences and hassles associated with all aspects of their child's career.

Make sure your child wants to be part of the business. He should enjoy the competition and view it as a game. Nothing is more frustrating or sad than watching an overbearing parent forcing a child to perform when it is obvious that the child doesn't want to do it. Forcing your child to do something he doesn't want to do in front of agents, directors, and production crews can be embarrassing and humiliating and can cause serious emotional trauma to your child, which can sometimes be irreversible. If your child wants to perform and is constantly displaying his gregarious showmanship, you will be the first to know. Lynda says:

> One thing that I dislike is parents that are really pushy. Parents that will force the kid
> who doesn't want to be there to be there. You can usually sense that through the child.

If you complain to your child about "all the inconveniences" you are suffering, you will often cause your child to become defensive. This will not help the child's overall sense of security and self-confidence. A parent's stress and nervous tension will translate to his child.

Parents have also been known to alter their child's appearance cosmetically, changing hair color, fixing teeth, applying makeup, and even resorting to cosmetic surgery. This is definitely extreme and unwarranted. Children lose their teeth. They often have unruly hair. They aren't physically perfect. This is why we love kids and enjoy seeing them in the media—they are truthful and real.

Parents should not lose sight of the fact that their child's interests should always be given first consideration. Even with millions of dollars sometimes riding on their performances, children can't always be expected to act like adults. Kids are not immune to the pressures of the business, although it is sometimes difficult to remember that these poised and self-confident, seasoned performance veterans are only children.

> Parents should explain to the child what he is doing. Explain what a "go-see" is—
> when you're taken out to different places to be interviewed by various people for
> potential jobs. Explain to the child that there will be times when [the casting people]
> aren't looking for his "look" but that there will be someone else who will. This way,
> the child has a sense of well-being without constantly thinking that he's being rejected.
>
> *Lynda Johnson-Garrett*

Don't push your child towards success. Love and encourage your child to do the best he can do. We asked Lynda what turned her off about kids in the business. She had this to say:

> I dislike it when I have go-sees and the parents come in and you see them primping
> the kids and the kids don't act like kids. The kids come in, and they want to shake

your hand all businesslike. And that's not what I'm looking for. I'm looking for a kid that's going to be outgoing and interesting as a kid and still remain a kid, as opposed to the kid who is thinking "this is a job and this is business and I have to do this." That really turns me off.

Kids' Photos

Initially, for children, snapshots are okay to use when seeking an agent. Once your child becomes established with some form of representation, an 8 x 10 photo is essential. Most agents frown upon the expense of headshot photos for babies and toddlers, because children change and develop so rapidly during this period. Babies and toddlers can get away with using snapshots until about the age of two. For children under two, keep your agent or manager supplied with updated photos every three months or so. The picture, whether a snapshot or an 8 x 10, should be natural and energetic, translating to the viewer your child's personality.

Children don't require the same type of pictures adults do. Children's photos can include their hands, props, eyeglasses, and anything else that will translate your child's personality. Children often use composite photos with two to five photos depicting their various moods and looks.

On the back of your child's snapshot, print the child's name, phone number, birth-date, current clothing sizes, and any other important information (such as ability to crawl, walk, talk, etc.) On the back of the 8 x 10 photo, staple a fact sheet. The fact sheet is similar to a résumé. It should include your child's name, phone number, height, weight, clothing sizes, coloring, and age range or birthdate. We recommend listing your child's birthdate so agents and casting people will know how old your child is when they receive the photo. List your child's professional and amateur performance credits in addition to your child's hobbies and skills.

You can also list your child's social security number on his fact sheet. All show business kids must have a social security number and work permit. Contact your local social security office for information on obtaining a social security number for your child. Contact your local labor department for information on obtaining a work permit for a child.

Kids' Agents

There are three categories of talent agencies you can look for. First, there are talent agencies that represent children and usually employ an agent within their office to specifically work with children. Second, there are talent agencies that represent children within a separate children's division of a larger agency. And third, there are talent agencies that handle children only.

You should employ the same methods of finding agents for a child as you would for an adult. Check out the trade paper special issues on kids in show business. Look up children's agents in one of the trade directories such as the *Madison Avenue Handbook* or *Studio Blu Book*.

What should a parent do if he's interested in getting his child involved in modeling? I think the parent should first and foremost find out what reputable modeling agencies are in his area. Send in candid polaroids of the child with all of his measurements—height, weight, clothing sizes, shoe size, the age of the child, their date of birth, and a phone number where they can be contacted. Then, if the agency is interested, they'll contact the parent and set up an interview with the parent and the child. The agency will interview the parent alone, the parent with the child, and the child alone, to see how the child interacts in various situations. The agent looks to see if the child is interesting and outgoing on his own—that's one thing. Or does the child act different around the parent? They take all this into consideration. After they meet with the agency, the agency determines whether or not they think that the child has an interesting look and will get enough work, because the agency is interested in children their clients are going to book a lot.

Lynda Johnson-Garrett

Send the child's photo with a letter requesting an interview. At your child's interview, he will probably be taken alone into a room to engage in friendly conversation. It is there that the agent will decide whether your child is the type that will be able to quickly adapt to the fast-paced show business world. Your child will be given copy geared to his age's reading level to see if he can read, memorize, and mimic simple line readings.

You can also look for a manager for your child. There are many managers who have large talent lists of children. When an audition call is placed with an agent, the agent calls several managers to submit his talent. So, if you work with a manager, you will have the opportunity to go on audition calls for many different agents.

Education

Your child's formal education should not be sacrificed for the money making potential of his professional career. Your local child labor laws will dictate how many hours your child can work on a given day, but, unfortunately, they don't spell out the laws as they relate to education.

The unions regulate educational requirements for child performers. The Screen Actors Guild has developed the clearest and most extensive policies regarding primary and secondary education.

SAG's policies address the areas of education, supervision, working hours, dressing rooms, play areas, medical care, personal safety, and child labor laws. If your child is guaranteed more than three days' work under an SAG contract, a tutor with proper teaching credentials must be hired at the expense of the producer or production company. Schoolroom facilities that closely approximate a real school classroom must also be provided by the producer. The parent must provide basic teaching tools (books, pencils, and paper), but the producer must provide black-

boards and other schoolroom equipment. These facilities are to be used only as a classroom. Your child will be individually tutored for about three hours per day.

As a parent, you should supplement the professional tutoring with your own educational lessons. You can bring creative materials with you to the set so that, during breaks, your child can use free time constructively.

Singing, dancing, and acting lessons are great learning disciplines for children and provide the rudimentary training ground for successful lives and careers.

> If you want to do anything for a child [who wants to become a successful performer], let him go to singing lessons, let him go to dance lessons, let him go where it's fun to perform. No charming child who's got "it" needs to be in a [formal acting class]. It's a waste of money. The kid either likes to do it and responds to the situation and enjoys it, but nothing in the world is going to make that kid do what you want them to do. Because when the parent is outside [the audition room]—I've seen it happen—the kid walks in the room and you say, "Why are you here?" and he says, "Because my mother made me!" And if it's not fun for the kid, and if the kid isn't loving it and enjoying it and doesn't have that kind of personality, leave him at home. As he gets older, pay attention to his reading skills. Again, dance classes, voice lessons. Teach him how to play the piano. Teach him how to play the guitar. Broaden his artistic horizons. Expose him to stuff. Let him have the fun of the performance. No heavy theater work for a kid under 18 or 19 or classes for a little cutie 7 to 10. He'll never need it, and the likelihood is that he'll be squashed as a result of it. It's hard enough teaching the adult actor or any adult creative person, because you're dealing with someone's feelings, his instruments, his fantasies, his dreams, his ego. It takes a long time to be able to feel your way to find out how to do it. It's a tremendous responsibility, because people can be hurt if they're not handled correctly. Bad teachers hurt people, particularly creative people who are so terribly vulnerable. If that can happen with an adult, imagine what can happen with a child.

> *Joan See*

On My First Big Break . . .

Well, it happened that I auditioned for Bill Cosby for *The Cosby Show*, and the episode that I did was a hit. Then I went to Virginia and did a play at Virginia Stage, and Bill called me back for another episode and offered to buy me out of that contract [the play at Virginia Stage]. So I left the first week of rehearsals, packed up my cat and my son in the cold, wet, and rain, and caught the plane back to New York. I got off the plane, sent my son to school, and went and worked that week on *The Cosby Show*. I finished taping on Thursday, picked up my son and cat, and took off back to Virginia for the third week of rehearsal in the play. It worked out wonderfully. I finished the play and, while I was in Virginia, I was offered a contract with *A Different World*. I went out to California and did one episode. They didn't use that episode because they changed all of their production personnel around and got rid of a lot of people. They didn't use me any more that year, and my contract was not picked up. And then the following year they said they were going to revitalize my character, and I went out there as a guest star. They flew me back and forth for each episode. When my contract was not picked up, I came back to New York and started working on *The Piano Lesson* up at Yale.

Lou Myers

I got my start from a photographer named Gustav Peterson, who was married to Pat Peterson, who's still the head of *The New York Times* fashion magazine. I went to see Gustav in 1967. I called him up first, and I said "Hello, my name is Naomi Sims. Have you time to see me?" He said, "Yes." This was highly unheard of, because a young woman must be with a modeling agency first. And when I went to see him, he asked if I had time to see his wife. I pulled out my appointment book, which was mostly blank

pages, and I said, "Yes, I do." So he had his secretary write down the name and address of his wife, and I got in a taxi and arrived at *The New York Times*. His wife liked me very much, and she asked if I could spend three days with her for a shooting. I said yes—I didn't bother to consult my appointment book this time, and I appeared on the cover in 1967 in August. That was my first major cover with many pages inside, *The New York Times* magazine called *Fashion of the Times*. That was my first job. I was 17 years old.

Naomi Sims

On the Casting Couch . . .

I got hit on a couple of times by photographers who tried to make me believe that they were going to make my career. I laughed because I knew that, if I've got it and I'm going to make it, I don't have to sell myself out.

Sheila Johnson

On Drugs and Alcohol . . .

I've seen drugs ruin many a person's life.

Naomi Sims

I will say this. I'm a Christian and I'm very thankful, as I had that as a foundation. When I got into modeling, I knew what was right and what was wrong. For some reason, I just believe that if you have the shield of knowledge, you'll know that it is wrong, that drugs are wrong, and that no one is going to get you anywhere you don't take yourself. Drugs are definitely in the industry—photographers, hair people, makeup people—it's there, running rampant. I've known two girls that died from overdoses. I know at least 20 girls who ruined their careers, ruined their reputations in the industry, lost all their money, because of what cocaine did to them. It's just not worth it. This career is a blessing, and drugs are going to be one of the first things that's going to say, "You've got money . . ." And you know what kind of friends drug money brings. So it's a one way street straight to nowhere.

Sheila Johnson

On What Turns Me Off . . .

What turns me off is two actors who fight each other. That's the biggest turn-off I can think of because two actors fighting each other is like two slaves fighting each other

when master goes away, instead of fighting the master. I will negotiate with a producer to the blood, but I have no intention of fighting another actor because we're both there to make a project work. With the television show, I find the actors are very clear, and it may be because they're making enough money and they feel that they're projected enough. But then, it may be because I'm working with younger people. I really don't know the reason. Actors who haven't been fortunate enough to have that seem to feel that another actor may be their competition. But I've found that actors who are thrust out into the business a little further see that other actors are really not their competition—it's really the casting directors and the producers. I find people at the off-Broadway level and the semi-Broadway and even Broadway levels get confused and think they should be fighting another actor.

Lou Myers

What turns me off? Dishonesty turns me off. And a lot of times, you meet people who have been in the business for a long time and they're a bit jaded and they have an attitude.

Blossette Kitson

Not being on time for an interview [makes me angry]. Being inarticulate [does] also. Being inarticulate, being difficult, in terms of not really expressing yourself in an interview. Or having it so the interviewer actually has to pull answers from you because you are not giving it up. To conduct yourself badly and then make the publicity department come behind you and clean the mess up.

Jacqueline Rhinehart

On the Lack of Work for Black Performers . . .

A black actor who wins an Oscar doesn't automatically get a million dollars a picture. In fact, probably the most tragic example of being nominated and the career not going anywhere is Howard Rollins. After *Ragtime* and being nominated, literally nothing happened for his career for a year, and he had to do a soap. Now he has *In the Heat of the Night,* but that's been years. If Howard Rollins Jr. had been some young white actor, I kid you not—a million dollars per picture, the whole thing. I think the same thing happened to Louis Gossett Jr. After he won the Oscar for *An Officer and a Gentleman,* he did a bunch of pretty unmemorable things for quite some time. And quite frankly, I can't say the momentum of his career has gotten to the point where I think it should be, because of the fact that he did win an Oscar. That's real tragic.

Jaki Brown-Karman

The number of jobs available are like night and day [for black vs. white performers]. When you read the scripts, whether it's television or features, they find a million ways to say young, white, and handsome or young, white, and beautiful. And every now and then there's a black role. And usually those roles go to those one or two black actors who are already there. And the only way the other black actors work is if those people are not available. And that's the sadness of this, because if you look at the young white stars, you can name them off. I can sit here for an hour just listing young white stars. But we have not replenished our young black stars. We don't really have any.

Travis Clark

There's a very limited area that we [African-Americans] can succeed in this industry. I don't care how much the trend is that they [White Hollywood] like blacks right now, that "black is back"—it's just gotten to be fashionable to be black right now.

Bethann Hardison

On What I'd Like to Change in the Industry . . .

If I could change anything in this town, what I would do is make every show hire one African-American person as a story editor, because I know within three years that person will be producing. Because story editors are the nuts and bolts of television. When you're a story editor, you learn at the table, you learn how to write and how to edit, because writing is just not writing. Writing for television involves the editing process and making sure you don't go over budget and all of these kinds of things. It's learning the whole process. That's how you become a show runner so that you can run a show. And [African-Americans] have very few of those people because we're not part of that process. *Cosby* is probably the only show that has the black writers. All those other shows have white and Jewish writers. Susan Fales [a black writer] started out as a writer [on *The Cosby Show*], then she went on to a story editor, then on to a producer [for *A Different World*]. Now she's an executive producer [for *A Different World*]. That's the process.

Travis Clark

On Success . . .

I'll tell you one thing that goes along with being seen by millions of people on television. I am recognized. I'm recognized a lot because the show is very popular, and I'm lucky to be on the show that so many young people watch—and old people, too. I'm stopped by all ages and all races. And it's amazing how many young men stop and recognize me and speak with such respect. So, if it means anything, then it means that

I do have to be living more carefully, because if the young people are watching, then I can't do some of the naughty things that I would like to do. A group of young black men came up to me, and I was a little nervous, and I felt guilty afterwards because they came up talking to "Mr. Gaines." But you know sometimes how loud they are, with their feet up and so forth, and I said to myself, oh no, are these kids coming to mess with me. They were on the subway kind of late at night, 'bout eleven o'clock, and they were coming to talk to "Mr. Gaines." While they were talking to me, they elevated to a level of great respect and understanding. What they did the minute after they left me, I'm not sure, but while they were talking to me, they think it's "Mr. Gaines." There's a level of respect that's amazing. All of this recognition gives me a responsibility. If there's more that's expected of you, then you have to live up to more. So having this job on television, it does give me a responsibility. I don't have a responsibility to build any particular image, but I do have a responsibility that I've always had, and that is to be the best person I can be at each given moment. So if you know people are watching you, it just helps you to live by that standard. You got to do it anyway, whether anybody sees you or not. But the fact that more people see you just kind of helps you. So this opportunity that I have to work is helping me discipline myself in areas where maybe I would fall down.

Lou Myers

After I got the series, friends called to congratulate me, and one of the first things they would say to me was, "You must be happy now that you're on a series!" I would respond, trying not to come off as ungrateful, by replying, "Yes, it's nice to be working." But behind that response I was thinking how happy I was with my life before I got the series, how getting a series does not make your problems go away, and believe you and me, how you work your butt and more off for every dime you get. Don't get me wrong—it was nice to be working steadily and it was also a boost to the actor ego that someone hired me to do what I enjoy most in life. But a lot comes with being a regular on a television sitcom. In the beginning, because the character I was portraying was so rich with possibilities (she was an African-American woman with an opinion), I made the assumption that this role would be a central part of the show. But being the only African-American in the cast (there was one other African-American on the production staff), I soon began to feel somewhat invisible. After the second week of production, my scenes dwindled from three to two, and sometimes one. And within those few scenes, I only had about three or four lines. On a few occasions, my one or two lines would get the biggest laughs, then the next week I would be reminded in a not-so-friendly way that I had the funniest line again! I never had a full conversation with any other character. The guest stars always had more to do than me. When it came time to promote the show, I was not included in any of the photos, television spots, or radio promos. There were even some issues about costumes. I can go on and on. After

pulling myself back into myself, what I had to keep in mind was that this was a job (J.O.B.!) and not to take it so seriously. There is an amount of stress that comes with the job; the facts are, as you should know, [African-Americans] always have to be on top of it, have our acts together, and still have to fight for what we think is right. It's a job, and what comes with every job is s--t. Believe you me, when I get my next series I will be more than prepared, because all that glitters isn't necessarily gold!

Anonymous Veteran Actress

On Being Black in the Entertainment Industry . . .

Black people in terms of image are a little more paranoid about the images that are perpetuated through an artist or even through the media, because normally, black artists have repercussions that are greater than those of what white artists experience—only because the black audience is normally so much more sensitive to the images that are portrayed. The black audience seems to feel as though it is almost a reflection on themselves, individually, about how their favorite artist looked, what he wore, and what he said—which is really kind of stupid because it really has nothing to do with the artist carrying the responsibility to be the best representative of all black people in the world. White artists don't have to worry about that. When Madonna wanted to wear a bra, she didn't have to worry about what all little white girls in the world were gonna think about it or whether she would be a good role model for all little white girls who had Barbie dolls. But black people seem to feel as though, when an artist has gotten to a certain level and is very popular, the artist should try his best to be the best representative for all black people because he doesn't know who's watching him—besides them watching, we're watching, our children need you, and they need you to be this, and need to grow up to look at you as a role model. The black audience really needs to separate itself from the images and the reality of the artist. They ought to be able to distinguish that which is real and that which is just an image and not get so caught up on the two because it really does hurt black artists. Black artists have to second-guess their publicity all the time because they have to look at it in that context—how black people are going to react to them. Look at when Sammy Davis Jr. hugged Richard Nixon. All of that flack over that. Both Louis Armstrong and Bojangles felt the sting of the black community's reaction to what they thought were negative images, with little or no regard given for their actual talents. The semantics of images are phony. It was a personal thing, but I'm sure it was probably a reflection in terms of his mass appeal to black folks. And we [as black people] do that a lot, whereas white artists don't have to contend with that type of restriction. It's kind of limiting in terms of how far we let an artist go. Take Prince, for example, who luckily seems to be beyond the flack and just doesn't seem to really give a damn about how we perceive

him—is he black enough, or he's on that horse with no clothes, and all that kind of thing. We carry on about that, and we limit the artist's creativity. It's gotten all caught up in images we're concerned about as black folks and that's kind of tired.

<div align="right">Jacqueline Rhinehart</div>

On the Entertainment Industry . . .

I think that we're in a business I like to describe as the ultimate "sadomasochistic" relationship because the highs are so incredible that they can negate the lows. And when we think of how hard it is to just get over and have any kind of career, to be a black actor, and say that you're a working actor, and you only derive your income from acting, is a feat in itself. But I think when people start to give themselves the wrong set of parameters—for example, I think we sometimes have a tendency to base where we are in our career on where other people are in their careers, that we know are our peers, and when we sometimes consider considerably less talented than we are. But what I think we have to do is just remember there's no guarantee when you go into this business that you're going to make it. There are no rules, and if there were rules, by the time you learned them they would have been rewritten. But it's something that I like to equate with a seminar I saw where Sidney Poitier spoke. He said something that I thought kind of summed it up and that was, to paraphrase him, that there are a lot of people that he finds much more talented and gifted than he is, who are black actors that were his peers when he was in New York. He said that a lot of them died unrequited in their careers. He feels very lucky to have reached the status that he did because, he says, quite frankly, he would have done what he did without being paid. So if you go into it thinking you're going to find fame and fortune, you're doing the wrong thing for the wrong reasons. But if you really believe that you have talent and can persevere, then the reality is, go for it until you just don't feel that you can do it anymore. But don't give yourself a time frame and say, "If I don't do it by this age . . ." or "I can't believe my friend so and so is doing a television series . . ." because that has nothing to do with your career. Just remember it's always you and don't worry about what other people are doing in their careers. That's the first thing that's going to trip you up. If you don't persevere and really give it your absolute all, how you can honestly say that you went for it?

<div align="right">Jaki Brown-Karman</div>

On the Black State of the Arts . . .

There are good times and bad times for African-Americans in the entertainment industry. Considering our limited employment opportunities in relation to the industry

workload, we must consider every job booked by a black actor or actress as a victory won. We should acknowledge our accomplishments, no matter how small or insignificant they may appear, but not get complacent, for there is a lot of work ahead in improving. The black state of the arts—the current status of being black in the entertainment industry.

Tanya Kersey-Henley and Bruce Hawkins

APPENDIX

RECOMMENDED READING

Acting in the Million Dollar Minute (Tom Logan, Communications Press, Washington DC, 1984)

Acting Professionally, 4th Ed. (Robert Cohen, Mayfield Publishing Co., 1990)

Acting World Books Seminars-To-Go Series:
"Audition Tapes, Audition Scenes, And Showcasing"
"The Film Actor's Career Building Stepladder"
"The Film Job, Step By Step - Before, During, After"
"How To Get, Work With, And Keep The Best Agent For You"
"Increasing Your Success Ratio in Interviews And Reading for Roles"
"Self Promotion, Self Publicizing, and Self Advertising for the Actor"

The Actor's Survival Guide for Today's Film Industry (Renee Harmon, Prentice Hall, 1984)

The Actor: A Practical Guide to a Professional Career (Eve Brandstein with Joanna Lipari)

Agents: The Guide To Today's Powerbrokers (Lynda Bensky, Paris Publishing, LA, 1987)

All About Health and Beauty for the Black Woman (Naomi Sims, Doubleday, 1976)

Audition (Michael Shurtleff, Walker & Co., NYC, 1978)

The Back Stage Handbook for Performing Artists (edited and compiled by Sherry Eaker, Back Stage Publications, NY, 1989)

Becoming A Professional Model (Larry Goldman, Beech Tree Books, 1986)

The Bicoastal Bible: A Survival Manual for the New York/Los Angeles Commuter or Transplant (C.R. Nelson, Hap Hatton, and Jim Jansen)

Black Hollywood—The Negro In Motion Pictures (Gary Null, Citadel Press, 1980)

The Dance Workshop (Robert Cohan, Simon and Schuster, 1987)

The Dancer's Survival Guide (Marian Horosko and Judith R.E. Kupersmith)

Eileen Ford's Secrets of the Model's World (Eileen Ford, Trident Press, 1970)

Everything You Always Wanted To Know About L.A.'s And N.Y.'s Casting Directors ... But Were Afraid to Ask (Wendy Shawn, Castbusters, LA, 1986)

Fornay's Guide to Skin Care and Makeup for Women of Color (Alfred Fornay, Simon & Schuster)

Getting Noticed: A Musician's Guide to Publicity and Self-Promotion (James Gibson)

High Visibility (Irving Rein, Philip Kotler, and Martin Stoller)

How to Act and Eat at the Same Time: The Business of Landing a Professional Acting Job (Tom Logan, Communications Press, Washington, DC)

How to Audition for the Musical Theatre (Donald Oliver, Drama Book Publishers, NY)

How to Be a Working Actor (Mari Lyn Henry and Lynne Rogers, M. Evans and Co., NY, 1986)

How to Get Cast in Soaps in NYC (Anne MacPherson, Screen Test Publishing, NY)

How to Get Into Commercials (Vangie Hayes with Gloria Hainline, Harper & Row, NY)

How to Meet the Press: A Survival Guide (Jack Herton)

How to Sell Yourself as an Actor (K. Callan, Sweden Press, LA

The L.A. Agent Book (K. Callan, Sweden Press)

Making It in Showbiz (The Stars Tell You How You Can Do It Too!) (George Goldberg, Contemporary Books, Chicago, NY, 1988)

Making It in the New Music Business (James Riordan)

Male Model—The World Behind The Camera (Charles Hix with Michael Taylor, St. Martin's Press, 1979)

Michael Maron's Instant Makeup Magic (Michael P. Maron, Rowson Associates, 1983)

Model (Mark Stevens, Harper and Row, 1981)

The N.Y. Agent Book (K. Callan, Sweden Press)

Opportunities in Acting Careers (Dick Moore, VGM Career Horizons, 1986, Lincolnwood, IL)

The Picture/Resume Book (Jill Charles and Tom Bloom, Theatre Directories, Dorset, VT)

Respect For Acting (Uta Hagen with Haskel Frankel, Macmillan Publishing Company, 1973)

Screen Acting (Brian Adams)

Seven Steps to a Better Resume (Paul Haker, Paul Haker Enterprises, 1988)

Split Image—African Americans in the Mass Media (Jeanette Dates, Howard Univ. Press, 1990)

TV Acting—A Manual For Camera Performance (James Hindman, Larry Kirkeman, and Elizabeth Monk, Hastings House Publishers, 1982)

Welcome to New York (Roberta Seret, Harper & Row, NY)

Word of Mouth: A Guide to Commercial Voice-Over Excellence (Susan Blu and Molly Ann Mullin, Pomegranate Press, Ltd.)

Your Film Acting Career: How to Break Into the Movies and Television and Survive in Hollywood (M.K. Lewis and Rosemary Lewis, Gorham House Publishing)

THEATRICAL BOOKSTORES

Many of these theatrical bookstores have mail order catalogs for people who don't live in the area. You can call or write for information.

Act 1 Bookstore, Ltd.,632 N. Lincoln, Chicago, IL 60614, (312) 348-6757

Actor's Heritage, 262 West 44th St., New York, NY 10036, (800) 446-6905, (212) 944-7490

Applause Theater/Cinema Books, 211 West 71st St., New York, NY 10023, (212) 496-7511

Backstage, Inc., 2101 P St., NW, Washington DC 20037, (202) 775-1488

Baker's Plays, 100 Chauncy St., Boston, MA 02111, (617) 482-1280

Cinema Books, 4753 Roosevelt Way, NE, Seattle, WA 98105, (206) 547-7667

Drama Books, 134 Ninth St., San Francisco, CA 94103, (415) 255-0604

Drama Book Shop, 723 Seventh Ave., New York, NY 10019, (212) 944-0595

Elliot Katt Books, 8568 Melrose, Los Angeles, CA 90069, (213) 652-5178

Intermission: The Shop for the Performing Arts, 8405 Germantown Ave., Philadelphia, PA 19118, (215) 242-8515

Larry Edmund's Bookshop, 6658 Hollywood Blvd., Hollywood, CA 90028, (213) 463-3273

Limelight Bookstore, 1803 Market St., San Francisco, CA 94103, (415) 864-2265

Model's Mart, 17 East 48th St., New York, NY 10017, (212) 688-6215

Philadelphia Drama Book Shop, 2209 Walnut St., Philadelphia, PA 19103, (215) 981-0777

Samuel French, 45 West 25th St., New York, NY 10010, (212) 206-8990

Samuel French's Theater and Film Bookshop, 7623 Sunset Blvd., Hollywood, CA 90046, (213) 876-0570; 11963 Ventura Blvd., Studio City, CA 91604, (818) 762-0535

The Theatre Arts Bookshop, 405 West 42nd St., New York, NY 10036, (212) 564-0402

Theatrebooks, 1600 Broadway, Room 1009, New York, NY 10019, (212) 757-2834

TRADE PUBLICATIONS
AND RESOURCE GUIDES

Audition News, 6272 W. North Ave., Chicago, IL 60639, (312) 637-4695—Monthly magazine covering employment opportunities for music, theatre, dance, variety and modeling. Primarily covers Chicago and the greater mid-West.

Back Stage/The Performing Arts Weekly, Back Stage Publications, 330 West 42nd St., New York, NY 10036, (212) 947-0020—Weekly trade paper for East Coast performers, includes audition notices.

Back Stage West/The Performing Arts Weekly, Back Stage Publications, 5055 Wilshire Blvd., Los Angeles, CA 90036, (213) 525-2356—Weekly trade paper for West Coast performers, includes audition notices.

Billboard, 1515 Broadway, New York, NY 10036

Black Masks, P.O. Box, Bronx, NY 10471, (212) 549-6908

Black Talent News, P.O. Box 7374, Culver City, CA 90233-7374, (310) 642-7658, fax (310) 642-7587, e-mail: *BTN@vine.org*—The only trade publication for African Americans in the television, film, music, and theatre industries. Includes casting information, production charts, how-to information, interviews with industry professionals, calendar of events, and industry news. Published 10 times a year. Subscriptions are $21 for one year and $36 for two years.

Casting Call, 11222 Weddington St., North Hollywood, CA 91601, (818) 506-1817— A bi-weekly entertainment publication for West Coast performers.

Call Board, 2940 16th St., Suite 102, San Francisco, CA 94103, (415) 621-0427—Monthly publication of Theatre Bay Area, covering theatre news and audition notices.

The C/D Directory, Breakdown Services—Lists feature film and television casting directors in Los Angeles. It also contains a listing of acting coaches, workshops, and schools. Published every three months and updated every two weeks.

Directory of Theatre Training Programs II, edited by Jill Charles, Theatre Directories, American TheatreWorks, Inc., P.O. Box 519, Dorset, VT 05251, $17.50—Published by Theatre Directories. Profiles 250 theatre programs at colleges, universities, and conservatories. Offers detailed information on admissions, degrees offered, faculties, courses, facilities, productions, and philosophy of training, plus articles on making choices about a career in the performing arts, and finding the training program most suited to your goals.

Drama-Logue, P.O. Box 38771, Los Angeles, California 90038-0771—Weekly LA trade paper includes LA and national audition notices.

Dramatics, 3368 Central Parkway, Cincinnati, OH 45225

Harlem Cultural Council Newsletter, 215 West 125th St., New York, NY 10027, (212) 316-6277)

Hollywood Reporter, 6715 Sunset Blvd., Hollywood, California 90028

Hollywood Variety, 1400 North Cahuenga Blvd., Los Angeles, California 90028

The International Directory of Model & Talent Agencies & Schools, Peter Glenn Publications, NY, $25—Lists model and talent agencies and schools, associations and pageant information in the USA, Canada and around the world. Over 2,000 listings.

The Madison Ave. Handbook, Peter Glenn Publications, NY, $45.00—Listings in every area of advertising, film, talent and casting agencies, etc. in NY, LA, San Francisco, Chicago, Detroit, Florida, Texas, and Canada.

NY Casting & Survival Guide . . . & Datebook, Peter Glenn Publications, NY, $15—Listings include sections on survival aids, professional services, casting, and a NYC geographical section that breaks down listings street by street.

New York Casting and Survival Guide, Peter Glenn Publications, 17 East 48th St., New York, NY 10017

The New York C/D Directory, Breakdown Services—Lists studio and network affiliates of New York casting directors. It is published monthly.

Performink, 2632 N. Lincoln, Chicago, IL 60614, (312) 348-4658—Bi-weekly theatre news journals includes articles by and for working theatre professionals, audition notices, and classified ads. Available free in the city or by subscription.

Regional Theatre Directory, Edited by Jill Charles, Theatre Directories, American Theatre Works, Inc., P.O. Box 519, Dorset, VT 05251—A national guide to employment in over 435 regional and dinner theatres for performers (Equity and non-Equity), and internship opportunities for students. Lists contact information, interview/audition procedures, salaries and housing, internships, facilities, and company profiles, plus articles and other resources. Annual publication.

Ross Reports Television, Television Index, Inc., 40-29 27th St., L.I.C., NY 11101, (718) 937-3990—Lists casting people, franchised agents with commercial casting in NY area, unions, literary agents, NY advertising agencies, casting in soaps (NY & LA), TV packagers, all prime-time network programming and production personnel. Published monthly.

Ross Reports USA: A Guide to Talent Agents & Personal Managers Nationwide, Television Index, Inc., 40-29 27th St., L.I.C., NY 11101, (718) 937-3990—Nationwide listing of union franchised talent agents and personal managers who are members of the National Conference of Personal Managers

The Studio Blu-Book/Hollywood Reporter, *Hollywood Reporter*—Resource book for the entertainment industry; lists services, personnel, and talent contacts in all areas of show business including agents, casting directors, production companies, and numerous talent services.

Summer Theatre Directory, edited by Jill Charles, Theatre Directories, American Theatre Works, Inc., P.O. Box 519, Dorset, VT 0525—Profiles employment opportunities at over 500 summer theatres (Equity and non-Equity) and summer training programs. Lists contact information, interview/audition procedures, salaries and housing, internships, facilities, and company profiles, plus articles and other resources. Annual publication.

Variety, Variety, Inc., 154 West 46th St., New York, NY 10036

The Working Actor's Guide to L.A., Paul Flattery Productions—Lists agents, personal managers, publicists, business managers, attorneys, casting directors, and their individual business descriptions as well as a wide range of career and personal services for the performing artist.

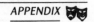

TALENT DIRECTORIES

The Academy Players Directory, The Academy of Motion Pictures Arts and Sciences, 8949 Wilshire Blvd., Beverly Hills, California 90211

The Black Players Directory, *Black Talent News*, P.O. Box 7374, Culver City, CA 90233-7374

The Players Guide, 165 West 46th St., New York, New York 10036

Whitmark Directory, Whitmark Associates, 4120 Main St., Dallas, Texas 75226

UNIONS AND GUILDS

This lists the national offices of the performing arts unions and guilds. For information on the local office in your area, contact the national office.

Actors Equity Association (AEA), 165 West 46th St., New York, NY 10036, (213) 869-8530

American Guild of Variety Artists (AGVA), 184 Fifth Ave., New York, NY 10010, (212) 675-1003

American Guild of Musical Artists (AGMA), 1727 Broadway, New York, NY 10019, (212) 265-3687

American Federation of Television and Radio Artists (AFTRA), 260 Madison Ave., 7th Floor, New York, NY 10016, (212) 532-0800

Screen Actors Guild (SAG), 5757 Wilshire Blvd., Los Angeles, CA 90036, (213) 954-1600

WHO'S WHO AMONG THE INTERVIEWEES

The following are biographical sketches, listed in alphabetical order, of the industry professionals who were interviewed for this book.

ADILAH BARNES, ACTRESS, TEACHER, DIRECTOR AND PRODUCER—Adilah Barnes is a seasoned stage and television actress. Her theatre credits include *Joe Turner's Come and Gone,* which she performed at the American Conservatory Theatre and Los Angeles Theatre Center. For three seasons, Ms. Barnes had a recurring role on the television sitcom *Roseanne,.* Other television credits include *thirtysomething, Blue Skies*, and two made-for-television movies, *The Image* and *Cast the First Stone*. Adilah also teaches a character development workshop in Hollywood and tours her one-woman show, "I Am That I Am Woman Black", all across the United States.

CONNIE BEST, FIELD REPRESENTATIVE, AFTRA, NEW YORK—Connie Best is the head New York Union Field Representation for the American Federation of Television and Radio Artists. She is also one of our most active African-American union professionals.

JAKI BROWN-KARMAN, INDEPENDENT CASTING DIRECTOR—Jaki Brown-Karman is one of the industry's leading black casting directors. She began her career as a talent agent in New York before making the transition to casting. Ms. Brown has been involved in casting *The Jacksons: An American Dream, The Five Heartbeats, South Central, The New Odd Couple, Hollywood Shuffle, The Last Dragon*, the PBS American Playhouse production of *Stand and Deliver, The Court Martial of Jackie Robinson, I'm Gonna Get You Sucka* and several other television movies and pilots.

TRAVIS CLARK, PRESIDENT, LTC ENTERTAINMENT & TRAVIS CLARK MANAGEMENT—Writer, producer and personal manager Travis Clark heads his own production company, LTC Entertainment. A graduate of UCLA, Travis began his show business career as a personal manager. His management firm, Travis Clark Management, has represented Philip Michael Thomas and Willie Gault, among others. Mr. Clark co-created the television series *Tour of Duty* and *A Man Called Hawk*, which he also wrote and produced.

WENDY CURIEL, COMMERCIAL TALENT AGENCY, OPPENHEIM-CHRISTIE AGENCY— Wendy Curiel is a leading talent agent, representing actors for commercials. Ms. Curiel is a well-known and respected top New York commercial talent, specializing in black and Hispanic performers.

IAN DAVIS, MANAGER—Ian Davis is a personal manager for musical artists. During a one-day stay in London, England in 1981, Mr. Davis got involved in managing the career of a musician friend, and ID Management was born. Mr. Davis has worked with Phil Collins, Bobby Lyle, Simon Harris, Gary Herbig, Side Effect, Manhattan Transfer, and Genesis. He has a master's degree in Business from the University of Southern California.

ALFRED FORNAY, BEAUTY EXPERT AND AUTHOR—Alfred Fornay is one of America's foremost authorities on skin care, makeup, fashion, and grooming. A graduate of the State University of New York's Fashion Institute of Technology and City College of New York, with degrees in merchandising and marketing, Mr. Fornay has held numerous top level positions in the beauty and fashion worlds. He was Creative Director for Revlon's Polished Ambers Collection, Marketing Manager for Clairol, Training Director for Fashion Fair, Beauty Editor for *Ebony* magazine, and Editor-in-Chief of *Ebony Man* magazine. Mr. Fornay is also the author of *Fornay's Guide to Skin Care and Makeup for Women of Color*.

SASSY GERHARDT, MARKETING AND CASTING CONSULTANT—Sassy Gerhardt formerly headed New York's Source Seeker Actors and Models Service. She is currently a marketing and casting consultant in Southern California.

PAT GOLDEN, INDEPENDENT CASTING DIRECTOR, GOLDEN CASTING—Leading New York City independent casting director and one of our country's top black casting directors, Pat Golden casts feature films, television, theater, industrials, and commercials. Her most prestigious casting credits include *Krush Groove*, *Beat Street*, *Ragtime*, *Platoon,* and *Blue Velvet*. She is also privileged to have cast Dr. Haing S. Nor in his Academy Award-winning role as Dith Pran in the blockbuster feature film *The Killing Fields*.

BETHANN HARDISON, PRESIDENT, BETHANN MANAGEMENT—Bethann was one of the first black models to reach international status as a runway fashion model in Europe. She now heads a successful New York talent and model management company, Bethann Management, which represents Tyson Beckford, one of the country's top black male models. Ms. Hardison is also the mother of *A Different World* star Kadeem Hardison.

DR. GEORGE HILL, CURATOR AND AUTHOR—Dr. George Hill is the author of *Blacks in Hollywood* and the producer/curator of the Dorothy Dandridge and Black Women in Film movie poster exhibits. Dr. Hill has authored 19 books, nine of them on blacks in communications, and he has one of the largest private collections of soundtracks, film memorabilia, books, and magazines chronicling the history of African-Americans in the film and television industries.

LOUIS JOHNSON, CHOREOGRAPHER AND DANCER—Louis Johnson is one of our country's leading black director/choreographers, and one of the first and most famous black classical ballet dancers. Louis was nominated for a Tony Award for choreographing *Purlie* and has won acclaim for his choreographic work in *The Wiz* with Diana Ross and Michael Jackson and road companies of *Porgy and Bess*. He has also choreographed several of Melvin Van Peeble's theatrical projects, including *Waltz of the Stork* and *Champeen*. Louis has appeared on Broadway and has the distinction of having choreographed two operas for New York's Metropolitan Opera Company as well as several ballets for the Alvin Ailey American Dance Theatre and The Dance Theatre of Harlem. Mr. Johnson has choreographed acts for Aretha Franklin, Sherman Hemsley, Julie Newmar, Dick Shawn, and Pearl Bailey and has partnered dance greats Chita Rivera and Gwen Verdon. Louis was known as a resident dance teacher for the Negro Ensemble Company, having taught Denise Nicholas, Hattie Winston, the late Rosalind Cash, Robert Hooks, Esther Rolle, Moses Gunn, Douglas Turner Ward, and Lynn Whitfield.

LYNDA JOHNSON-GARRETT, CHILDREN'S STYLE EDITOR, FAIRCHILD PUBLICATIONS—As the Style Editor for one of the apparel market's leading trade publications for children's apparel, Lynda Johnson-Garrett is responsible for casting child models for print advertisements. Previously, Ms. Garrett was editor of Fairchild Publication's *Sportstyle* magazine. A graduate of New York's prestigious Fashion Institute of Technology (FIT), Ms. Garrett now serves as a faculty memeber at FIT and also does freelance fashion reporting for *Essence* magazine and works as a freelance fashion editor for Mattel's *Barbie* magazine.

SHEILA JOHNSON, MODEL-ACTRESS—Born in a small town outside Boston, supermodel-turned-actress Sheila Johnson spent only 2-1/2 years at Emerson College as a Theatre major before deciding to move to New York to pursue an acting career. While studying with Anna Strasberg at the famed New York Actors Studio, Ms. Johnson was discovered by a fellow student, Michael Wright, who suggested she try her hand at modeling and sent her to the Elite Modeling Agency, who signed her immediately. That was more than 16 years ago. Since then, Sheila has appeared on more than 20 magazine covers including *Vogue*, *Ebony,* and *Essence*. She was the third black model ever to appear on the cover of *Vogue*. Ms. Johnson has also appeared in print advertisements for Virginia Slims cigarettes, Covergirl cosmetics, Napier Jewelry, and several hair products. Her travels have taken her all over the world including Africa, Europe, Italy, Greece, and Israel. Sheila is currently living in Los Angles pursuing modeling and acting.

PAUL LAURENCE JONES, RECORD PRODUCER AND RECORDING ARTIST—Paul Laurence Jones began his musical career in school and in the church choir. He is now an accomplished record producer, composer, recording artist, and businessman who runs his affairs through his

production company, StoneJones Productions, and his music publishing company, Bush Burning. Paul lists among his many credits composing and producing the Orpheus Pictures film score for Def by Temptation. He is probably best known for his work with singer Freddie Jackson, having written and produced some of Freddie's biggest hists, including "Rock Me Tonight," "Jam Tonight," and "Tasty Love," and Stephanie Mills' "Puttin' a Rush On Me." Mr. Jones has also written and produced songs for Smokey Robinson, Johnny Gill, Lilo Thomas, Evelyn Champagne King, and Keith Washington.

SHIRLEY JORDAN, ACTRESS/WRITER—Shirley Jordan is a veteran actress with over 15 years of experience to her credit. She has worked in every area of the business from feature films and television to commercials and industrial films. Hailing from Pawcatuck, Connecticut (right outside of Mystic), Shirley attended the University of Connecticut where she received a B.F.A. in Theatre. Stints in summer stock and theme park followed graduation, and it wasn't long before she began to work professionally as an actress. Jobs in commercials, print work, and voiceovers and roles on *All My Children* and *One Life to Live* quickly followed. Theatrically, Shirley has studied privately with Martin Fried (Strasberg) and Michael Shurtleff. Her career has led her to work in prime time television with such greats as Bill Cosby, Faye Dunaway, Shelly Fabares, and Robert Urich, and on stage with John B. Williams and the OBIE-award winning playwright Bradley Rand Smith, to name just a few. Shirley is also the Executive Editor of *Black Talent News, The Entertainment Industry Publication for African-Americans.*

BLOSSETTE KITSON, ASSOCIATE DIRECTOR OF A&R, SBK RECORDS—Blossette has worked with Tracy Chapman and Gregory Abbott as Administrative Coordinator for SBK Productions, and she is responsible for signing Sami McKinney ("Just Because"), La La ("You Give Good Love"), and Johnny Kemp as writers to SBK Publishing. As Associate Director of A&R, Blossette is responsible for signing and developing new talent for the label.

ANNAMARIE KOSTURA, NETWORK CASTING DIRECTOR—Formerly casting director for the ABC soap opera *One Life to Live*, Annamarie is currently a network casting director for NBC.

JAMES KRIEGSMAN JR., PHOTOGRAPHER, KRIEGSMAN STUDIO—Kriegsman Studios is a family-owned photography business that has been in existence for over 50 years. The studio, one of the leading theatrical photo studios in New York City, has photographed countless movie stars, recording artists, and celebrities, including Ben Vereen, the Supremes, the Marvelettes, and Ben E. King. One of the oldest theatrical photography studios in New York, Kriegsman Studios was located in the Actors Equity building. James Kriegsman has been photographing African-American performers for more than 20 years.

PETER LERMAN, FORMER AGENT, ROGERS & LERMAN—In 1986 Peter Lerman merged his commercial print modeling agency, Models/Models, Inc., with Wallace Rogers, Inc. Since that time an association with theatrical talent agent, Dale Lally, has helped Rogers and Lerman to become one of New York's leading commercial print modeling and talent agencies.

ERIC MANSKER, STUNT PERFORMER, STUNT COORDINATOR ,AND ACTOR—Eric Mansker is a well known and highly respected stunt performer, stunt coordinator, and actor. Mr. Mansker is currently the Chair of the AFTRA/SAG Coalition for Stunt Performers of Color.

TRACEY MOORE-MARABLE, INDEPENDENT CASTING DIRECTOR—Tracey is one of the industry's leading African-American casting directors. She is currently casting feature films, television, music videos, and commercials. Her long list of television and film casting credits include *A Brother's Kiss*, *Siao Yu*, *New Jersey Drive*, *Music Scoupe*, *Just Another Girl on the I.R.T.*, *New York Undercover*, and *Girl 6*. Ms. Moore-Marable has cast commercials for Family Donor, the *New York Times*, and Planned Parenthood. She has cast several of director Spike Lee's commercial spots including Nike, Taco Bell, AT&T, and ESPN. She has also cast music videos for Naughty by Nature, Branford Marsalis, Father M.C., Jodeci, Heavy D, Full Force, SWV, Bobby Brown, and Marky Mark.

LOU MEYERS, ACTOR—A native of Coal Mines, West Virginia, Lou Meyers has been acting all of his life. He began his career working on the road narrating jazz groups and dancing. He performed in churches, schools, jails, hospitals, and senior citizen centers and in community theater before he got his break on off-Broadway. Lou has toured over 75 colleges in the U.S. and throughout Japan with his Drama in Concepts theatrical ensemble. Mr. Meyers is probably best known for his work in NBC's *A Different World* as the lovable "Mr. Gaines." Lou Meyers has a distinguished list of professional credits that include *The Piano Lesson* on Broadway, *Fat Tuesday* at the New Heritage Theater, and the Broadway production of *The First Breeze of Summer*, produced by the Negro Ensemble Company.

BILL OVERTON, PRODUCER/ACTOR—A graduate of Wake Forest University, Winston-Salem, North Carolina, Bill Overton enjoyed success as one of the few black male models in the early 1970s after a short stint in professional football. Following his eight years in the modeling business, Bill made his way to California where he built up a long list of professional stage, television, film, and commercial credits. Mr. Overton combines a successful marriage to actress Jayne Kennedy with whom he has three daughters, his acting and production projects, a real estate business, and active community involvement.

TUCKER PARSONS, CO-FOUNDER, THE VINE—Tucker Parsons is one of the co-founders of The Vine, an online service for the entertainment industry.

STACEY RAIDER, TELEVISION PRODUCER—Stacey Raider formerly cast actors for ABC's daytime soap opera *All My Children*. Currently producing educational television projects, Ms. Raider produces the award-winning children's series *Reading Rainbow*.

BETTY REA, CBS-TV, CASTING DIRECTOR—Veteran casting director Betty Rea has been doing principal casting for the CBS soap opera, *The Guiding Light* for more than 24 years.

JACK ROSE, TALENT AGENT—As a prominent attorney, Jack Rose was known as one of the most skillful negotiators in the entertainment industry. He then went on to produce numerous motion pictures and television shows before forming the Jack Rose Agency, which sadly closed its doors in the early 1990s. As an agent, Mr. Rose represented Kim Fields and Pat Colbert, among others.

JACKIE RHINEHART, DIRECTOR OF R&B PUBLICITY, ARISTA RECORDS—As Arista Records' Director of R&B Publicity, Jacqueline Rhinehart is responsible for publicizing and promoting the careers of recording artists Whitney Houston, Jermaine Jackson, Lisa Stansfield, Aretha Franklin, Dionne Warwick, Taylor Dane, Ashford & Simpson, Kenny G, Jennifer Holiday, The Four Tops, Jeffrey Osborne, Kashif, and The Eurhythmics.

KERRY RUFF, ACTOR—As a "working actor," Kerry developed a long list of commercial, print, voiceover, industrial, stage, film, and television credits to his name. He also co-founded The Source Seeker Actors and Models Service.

KIDANE SAYFOU, INTERNATIONAL FASHION MODEL AND ACTOR—Ethiopian-born model Kidane Sayfou began his show business career in Europe as a dance understudy with Maurice Bejart's Ballet Twentieth Century. His face has graced the fashion pages of countless publications including the *New York Times* fashion supplements, *Essence*, *GQ* and *Ebony*. Known for his exotic looks, Kidane was first discovered by Elite Modeling Agency owner John Casablancas while cooking a party dinner.

JOAN SEE, ACTRESS AND ACTING COACH—Joan See owns and operates Three of Studios and Actors in Advertising, one of New York's top theatrical training and casting facilities. A veteran of radio commercials, Ms. See is an accomplished actress with over 30 years' experience in the business and close to 1,000 commercial acting credits.

RASHID SILVERA, INTERNATIONAL FASHION MODEL—Boston native Rashid Silvera has been long recognized as one of the world's top black male models. Mr. Silvera has appeared on the cover of countless magazines including *GQ*, *Essence,* and *Ebony*, and several television commercials. Rashid combines his theatrical endeavors with a full time teaching career as a history teacher in Westchester County, New York.

NAOMI SIMS, INTERNATIONAL BEAUTY EXPERT, AUTHOR, AND FORMER SUPERMODEL—Naomi Sims was the first black model to appear on the cover of a national magazine when in 1969, at the age of 19, she graced the cover of *Life*. A native of Oxford, Mississippi, and raised in Pittsburgh, Pennsylvania, Naomi Sims is recognized as one of the country's foremost experts on beauty, hair, makeup, and skin care for black women. She is the author of *All About Health and Beauty for the Black Woman*. Ms. Sims also has her own makeup and skin care collection in addition to her famous Naomi Sims Wig Collection.

WINSOME SINCLAIR, INDEPENDENT CASTING DIRECTOR—Winsome Sinclair has cast several projects for Spike Lee, including the epic *Malcolm X, Mo' Better Blues, Jungle Fever, Crooklyn, Dead Presidents,* and *Clockers*. In film, Winsome has collaborated with history-making African-American film directors Mario Van Peebles, Ernest Dickerson, Forest Whitaker, John Singleton, and Ayoka Chenzira. Her reputation and work have forced her into the spotlight of filmmaking's black elite, becoming one of the hottest young new casting directors around town.

TONY SINGLETARY, DIRECTOR—While walking down the halls of Channel 13 KCOP-TV in Los Angeles, Tony Singletary overheard that the news director didn't show up, so he applied for the job on the spot. He was given the chance and has been directing ever since. A graduate of the University of California, Santa Barbara, with a degree in telecommunications (television and film), Tony began his career working in the mailroom of Channel 13. Seven months later he wound up with a stage crew position building sets and doing props before his chance encounter with destiny in the television station hallway. Mr. Singletary lists among his many directorial credits *The Cosby Show, 227, The Jeffersons, Head of the Class, Gimmie a Break, One Day at a Time, Archie Bunker's Place, Open All Night, Benson, Teachers Only, The Ropers, Bustin' Loose, Different Strokes,* and *What a Country*.

J.B. SUTHERLAND, FREELANCE NEW YORK TALENT AGENT—J.B. began her casting career as an assistant casting director in the television commercial casting department of Ogilvy & Mather Advertising in New York City. For 20 years she supervised Ogilvy & Mather's print casting department, casting models and actors for print advertisements. Currently, Ms. Sutherland is a freelance talent agent with a leading New York talent agency.

JAMES THOMAS, PRESIDENT, BEM ENTERTAINMENT—James Thomas has over 10 years of entertainment industry experience. Mr. Thomas is President of BEM Entertainment, which is the parent company for *The Hollywood Music Showcase*, The Entertainment Industry Expo, *Black Entertainment Magazine*, BEM Records, and BEM International. Mr. Thomas is also the Music Editor for *Black Talent News: The Entertainment Industry Publication for African-Americans*.